OTTOMAN CAIRO

OTTOMAN CAIRO

RELIGIOUS ARCHITECTURE FROM SULTAN SELIM TO NAPOLEON

Chahinda Karim

With contributions by Menna M. El Mahy

The American University in Cairo Press

Cairo New York

In loving memory of Chahinda Karim, who passed away just as this book was going to press; a name so close to the hearts of generations of students of the American University in Cairo.

Dr. Karim devoted her life to sharing with her students her passion for Islamic art and architecture, and to unraveling the riches and beauty of the architectural eras she taught.

Beyond the AUC community, she was much loved and respected by all who crossed her path on Cairo's historic sites and streets.

This book is the last milestone on her road of achievements. May God accept it as ongoing charity on behalf of her pure soul.

Dr. Chahinda, having you as my mentor was a privilege, and working with you on this book was an honor. I owe you everything.

Menna M. El Mahy

First published in 2021 by
The American University in Cairo Press
113 Sharia Kasr el Aini, Cairo, Egypt
One Rockefeller Plaza, 10th Floor, New York, NY 10020
www.aucpress.com

ISBN 978 1 6490 3084 9

Library of Congress Cataloging-in-Publication Data applied for

1 2 3 4 5 25 24 23 22 21

Designed by Sally Boylan
Printed in China

Contents

Acknowledgments

This book would have never come to light without the encouragement of my students at the American University in Cairo, who kept asking me about a book that offers a comprehensive study on Ottoman architecture in Cairo. Several years ago, when I was preparing a course for graduate students of Islamic Art and Architecture at the American University in Cairo (AUC), I was faced with the fact that there were few secondary sources in English and Arabic available for students to refer to, and most of the pictures in the sources were of poor quality. We were lucky to be in Cairo and were thus able to go and visit as many buildings as possible during the semester. This book finally provides a much-needed comprehensive study for students of Islamic architecture, religious architecture, and medieval architecture in Cairo, as well as for the reader interested in the city of Cairo.

Foremost, my thanks go to Menna M. El Mahy, my former student, teaching assistant, and now my colleague at AUC, who agreed to help me with collecting data, taking pictures, and editing the manuscript. I can say with certainty that without her, I would have probably given up the project some time ago.

My sincere thanks also go to Professors Bernard O'Kane, Ellen Kenney, Leonor Fernandes, and Amira Elbendary, my long-time colleagues at the Department of Arab and Islamic Civilizations at AUC, and my dear friend and former colleague Doris Behrens-Abouseif for their constant encouragement and readiness to help whenever needed.

Members of a family with close ties that keep them together will always be the wall you can lean on at all times. Thank you may not be enough to express my gratitude to my daughter Soad Mahmoud Saada, who bore with my changing moods; my son Karim Mahmoud Saada who, despite his busy schedule, channeled his love of photography to go out with me to photograph monuments; and to my youngest daughter Laila Mahmoud Saada who, despite being far away, agreed to read and help edit the final version of the manuscript before I submitted it.

A book on Ottoman architecture cannot materialize without the support of the team at the Rare Books Library at the American University in Cairo. Special thanks go to Eman Maher Morgan for her tremendous help in finding sources and maps, and

for her support during the lockdown period of COVID-19.

Finally, I shall always remain grateful to my late parents, Dr. Sayed Karim (architect) and Doreya Loutfi, and to my late husband Dr. Mahmoud Youssef Saada, Vice President of the Academy of Scientific Research, for their belief that in spite of my very busy schedule over the many years as an adjunct lecturer in Islamic Art and Architecture at AUC, the Faculty of Tourism of Helwan University, and Cairo University, as well as a licensed guide to the history and monuments of Egypt, I would still one day sit down and start writing.

Preface

There is a common conception that portrays Ottoman religious architecture as an apparent decline in taste and craftsmanship when compared to the architecture of their predecessors. Nezar AlSayyad's *Cairo: Histories of a City* mentions that during the late nineteenth century, the architects of the Comité de Conservation des Monuments de l'Art Arabe "operated under the assumption that only Mamluk architecture was truly representative of medieval Cairo. They did not consider the Ottoman architectural legacy to be worthy of preservation, nor did they possess a general, let alone thorough, understanding of Cairo's complex architectural history."[1] This book aims to argue against the existing "cliché" through a survey and analysis of a large number of buildings from the year 1517 to the end of the eighteenth century.

There is a wealth of primary sources on Ottoman religious architecture in Cairo, the most important of which for this study are the *waqf* (plural *awqaf*) documents. These were a source of great interest to the Ottomans when they entered Cairo. *Waqf*s secured a source of income for religious institutions that played an important role in Mamluk Egypt. Revenues from real estate, land or a commercial structure were thus legally bound to finance the administration and upkeep of the religious institutions. These endowments were either *khayri* (pious) or *ahli* (to secure private property within a family) as dictated by the founder. A *waqf* allowed the founder to provide an income for his family and descendants and was a means to keep an estate intact rather than broken up into small parts because of the rule of succession. During the Mamluk period, the revenue-producing estate or land was usually in the same area as the pious institution, which helped the urbanization of the center of the city.[2] The prestige of a foundation was tied to the size and number of the properties in its endowment. Large urban *waqf*s sometimes became real urban projects, and could lead to the remodeling of a quarter.[3]

These *waqf* documents can be found in the Citadel Archives of the Dar al-Watha'iq al-Qawmiya (Dar al-Watha'iq) and the archives of the Ministry of Religious Endowments (also known as the Ministry of Awqaf). A list of the *waqf* documents was published by Doris Behrens-Abouseif in *Egypt's Adjustment to Ottoman Rule: Institutions, Waqf and Architecture in Cairo (16th*

& 17th Centuries) and in Muhammad Hamza Isma'il al-Haddad's *Mawsu'at al-'imara al-islamiya fi Misr: min al-fath al-'uthmani ila nihayat 'ahd Muhammad 'Ali, 923–1265 AH/1517–1848 CE,* while many extracts of waqf deeds have been published in Muhammad Abu al-'Amayim's *Athar al-Qahira al-islamiya fi al-'asr al-'uthmani.*

Waqf documents are a great help to researchers when describing a building at the time of its foundation and comparing it with its present state of preservation. I depended very much on the readings of several endowment deeds in the above-mentioned books, which proved to be a great help in trying to visualize the changes that occurred in a building over time. One can add here the collection of microfilms housed at the Arab League and the Egyptian Ministry of Culture (al-Majlis al-A'la lil-Thaqafa).

Primary sources that proved very helpful in this study were Muhammad ibn Ahmad ibn Iyas al-Hanafi's *Bada'i' al-zuhur fi waqa'i' al-duhur,* al-Bakri's *Kashf al-Korba fi Raf' al-Talaba,*[4] Abd al-Rahman al-Jabarti's *'Aja'ib al-athar fi al-tarajim wa-l-akhbar,* Muhammad ibn 'Abd al-Rahman Sakhawi's *al-Daw' al-lami' li-ahl al-qarn al-tasi',* Shihab al-Din Abu al-'Abbas Ahmad ibn 'Ali ibn Ahmad 'Abdallah al-Qalqashandi's *Subh al-a'sha fi sina'at al-insha',* Jalal al-Din 'Abd al-Rahman al-Suyuti's *Husn al-muhadara fi akhbar Misr wa-l-Qahira,* and finally 'Ali Pasha Mubarak's *al-Khitat al-tawfiqiya al-jadida li-Misr al-Qahira wa-muduniha wa-biladiha al-qadima wa-shahira,* the first six volumes of which are on Cairo.

The early works of Hautecoeur and Wiet, titled *Les mosquées du Caire* and the article by John Alden Williams, "The Monuments of Ottoman Cairo," were the only written sources until recent times, and their importance cannot be underestimated because they formed the basis for many later works. The many publications by André Raymond proved to be of primary importance and very useful. Sources on Sufi architecture in Egypt during the Ottoman period include the article by Leonor Fernandes, "Some Aspects of the Zawiya in Egypt at the Eve of the Ottoman Conquest," in *Annales Islamologiques 19,* and her joint article with

Doris Behrens-Abouseif, "Sufi Architecture in Early Ottoman Cairo," in *Annales Islamologiques 20,* and Behrens-Abouseif's article on the Takiya of Ibrahim al-Kulshani in *Muqarnas V* (1988).

Unfortunately, Arabic, English, and French secondary sources available to students, scholars, and interested readers are not many. An introduction to Ottoman sources about Egypt has been dealt with by Nelly Hanna in her *Ottoman Egypt and the Emergence of the Modern World: 1500–1800.* Several books and articles also proved to be very helpful, the earliest of which is Hasan 'Abd al-Wahhab's *Tarikh al-masajid al-athariya allati salla fiha faridat al-jum'a sahib al-jalala* and his article in *Majallat al-'imara,* "al-Ta'thirat al-'uthmaniya 'ala al-'imara al-islamiya fi Misr." In addition, the volumes by Su'ad Mahir, *Masajid Misr wa awliya'uha al-salihun,* and Ülkü Bates's study on the Ottoman architecture of Egypt were very helpful.

More specialized studies tended to focus on a certain patron, namely *Dirasat fi watha'iq Dawud Basha wali Misr* by Amal 'Amri and Tarek Swelim's article on the Mosque of Sinan Pasha, as well as Ahmed El-Masry's thesis on the buildings of Suleiman Pasha al-Khadim. Several books and articles analyze the decorative style of Ottoman architecture in Cairo, including Muhammad Marzuq's *al-Funun al-zukhrufiya al-islamiya fi al-'asr al-'uthmani* and Behrens-Abouseif's article "The 'Abdel Rahman Katkhuda Style in 18th Century Cairo" in *Annales Islamogiques.* The two volumes by Muhammad Ahmad 'Abd al-Latif on Ottoman minarets, *Mawsu'at al-ma'adhin al-'uthmaniya* were of great help. The book by Mahmud al-Husayni, *al-Asbila al-'uthmaniya bi-madinat al-Qahira,* is a comprehensive study on public water fountains built in Cairo during Ottoman rule that proved to be one of the important sources referred to in this book's annex: Four Ottoman *Sabil-Kuttab*s. Publications that focus on certain districts include Hanna's article in *Annales Islamologiques* on the district of Bulaq in Cairo, and Behrens-Abouseif's article on al-Azbakiya.

Finally, several unpublished master's and PhD theses from AUC and other universities contributed to the writing of this study.

Note to Reader

It is impossible to attempt to deal with all the buildings erected by the Ottomans in Cairo during their reign. Therefore, it was necessary to decide to concentrate either on a specific century or on a specific type of building over an extended longer period of time. The choice made here was to limit the discussions to one type of building, namely religious ones, where prayers and religious teachings took place. This includes mosques, *zawiya*s and *takiya*s. *Sabil-kuttab*s and mausoleums are included only when attached to religious buildings, for two reasons: the first is the large number of freestanding *sabil-kuttab*s that still stand in Cairo, and the second is that these, as well as mausoleums, fall under the category of pious institutions, but in most cases no prayers or official teachings took place in them. An annex with the discussion of four *sabil-kuttab*s written by Menna M. El Mahy is included at the end of this book. The decision to conclude this book at the end of the eighteenth century, before Muhammad 'Ali's rule, was also based on two reasons: the first is that the change in the political structure of the ruling dynasty led to a different architectural style, and the second is that the dynasty founded by Muhammad 'Ali, which ended with the deposal of King Faruq in 1952, deserves a complete study in itself.

Illustrations

Unless otherwise indicated, photographs without attributions are by Menna M. El Mahy.

Chapter 2: Buildings of the Sixteenth Century

Chapter 4: Buildings of the Eighteenth Century

Historical Introduction

The Origin of the Ottomans and the Architecture of the Beyliks in Anatolia

A. The Seljuks

The expansion of Shi'i power in the Islamic world during the eleventh century resulted in the invasions of the Sunni Muslim tribes known as the Seljuks, a military power from the Oghuz (Ghuzz) Turkish tribes. They were part of a confederation of Turkish tribes who lived, at least until the eleventh century, in the steppes of Central Asia and Mongolia. They founded by the middle of the eleventh century an Empire that included Iran, Mesopotamia, and most of Syria, in addition to Palestine. In the year 464/1071, their leader Alp Arslan defeated the Byzantine army at the Battle of Manzikert, a defeat that encouraged many Turkish tribes to settle in Asia Minor. The Seljuks built many madrasas (Islamic teaching institutions) to diffuse the teachings of Sunni Islam all over their Empire.

As their power increased in Anatolia, their leader Suleiman ibn Qutulmish declared himself Sultan of Rum in 468/1075, which became an independent Seljuk state in Anatolia, whose capital was the city of Iznik. His son and successor Kilij Arslan later moved the capital to the city of Konya.

The Mongol invasions of the beginning of the thirteenth century put an end to Seljuk power in Iran, but it survived in Anatolia until the year 641/1243 when they also lost their autonomy to the Ilkhanids at the Battle of Köse Dağ. For the rest of the fourteenth century, they acted as vassals for the Mongol Ilkhanids, but this dissolution of their power left behind small principalities known as Beyliks.

B. The Beyliks

The power of the Beyliks increased after the fall of the Ilkhanids in 735/1335. The leaders of one of the Beyliks was the Osmanli household who were centered first around the city of Konya, but later moved to the city of Bursa. They constantly recruited new soliders, growing in strength and taking over rival Beyliks around them. By the year 758/1357, they had even crossed the Dardanelles into Europe and they moved their capital again to the city of Edirne. During their campaigns, they captured many Christian children who were then given a military

and religious education and converted to Islam. These new troops became known as the Janissaries, who like the Mamluks of Egypt, became the elite of their army. An invasion by the Mongol ruler Timur, created a setback in their power in 804/1402, but this was short-lived and they managed to regain all their territory.

C. The Ottomans

The origin of the Ottomans can be traced back to Osman Ghazi, leader of the Osmanli family, who managed to unite the power of the Beyliks under his rule. After Ghazi's death in 723/1323, his successors managed to gain power, in spite of the setback of the Timurid invasion. Mehmet II, known as the conqueror, captured the city of Constantinople in 857/1453, putting an end to the Byzantine era and extending his empire into the Balkans. The name of the city was changed from Constantinople to Istanbul, and it became the capital of the Ottoman Empire.

For over five hundred years, they ruled an area now occupied by fifteen states. Depending on the length of rule and the amount of direct control they had in an area, Ottoman architecture can be seen in many places in varying degrees. To explain briefly what the Ottoman style of architecture is, one has to trace it back to the architecture of the Beyliks.[1]

The Beyliks, especially the house of Osman, were great builders. Aptullah Kuran[2] divided the early Ottoman mosques into three prototypes.[3] The plan of the single-unit prototype is a domed square chamber with a front porch and a minaret. The iwan prototype combines one or more iwans around a central domed area with rooms, in the presence of a front porch and a minaret. The third prototype, which is the multi-unit type, is described as a large interior space divided into smaller spaces by columns or pillars with the central space topped with a large dome. In this case, instead of a porch, an open court surrounded by a portico that is covered with shallow domes precedes the closed interior space.

An example of the single-unit prototype is the Mosque of Orhan Gazi in the town of Gebze, located near Istanbul. It is built of coarse rubble masonry. The large dome sits on squinches "whose arches are tied by iron bars." Both the iron hooks above the entrance door and the Byzantine capitals used as bases for posts suggest a wooden porch. One of the largest domes in a single-unit type mosque can be seen on the Mosque of Yıldırım Bayezid in Mudurnu built around the year 784/1382.[4] The 19.65-meter dome sits on squinches, and the walls under the squinches are thickened to safeguard against the heavy weight of the dome. A three-bay porch stands at the front of the central bay and is covered by a small, fluted dome. The minaret is not the original one, and dates from 1157/1744 (figure I.1).

An example of the second prototype, namely the iwan type, is the Mosque of Orhan Gazi built in 740/1339 in the city of Bursa. It is also known as a

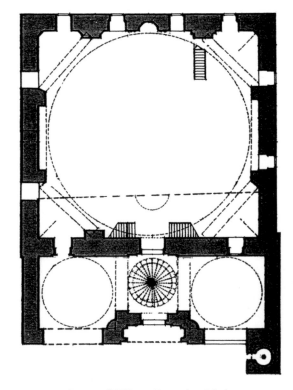

Figure I.1. Mosque of Yıldırım Bayezid in Mudurnu (plan after Archnet).

zawiya-type multifunctional mosque. The plan shows a five-bayed portico, which leads to a central hall covered with a large dome. Beyond this central hall, two steps lead up to the *qibla* iwan, which is covered with an elliptical vault. Two raised side iwans can be seen, one on each side of the central hall, and are also covered by domes. The function of the two side iwans may have been as "hostels for travelling dervishes and the religious brotherhoods."[5]

Another example of the *zawiya*-type building is the Mosque of Murad I in Bursa (c. 767–87/1366–85). The combination of the *zawiya*-type on the ground floor with a madrasa on the second floor is an interesting design. The porch with its five bays leads through a vestibule to the main central hall, in this case a domed court surrounded by four iwans with six rooms filling the corner spaces. The two staircases flanking the vestibule, which can be seen on the plan, lead up to the madrasa on the second floor. On the second floor there is a gallery over the portico and a vaulted room over the vestibule. A barrel-vaulted gallery runs around three sides of the domed court with cells opening onto the gallery. A narrow passage runs around the *qibla* iwan and leads to a small domed room behind and above the *mihrab*. Although the function of this room is not clear, it could have possibly served as a small oratory on the upper floor (figure I.2).[6]

In the year 816/1413, Mehmet I Çelebi (r. 816–24/1413–21) became the ruler of a unified empire in Europe and Anatolia, with the city of Edirne serving as its capital. Bursa remained important because it was the traditional burial place of early Ottoman rulers of the Beyliks period. The famous Yeşil complex in Bursa, which included a madrasa, a hammam, a tomb, and a soup kitchen, shows a continuation of the *zawiya*-type mosque with the addition of a royal balcony overlooking the central hall. Its extensive tile decorations consist of hexagonal monochrome tiles with stenciled gold designs, and the *mihrab* shows tile mosaic and cuerda seca tiles.[7] This tile decoration suggests Timurid influence; in fact, one of the craftsmen's signatures reads, "work of a master from Tabriz." The octagonal tomb also shows tile decoration.

The third prototype, namely the multiunit type, can be seen in the Üç Şerefeli Mosque, begun by Murad II in the city of Edirne in 841/1437. Üç Şerefeli refers to the three balconies on its southwestern minaret. The plan shows a square space divided into a court surrounded by a portico that is covered with shallow domes. The mosque has four minarets, one at each of its four corners, followed by an oblong domed prayer hall. A huge dome covers the center of the prayer hall, which is supported by massive hexagonal piers on the east and west sides, and by exterior walls on the other two sides. Four smaller domes cover the four corners of the oblong prayer hall, while the triangular spaces between the central dome and the corner units are filled with tripartite vaults, with stalactites and supporting small domes in the centers. The exterior gives the impression of "a cascade of domes,"[8] which starts with the big dome and goes down to the domes of the portico of the court. Arched buttresses surround the drum of the central dome, and the interior tile decoration is a continuation of the style seen in the earlier Yeşil Camii in Bursa. The many new features seen in this mosque influenced many later Ottoman buildings (figure I.3).

In 847/1453, Mehmet II, also known as Mehmet the Conqueror, defeated the Byzantine Empire and took over Constantinople, renaming it Istanbul and having it serve as the Ottomans' new capital. The Byzantine Church of Hagia Sophia was transformed into a mosque. The massive dome of the Hagia Sophia inspired the Ottomans to develop the idea of "the cascade of domes" seen in the aforementioned Üç Şerefeli Mosque. Istanbul became a center of the arts. Craftsmen came from all over the world to work, and palaces as well as religious complexes were built and lavishly decorated. A good example of the latter is the Fatih Complex built by Mehmet the Conqueror, which was begun in 867/1463 and completed by 876/1471. This was built on the fourth of the seven hills of Istanbul, the former site of the Church of the Holy Apostles and the burial place of the Byzantine emperor. Its architect was Sinan the elder, whose son Sinan is considered the most famous architect of the Ottomans.

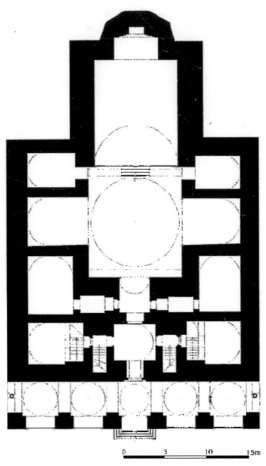

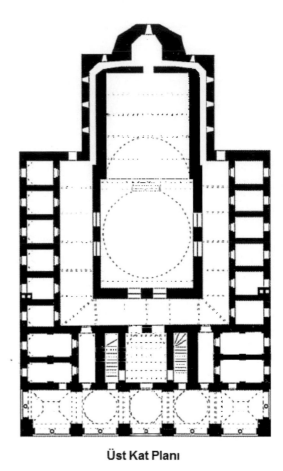

Üst Kat Planı

Figure I.2. Mosque of Murad I in Bursa (plan after Archnet).

Even before the conquest of Constantinople, the Ottomans also built madrasas, the first of which was founded in the city of İznik (c. 731/1331), followed by many in Bursa, Edirne, and then Istanbul after the conquest. They consisted of open courts surrounded by rooms. Since madrasas were important for the dissemination of Turkish culture, they spread all over the empire and were maintained through *waqf* documents. The Ottomans also built caravanserais, not only on trade routes but also in towns for wholesale trade, as well as other commercial structures that provided a steady source of revenue for religious buildings.[9]

Mehmet the Conqueror built magnificent palaces with lavish decoration in Istanbul, employing craftsmen from Europe, Persia, and provinces that were part of the Ottoman Empire. His religious architecture was, on the other hand, more conservative. He continued building complexes with a large mosque in the center and madrasas and other functional buildings surrounding it. The Fatih Complex in Istanbul is a continuation of earlier examples. The mosque was built on the multiunit prototype. In this case, two huge porphyry columns, two pillars, and the walls supported the 26-meter diameter dome. (The dome of the Hagia Sophia is larger at 31 meters in diameter,

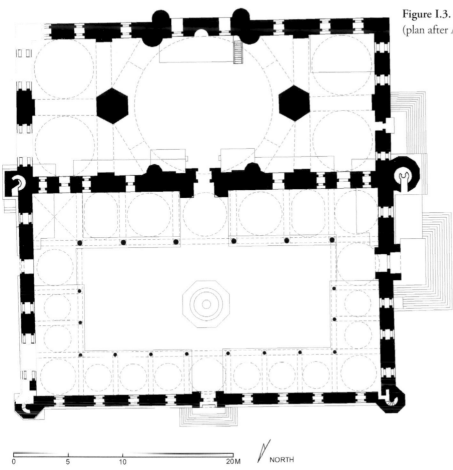

Figure I.3. Üç Şerefeli Mosque in Edirne (plan after Archnet).

0 5 10 20M NORTH

and that of the Üç Şerefeli Mosque smaller at 24.10 meters in diameter). The major development here was the presence of the semidomes inspired by the architecture of the Hagia Sophia. The original mosque, unfortunately, did not survive.

Mehmet the Conqueror was succeeded by his son Bayezid II (r. 886–918/1481–1512), followed by his grandson Selim the Grim (r. 918–26/1512–20). Bayezid's most famous monument is his complex in Istanbul (c. 905–10/1500–05). The plan of the prayer area consists of a central dome encompassed by a semidome at each end and an aisle with four small domes on each side. "The cascade of domes from the mosque to its courtyard shows a far greater

sense of integration than does the Fatih mosque."[10] Sultan Selim the Grim was not as interested in architecture as his predecessors, but it is during his reign that the famous architect Sinan appears on the scene. The son of a Christian family from Anatolia, he was trained in both science and architecture and even became a Janissary in 927/1521. He became the chief court architect during the reign of Sultan Selim's son Suleiman, also known as Suleiman the Magnificent. His first major commission was the Şehzade Complex in Istanbul in memory of Sultan Suleiman's son, who had died from smallpox at the age of twenty-two.[11] The complex was built between 952/1545 and 955/1548 on the third hill of Istanbul. The multiunit

mosque plan shows a 19-meter diameter dome on four pillars surrounded by four semidomes and four small domes in the corners. The load of the dome is carried on the four pillars and the buttresses located along the exterior walls. "The massiveness of the buttresses has been concealed by removing the exterior walls, except on the side of the mosque facing the court towards the inner face of the buttresses. In that way most of their bulk lies outside the mosque."[12] Sinan the architect is credited with designing buildings in several provinces of the Ottoman Empire including Syria, but not in Egypt.

Years later, by 923/1517, the Ottomans had taken both Syria and Egypt from the Mamluks, and by 932/1526 their borders reached as far as Hungary, which they incorporated into their empire, and abutted Mughal India.

The city of Cairo had been the capital of the Islamic Empire since the destruction of Baghdad by the Mongols in 656/1258, and was full of splendid Mamluk buildings, very different from the ones built in Anatolia. The question immediately arises: which architectural style would prevail? The Ottoman or the Mamluk? Before an attempt is made to answer the question, a short look at Ottoman architecture after the conquest of Constantinople and at the time of the conquest of Egypt is necessary.

The Ottomans of Egypt

The Mamluks took over power in Egypt from the Ayyubids in 648/1250 and ruled both Egypt and Syria for over two hundred years, becoming not only military rulers but also great patrons of art and architecture. Their monuments still stand witness to their love of architectural patronage. The Ottoman sultan Selim wrested control first of Syria and then of Egypt from the Mamluks in the year 922/1516. The Ottoman period in Egypt began with the defeat of the Mamluk army led by Sultan Tumanbay II (r. 922–23/1516–17), Qansuh al-Ghuri's fleeting successor, by the Ottoman forces in Ridaniya at the gates of Cairo on 29 Dhu al-Hijjah 922/23 January 1517. On the following day, a Friday sermon was given in the name of Sultan Selim Shah from all the pulpits of Old Cairo.[13] The last Mamluk sultan, Tumanbay II, was hanged at Bab Zuwayla and Egypt was reduced to a province, one of thirty-two under the Ottoman Empire. Cairo had been the capital of the entire Islamic Empire, the seat of the sultan and the caliph during the Mamluk dynasty from the time of Sultan Baybars al-Bunduqdari (r. 658–75/1260–77), who revived the Abbasid caliphate in Egypt with the appointment of a member of the Abbasid family after the Mongols killed the caliph in Baghdad. Now Cairo became the capital of Egypt only, and the caliph was taken to Istanbul. The Mamluks, who had ruled Egypt from 1250 to 1516 and had possessed the strongest army, an army that had defeated the Mongols at the Battle of 'Ain Jalut in 656/1258, were now defeated by the Ottoman army. At first, the Ottoman sultan wanted to exterminate the Mamluk army, but he quickly changed his mind and incorporated them into the Ottoman army. He most probably realized their strength and their common origin with the Ottoman Janissaries as Mamluks, and the fact that many already spoke Turkish. The Mamluks were military slaves brought by slave merchants to Egypt from the Qipshak Steppes, southern Persia, northern Turkey, and Mongolia, while many of the Janissaries were of European origin. The Mamluks received military training and were taught the Arabic language and the religion of Islam, since they would be serving in a Muslim army. After many years of studying and training, they were partially manumitted after becoming the educated elite with the highest posts in the army.

Immediately after the conquest of Egypt, Sultan Selim made it clear that pious endowments were foremost in his mind. He ordered a survey of fief documents and *waqf* documents, and new registries were made (but the old ones kept reappearing). A new *nazir al-awqaf* (administrator of *waqf* documents) was appointed in 928/1522. He instituted reforms that allowed Ottoman Turks to lodge and to be employed in all the major religious institutions. He also restrained the power of Sufi shaykhs and religious

scholars and tried to prevent the violation of *waqf*s, which was common at the end of the Mamluk period. He stipulated that Mamluk pious endowments should not be violated as long as their legality was confirmed. Under the Mamluks, pious endowments were exempt from taxes. This law was rejected by the Ottomans because of their need to find revenue for the treasury (*bayt al-mal*). This, of course, led to problems because the religious establishment in Egypt lived on posts in the *waqf* structures and they fought for their interest.[14] The Ottomans prohibited *istibdal*, the exchange of *waqf* property, but it still continued, and was often misused to disguise the sale of an endowed property so that taxes were then collected on the property.[15] Other methods of dissolution of *waqf*s continued, such as long-term leases and *khuluw*,[16] in which shops were rented for a specified time in return for a large sum of money.[17] These methods were applied in dealing with a large *waqf* estate that was no longer lucrative for a new tenant to restore it.[18] Religious endowments were re-endowed and adapted to meet the requirements of the new owner. The Khanqah Nizamiya, for example, became a *zawiya* for the Khalwati Order, and the Madrasa of Amir Sunqur Sa'di a *takiya* for the Mevlevi Order. In fact, when the Ottomans conquered Egypt, they wanted to secure the support of its scholars by maintaining the *waqf* system. Ironically, "most of the Turkish chronicles dealing with the conquest emphasize the abuses of the waqf system by Sultan Al-Ghuri as a good argument for the Ottomans to overthrow his regime,"[19] due to the illicit exchange of *waqf* property, a procedure used to replace a nonprofitable estate with a profitable one.

When Sultan Selim decided to return to Istanbul, he appointed the Mamluk amir Khayrbak as viceroy. Khayrbak had been the Viceroy of Aleppo and was the traitor who helped the Ottomans conquer Egypt. The sultan also appointed the Mamluk Janbirdi al-Ghazali as viceroy over several districts in Syria. Selim understood that the Mamluks knew the area well and therefore were more capable than an Ottoman official alone. He, in fact, divided Syria into only two

districts, compared to the seven districts under the Mamluks, and he chose an Ottoman viceroy for one district and a Mamluk viceroy for the other. The result was a revolt by Janbirdi al-Ghazali, who tried to control all of Syria by appointing himself as sultan, but the revolt was crushed by an Ottoman army in 927/1521, just three months after it started.[20]

The revolt in Syria encouraged the Turkish Viceroy of Egypt, Ahmad Pasha, who had succeeded Khayrbak, to also revolt in 930/1524. But he was also crushed and replaced by Sultan Suleiman the Magnificent with the help of Pargalı Ibrahim Pasha, grand vizier and brother-in-law of Sultan Suleiman.[21] These revolts pushed Suleiman the Magnificent to change his policy of appointing governors in Syria and contained them in Egypt under one Ottoman viceroy. With Ibrahim Pasha[22] suppressing the revolt of Ahmad Pasha in Egypt, in 931/1525 the Sultan promulgated the Kanunname, which established the military and civil administration of the empire. This rested on three basic elements: the governor (the pasha), the judge (the *qadi*) and the Janissaries. The jurisdiction of the pasha was very broad and included civil and military authority. Appointed pashas lived in the Citadel of Cairo, but the sultan tended to change them frequently to prevent them from trying to become independent. The pasha's power was also limited because he was supervised by the judge and the agha, who were also appointed by the sultan.[23] The power of the judge lay in his boundless jurisdiction in the courts, which included disputes about *waqf* documents, especially the ones that included estates or commercial buildings producing an income to be used for the restoration of religious buildings. The agha commanded the Janissaries. They had helped to conquer both Syria and Egypt and remained to help the pashas administer the country. They became known as *mustahfizan*, meaning the guardians, and they were assisted by several other militia, the most important being the 'Azabs. Their leader was an agha, but they also took their orders from a *katkhuda* who was equivalent to a lieutenant. The Ottomans allowed a number of Mamluks in Egypt to keep their posts

and positions, such as maintaining control of the administration of the provinces, and holding important posts in the army. The Mamluks were considered an elite class, and they were allowed to buy new slave soldiers and maintain large households; they remained long-time rivals of the Janissaries.

According to the Kanunname, the Ottoman army in Egypt was made up of several corps or *ojak*s:

- The Janissaries.
- The 'Azabs, infantrymen whose number was limited to five hundred and who were all Anatolians.
- The Mutafarriqa, a combined infantry and cavalry corps who were Mamluks.
- The Jawish, with forty men attached directly to the pasha.
- The Sipahis, a cavalry corps of riflemen whose number was limited to nine hundred, and who led a series of rebellions at the end of the sixteenth century.
- The Volunteers, whose number could not exceed eleven hundred men.
- The Circassian cavalry, whose number was not limited by the Kanunname.

In time, members of these *ojak*s married and settled in Egypt, and were assimilated into society. The Mamluks, who reached the rank of officers in the army, became beys. A bey is equivalent to an amir in the Mamluk dynasty, but the bey was not a fief holder; he was paid for his services. Later in the seventeenth century, salaries were replaced by *iltizam* rights (tax-farming rights).[24] The *iltizam* could be inherited as long as the heirs paid a certain tax.

The pashas managed to control the affairs of Egypt for the first one hundred years after the conquest. In the next century the beys entered the stage as a power. Not all beys were Mamluk recruits, and many sons of Mamluks became beys. Sultan Selim had, in fact, entrusted the government to officials from the former regime, thus retaining Mamluks and their institutions. One has to bear in mind, as mentioned before, that the Mamluk slave system was similar to the Ottoman *devshirme* recruitment of Janissaries.[25] This would allow the Mamluks later to reorganize themselves and compete with the pashas. Egypt was in fact divided into five main provinces by Suleiman Pasha al-Khadim, the viceroy sent to Egypt by Suleiman the Magnificent. These main provinces were subdivided into twenty-four smaller units: three in Upper Egypt, seven in Middle Egypt, and fourteen in Lower Egypt; but this structure was changed several times after that. Cairo remained the capital, the seat of the government, and the residence of the pasha. Cairo was also considered the second capital of the empire after Istanbul.[26] The Ottoman conquest, of course, resulted in a regular influx of not only military personnel, but also of officials from the Ottoman capital. Some were only appointed for a short period, while others settled in Egypt. On the other hand, many Egyptians went to Istanbul to study and returned to become teachers. They joined intellectual and religious gatherings, which included both Turkish and Egyptian dignitaries. One would have expected a strong Ottoman influence on the culture and architecture of Egypt, as can be seen in other Ottoman provinces, for instance in Syria, but this did not occur in Cairo. When we look at Cairene architecture during the Ottoman period prior to the reign of Muhammad 'Ali, only four mosques were built imitating grand mosques in the Turkish capital: Suleiman Pasha al-Khadim at the Citadel (c. 930/1524, monument number 142); Sinan Pasha in Bulaq (c. 979/1571, monument number 349); Malika Safiyya, near Muhammad 'Ali Street (c.1019/1610, monument number 200); and Muhammad Bek Abu al-Dhahab opposite al-Azhar mosque (c. 1188/1774, monument number 98). This is a very small number considering that, as André Raymond points out, 175 mosques were built during that period in Cairo.[27] Reasons for this can only be suggested, such as Selim the Grim's admiration of Mamluk buildings to the point of sending Egyptian craftsmen to work in Istanbul, and the lack of space for an Imperial-style mosque in already crowded Cairo, where Mamluk architects had designed their

architectural plans to fit available spaces and streets. Raymond, relying on a study of the location of Mamluk monuments, estimates the built-up area in Cairo in 923/1517 at 453 hectares with a population of about 200,000.[28] By the time of the *Description de l'Égypte*, it had become 660 hectares and 260,000 inhabitants, indicating little development in size of the built-up area or the population.[29]

A clear Ottoman influence can be seen in the round, pencil-shaped minarets of most, but not all, Ottoman mosques in Cairo, and in the diffusion of *sabil-kuttab*s across the city. *Sabil-kuttab*s attached to buildings, as well as freestanding ones, were already known in Cairo during the Mamluk period. In fact, the first Ottoman *sabil-kuttab*, built by Khusruw Pasha (c. 945/1538, monument number 52) and attached to the wall of the Madrasa of al-Salih Najm al-Din Ayyub in the al-Gamaliya area, is almost a copy of the one built in the same neighborhood by Sultan al-Ghuri (c. 909/1503, monument number 67), although Khusruw Pasha is known to have built Imperial-style buildings at Diyarbakır, Aleppo, and Sarajevo.[30] The more typical Turkish-style rounded *sabil* did not appear in Cairo before the middle of the eighteenth century.

The following chapters divide Ottoman Cairene architecture into three distinctive periods, each influenced by and serving its accompanying socioeconomic changes. The first chapter is "The Bridge from Mamluk to Ottoman," which brings forward the impact of Mamluk religious architecture on the newcomers and the search for a new identity. The next three chapters follow a century-based chronology with the aim of showing a timely evolution of a newly emerging Ottoman identity that echoes that of the capital, Istanbul.

<div align="right">Chapter 1</div>

The Bridge from Mamluk to Ottoman in the Early Sixteenth Century

This section refers to buildings built at the end of the Mamluk dynasty and inaugurated during the early years of the Ottoman dynasty.

Cairo during the Mamluk period was the capital of the whole Islamic Empire and the seat of a sultan as well as a Sunni caliph. The Mamluks were great builders, and the glorious buildings still standing remain as witnesses to their love of art and architecture. It is sufficient to recall the dictum of the chief qadi of Fez who said, "He who has not seen Cairo does not know the grandeur of Islam. . . . It is the city of the universe, the garden of the world."[1] The Ottomans and Sultan Selim were not blind to the beauty of the city they entered and conquered. In fact, Sultan Selim was so fascinated by Mamluk art and architecture that he carried off craftsmen, masons, and materials from Cairo to Istanbul. Nevertheless, Ibn Iyas mentions three incidences in Rajab 925/July

1519, Jumada al-Awwal 926/April 1520, and Jumada al-Awwal 927/April 1521 of some of these ironsmiths, builders, woodworkers, marble workers, and masons coming back to Cairo after a period of no longer than three years.[2] 'Abd al-'Aziz al-Shinnawi speculates that, on the other hand, another group of workers preferred to stay in Istanbul for the abundance of opportunities and perhaps for the fact that they had married Circassians and settled down.[3] This pushed Suleiman the Magnificent to issue a decree in Rajab 928/May 1522 ordering the sentencing of every Egyptian who refused to return to Egypt.[4]

After the Ottoman conquest and for the three following centuries, Egypt lost its independence and became a province, and Cairo lost its position as the capital of an empire, to remain as the capital of Egypt only. An Ottoman pasha could not afford to build monuments on the same scale as the Mamluks because after 930/1524, the treasury remittance necessitated that a

yearly sum, fixed at a million gold pieces, be sent to the Imperial Treasury in Istanbul. In case of internal problems in Egypt, the pasha had to send the sum from his own income. One must add here that most of the pashas of the sixteenth and seventeenth centuries were from the *devshirme*, and had been educated in the imperial household. But in spite of that, most of them had short terms of office.

The Ottoman buildings in Cairo are divided into two main categories: the Imperial style and the local Ottoman style. One would have expected the Imperial style to dominate, but in fact, a local combination of Ottoman and Mamluk styles, where the Mamluk one dominated, is what spread in Cairo. The main building materials used by the Ottomans were baked bricks, cut limestone, marble, and wood. They also used glazed tiles and glass for decoration. Arches, domes, and vaults were made mostly of bricks. The domes were covered with tiles until the sixteenth century, after which lead was used. Polychrome glazed tiles from the city of İznik replaced marble from the sixteenth century onward. The Ottomans introduced new types of buildings while continuing earlier ones. The *khanqah* institution, for instance, was abandoned and replaced by *zawiya*s and *takiya*s. Freestanding *sabil*s and *sabil-kuttab*s spread all over the city, especially during the seventeenth century, probably because they were not as costly as other religious buildings to build and maintain. Palaces and houses continued the Mamluk style of architecture, as did the upper floors in *wikala*s, which served as hotels for merchants. Ottoman buildings in general have been considered as a decline when compared with Mamluk ones; nevertheless, many of the monuments are worthy of detailed studies.

The sixteenth century is, unfortunately, not well documented in Arabic primary sources. The most important sources for that period are the chronicles of Ibn Iyas, but they end in 928/1522, and the historical accounts of Muhammad bin Abi al-Surur al-Bakri, which cover events until 1061/1651. Turkish literature dealing with the Ottoman conquest of Syria and Egypt is abundant, but until the mid-seventeenth century, Turkish authors depended on Egyptian sources. An

exception is the works of 'Abd al-Samad al-Diyarbakri, an Ottoman qadi who lived and worked in Egypt after the conquest, but he only covers until 945/1528. Biographical compendia also provide important information about several religious establishments.

"The Bridge" refers to buildings begun at the end of the Mamluk dynasty and finished during the early years after the Ottoman conquest. Five buildings will be discussed in this section:

- The Mosque and Madrasa of Khayrbak (1502–20)
- The Takiya of Ibrahim al-Kulshani (1519)
- The Zawiya of Hasan al-Rumi (1522)
- The Zawiya and Dome of Shaykh Seoud (1534)
- The Mosque of Shahin al-Khalwati (1537)

The Mosque and Madrasa of Khayrbak (908–26/1502–20)
Monument Number: 248

The founder
Khayrbak ibn Malbay was a Mamluk amir who was sent to Aleppo as viceroy by the Mamluk sultan al-Ghuri toward the end of the Burji Mamluk period. He became known as The Traitor, or *kha'in bak*, because he helped the Ottomans conquer both Syria and Egypt while still serving as the Viceroy of Aleppo under the rule of Sultan al-Ghuri. He was appointed by Sultan Selim as the first Viceroy of Egypt under Ottoman rule. He became a great ally to the Ottomans and helped them in their fight against the revolutions in Syria and was even granted the title *Amir al-Umara'* (the Leader of the Amirs) for life in return for his services.[5] He ruled Egypt as the viceroy until his death in 928/1522 during the reign of the Ottoman sultan Suleiman the Magnificent. His direct successor was Sinan Bey, who ruled for only thirty-eight days until the arrival from Istanbul of Mustafa Pasha, who became the first Turkish pasha to rule Egypt. Mustafa Pasha was replaced after one year by Ahmad Pasha, who tried to become independent from the Ottomans in 930/1524 by claiming the title of Sultan of Egypt.

Sultan Suleiman sent Ibrahim Pasha, who managed to defeat Ahmad and replace him as the pasha of Egypt. While still a Mamluk amir, Khayrbak built a mausoleum attached to the palace of the Mamluk amir Alin Aq, which he had acquired in the Tabbana Quarter in 908/1502. When he became the Ottoman viceroy, Khayrbak established the *waqf* document for the madrasa, which is dated Jumada al-Awwal 927/April 1521. Additions were made to the document by his mamluk Janim al-Hamzawi in 937/1530. These stipulated that the madrasa was to teach hadith but not *fiqh*, with no specification of a particular *madhhab* and no mention of a Friday prayer, although it was common by that time to hold Friday prayers in all religious buildings. The minbar for the Friday sermon was added in the month of Ramadan 943/February 1536 during the second governorship of Suleiman Pasha al-Khadim, who also added the hanging *dikka* opposite the minbar. In spite of the small size of the madrasa, a large number of staff were appointed in it and their wages were paid from the revenues of the *waqf*. Among the personnel were nine Qur'an reciters, a Sufi shaykh, and twelve Sufi reciters to read a section of the Qur'an daily.

The façade

The main façade overlooks Tabbana Street. The mausoleum, which was built first, is at an angle on the south side of the building and is connected to the palace of Alin Aq by an arch with an interior staircase. When approaching the complex from the Citadel, one sees two sides of the mausoleum. The stone dome of the mausoleum is decorated with a stem and leaf design, which continues the tradition of the dome of Sultan Qaytbay in the Northeastern Cemetery; nevertheless, the exterior transitional zone is pyramid-shaped like the dome of the Mosque of Qijmas al-Ishaqi further down the road going toward Bab Zuwayla (c. 885/1480). The carved decoration on the mausoleum dome displays two superimposed and intertwined patterns of repetitive curved lozenges, forming heart shapes, and scrolls of arabesque. The windows of the mausoleum are accentuated with fine marble inlay, and the mausoleum

on the whole imposes itself visually on anyone approaching along the street from the Citadel. The wide and receding archway connecting the mausoleum with the Palace of Alin Aq creates the illusion of a unified façade rather than two distinct buildings from two different dynasties, but the fenestration on the zone of transition of the dome consists of three bulls-eye windows above two vertical ones, a progression from the one bulls-eye window above two vertical ones that can be seen on the façade of the earlier Alin Aq Palace. The minaret beside the dome also continues the Mamluk tradition of an octagonal shaft over a small square base with a round second tier. What would have been the typical Mamluk pavilion top was rebuilt by the Agha Khan Foundation, which restored the whole building in 2006. It is a brick minaret and not of stone, unlike most late Mamluk minarets, and the first octagonal shaft is decorated with keel arched recesses while the rounded second tier is decorated with an unusual geometrical design. The balconies around the shafts are supported by muqarnas and, according to an archive photograph by Girault de Prangey, the minaret had a wooden bulb at the top, like the one on the minaret of the Madrasa of al-Zahir Jaqmaq located in Darb al-Sa'ada, which runs parallel to Port Said Street.[6]

The façade of the mausoleum is more decorated than the façade of the rest of the building. It is pierced with arched windows in pairs surmounted by circular oculi. Engaged slender columns flank the arched windows, which are framed by a shallow band. The lower windows are rectangular, surmounted by joggled lintels with waved joints. Empty cartouche bands separate the upper and lower windows. Two engaged corner columns with shafts decorated with a chevron pattern and muqarnas capitals can be seen in the projecting corners of the mausoleum. The façade of the mausoleum also shows carved stone panels in relief, which retain the spirit of the decorated panels of the period of Sultan Qaytbay.[7] In contrast, the façade of the mosque is pierced with arched windows above rectangular ones placed within muqarnas niches, and no carved stone panels are included in the decoration (figure 1.1).

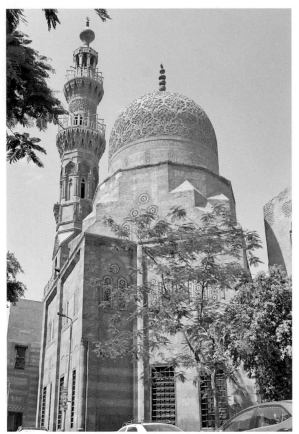

Figure 1.1. The façade and mausoleum of Khayrbak.

The entrance

The entrance, which lies at the northern end of the recessed façade of the mosque, is placed in a tri-lobed groin vaulted portal and is reached by a short flight of descending steps caused by the rising street level (figure 1.2). The entrance then leads to a rectangular space topped by a barrel vault, followed by a groin vault. Opposite the entrance, one sees a recess that bears a painted Qurʾanic inscription from Sura 2:25 (figure 1.3). The entrance then bends to the left, leading to the entrance of the *sabil* on the left and the backyard with the entrance of the mosque-madrasa on the right. One has to ascend several steps to reach the entrance of the madrasa. The large backyard, which is behind the madrasa on the east side, is occupied

by the Tomb and Zawiya of Shaykh ʿAbdallah al-Baz (eleventh/seventeenth century, monument number U58)[8] and is bordered by the Ayyubid wall of Salah al-Din separating it from the cemetery of Bab al-Wazir (plate 1.1). The tomb of the shaykh is a freestanding octagonal domed structure (A in plate 1.1) while the *zawiya* is relatively plain but with an interesting skewed *mihrab* (B in plate 1.1). Five rooms located beneath the madrasa of Khayrbak open onto this backyard, and they were dedicated for the residence of the twelve Sufis mentioned in the *waqf* document. The *waqf* document also includes the salaries for nine Qurʾan reciters to read at the windows of the mosque in addition to the reading of the twelve Sufis and two additional readers mentioned in the mausoleum. A hadith reader to read during the months of Rajab, Shaʿban, and Ramadan is also mentioned in the *waqfiya*.[9]

The plan

The interior of the prayer area is reached by a flight of steps leading to a plain tri-lobed entrance framed by a double molding with continuous circular loops (figure 1.4). Above the doorway are an uncarved lintel and relieving arch topped by an empty cartouche and a square window. The entrance with its pharaonic sill opens onto a small vestibule followed by an elongated hall covered by three cross vaults supported by pointed arches (plate 1.2). The central vault is pierced with an octagonal oculus to bring in light. The plan is unusual, but the late Mamluk mosques of Qanibay al-Rammah near the Citadel and of al-Ghuri at Sabil al-Muʾminin[10] are also entirely roofed with vaults.[11] The vaults are constructed with alternating courses of terra-cotta and biscuit-colored *ablaq* masonry.[12] The lower walls are covered with colored marble panels topped by an inscription frieze of black paste incised in white marble. The *mihrab* is placed in the center of the eastern wall with a plain stone conch. The windows above the *mihrab* are partly hidden by the springing of the arch supporting the central vault. This may indicate that the original roof was flat and was changed to a cross vault when the building

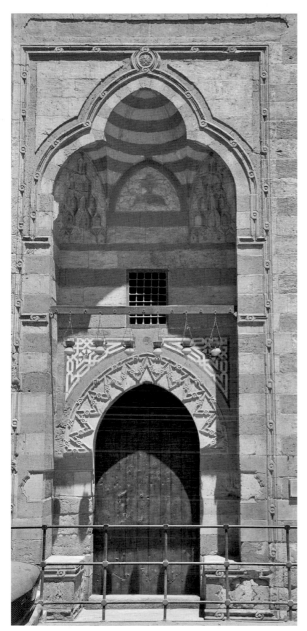

Figure 1.2. The entrance of the Mosque and Madrasa of Khayrbak.

mihrab, as well as the skewed orientation of the *qibla* wall indicate an earlier date of the wall. The madrasa has no dated inscription, but there is no break in the bond of the masonry of the madrasa and the mausoleum to suggest they were built at different times.[13]

A hanging wooden *dikka* (figure 1.5) stands directly opposite the *mihrab* and the minbar on the western wall. This wall, which was adjusted to respect street alignment, includes five recesses with windows, mirroring the same arrangement of the *qibla* wall opposite but with the *mihrab* in the center. The base of the *dikka* seen by the viewer from below is a carved, painted wooden base that is divided into squares painted with floral designs with a Qur'anic inscription frieze running underneath. Under the *mashrabiya* balustrade of the *dikka*, there is another line of painted Qur'anic inscriptions placed in cartouches. The *qibla* wall in this madrasa does not have the same orientation as the *qibla* wall of the mausoleum with a precise diversion of 29 degrees. This does occur in several buildings, but the correct orientation in this building is in the mausoleum, which is quite unusual.[14]

The mausoleum

The mausoleum, which lies on the southern side of the prayer hall, has an interesting entrance. It looks like an outer entrance framed by a double molding with continuous loops flanked with side benches. It is placed in a tri-lobed recess with a groin vault decorated with *ablaq* masonry and stalactites in the two side lobes. The walls of the mausoleum lie at an angle to the street; the inner window openings do not correspond to the outer ones so that openings run obliquely through the thickness of the wall (figure 1.6). The first recess on the right of the entrance of the mausoleum leads to a small corridor that ends in a square area topped with a shallow dome. The dome is made of masonry stones arranged in concentric circles, the apex of which features a whirling design, surrounded by a frieze of Qur'anic inscription. Another larger carved Qur'anic inscription band runs around the four sides of this small shallow-domed space (figure 1.7), above which stands the brick minaret.

became a madrasa, suggesting that there may have been a small *musalla* (prayer area) attached to the mausoleum, which was turned into a madrasa when Khayrbak became the Viceroy of Egypt. The partly hidden windows, the lack of an oculus above the

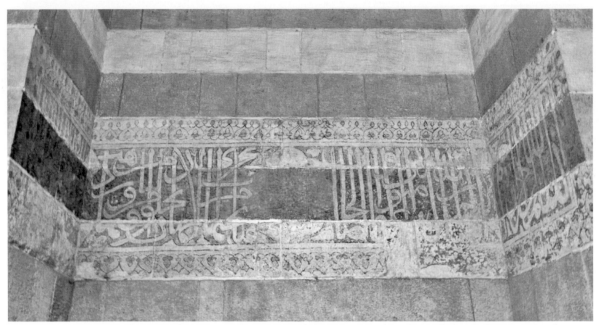

Figure 1.3. The recess in the vestibule, opposite the entrance of the Mosque and Madrasa of Khayrbak. Inscription from Qur'an 2:25.

Figure 1.4. The plan of the Madrasa and Mausoleum of Khayrbak (plan after Archnet).

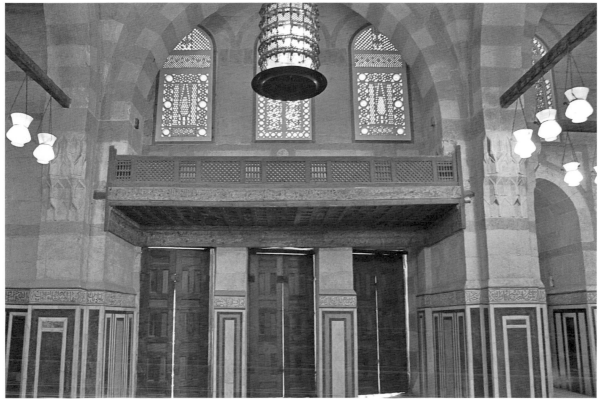

Figure 1.5. The *dikka* of the Mosque and Madrasa of Khayrbak.

The mausoleum consists of a large square room topped with a large stone dome. The interior of the dome shows at its apex a carved band of inscription with a whirling design in the center. The rest of the dome is decorated with a painted design of upright and inverted tri-lobed leaves knotted together in a continuous pattern. The large dome is supported on huge stalactite pendentives in contrast to the pyramid-shaped transitional zone on the outside (figure 1.8). A large frieze of carved inscriptions runs around the walls of the mausoleum, which includes the foundation inscription, verifying its earlier construction date. As mentioned before, this mausoleum was built in 908–9/1502–3 and was attached to the palace of the Bahri Mamluk Amir Alin Aq (c. 693/1293), which served as the residence of several amirs before Khayrbak and later housed Ibrahim Agha Mustahfizan. The cupboard on the left side of the mausoleum's *mihrab* is a disguised entrance that leads to a staircase that connects the mausoleum with the palace. The lower parts of the walls of the mausoleum are covered with colored marble panels, similar to those inside the prayer area; nevertheless, the frieze above the panels in the mausoleum is decorated with geometrical designs (figure 1.9).

The *sabil*

The *sabil* and *kuttab* were added by al-Hamzawi at the same time as the madrasa, as mentioned earlier, and lie north of the entrance on the street. The *sabil* has three windows overlooking the main street and projects out to align more or less with the façade of the mausoleum. The windows of the *sabil* are framed with double moldings with loops, which also frame the lintel and the relieving arch, and divide them into

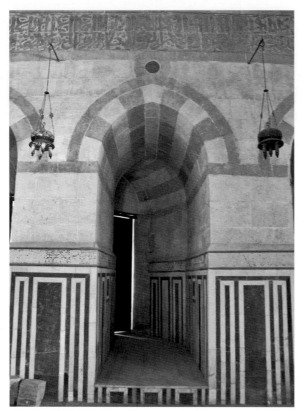

Figure 1.6. The inner window openings do not correspond to the outer ones so that openings run obliquely through the thickness of the wall inside the Mausoleum of Khayrbak.

a number of panels that are carved with geometrical and floral designs. The lintel is decorated with marble inlay featuring a tri-lobed motif in both upright and inverted positions. Inside, the *sabil* hall is topped with a shallow dome on spherical triangle pendentives, with stone carvings covering the walls showing both geometrical and floral designs. The wall on the left side of the entrance to the *sabil* contains a niche with a stalactite hood, which contains the *shadirwan*.[15]

Summary

The mausoleum was built in 908–9/1502–3 and was probably attached to a small prayer area built on top of five rooms for Sufis whose job was to recite sections from the Qur'an daily.

In 927/1521 the prayer hall was turned into a madrasa and the *waqf* document was written to include the details of salaries and all the people to be paid. The roof was probably changed to groin vaults, causing some of the windows above the *mihrab* to be hidden, and the hanging *dikka* was added. The madrasa was to teach only hadith and no specific rite was mentioned.

In 931/1530, the amir Janim al-Hamzawi made additions to his master's *waqf* document. A year later, the minbar commissioned by Suleiman Pasha al-Khadim was added and Friday prayers were introduced.

The *sabil-kuttab* was added by Janim al-Hamzawi, and it is located on the left of the entrance corridor. The wood and stone carving in the interior, and the shallow dome of the *sabil,* might be compared to those formed on top of the vaulted ceiling in the Mosque of Qanibay al-Rammah, behind al-Mahmudiya Mosque on Salah al-Din Square (c. 908/1503).

The Takiya of Ibrahim al-Kulshani (926–30/1519–24)
Monument Number: 332

Also known as the Takiyat al-Kulshaniya, it is the first religious foundation built in Cairo after the Ottoman conquest in 923/1517, and the first building to be designated as a *takiya* by its foundation or *waqf* deed. The first *waqfiya* containing a description of the original building and its dependencies, as well as its function, has fortunately survived. Although the building is called a *takiya* in the *waqf* deed, the biographers of Shaykh al-Kulshani call it a *zawiya* because, like the Zawiya of Shaykh Hasan al-Rumi, it contains living quarters for Sufis, as well as the tomb of the shaykh and a prayer area. Doris Behrens-Abouseif assumes that *takiya* and *zawiya* were synonyms at the beginning of the Ottoman dynasty.[16] In fact, *takiyas* will later also be called madrasas, as we shall see with the Takiya-Madrasa of Suleiman Pasha al-Khadim.

The founder

Ibrahim al-Kulshani was a Sufi shaykh who had escaped from the Safavid conquest of Azerbaijan to Cairo during the reign of Sultan al-Ghuri. He

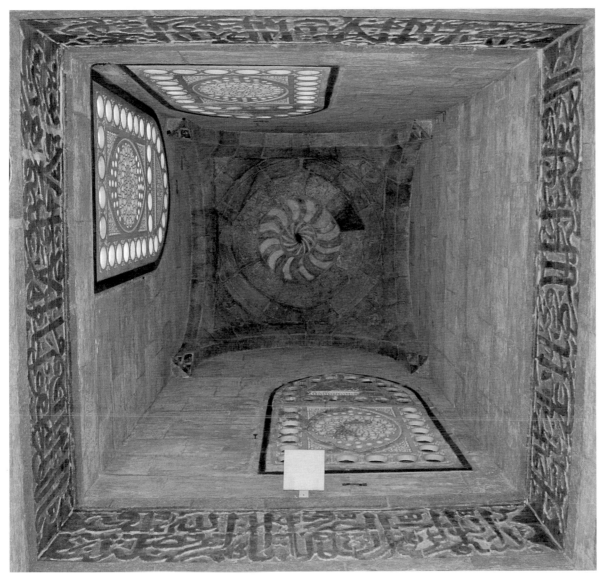

Figure 1.7. The square area between the mausoleum and the outer window with its Qur'anic inscription and shallow dome.

belonged to the Sufi Khalwati order like the two other Khalwati Sufi shaykhs who had settled in Cairo during the reign of Sultan Qaytbay, namely 'Abdallah al-Damirdash and Shahin al-Khalwati. Ibrahim settled down first in a *zawiya* outside of Cairo until he was granted living quarters in the Mosque of Sultan al-Mu'ayyad Shaykh at Bab Zuwayla. After

the Ottoman conquest, he built a *zawiya* in the same area where he became very popular. His popularity gave rise to suspicion, to the degree that he was summoned by Sultan Suleiman the Magnificent to Istanbul. He was then allowed to return to Cairo, where he lived in his *zawiya* until he died during a plague epidemic in 950/1543. He was, in fact, a rich

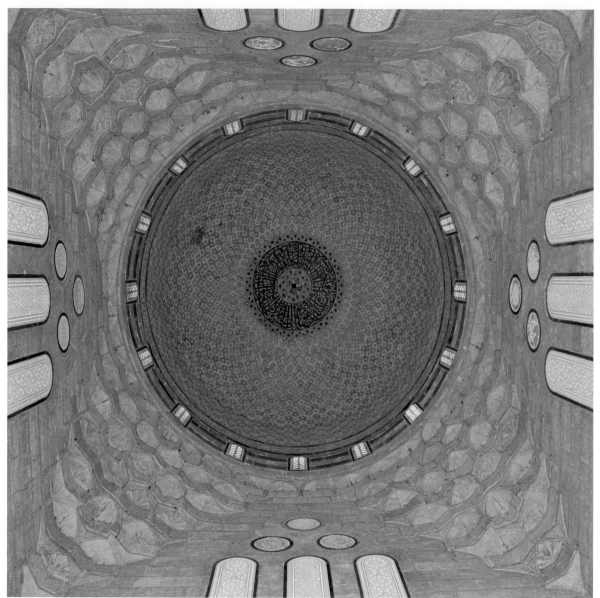

Figure 1.8. The interior of the dome of the Mausoleum of Khayrbak with its large stone stalactite pendentives.

man and was therefore not in need of a sponsor, and was regarded as a great scholar who authored several theological and poetical works. He was almost venerated by his disciples, who apparently "quarreled for the right to drink the remains of his washing water."[17] The *waqf* document of his *takiya* or *zawiya* is dated to Ramadan 948/January 1541, which is eight years after his death.[18] 'Ali Pasha Mubarak published a resume of this document in 1306/1888 in his *al-Khitat al-tawfiqiya*.[19] The *waqf* is in the name of Ibrahim's son al-Shalabi Ahmad, but it says that Ibrahim himself sponsored the endowment.

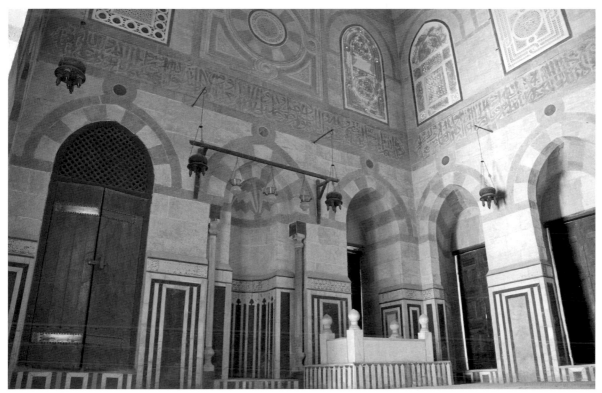

Figure 1.9. The interior of the Mausoleum of Khayrbak.

Al-Kulshani's authority and popularity encouraged other Sufi orders to arrive in Cairo, knowing that they would find the support of their Sufi brothers. In one of the publications issued by the Italian Egyptian Center for Restoration and Archaeology, Dr. Giuseppe Fanfoni was provided with the following note about the settlement of the Mawlawi order in Egypt, passed along by Professor Mahmut Erol Kılıç:

It is known, from Mevlevian sources, that the first Mevleviya was established in the Zawiya of Shaykh Sadaqa and the first Shaykh was Ahmed Safi Dede. But we know from Gulshani sources from Ubudi's Menaqib (still alive in 1604) that at the beginning the Mevlevi in Egypt were hosted in the Takiya Gulshani where Ibrahim Gulshani gave them some rooms and the Mevlevi joined the Gulshani dervishes for their sama'.[20]

The location

It is located on the western side of Taht al-Rabʻ Street opposite the southern wall of the Mosque of al-Muʼayyad Shaykh near Bab Zuwayla.

The plan

A flight of steps ascend up to the entrance of the *takiya* (figure 1.10), which stands in a shallow, plain tri-lobed recess crowned by a cornice of stalactites that forms a pishtaq entrance topped with a double leaf cresting (plate 1.3). Two superimposed windows are found above the lintel and relieving arch of the entrance; the upper one is placed in a stalactite recess. A double molding with continuous circular loops frames the whole portal recess. Two lines of inscription bands run on either side of the door. The upper inscription is Qur'anic and the lower is illegible with many grammatical mistakes in Arabic but the subject

seems to concern land ownership. It seems to be a justification or an apology from Ibrahim al-Kulshani for having built the *takiya* on a piece of land that did not really belong to him, since this particular plot was originally the *waqf* of Amir Aqbugha, part of which was taken by Sultan al-Ghuri, and therefore, was illegally acquired land.[21]

The whole façade is broken into recesses with windows. The ones below are rectangular and above each lower window are two arched windows. Shops can be seen on the ground level under the recesses. The far left of the façade features a visible break-in-bond between what would have been the original façade and what seems to be a later restoration, as seen in the elevation drawing by Doris Behrens-Abouseif.[22] A small *musasa sabil*, which is found to the left of the entrance, blocks a window and is therefore a later addition to the façade.[23] This fountain is dated by inscription to 1258/1842–3 and was sponsored by Ibrahim 'Ali al-Kulshani, a servant of the Kulshani order.[24] A Kulshani hospital mentioned by Muhammad Abu al-'Amayim was still standing until the twentieth century, but is no longer extant.[25]

The entrance of the *takiya* opens onto a vestibule, which is followed by an ascending flight of steps leading to a platform, which occupies the center of the building and on which stands the mausoleum of the shaykh in the middle. This pathway to the platform is a later addition. An arch to the right-hand side of the *takiya*'s entrance indicates an original bent entrance that leads to the platform by a flight of steps. Facing the vestibule arch, one finds two recesses with stalactite cornices, which may have been doors or windows from an earlier building that concealed this route to the platform.[26]

The door on the left-hand side of the *takiya*'s vestibule opens onto the mosque, which is situated lower than the level of the platform. The lower parts of the walls of the mosque still retain traces of paint resembling marble panels, and its *mihrab*, which shows remains of stucco carving, should have been skewed to the right for the correct direction of Mecca (figure 1.11). The windows of the mosque correspond to the

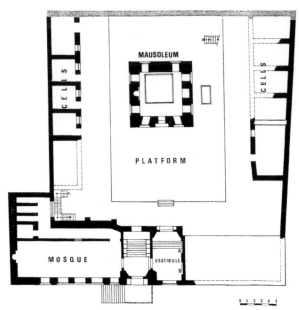

Figure 1.10. The plan of the Takiya of Ibrahim al-Kulshani (after Doris Behrens-Abouseif, "The Takiyat Ibrahim al-Kulshani in Cairo," 46).

second level of windows on the façade. Beside this prayer area on the northeastern side of the platform are ruins that include a *bayara* (well), so probably they were an ablution area, a bath, and latrines. The floor above the mosque was once an apartment, and both the mosque and the apartment overlooked Taht al-Rab' Street; the remains of steps leading to this apartment can be seen behind the well.

The rear side of the door of the vestibule leading to the platform features the foundation inscription of the *takiya*. It refers to the building as "*al-makan*" (this place) and "*munsha'a*" (an institution), and mentions the beginning and inauguration dates and the fact that it was dedicated to the Khalwati group (figure 1.12).[27]

The platform of the *takiya* is paved with stone, under which nowadays are a number of burial chambers scattered around the mausoleum dome. They belong to the descendants of al-Kulshani, namely Ahmad Effendi Bushnaq, Ahmad Nazif Bek, 'Abd al-Rahman Bek, who served as Nazir Dar al-Darb, his

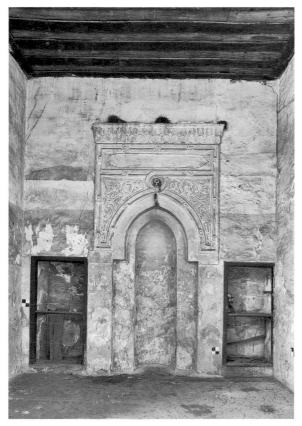

Figure 1.11. The *mihrab* of the mosque of Takiya al-Kulshani (courtesy of the World Monuments Fund website).

daughter Amina, and her servant Effat, in addition to Gulfidan, Dawardi Bek, Shaykh Khalil al-Kulshani, and Zulaykha al-Kulshaniya. Other burials were recently discovered in the room at the end of the cells in the northeastern corner, which is larger than the other cells, yet no traces of a vault can be seen, so probably it used to be covered by a flat roof. These burials belong to more members of al-Kulshani's family and to followers who wanted to be buried near their teacher. A large room behind the mausoleum, known today as Lady Zulaykha's room, refers to Lady Zulaykha al-Kulshaniya, one of the ladies buried in the court, and was referred to by one of the restoration experts working on the research and documentation project of the *takiya* in 2019.[28]

According to the *waqf* deed, there were eight cells on two floors on the right side of the mausoleum dome, in addition to a kitchen. Above the cells and kitchen was an apartment, like the one above the mosque. Both the kitchen and the apartment did not survive, and only part of the vaulting of the cells still stands today. To the right of the vestibule were an additional four cells, which did not survive, except for a few walls with graffiti. An interesting piece of calligraphy on the walls of one of the cells names the building a *khanqah* (figure 1.13).

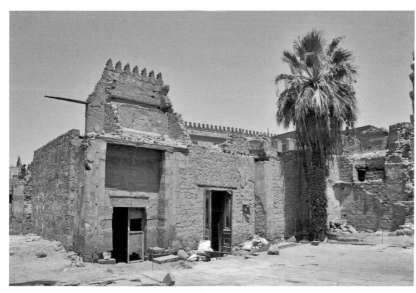

Figure 1.12. The entrance to the platform of the Takiya of al-Kulshani from the vestibule.

Figure 1.13. A detail of the calligraphy on one of the walls of the cells naming the building a *khanqah*.

To the left of the mausoleum dome, there used to be twelve cells on two floors, of which only three of the lower cells still survive. A nineteenth-century photograph, published by Behrens-Abouseif and obtained by her from the Department of Antiquities, shows that the cells on the left side of the mausoleum were faced by a portico, which was supported at one point in time by slender wooden columns. These had disappeared by the time Behrens-Abouseif published, and were later replaced by tree trunks. The upper floor and the portico collapsed and are nonexistent today.[29]

Old photographs by Hautecoeur show a building that almost obstructs the right corner of the main façade of the mausoleum of al-Kulshani. Unpublished plans by the Comité and photographs by Hautecoeur make it possible to determine the architecture of this building. On the ground plan, this building rests on eight slender columns (figure 1.14). On the first-floor plan, it seems like this building was part of the apartments that were built above the kitchen and the cells to the right-hand side of the vestibule (figure 1.15). It is also plausible that because of this structure, the title decorations at the right edge of the mausoleum dome, which Behrens-Abouseif and Hautecoeur mention were retiled between 1255/1839 and 1258/1842, do not continue and today this part is plainly plastered (plate 1.4).[30]

The mausoleum of Ibrahim al-Kulshani stands in the center of the *takiya*'s platform. It is a freestanding square structure topped with a stone dome. The entrance is placed in a shallow tri-lobed recess. The whole mausoleum is built of stone like earlier Mamluk ones. The transitional zone is pyramid-shaped, recalling the dome of the Mosque of Qijmas al-Ishaqi in al-Darb al-Ahmar.

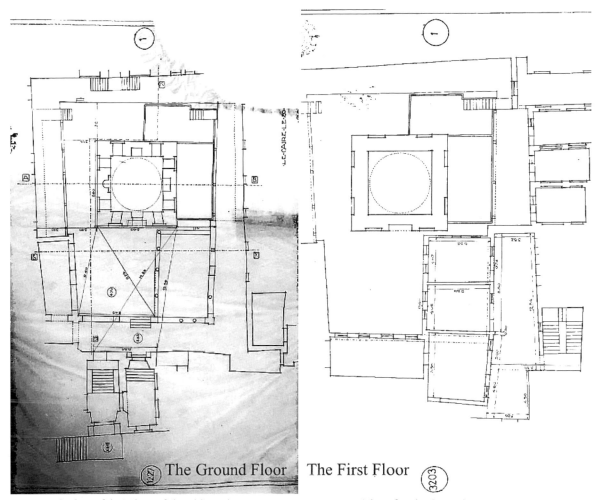

The Ground Floor The First Floor

Figure 1.14. Plans of the Takiya of al-Kulshani showing nonextant structures (plan after the Comité).

The mausoleum's façade around the entrance is covered with remains of Turkish tiles in a variety of styles and patterns. This feature was not mentioned in the description of the mausoleum dome in the *waqf* document. Also, the fact that these tiles do not follow a certain layout or rhythm affirms that they were added later. A closer look at those patterns shows tilework depicting chrysanthemums in a vase, tulips, Chinese lotus, tilework with damascene leaves, fragments from panels depicting al-Haram al-Sharif in Mecca, and poor-quality Dutch delft tiles. Parallels to these tiles are found in buildings all over Cairo, some of which resemble tilework installed on *sabil*s like that of Mustafa Sinan (c. 1082/1672) and Uda Pasha (c. 1083/1673), and on the *qibla* wall of the Mosque of al-Mu'ayyad Shaykh, on the façade of the Mosque of Hasan Pasha Taher (c. 1224/1809), and the entrance of the Mosque of al-Jawhari (c. 1261/1845). Also, the delft tiles are similar to the ones found in the Sabil of Sultan Mustafa III (c. 1172/1759) opposite the Sayyida Zaynab Mosque, which may date the installation of the tilework on the façade of the mausoleum to the second half of the eighteenth century. The tiled façade of Takiyat al-Kulshani also features

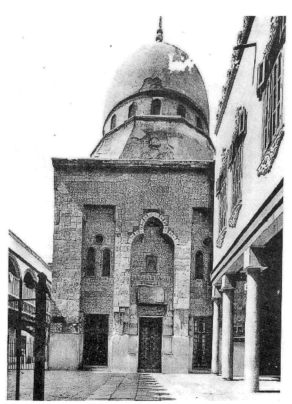

Figure 1.15. An archive photograph by Louis Hautecoeur showing the nonextant structure on the right of the mausoleum dome of al-Kulshani (after Louis Hautecoeur and Gaston Wiet, *Les mosquées du Caire*).

Inside the mausoleum today, one sees wooden tombstones and a transitional zone of stalactite pendentives painted in a nineteenth-century style (figure 1.16), as well as two inscription bands adorning the interior in a Mamluk *thuluth* script. A third painted inscription in cartouches and *nastaliq* script, probably dated to 1251/1830, contains poetry. This seems to be part of the work of ʿAli, servant of the Kulshani order who added the *sabil* in 1258/1837. Three Sufi shaykhs are buried under the dome: Shaykh Ibrahim al-Kulshani, his son Shaykh Ahmad, and his grandson Shaykh ʿAli.[32]

Salaries paid in the *zawiya* were, according to the deed, mostly for the family of the shaykh, who were allowed to occupy the now nonextant two apartments in the upper floors. The duties of the Sufis are not specified and no salaries are mentioned for them. Visiting Sufis were allowed to stay on a full board basis for three days only, and since the biography refers only to Turkish disciples, they were probably Turks, as in the Zawiya of Hasan al-Rumi. Evliya Çelebi describes the *takiya* during his visit to Egypt (1083–91/1672–80) and he mentions a *mazmala* (a place to store water jars for drinking) in the vestibule to distribute water, in addition to the fact that three hundred Sufis lived in this *takiya*.[33] He also points out that Sufis were buried under their cells and their belongings were sold for the benefit of the *takiya*.

This building does not show any new Ottoman influences except for the location of the freestanding mausoleum, which has no parallels in Cairo. It cannot be seen from the street like Mamluk mausolea and it is detached. In spite of that, the mausoleum dominates the minute you enter. Since Hasan ʿAbd al-Wahhab and al-Shaʿrani[34] recount that Ibrahim al-Kulshani told his disciples not to make the pilgrimage to Mecca "for a more genuine approach to God," Doris Behrens-Abouseif raises the question of whether or not he intended for his mausoleum to be reminiscent of the Kaʿba.[35] Another plausible possibility is that he thought of himself as a mediator between his disciples and God, since "he considered himself almost holy."[36]

pomegranate fruits and trees, which Doris Behrens-Abouseif observed were identical to examples from Sárospatak Castle and Regéc Castle, both located in northeast Hungary.

Above the entrance of the mausoleum, there is a marble slab in two lines in *nastaliq* script from Sura 39:73 of the Qurʾan. Above it, old photographs show that at one time there was a panel with lines of inscriptions. A picture from Ahmet Bayhan's article shows a close-up of that panel featuring six lines of Ottoman Turkish script. The last line of the inscription gives the date of 931/1524. The translation of the text is as follows:[31] "Sunni Shaykh Ibrahim al-Kulshani emigrated from the mortal rose garden (world) to the Jasmine scented divine. He reached the threshold of the ancient God (peace)."

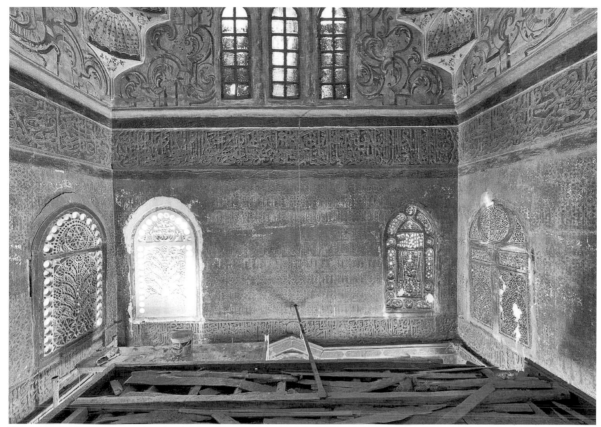

Figure 1.16. The inscription bands adorning the interior of the mausoleum dome of the Takiya of al-Kulshani.

The Zawiya of Hasan al-Rumi (929/1523)
Monument Number: 258

*Zawiya*s in Cairo were of two types. The first type was a small mosque for everyday prayer without a minaret or a minbar, and the call to prayers was carried out from the door or a small balcony above the door. The other type was more like a *khanqah* with residential units. The Zawiya of Hasan al-Rumi is an example of the second type.

The founder

Amir Khayrbak built this *zawiya* for Hasan ibn Ilyas ibn ʿAbdallah al-Rumi al-Hanafi, a Turkish shaykh who came to Egypt during the reign of Sultan al-Ghuri.[43]

The shaykh was popular among the Egyptians, so the Mamluk amirs turned the sultan against him, who then ordered him beaten, resulting in his being badly injured. The Egyptians took care of him until he recovered. For four years (one year during the reign of Sultan al-Ghuri and three years after the conquest of the Ottomans), he spent his time sitting by a column in the *riwaq* of the Turks in the mosque of al-Azhar reading the Qurʾan, so he became known as *Shaykh al-ʿAmud* (the shaykh of the column). When Khayrbak became the Viceroy of Egypt, he was told by the people that Shaykh Hasan al-Rumi had begged God to torture Sultan al-Ghuri the way he had been tortured under the hooves of horses, and that his wish had come true since al-Ghuri fell from his horse in the battle with the Ottomans and was trampled to

THE ROLE OF SUFISM AT THE BEGINNING OF THE OTTOMAN PERIOD

Sufism is a spiritual as well as an intellectual current that appeared early in Islam and was first characterized by the wish to lead a solitary, simple life devoted to prayer. Slowly this asceticism started to take on a new light. Many became not just passive individuals or groups living on the fringe of life, but individuals who devoted long periods to studying and teaching religious studies in addition to the way to see and feel the inner depth of Islamic teachings. In doing so, they started to attract many followers and to become an influence in public life. They became not just Sufis, but also highly respected scholars of religious studies who combined philosophy with Islamic jurisprudence *(fiqh)* and Qur'anic exegesis. This led to the development of *tariqa*s based on the teachings of a particular scholar, each *tariqa* exerting effort to guide public opinion. Sufi shaykhs under the Ottomans became sponsors of several religious foundations. It is true that under the Mamluks, Sufi shaykhs had sponsored many religious foundations; however, these were overshadowed by the greater number of royal foundations. Some shaykhs even took on a political role and, as mentioned by Doris Behrens-Abouseif and Leonor Fernandes,[37] the overthrow of the Mamluks has been attributed to the Sufi shaykhs Dashtuti, al-Bakri, and Abu al-Seoud al-Garhi urging Sultan Selim "to rescue Egypt from the tyranny of" the Mamluk sultan al-Ghuri.[38] Shaykh 'Abd al-Qadir al-Dashtuti died in 924/1518, shortly after the Ottoman invasion of Cairo. His *zawiya*, which was originally built at the end of the Mamluk period, can still be seen northeast of the Mosque of 'Amr ibn al-'As, in the area known today as Old Cairo. He was a son of a merchant in Cairo who at first followed in the footsteps of his father, but his inclination to solitude made him leave everything to lead a solitary life. He was even described as inflicting self-torture by remaining in an underground cave alone during the holy month of Ramadan. His *zawiya*-mosque was in fact built for him by Sultan al-Ghuri, and his fame gathered him many disciples, among whom were Mamluk amirs and the sultan himself, who paid him a visit during which Dashtuti advised him to care for his people. When al-Ghuri died, the amirs came to Dashtuti for advice and to help them convince Amir Tumanbay to take control of the Mamluk Empire as Tumanbay II, which shows Dashtuti's great influence on the politics of the state. In fact, he even passed a death sentence on the *muhtasib* (supervisor of bazaars) Zayn al-Din Barakat, a powerful figure at the time, and it took great effort to revoke the sentence. Miracles were attributed to him, including the curing of illnesses.[39] This shows the political involvement of some Sufi shaykhs at the end of the Mamluk period. When the Ottomans removed the Abbasid caliph from Cairo in order to continue the caliphal authority in Istanbul, Sufi leaders took over the power of the religious authority.

The financial power of the shaykhs, which was also supported by the contributions of their followers, translated itself into an increasing building activity. Buildings associated with Sufism are *khanqah*s, *ribat*s, *zawiya*s, and later, *takiya*s. The first *khanqah* in Egypt was built by Salah al-Din al-Ayyubi in the late twelfth century and was known as Khanqah Sa'id al-Su'ada' (monument number 480). This was a continuation of the institution that was started by Abu Hamid al-Ghazali, the famous scholar of Islamic law and *fiqh* who wrote *Ihya' 'ulum al-din (The Revival of the Religious Sciences)* and incorporated Sufism in his teachings. The earliest surviving *khanqah* in Egypt, so called in its foundation inscription, is the Khanqah of the Mamluk sultan Baybars al-Jashankir (c. 710/1310, monument number 32). According to its *waqf* deed, this *khanqah* had lodging for a hundred Sufis, with two hundred more coming during the day and another hundred visiting Sufis lodging in the attached *ribat*.[40] The *khanqah* started as a monastic institution

sponsored by rulers in which Sufis could retreat to worship and remain dedicated exclusively to religion. In time, seclusion and asceticism were abandoned, and Islamic law and *fiqh* were introduced, which allowed some of the Sufis to become scholars. Friday prayers were at first not allowed in a *khanqah*, but in time this was also introduced. This *khanqah*-mosque-madrasa function became popular during the Burji Mamluk dynasty and integrated Sufism with urban life. By the late Mamluk period, the Khanqah of Sultan al-Ghuri was not monastic and had no living quarters. The Sufis lived and worked outside the *khanqah* and only met for *al-hudur* sessions.

The term *zawiya* appears much earlier in Islamic history. Al-Maqrizi mentions eight *zawiya*s that formed part of the Mosque of 'Amr ibn al-'As. Each *zawiya* was reserved for a teacher-shaykh and his students. The funds needed for each *zawiya* came from *waqf*s endowed for each of them.[41] This means that originally *zawiya*s were teaching areas not directly related to Sufism. The first mention of an independent structure for a Sufi shaykh called a *zawiya* is the one for Dhu al-Nun al-Misri (d. 245/859). He

was buried in his *zawiya*, which was later restored by Sultan Barsbay in 834/1430. In his *waqf* deed it is described as an independent structure and was allocated a monthly payment to restore the tomb and to buy water, mats, and lamps from the revenues of its *waqf*. In fact, most early *zawiya*s did not survive, perhaps because no endowment deeds were written for them. A shaykh lived in the *zawiya*, which in many cases was built for him by rich Mamluk amirs or sultans, and most shaykhs refused to accept *waqf* donations.[42] When the shaykh died, he was then buried in his *zawiya*, which became a shrine. The rules of each *zawiya* were normally imposed by the shaykh himself. The Burji Mamluks are the ones who imposed *waqf* deeds on the *zawiya*s in order to maintain their upkeep, and this led to *zawiya*s becoming centers for *tariqa*s. Therefore, when the original shaykh died, his teaching was continued by one of his students and his teaching became a *tariqa*. This was the rise of *tariqa* Sufism and the decline of *khanqah* Sufism. The rise of *tariqa* Sufism will cross the bridge from the late Mamluk to the early Ottoman period.

death. The shaykh had become a saint to many, and therefore Khayrbak ordered a *zawiya* to be built for him, to also become a resting place for him after his death. The work was started in 928/1522, but it was finished after the death of Khayrbak and during the reign of Suleiman Pasha al-Khadim.[44]

This *zawiya* was for *ta'ifat al-'ajam*, which indicates the foreign Sufis who were allowed to reside in the *zawiya* and to go to al-Azhar shaykhs to gain knowledge as long as they did not miss the midday prayers in the *zawiya*. The number of Sufis appointed to this *zawiya* was only ten.[45] One must add here that many of the Mamluk *khanqah*s were also dedicated for foreign Sufis.

The location

It is on al-Mahgar Street on the right as one goes up toward the original gate of the Citadel, the Bab al-Mudarraj.

The façade

The building today has two exposed façades: the northwestern (figure 1.17) and the southwestern. The northwestern façade contains the main entrance to the *zawiya*, despite that originally, according to the *waqf* document, it had three entrances on that side. The main entrance to the *zawiya* (1 on figure 1.18) opens by a pointed arch with cushion

Figure 1.17. The northwestern façade of the Zawiya of Hasan al-Rumi.

voussoirs, under which is a window, and the doorway of the *zawiya* is flanked by two small *maksalas* (side benches). An archive photograph by Creswell shows a column hanging from the keystone of the arch by a chain, from which the name *Shaykh al-'Amud* was derived (figure 1.19).[46] This column disappeared in 1983, during the restoration works that took place in the Citadel. The foundation inscription of the *zawiya* is located above its main entrance and carved onto a marble slab above the plain lintel, but all that remains of the inscription is, "Khayrbak by the order of Sultan Suleiman son of Selim Khan in the year 929" (figure 1.20). This inscription is mentioned in several sources and can be regarded as the earliest mention of the name of the Ottoman sultan after the conquest.[47] To the left of this door is a rectangular window with metal grilles that overlooks the tombstone of the shaykh. Above this window one can see the remains of a carved stone inscription with the name of Shaykh Hasan al-Rumi that seems to have been part of a wider text that no longer exists.

The *waqf* document mentions three doors and eight windows on the main façade.[48] This door and the wall into which it was fitted appear to be a later addition than the construction date of the *zawiya*, as there is an apparent break in the bond of the wall, in addition to the fact that it cuts into the cushion voussoirs that crown the main entrance. A small door that no longer exists can be seen in figure 1.18. It was located on the right as one faces the main entrance to the *zawiya*, and led to a small ablution area, given that a well appears on the plan (A in figure 1.18).[49]

The second door, labeled 2 on figure 1.18, which led to an area to the left of the main door of the *zawiya*, no longer exists. It was a square, double shutter door that, according to the deed, led to a *turba*, with a burial area, a garden filled with pomegranate and jasmine trees, and four *khilwa*s.[50] [51] Nowadays, nothing exists from the description mentioned in the *waqf* document, which describes the building as consisting of a *zawiya* in the center, a court with a mausoleum on the left of the main entrance, and a garden with tombs on the right. In fact, according to the Bulletins of the Comité, the land was subject to being sold by the Ministry of Religious Endowments. The Comité did not advise against it as long as there was a two-meter buffer zone between the *zawiya* and the sold land.[52]

The third door of the complex, labeled 3 on figure 1.18, led to a *hawsh*[53] and the tomb of Sayyidna al-Shaykh Muhammad al-Fara.[54] Today, a modern clinic exists on the site.

The southwestern façade shows a tri-lobed recess with a rectangular window below and an arched window above. To the right of this, one sees a small square door with three arched windows above (figure 1.21). An engaged column with a stalactite capital decorates the southwestern corner of this façade.

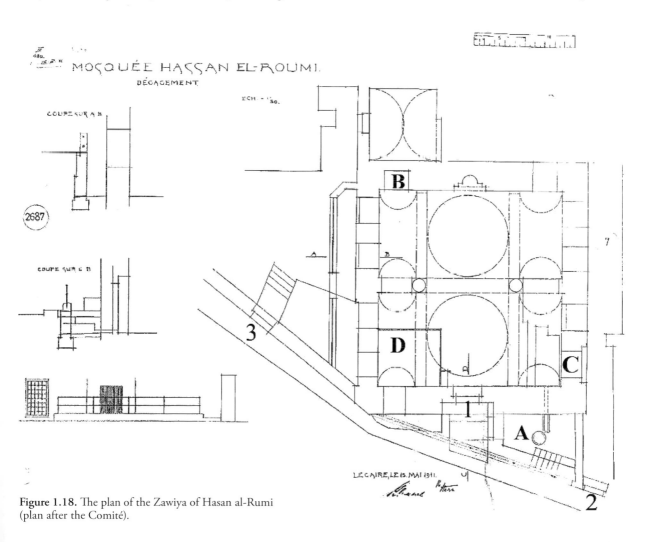

Figure 1.18. The plan of the Zawiya of Hasan al-Rumi (plan after the Comité).

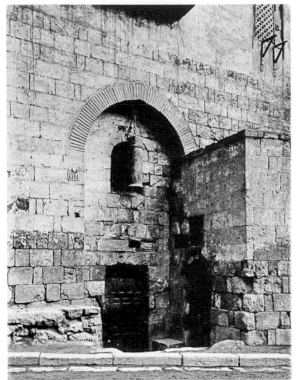

Figure 1.19. An archive photograph by Creswell of the entrance of the Zawiya of Hasan al-Rumi (courtesy of the V&A online art collection).

The interior

The main entrance leads directly into the interior of the *zawiya*, which consists of a rectangular space that measures 9.70 × 9.22 meters, divided by three round arches on two granite columns in the center into three aisles parallel to the *qibla* wall. The middle arch measures wider than the two side arches (figure 1.22).

The *mihrab*

It is plain and the two columns that were at one point engaged to its sides are no longer extant. To the left of the *mihrab* is a recess, currently used as a cupboard, although the *waqf* document mentions a door that led to a covered court behind the *zawiya* with a *bayara*, and to the kitchen, which was vaulted with stone and contained ovens, as well as to *khilwa*s off of that court (B in figure 1.18 and figure 1.23).[55]

Inside the *zawiya*, in the southwestern wall of the first aisle, one can find two cupboards with windows above and in the northeastern side there are two pointed arched recesses with two windows

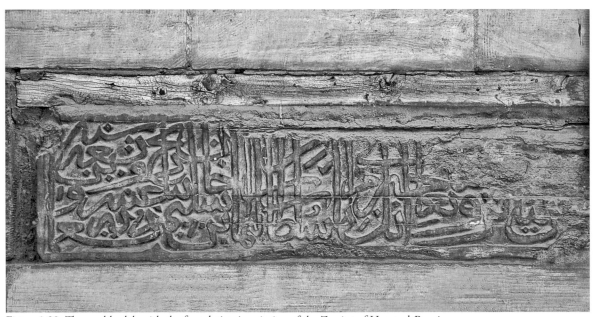

Figure 1.20. The marble slab with the foundation inscription of the Zawiya of Hasan al-Rumi.

Figure 1.21. The southwestern façade of the Zawiya of Hasan al-Rumi.

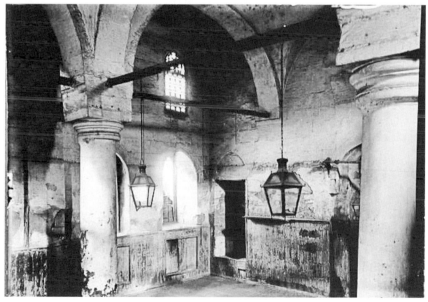

Figure 1.22. An archive photograph by Creswell of the interior of the Zawiya of Hasan al-Rumi (courtesy of the V&A online art collection).

below and one window above each. In the southwestern side of the second aisle there is a pointed arched recess with a door on the lower level and a window above it that is still visible today, followed by a similar recess to the left side of it with windows in the two levels. These are the same windows that can be seen on the outside placed within a tri-lobed recess with engaged columns. In the *waqf* document, it says that originally there was a door in this recess that led from the court to the western side of the *zawiya* to the ablution area that was mentioned above to the left and steps leading up to the four *khilwa*s on the right (C in figure 1.18).[56] This door was converted into a window by the Comité in 1944.[57]

Figure 1.23. An archival photograph of the southwestern façade of the Zawiya of Hasan al-Rumi and its rear behind the *qibla* wall where it had a vaulted kitchen and *khilwas* (after Abu al-'Amayim, *Athar al-Qahira al-islamiya fi-l-'asr al-'uthmani,* 15).

In the middle of the wall opposite the *mihrab* is the main entrance of the *zawiya,* and the mausoleum of the shaykh is located in the northern corner (D in figure 1.18). The ceiling of the *zawiya* consists of shallow domes in the central aisles with elongated vaults in the side aisles.

The plan of this *zawiya* is very different, and architecturally it introduces a new type of plan without any clear Mamluk influences.[58] The plan shows similarities with the early Ottoman Şehadet Camii in Bursa, and the two shallow domes on pendentives above the central aisles are probably the earliest Ottoman-style domes in Cairo. This is very different from the contemporary mosque of Khayrbak where the Mamluk influence is very apparent.[59] This *zawiya* is in fact the only one that completely follows an Ottoman plan. The Turkish origin of the shaykh and the majority of his disciples was perhaps a major factor in this architectural choice of plan.

The Zawiya and Dome of Shaykh Seoud (Before 936/1529–30)
Monument Number: 510

The founder
Suleiman Pasha al-Khadim, the Pasha of Egypt, built it especially for the famous Sufi shaykh of the Refa'i

order, Shaykh Seoud, known for his piety and spirituality, to the point of being visited regularly by well-known scholars of his time.[60] His *waqf* specified that the building consisted of a mosque intended for prayers with an attached secluded place for prayers, and that the dome was to host the shaykh after his death.[61]

The location
It is located on Suq al-Silah Street and parallel to al-Darb al-Ahmar Street.

The date
The dome was dated by Hasan 'Abd al-Wahhab, 'Asim Rizq, Su'ad Mahir, and Nicholas Warner, and in the Index of Islamic Monuments in Cairo to 941/1534, which is the date of the shaykh's death. Nevertheless, Doris Behrens-Abouseif mentions that the endowments of Suleiman Pasha were made over a number of years, the earliest being in 936/1529–30 while the latest dates to 949/1542–3. She clearly states that the Zawiya of Shaykh Seoud belongs to the earliest endowment (936/1529–30), so one can assume that the building was completed before that.[62]

The *zawiya* was built as a prayer area and a burial area for the shaykh, and he attached to it two shops (*hanutayn*), and above them a *riwaq,* so that their revenue could support the maintenance of the *zawiya.*[63] The *riwaq* was for the residence of the shaykh during his lifetime, and then after his death it was to be rented so that the income could be added to the other revenues to maintain the *zawiya* and the salaries of its functionaries. Other dependencies are mentioned in the *waqf* document; these are two *hasilayn* (storage areas) and an iwan with a *mihrab* in the open court, which today is reached by a door on the right of the entrance door to the *zawiya.* The rest of the dependencies have all disappeared, and today new buildings stand in their place. In fact, the only remaining structure is the dome of the burial of the shaykh, which is built of bricks and according to the *waqf* was all covered with green tiles.[64] When the shaykh died in 941/1534, he was buried under the dome.

The exterior

The *zawiya* dome has one façade, the southeastern one, which overlooks Suq al-Silah Street. The façade is broken into two recesses, one on each side of the *mihrab* inside. Each recess has a rectangular window and a pointed arch above the lintel (plate 1.5).

The square structure of the burial chamber is topped by a dome resting on a pyramid-shaped transitional zone with Qalawun set windows in between. Remains of green tiles nailed onto the dome can still be seen today. The tiles are fixed in place by a nail in their center, following the style of the mosque of Suleiman Pasha in the Citadel and before that the dome of Imam al-Shafi'i mausoleum, rebuilt by the Mamluk sultan al-Ghuri. A recessed entrance with a window overlooks the interior. According to the *waqf* document, this was not an arched entrance, but today it is topped with a round arch.[65] To the right of this entrance were the two shops, and the above mentioned *riwaq*, but these are no longer extant.

The interior

The entrance leads to a corridor with a plain wooden ceiling. The corridor leads to an open court that had an iwan and a *mihrab*, two staircases, and four doors.[66] The first extant door leads to the domed chamber. The other doors, which led to the shops, the *riwaq*, and the dependencies, are no longer extant. The iwan is now replaced by a modern building.

The plan

The door of the mausoleum is placed opposite to the *qibla* wall. The plan shows a square room, each side measuring 4 meters in length, one of which contains a plain *mihrab*. The original window beside the door, which is now blocked, has in front of it the steps to the burial chamber. The tombstone is new. On the inside, the transitional zone consists of pendentives with stalactites with windows in between, which have lost most of their original stucco grilles and stained glass. The drum shows eight windows and eight *mudhahayat* (blind recesses).

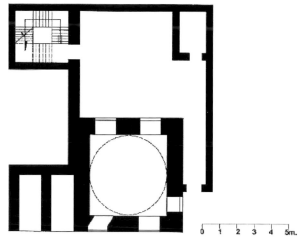

Figure 1.24. The plan of the dome of the Zawiya of Shaykh Seoud (plan after Abu al-'Amayim, *Athar al-Qahira al-islamiya fi-l-'asr al-'uthmani*, 40).

This little *zawiya* is different from the ones discussed earlier, with its open court with the *mihrab*, mosque, and iwan, which was probably for the shaykh when he met with his disciples. The small size of the mausoleum is made up for by the use of green tiles to cover the dome, and this was probably very eye-catching on the road in an area full of Mamluk monuments. The Zawiya of Shaykh Seoud shows clearly that *zawiya*s, unlike mosques, did not follow a certain plan. The plan depended mostly on the available space and the need of the shaykh for whom it was built.

The Mosque of Shahin al-Khalwati (945/1538)
Monument Number: 212

The founder

Shahin al-Muhammadi was born in Tabriz and grew up there before arriving as a young man in the slave market of Cairo. His youth and physical fitness attracted the attention of the Mamluk sultan Qaytbay, who bought him to join his military mamluks. Shahin's main interest was in religious studies, and

he became a scholar known for his deep knowledge of the Qur'an and Hadith as well as a close companion of the sultan, who trusted him. Shahin then asked the sultan to let him devote the rest of his life to studies, prayers, meditation, and devotion, and the latter agreed and manumitted him. Shahin decided to return to Tabriz, where he joined the circle of the Sufi shaykh Omar al-Rashni to gain more knowledge. He later returned to Cairo, where he joined the circle of Shaykh Muhammad al-Damirdash in the area of al-Abbasiya. When the shaykh died, Shahin decided on a solitary life of devotion and moved to the lower part of the Muqattam Hills overlooking the area where several Companions of the Prophet Muhammad were buried. He built there a *ma'bad* or a small prayer area beside a cistern, and dug a tomb for himself (figure 1.25).[67] Among the Companions of the Prophet buried in that area are 'Uqba ibn 'Amir and 'Amr ibn al-'As. Also buried in that area are Imam al-Shafi'i, rulers such as Ahmad ibn Tulun and Muhammad ibn Tughj al-Ikhshid, Mamluk amirs such as Qutuz, and later, many members of the Muhammad 'Ali dynasty. Almost abutting the dome of the mausoleum of Shaykh Shahin is the wall of al-'Arid, a cave from pre-Fatimid times that was restored by the Fatimid caliph al-Hakim and to which he added a minaret, as mentioned by al-Maqrizi.[68] Shaykh Shahin lived there for thirty years and never descended from the hills to the city, but his reputation as a devout Sufi and scholar inspired many followers from both the Mamluk and early Ottoman dynasties to go and join him by carving cells for themselves in the rocks. According to al-Nabulsi,[69] Shaykh Shahin died in 953–4/1547 and was buried in a mausoleum that, according to al-Manawi, was built for him by Sultan Suleiman the Magnificent[70] and was attached to his prayer area. Shaykh Shahin's son Jamal al-Din built the complex, which is unfortunately today in complete ruins. The complex consisted of a mausoleum, a mosque with a minaret, cells for Sufis under the mosque, a cistern, and an ablution area.[71]

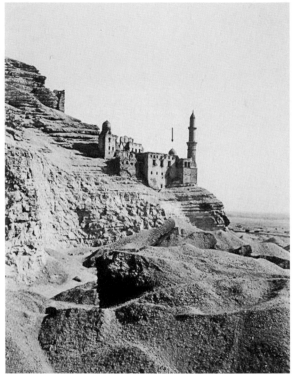

Figure 1.25. The Mosque of Shahin al-Khalwati built on the Muqattam Hills (after Archnet).

The plan

The complex (figure 1.26) has one clear but plain entrance on the northern side (figure 1.27). The entrance leads to a flight of steps leading up on the left side to a corridor with three cells for the Sufi dwellers and on the right to another corridor with cells (figure 1.28). The steps continue upwards and open onto the middle of the mosque. This could not have been the main entrance to the mosque, as it leads to the center of the prayer area, where according to 'Ali Mubarak and Su'ad Mahir, four stone columns, presumably located in the center, supported a ceiling.

Judging from what can be seen today, the *mihrab* of the mosque was decorated in the typical Mamluk style; its conch shows the remains of a chevron design, followed by a frieze with what appears to be mini-colonettes, under which are two sections of marble

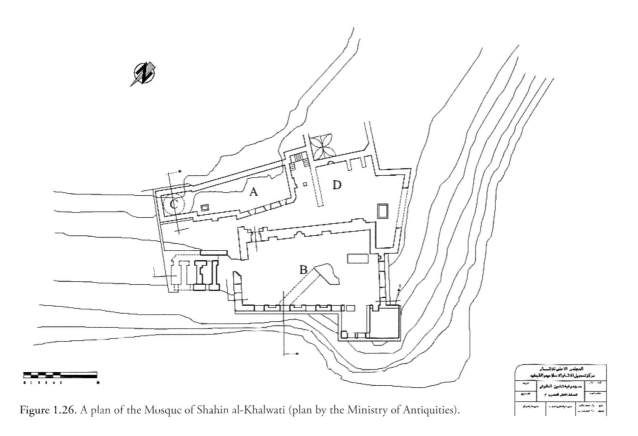

Figure 1.26. A plan of the Mosque of Shahin al-Khalwati (plan by the Ministry of Antiquities).

paneling (figure 1.29). According to Mubarak and Abu al-'Amayim, the *mihrab* was also decorated with marble and mother of pearl and was flanked by two marble columns, which is quite strange considering the fact that this was for Sufis who seek poverty and simplicity in life. But the tiles in the Takiya of al-Kulshani demonstrate that decoration had become acceptable to show the importance of a Sufi shaykh. Mubarak and Mahir also mention that the mosque had a wooden minbar and *dikka* supported on a marble column.[72]

A burial area can be seen on the right-hand side in what was once the prayer area of the mosque. Archive photographs, which show the complex in a state of ruins and abandonment, indicate that this burial was once topped by a dome. The minaret of the mosque stands at the utmost right corner (figure 1.30). It is the third minaret to be built after the Ottoman conquest of Egypt. It is a typical Ottoman minaret with

a round shaft and two balconies topped by a pointed finial. Remains of small parts of green tiles are still visible from within the mosque, indicating that the hood of the minaret was once covered entirely with green tiles fixed in the center by nails (figure 1.31). To the left of the *mihrab*, one finds a door. On its rear side, inscriptions and decorations indicate that this was once the portal to the mosque. It is a pointed arch recess flanked with two benches. Its lintel contains a marble plaque with two lines of inscriptions, Qur'anic and foundation, mentioning the son of the Shaykh Shahin, Jamal al-Din, as the founder in 945/1538 (figure 1.32). The location of this inscription band is rather peculiar; it appears as an external entrance but in fact it is located on the rear side of the *qibla* wall and is invisible to those residing in the cells under the mosque. A second area with a *mihrab* can be seen to the south of the mentioned portal. A

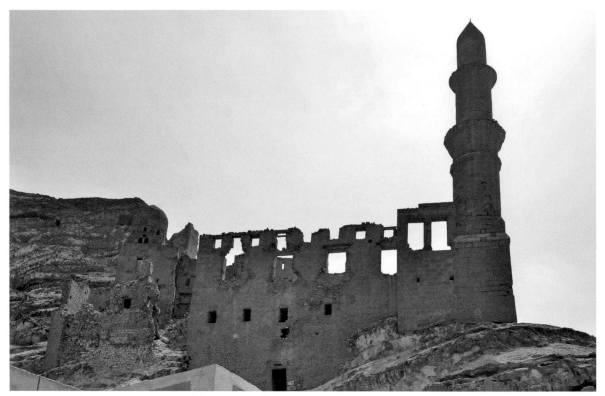

Figure 1.27. The surviving structures of the Mosque of Shahin al-Khalwati.

section drafted by the Ministry of Antiquities shows a flight of steps to what may have been more cells for the Sufis. To the left of those steps, on the southeastern side, is a triple arch arrangement leading to another area, which once led to the mausoleum of the shaykh and his two sons, built at a higher level than the prayer area (Figure 1.33). The dome of the mausoleum is plain and made of bricks. It rests on a squinch interior transitional zone and a stepped outer one, and may have had a tiraz[73] band, which shows earlier Mamluk influence. A cistern and a burial chamber were uncovered in that area. The entrance to the mausoleum no longer survives; the dome currently rests on three of its four walls.

This complex imposes many problems regarding the date of its plan and construction. There are three different construction materials used in this complex: stone masonry, plastered rubble, and plastered bricks, with breaks in the bond in several places. Four dates have to be taken into consideration. The first is 929/1523, the death of Shahin al-Khalwati's tutor Shaykh al-Damirdash and Shaykh Shahin's decision to seclude himself on the cliffs of the Muqattam Hills. The second is 945/1538, which is the construction date of the mosque by his son, Jamal al-Din al-Khalwati. The third is his death in 953/1547, and finally the *waqf* added to this complex by Sultan Suleiman the Magnificent, who built the dome above the shaykh's burial. Keeping these dates in mind, an attempt at dating different parts of the plan to show its development can only be proposed hypothetically because of its poor state of preservation.

Stage A: According to ʿAli Pasha Mubarak, Shahin al-Khalwati initially built a *maʿbad*, which indicates

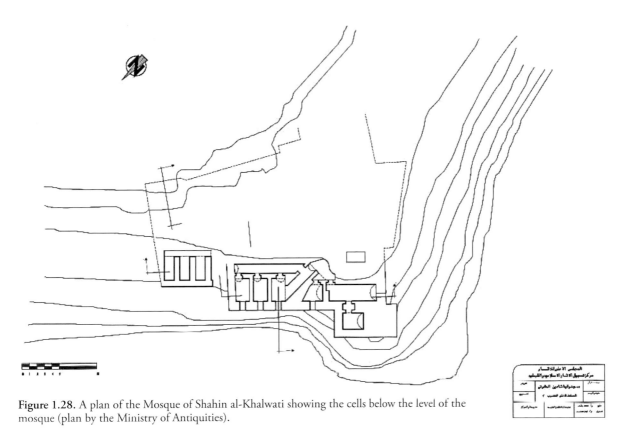

Figure 1.28. A plan of the Mosque of Shahin al-Khalwati showing the cells below the level of the mosque (plan by the Ministry of Antiquities).

a small prayer area, and dug a tomb for himself.[74] It can be assumed that a cistern was also constructed since he was known to have bathed before each prayer. The burial chamber and the cistern, as well as a recess carved in the rocks that could have been a *mihrab*, can be seen today, and were entered through a triple arch.

Stages B and C: Jamal al-Din built the mosque with its entrance facing the triple-arch arrangement nine years before the death of his father, probably due to the increasing number of his followers. Dating the minaret can be quite tricky and two possibilities present themselves: either that it was built at the same time as the mosque since the minaret and its entrance are both built with stone masonry and a visible break-in-bond can be seen from the exterior of the mosque, or that it was built with the construction phase of the

mausoleum dome above the shaykh's tomb chamber. The reasoning for the second possibility is the fact that the minaret has two balconies, which usually carries a royal connotation, and hence is attributed to Suleiman the Magnificent, who ordered the addition of an endowment deed in 958/1551.

Stage D: This includes the area south of the mosque, which today contains remains of burials and a small *mihrab*, as well as remains of walls and stairs that probably led to floors containing more cells for Sufis.

This building today is in a state of ruins and very difficult to reach, as the ramp that led up to it collapsed, as did parts of the hillside leading to it. It was included in this part of the book because it shows the importance and variety of buildings for Sufi shaykhs who played an influential role in the transition period from Mamluk to Ottoman.

Figure 1.29. The *mihrab* of the Mosque of Shahin al-Khalwati.

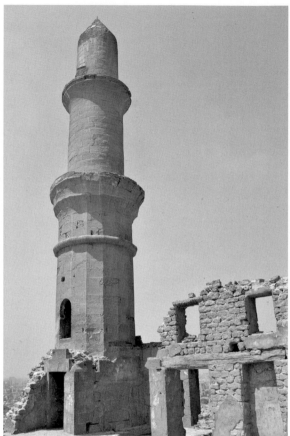

Figure 1.30. The minaret of the Mosque of Shahin al-Khalwati.

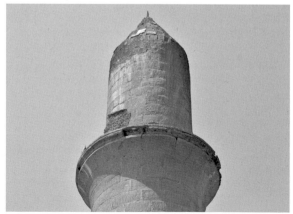

Figure 1.31. A detail of the green tiles found on the top of the minaret of the Mosque of Shahin al-Khalwati.

Conclusion

Newcomers entered Egypt as conquerors and came face-to-face with the local population who were already used to foreign rulers. Ever since the time of Alexander the Great, Egypt was used to being ruled by foreigners. The Mamluks were mostly from Central Asia and Turkey, and even though in time they adopted the Arabic language, Islam, and local culture, they were still considered foreigners by most of the local people. They were in fact highly educated compared to the majority of the Egyptians, who had remained illiterate. With the declining economy at the end of the Mamluk period, especially after the discovery of the Cape of Good Hope and several

Figure 1.32. The entrance of the Mosque of Shahin al-Khalwati.

Figure 1.33. The mausoleum dome of Shahin al-Khalwati.

plagues that hit Egypt, the local population lost their trust in the power of their rulers and turned more and more to Sufi shaykhs, hoping to be supported by their spiritual power. Sufism was widespread all over the Islamic world, and many Sufis came to study and reside in Egypt, especially Cairo, which was the capital of the Islamic Empire and where the Sunni caliph resided. These Sufi shaykhs, regardless of their origin, became the spiritual support at a time of turmoil, especially when the Sunni caliph was sent to reside in Istanbul, the new capital of the Islamic Empire, and they—the Sufi shaykhs—formed the link between the newcomers and the local population.

It seems clear that Sufism was the major factor that dominated the period that constituted the bridge from the end of the Mamluk period into the early Ottoman one. One must bear in mind that Ottoman soldiers as well as pashas also paid respect to those shaykhs, and this formed a point of mutual understanding between the conquerors and the local population. This can explain the profusion of *zawiya*s in the early sixteenth century. The only mosque built at that time, namely the mosque of Khayrbak, the Mamluk who became the first Ottoman Viceroy of Egypt, was started at the end of the Burji Mamluk period and it shows a variation of the plan of the mosque without a central court. The rectangular

chamber covered with cross vaults seems unique, but it cannot be considered an introduction of a new plan to Egypt, since the mosque of the Mamluk amir Aqsunqur (c. 746/1346) is also covered with cross vaults, and a prayer area without an open court was also seen in the Khanqah-Mausoleum of Sultan Barsbay (c. 833/1430) in the Northeastern Cemetery. The addition of the hanging *dikka* can be considered the beginning of Ottoman features in Cairene buildings. The other buildings were all built for Sufi shaykhs, who already lived and were popular in Egypt during the late Mamluk period. *Zawiya* architecture was, as mentioned earlier, known in Egypt from the early Bahri Mamluk dynasty such as in the Zawiya of Shaykh Zayn al-Din Yusuf (c. 695–725/1296–1325), but *khanqah* Sufism dominated because these were better controlled by the state and did not influence public opinion. As *khanqah* Sufism declined, *zawiya* Sufism flourished in Egypt and continued into the Ottoman period. Five of the seven buildings discussed above alternate between being *zawiya-takiya* or *takiya*-mosque, and they were all dedicated to Sufi shaykhs. They show different plans and sizes depending on the popularity of the shaykh and the generosity of the founder. A new Ottoman identity was

definitely not yet achieved. The problems caused by Khayrbak's successors—especially by Ahmad Pasha, who revolted against Ottoman power, leading to frequent changes of pashas and the incorporation of the Mamluks into the Ottoman army as beys—did not help in forming a new identity.

The buildings described in this chapter show a clear rise in Sufi foundations compared to mosques and madrasas. The reason for this could be the large number of surviving multifunctional buildings (mosque/madrasa/*khanqah*) at the end of the Mamluk period and the rise in importance of Sufi shaykhs. Sufi foundations discussed above show a variety in plans, quite different from the Mamluk ones, which did not differ from the madrasa or mosque plans. Minarets tended to disappear unless a mosque was attached as in the case of Shahin al-Khalwati. Cairo was still a Mamluk city. The only real change was the new shape of the minaret seen in the mosque of Shahin al-Khalwati and the hanging *dikka* opposite the *mihrab* seen in the Madrasa of Khayrbak. The first changes appeared gradually during the reign of Suleiman the Magnificent and the promulgation of the Qanunname, which brought some order to the political organization and the country as a whole.

Buildings of the Sixteenth Century

Cairo, the "Shining Star" capital city of the Islamic Empire during the Mamluk period, becomes a province. Major religious buildings from the sixteenth century seek an identity.

THE BUILDINGS OF SULEIMAN PASHA

The Mosque of Suleiman Pasha in the Citadel, also known as the Mosque of Sariyat al-Jabal or Sidi Sariya
(935/1528)
Monument Number: 142

The location
This mosque is inside the walls of the Citadel in the quarters of the Janissaries. According to David Ayalon, as mentioned by Behrens-Abouseif: "Its Turkish Hanafi staff, and the use of the Turkish language all indicate that the mosque of Suleiman Pasha

was dedicated to the janissary corps."[1] It is located at the corner of the northeastern edge of the Northern Citadel enclosure. The mosque was built on the site of an earlier building built by al-Amir Abu Mansur Qasta, a governor of Alexandria during the reign of the Fatimids who was related to Sidi Sariya, one of the companions of the Prophet Muhammad. Sidi Sariya is supposedly buried below the dome in the northwest corner of the mosque's courtyard.[2] However, there is no proof of the arrival or death of this holy figure in Cairo.[3]

The founder
Suleiman Pasha al-Khadim was the Viceroy of Egypt sent by Sultan Suleiman the Magnificent. He was the viceroy from 931/1524 to 941/1534 and again from 943/1536 to 945/1538, which is one of the longest reigns of an Ottoman viceroy. Suleiman Pasha was a eunuch who had served in the harem of the

sultan, which explains his title *al-Khadim* (the servant).[4] He was appointed Viceroy of Damascus in 930/1523, and of Egypt two years later. He was replaced by Khusruw Pasha for seventeen months while on an expedition to India. He was then called back to Istanbul in 945/1538, where he remained until his banishment to Malgara in East Anatolia, where he died in 955/1548.[5]

The *waqf* document of this mosque, which is published by El-Masry,[6] consists of forty small documents on pages 1–327; the most important ones for architecture are the second ones, dated 1 Rajab 936/1 March 1530, where it says that Suleiman Pasha built a mosque in the Citadel as well as a *zawiya* near Bab Zuwayla. On pages 64–68 of the document, which is dated Jumada al-Thaniya 938/January 1532, a *sabil* and *kuttab* in Bulaq, which have not survived, are mentioned. In the fifth document, pages 75–83, dated to 8 Ramadan 938/14 April 1532, a mosque in Bulaq, which was rebuilt, as well as a *wikala* are described. In several other documents a house with seven rooms as well as a mosque are mentioned in the city of Rosetta. Suleiman Pasha was therefore a great builder who expected to remain a long time as Viceroy of Egypt.

The exterior

This can be considered a complex since it includes an earlier mausoleum, a nonextant *sabil*, two courts, and a *kuttab*. The mosque is entered through a low enclosure wall like many late-fifteenth- and sixteenth-century Ottoman Imperial-style mosques, and it is also built on a slightly higher level than the rest of its surrounding typography (figure 2.1). On the right as one enters, there is an elevated area with the opening of a well. The main portal, which is on the south side, leads directly to the prayer area and not to the court as typical of Ottoman mosques in Turkey, and the stalactite conch of the tri-lobed portal is obviously influenced by the Bahri Mamluk Mosque of al-Nasir Muhammad, also found inside the walls of the Citadel. Ülkü Bates suggests that this entrance may predate the Mosque of Suleiman Pasha and that it

probably belonged to an earlier structure, since it is overlapped by the base of the minaret.[7] The wooden shed in front of the main portal is not mentioned in the *waqf* document.[8]

The minaret

It is an Ottoman-style minaret located on the left of the entrance portal, and it is tall with two balconies, like that of his nonextant mosque in Bulaq, which is described in the *waqf* deed. The conical top of the minaret is covered with green tiles to match the tiles that cover the domes. This is the first round Ottoman-style minaret with a conical top in Cairo, and the appearance of two balconies will not be common in later minarets. The two different muqarnas patterns under the balconies recall Mamluk decoration. Also Mamluk is the use of green glazed tiles on the pointed cap and the domes, since these were seen before on the mosque of al-Nasir Muhammad in the

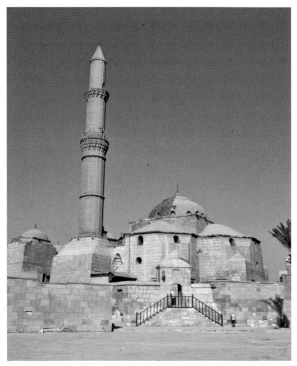

Figure 2.1. The façade of the Mosque of Suleiman Pasha al-Khadim in the Citadel (courtesy of Jehan Reda).

Citadel and earlier on the minaret of the Khanqah of Baybars al-Jashankir in al-Gamaliya. Although not common, it was also seen as late as the dome of al-Ghuri. Interesting are the three rings of arches that can be seen beneath the balconies.[9]

The plan

This consists of a domed central space flanked on three sides by three semidomes: the *qibla* side and the two sides but not the side opposite Mecca, a plan which is known as the inverted T-shape plan. The exterior courtyard is the usual Ottoman-style courtyard surrounded by a portico with shallow domes. This plan can be considered an Ottoman-style plan, which started with the beyliks and continued in Istanbul after the conquest of Constantinople. The northeastern corner of the courtyard is occupied by the slightly bigger dome of the pre-existing shrine of the twelfth-century shaykh (A on figure 2.2). The division of the rectangular space in two, one half for the prayer area and the other half for the courtyard, is very different from earlier Cairene mosques.

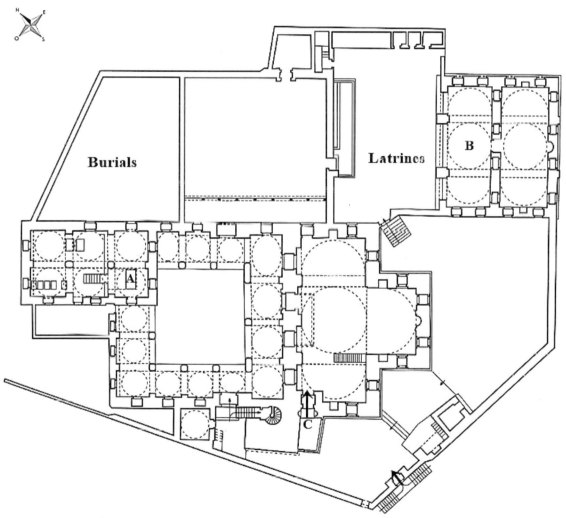

Figure 2.2. The plan of the Mosque of Suleiman Pasha al-Khadim (after Archnet).

The interior

Also, the rather plain façade outside and the shallow domes on spherical triangular pendentives inside appear as an introduction of a new style of architecture. Here one must, of course, point out that a shallow dome on spherical triangle pendentives appeared as early as the dome of Bab al-Futuh, but it did not become popular in Cairo (plate 2.1).

Interesting are the marble panels decorating the lower walls, similar to marble dados of the Mamluk period in black, white, and red topped with an inscription frieze where the white marble is incised with inscriptions, which are filled with a black paste to give the impression of marble mosaic (figure 2.3). This was seen before in the Mosque of Qijmas al-Ishaqi, an amir of Sultan Qaytbay during the last quarter of the fifteenth century, and during the early Ottoman period in Cairo in the Mosque and Mausoleum of Amir Khayrbak. The plan is explained in the document as a *durqa'a* (an inner covered court) with a dome supported by the arches of the flanking iwans. The eastern iwan is in fact considered part of the *durqa'a* in the document because it is not a step higher as are the two other iwans.[10]

A plain area is left between the inscription above the marble dado and the painting of the central dome and semidomes. The paintings, in general, show a variety of designs that accentuate the architecture, since each architectural area is painted with a different design and almost all the inscriptions are verses from the Qur'an.[11] The paintings display a variety of floral patterns, which cannot be compared to earlier Mamluk patterns or even later Ottoman ones in Cairo. Doris Behrens-Abouseif believes that they show some similarity with the exterior stone carving of the dome of the Mausoleum of Khayrbak.[12]

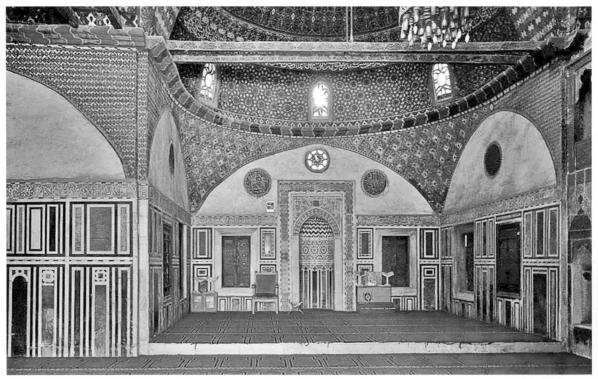

Figure 2.3. The *qibla* iwan of the Mosque of Suleiman Pasha al-Khadim (courtesy of Museum with No Frontiers Islamic Art online collection).

The minbar of this mosque is the earliest surviving Ottoman marble minbar in Cairo. It is a large carved and painted marble minbar, with a conical top similar to the one on the minaret (figure 2.4). Mamluk minbars were usually topped with a pavilion top and a bulb that echo those found on their minarets. Interesting is the location of the minbar. It is not placed beside the *mihrab* as usually found in Cairene mosques; here it is under the big dome, in the middle of the prayer area. The reason for this placement may be due to acoustics, since minbars in Turkey were usually placed beside their *mihrabs*. It could also be the small size of the *qibla* iwan in this mosque where the space beside the *mihrab* is too narrow to accommodate this size of a minbar. The wooden door of the minbar is inlaid with mother of pearl, and the inscription in cartouches on it is a verse from the Qur'an, 33:56; however, its last part is missing. The minbar's hood was originally painted but no paint can be seen on it today.[13] Ten medallions can be seen on the walls of the prayer area and they contain historical inscriptions.

The *mihrab* in the middle of the *qibla* wall is decorated with colored marble similar to Mamluk *mihrabs*, its colors matching the panels of the marble dado. Two candleholders were donated by Suleiman Pasha to his mosque[14] and were probably placed one on each side of the *mihrab*, as mentioned in the *waqf* document.[15] Each candleholder has two inscriptions: one in tughra script on the neck reads "*sahib Suleiman Pasha* [the owner Suleiman Pasha]" while the other one on the upper part of the body consists of several verses from the Qur'an that mention light.[16] According to El-Masry, these candleholders were gilt,[17] and the *waqf* document mentions that

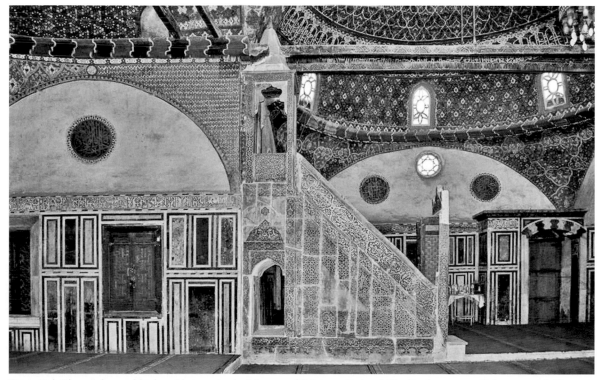

Figure 2.4. The minbar and higher side iwan in the Mosque of Suleiman Pasha al-Khadim (courtesy of Museum with No Frontiers Islamic Art online collection).

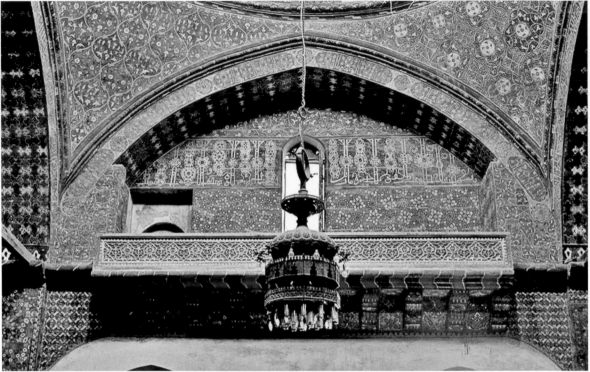

Figure 2.5. The *dikka* of the Mosque of Suleiman Pasha al-Khadim (courtesy of Museum with No Frontiers Islamic Art online collection).

each candleholder held a candle the size of a full-grown man. They were made of beeswax and were lit each night.[18] A Qur'an chair is also mentioned although none exists today in the mosque.[19]

The hanging wooden *dikka* lies above the door leading to the open court opposite the *qibla* iwan and is supported by corbels (figure 2.5). It is painted with designs similar to the dome and semidomes, and each corbel is painted with a different design. The prayer area has three wooden doors: the above-mentioned door opposite the *mihrab* that leads to the courtyard, the main door leading to the prayer area from outside (C on figure 2.2), and a northeastern door that leads to another open court with burial chambers and the ablution area.

Above the door facing the court is the foundation inscription in gold-colored *naskhi* script on a blue background. The only part that shows intensive decoration in the court is found above this entrance. The

tympanum above the rectangular frame of the door and the small dome (figure 2.6) above are decorated with a Chinese cloud ornament carved in stucco that resembles the ornament on İznik ceramics from the sixteenth century.[20] The portico surrounding the court is called an iwan in the *waqf* document. The arches of the portico are supported on polygonal pillars and the rear wall, forming bays covered with shallow domes on pendentives of varying sizes (figure 2.7). The portico is a step higher than the floor of the court except at the entrance of the prayer hall and the side entrance, which leads to the side court and ablution area and the entrance opposite, which is closed today. Two sundials were placed on the spandrels of the arches of the courtyard: one on the mausoleum of Abu Mansur ibn Qasta, and another on the portico to its right. The inscription above the marble dado in the court is similar to the one in the prayer hall inscribed with a Qur'anic inscription where the letters

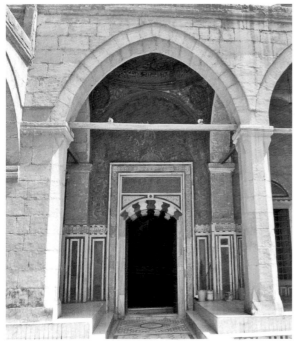

Figure 2.6. The entrance to the domed prayer area from the courtyard (courtesy of Museum with No Frontiers Islamic Art online collection).

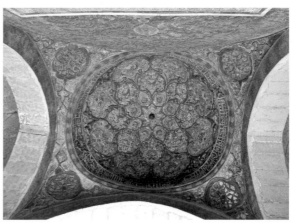

Figure 2.7. The portico of the courtyard of the Mosque of Suleiman Pasha al-Khadim (courtesy of Museum with No Frontiers Islamic Art online collection).

are inlaid with a dark paste filling the incisions in the white marble.[21]

In the northwestern side of the court is the shrine of Abu Mansur ibn Qasta from the twelfth century. The pointed, rebuilt dome of the shrine is higher than the domes of the portico, and the names of Muhammad and 'Ali are inscribed on the transitional zone facing the court (figure 2.8). The shrine also includes the burial sites of Ottoman officials, and one can see tombstones with various headdresses carved in marble. The oldest Ottoman tomb dates from 1212/1797 (Figure 2.9).

This dome was topped with a boat finial like that on the dome of the Mausoleum of Imam al-Shafi'i, but this is no longer extant. A hall covered with a wooden roof precedes the entrance to the mausoleum. This was, according to the *waqf* document, an open court with two latrines and some tombs.[22] The latrines were removed at an unknown date and the tombs were

covered with tombstones. Inside, the mausoleum is divided into two aisles with two central pillars carrying arches running parallel and perpendicular to the walls, forming six bays covered by shallow domes on pendentives. The floor of the south part is 0.35 meters higher than that of the north part. A flight of steps leads down to the original shrine of Sidi Sariya, and above the door is an inscription that is carved in stone. The first part is an extract from the Qur'an,[23] which is then followed by the name of the founder, Amir Abu Mansur Qasta with the date 535/1141.

The entrance of the minaret is from the south side of the court and can be reached by going up a flight of nine steps. A second courtyard lies on the north side and can be entered from the first one and from the prayer area. There is one portico as one enters the court, with wooden columns topped by a wooden roof, which is painted inside and covered with green tiles on the outside. Under the ceiling is a painted Qur'anic inscription frieze, and in the middle of the court there was a *fisqiya* (drinking fountain) that is no longer extant. The small room opposite the portico seems to be of a modern date. This second open courtyard leads to the ablution area, which includes three latrines[24] followed by an oblong building roofed with two domes and four semidomes on spherical

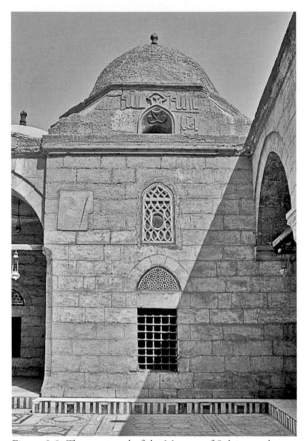

Figure 2.8. The courtyard of the Mosque of Suleiman al-Khadim, which shows the domed shrine of Abu Mansur ibn Qasta (courtesy of Museum with No Frontiers Islamic Art online collection).

triangular pendentives, all also covered on the outside with green tiles. This building opens by three arches on two square pillars; the central one is higher and wider than the side arches. The interior is divided into eight bays covered with domes and half domes; the domes rest on pendentives and the half domes on a row of stalactites (B on figure 2.2). This building, according to the foundation deed, was the *kuttab*, where a *mihrab* with three rows of stalactites in the conch, resembling the *mihrab* of the Üç Şerefeli Mosque in Edirne (c. 833–50/1430–47) can be seen. Above the *mihrab* is a bull's eye window flanked by more windows on each side of the

mihrab. The *waqf* deed does not mention a marble dado decorating the walls in the *kuttab*.

The Mosque of Suleiman Pasha al-Khadim is the first Ottoman plan surviving in Cairo in its original state with a few additions and changes summarized in the following points:[25]

The wooden roof in front of the main entrance was added.

The old door leading to the hanging *dikka* was blocked and a new door was added.

The wooden roof above the entrance to the mausoleum was added.

The ablution fountain was moved to the court in front of the *kuttab*.

New tombs were added in the mausoleum.

New marble was laid in the prayer area and the court.

The *kuttab* had a wooden door, which is no longer there.

The window grilles of the portico and the *kuttab* had stained glass.

The mosque was renovated by Muhammad 'Ali and King Faruq, and in the year 1983 the colors were restored, parts of the dado and floor were replaced, and the side walls of the minbar and parts of the outer walls were restored.

The *waqf* document mentions the people employed in the mosque:

An imam, who had to be a member of the Hanafi school, to lead the prayers.

A *muraqqi'*, whose function was to help the imam.

A *khatib*, who had to speak either Turkish or Persian, to give the sermon on Fridays.

Four muezzins for the call to prayers, two for every day and four on holidays.

A *mu'aqqit*, to inform the muezzins of the times of prayer. Two sundials in the court with the portico and in the mausoleum were for telling time.

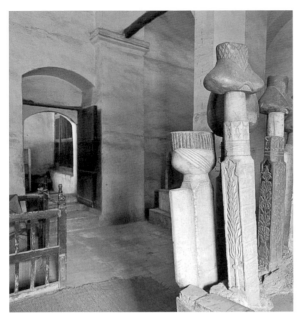

Figure 2.9. The interior of the domed shrine of Abu Mansur ibn Qasta with the headdress-decorated tombstones (courtesy of Getty Images).

Qur'an reciters, one main reader and thirty-two other readers.

A *madih* to praise the prophet every Friday.

A *qari' al-hadith*, to read hadith from Sahih al-Bukhari during the three holy months.

A *mu'adib al-aytam* to teach in the *kuttab*, which was for orphans.

An *'arif* to help the *mu'adib al-aytam*.

A *qayyim* to open doors, light candles, carry Qur'ans, and burn incense on Fridays.

Six slaves to clean the building and two to carry water into the mosque and the *kuttab*.

A gardener.

A caretaker for the mausoleum.

The Mosque of Suleiman Pasha al-Khadim is a hybrid of an Ottoman plan with an iwan with Mamluk features, which include the colored marble dado, the Kufic inscription in dark paste incised into the white marble above the dado, and the typical Mamluk-style *mihrab*.

The Mosque of Suleiman Pasha in Bulaq (937/1531)

The location

The original Mosque of Suleiman Pasha al-Khadim in Bulaq was located in Harat al-Suleimaniya, off Suq al-'Asr Street. The area known as Bulaq lies on the eastern bank of the Nile opposite the island of Zamalek and north of the city center of Cairo. The course of the Nile has changed several times over the years and has shifted west, leaving an alluvial plain on the eastern bank. This alluvial plain continued to dry up over time. The result was that the distance between the Nile and the city grew. By the end of the thirteenth century, a set of docks appeared to replace the old port of al-Maqs, which had become unusable. The port of Bulaq was first mentioned as early as the reign of Sultan Baybars al-Bunduqdari (r. 657–76/1259–77). According to Wiet in Hanna's *An Urban History of Bulaq in the Mamluk and Ottoman Periods*, in 725/1324, Sultan al-Nasir Muhammad took steps to urbanize Bulaq after the port of al-Maqs fell out of use.[26] This gave rise to the port of Bulaq, especially after the Sultan's digging of al-Khalij al-Nasiri to facilitate international trade. By the fifteenth century, the area had become an important trade center, even after the discovery of the Cape of Good Hope, which was considered a blow to the Egyptian economy. International trade recovered quickly and was prosperous at the end of the Mamluk dynasty and well into the Ottoman one. This becomes clear when one sees the amount of *wikala*s for trade built in Bulaq during that time.

The founder

The founder is Suleiman Pasha al-Khadim who built the Imperial-style mosque in the Citadel that is commonly known as the Mosque of Sidi Sariya. 'Ali Pasha Mubarak states that Suleiman Pasha's mosque in Bulaq included twenty-four stone columns and was accessible through two entrances, and attached to it was an ablution area as well as many dependencies and a minaret. Mubarak adds that al-Ishaqi mentions

that the pasha added next to it *wikala*s, suqs and *rab*'s.[27] Amir Muharram Bey was appointed *nazir al-awqaf* for Suleiman Pasha. He renovated the mosque by expanding it and raising its ceiling.[28]

The plan
According to the *waqf* document, the mosque had two entrances, as described by 'Ali Mubarak: one on the eastern side facing Harat Masjid al-Suleimaniya and a main entrance of the western side on 'Atfat al-Suleimaniya, which is now lower than the street level.[29]

The plan of the mosque is rectangular and measures 27 × 23.5 meters. It consists of five aisles with arches running parallel to the *qibla* wall and a lantern in the middle supported by four arches.

Abu al-'Amayim mentions that the mosque had a plain tri-lobed entrance framed by a double molding with loops with a rectangular panel above the arch of the door, which probably included the foundation inscription.[30]

What is really peculiar about this mosque is the location of the minaret in the second aisle upon entering the mosque. It can be presumed that this minaret was once on the façade of the mosque before it was expanded by Amir Muharram Bey. The minaret has a round shaft that rises above the ceiling of the mosque, ending with several rows of stalactites under its two balconies. The shaft of the minaret includes several rows of pointed recesses, some pierced while others are blind. It has a pointed top, typical of Ottoman minarets.

A recent visit to the mosque showed a completely rebuilt building with more or less the same plan mentioned above, with the minaret's base standing in the center of the mosque. The stone columns mentioned by Mubarak have been rebuilt into pillars clad with marble, and the lantern that was once in the center of the mosque has been rebuilt as a shallow dome. The lower part of the minaret inside the mosque appears original. The mosque can be reached by going through the *wikala* of Suleiman Pasha through two gates facing each other. The second still retains the foundation inscription of the building.

The Takiya-Madrasa of Suleiman Pasha, also known as the Takiya Suleimaniya (950/1543)
Monument Number: 225

This building, according to an inscription on a marble panel above the doorway, is called a madrasa, and was founded under the reign of Sultan Suleiman by the Grand Vizier Suleiman Pasha al-Khadim in the year 950/1543 (figure 2.11). Fascinating about this inscription are the many honorific titles added to the name of the sultan, including titles that were not used before on any other building. The pompous titles of the sultan are followed by those of the founder, whose titles here are higher than those on his mosque in the Citadel. By the year 950/1543, Suleiman Pasha had already been granted the title of Grand Vizier, and these titles are those of the Grand Vizier of Istanbul and are unique in Cairene epigraphy. The inscription labels the building as a madrasa and not a *takiya*.

Madrasas were usually institutions for advanced education where various branches of religious studies were taught. Ottoman madrasas, like Mamluk ones, had rooms for the lodging of teachers and students, so they served partly as residential buildings, but with different plans. Ottoman madrasas consisted mostly of an open courtyard surrounded by a portico covered with shallow domes behind which were the rooms, normally placed on one floor only. They included, beside the residential rooms, a communal classroom, a prayer area, and sanitary arrangements. In most cases, a kitchen was not included, for in Turkey meals were obtained from an *imaret*,[31] which was a public cookhouse.[32] Some of the larger madrasas also included a library. The Madrasa of Suleiman Pasha does not vary from the plan mentioned above, but it probably became known as a *takiya* when it was taken over by the Qadiri order of Sufis during the sixteenth century, dated by the mausoleum of the shaykh buried in it.

Although Suleiman Pasha left a large endowment deed, comprising forty endowment documents made over twelve years—dating from 936/1530 to 948/1542—this *takiya*-madrasa was not mentioned

in his endowment, nor has its *waqfiya* appeared later or elsewhere.[33] Abu al-'Amayim adds that the Takiya-Madrasa of Suleiman Pasha was still in use until the mid-twentieth century, as mentioned in a *waqf* document in the name of Khedive Ismail, numbered 866 in the Ministry of Religious Endowments.[34] 'Ali Pasha Mubarak mentions that it was first built as a madrasa, then it became a *takiya* for the Qadiriya *tariqa* where they buried two of their shaykhs, Shaykh Rasul al-Qadiri and Shaykh Ibrahim al-Tabtal al-Qadiri, and that it was provided for by twenty-five feddans in Giza.[35] The exact date of the change seems to be unknown, but the possibility of it being intended for a Sufi order from the beginning cannot be excluded, since the burial of the Qadiri shaykh is dated to the late tenth/late sixteenth century, so shortly after the inauguration date of the madrasa.

The location

The building lies on the eastern side of al-Surujiya Street, which is the southern extension of the Fatimid Qasaba outside of Bab Zuwayla to Muhammad 'Ali Street behind the Mosque of Sultan Hassan. The building overlooks three streets: the main façade on al-Surujiya Street, the northern façade on 'Atfat al-Lamuna, and the back or eastern façade on Hammam Bishtak Street.

The plan

From the street, the main entrance is flanked by four shops on the right and three shops on the left, all topped with vaults, above which are two stories of residences. In the center of this long façade, a degenerate portal in the Qaytbay style opens, giving access to stairs ascending to an open courtyard. The main portal is very similar to the south door of the Mosque of Qaytbay at Qal'at al-Kabsh, yet it is not as finely decorated (figure 2.13). One can see the same tri-lobed arch framed by a molding with loops, and the spandrels carved with a stem and leaf design and knotted ribbons. In the portal of the Takiya Suleimaniya, the side lobes of the tri-lobed arch are decorated with the sun-ray motif and stalactites.

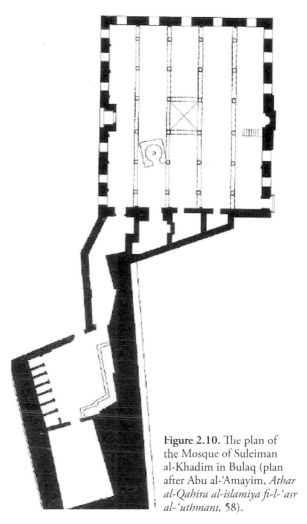

Figure 2.10. The plan of the Mosque of Suleiman al-Khadim in Bulaq (plan after Abu al-'Amayim, *Athar al-Qahira al-islamiya fi-l-'asr al-'uthmani*, 58).

Unlike the joggled voussoirs of marble in Qaytbay's portal, in this building the voussoirs are of uncarved stone, but the marble columns of the window above the door of the *takiya*-madrasa are finely carved and may have been reused from an earlier building.

Entering through the portal, one descends three steps, followed by thirteen ascending steps. This corridor, which is covered with three cross vaults that slope upwards, leads to a small domed vestibule covered with a shallow dome on pendentives (figure 2.14).

Figure 2.11. The foundation inscription of the Takiya-Madrasa Suleimaniya.

The only decoration consists of three tiers of angular stalactites at the springing of the arch opening onto the court. The open court with its portico covered with shallow domes and the rooms behind the portico form a perfect square (figure 2.15). The marble columns and their different capitals are all spolia. On axis with the vestibule, one finds an iwan opening by an arch onto the portico, which includes a *mihrab*. The two arches leading to the *mihrab*—the portico and the iwan arch—have stalactites at the springing of the arch carved with a stem and leaf design reminiscent of the Qaytbay style. The *mihrab* (figure 2.16), which is high and deep like most Mamluk *mihrab*s, and not wide and shallow like Ottoman ones seen in Cairo so far, is slightly askew to face Mecca. The lower part of this *mihrab* is undecorated, except for the two faceted marble columns at its corner. A frieze of a carved *naskhi* inscription runs above the columns and across the recess of the *mihrab*, and above this the conch is decorated with radiating *ablaq* while each radius of the frame is carved in alternating fashion with an arabesque and linear design. The spandrels are also decorated with a carved arabesque design, and two side panels show a carved linear rosette. The whole *mihrab* is in fact reminiscent of the Qaytbay style.

To the left as one enters the portico surrounding the courtyard is a room with a grilled window overlooking the portico, and beside it an arch leading to a washing area. The northern side of the courtyard includes four rooms with grilled windows overlooking the portico and the court, then a rectangular door leading to an open area with what seems to be a modern washing area and latrines. One can only wonder if this area was originally a *rab'* belonging to the *takiya*-madrasa. On the right, before reaching this open area, one sees a door leading to a large room overlooking the portico through a grilled window and covered with two domes, today split into two by a wooden door. This could have been a second teaching area beside the iwan or a special meeting place.

Beside the open iwan on the eastern side is another room with a grilled window overlooking the portico, followed by a large room with the burial place of the two Qadiri shaykhs but only one tombstone. The room is covered with a dome and a semidome covering the chamfered corner overlooking 'Atfat al-Lamuna.

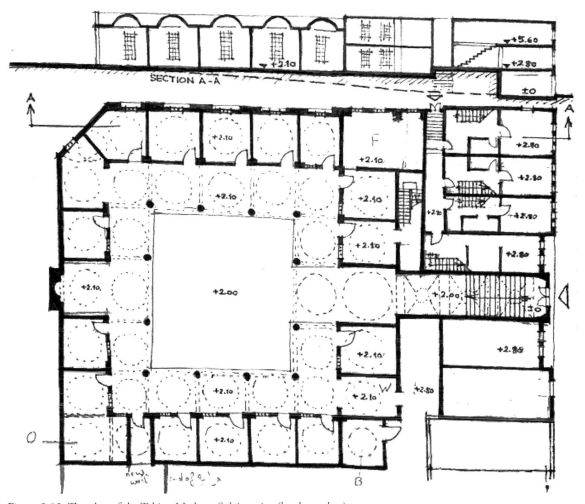

Figure 2.12. The plan of the Takiya-Madrasa Suleimaniya (by the author).

The southern façade overlooking 'Atfat al-Lamuna is pierced with five doors, but only the last one has a grilled window overlooking the portico. The last room, in fact, leads to a slightly bigger inner room, which may have been for the teacher or Sufi shaykh.

Finally, the part on the right of the main entrance at the western side of the building has two rooms, both with grilled windows overlooking the portico. According to the present inhabitants of the *takiya*, who claim to be descendants of the Qadiri shaykhs, one of those rooms used to serve as a kitchen. In fact, behind this room there is a corridor and stairs that lead up to the roof, and since no *imaret* or separate cookhouses were built in Egypt during the Ottoman period, this room could well have originally been the kitchen.

All the windows and doors have joggled voussoirs surmounted by relieving arches and lunettes, and all the domes of the rooms are pierced with an oculus except for the mausoleum of the Qadiri shaykhs. The oculus is a common Ottoman architectural element because most rooms in Turkey included a fireplace for cold winters, which was considered unnecessary in

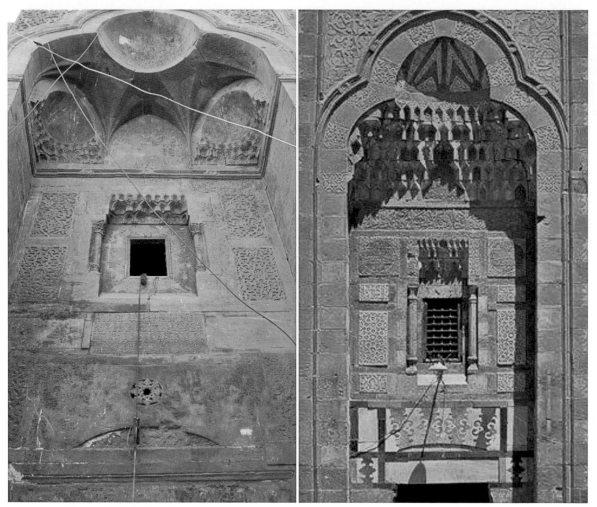

Figure 2.13. The entrance of the Takiya-Madrasa Suleimaniya and the Mosque of Sultan Qaytbay in Qal'at al-Kabsh.

Egypt. All the arches are semicircular and are framed with a molding with a knot at the apex, except at the side entrance, where no knot can be seen.

The entrance façade with its portal and barrel-vaulted shops mentioned above was the main façade of the building. The income of these shops, one can assume, was probably used for the upkeep of the building, in addition to the land in Giza mentioned by 'Ali Pasha Mubarak. A small rectangular portal can be seen on the side façade on 'Atfat al-Lamuna leading to the living quarters above the shops

of the main façade, which were probably part of a *rab'* belonging to the *takiya*-madrasa, since no break in the bond can be detected. These were living quarters probably used by married Sufis, since the tradition at the time was for single Sufi men to live around the court. After the portal on that side, one sees four windows in four rectangular recesses, all with carved joggled voussoirs. The third façade, which is the back wall of the building, overlooks Hammam Bishtak Street and is plain, with a projection for the *mihrab*. Interesting is the chamfered corner between the two

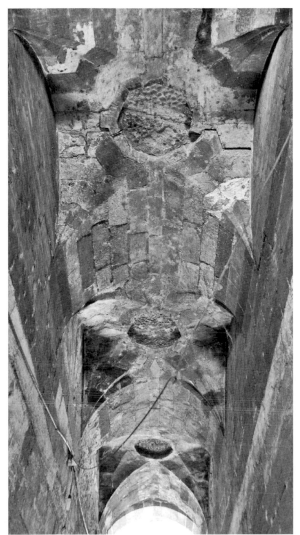

Figure 2.14. The vaulted corridor leading to the courtyard of the Takiya-Madrasa Suleimaniya.

façades, the one on 'Atfat al-Lamuna and the one on Hammam Bishtak Street. Was it to make room for the window overlooking the mausoleum of the two Qadiri shaykhs, allowing people to remember and say a prayer to them? If so, this may indicate that the building was intended, designed, and built as a *takiya*-madrasa for the Sufi order from the start.

There is on the whole very little mention in the Comité de Conservation about any restoration done to this building. In one fascicule a *waqfiya* is mentioned, but none has come to light and the present inhabitants say it was lost a long time ago.[36] They claim to have legal papers and inherited rights that prove their rightfulness to live in it.

To conclude, the plan with stairs leading to an open courtyard, a portico covered with shallow domes, and domed rooms with an oculus is definitely an Ottoman plan of a madrasa, but apart from the plan, very little can be considered Ottoman. The portal is built in the late Mamluk style, and all the decorative elements have prototypes in late Mamluk buildings. Therefore, it can be speculated that the plan was sent from Istanbul, but the execution of the plan was done by local craftsmen. If the craftsmanship is of a lesser quality than what we see in late Mamluk buildings, this can be explained by the fact that the best craftsmen were taken to Istanbul by Sultan Selim. A question arises here: why is this building so "cheaply" done compared to Suleiman Pasha's mosque in the Citadel, despite the fact that the titles show that the founder had become the Grand Vizier in Istanbul? The answer is probably the *'Irsaliya-i Khazine.* During the first decade of Ottoman rule in Egypt, the revenues of the Imperial Treasury were devoted to expenditures for Egypt and the Holy Cities and to purchases of commodities sent to the Sublime Porte (Ottoman government). Periodic gifts, in cash or in kind, were sent to the Sultan by Khayrbak; however, the Imperial Treasury in Istanbul became more and more in need of new revenues to support the growing bureaucracy and military ambitions of Sultan Suleiman. When Ibrahim Pasha restored Ottoman rule and administration in Egypt after the failure of the ill-fated revolt of Ahmad Pasha in 931/1524–5, arrangements were made for the dispatch to the Porte of a fixed annual payment as *'Irsaliya-i Khazine,* or remittance, from the Imperial Treasury of Egypt. These were to provide an annual surplus of four hundred thousand gold pieces to be sent annually to Istanbul. This amount was sent regularly by Suleiman Pasha al-Khadim from 931/1524 to 941/1534 and again from 943/1536 to 945/1538. The annual sum was then increased to five hundred thousand gold pieces.[37] This led to a deficit in available funds for two expensive foundations.

Figure 2.15. The courtyard of the Takiya-Madrasa Suleimaniya.

All the buildings discussed above were built by the Governor Suleiman Pasha al-Khadim, who was sent by Sultan Suleiman the Magnificent to rule the province of Egypt. This was his last post before returning to Istanbul to be promoted to Grand Vizier, the dream of any high official in the Ottoman court. Yet his interest in Cairo did not diminish after his promotion; several buildings were attributed to him after his departure from Cairo, including this mausoleum. The question arises: was he so fascinated by the city of Cairo that he planned to return and settle down after his retirement? His first mosque, which was built in the Citadel, was a piece of Ottoman propaganda showing the local inhabitants that a new power was now in control of their land. But all his other buildings were sending a different message; the new rulers were absorbed in society and had started considering Egypt their new home.

The Mosque of Muhibb al-Din Abu al-Tayyib (934-6/1527-9)
Monument Number: 48

The founder
Not much is written about the founder, and the *waqf* document is not complete, as its first pages are missing.[38] The *waqf* document attributes several monuments to its founder, but only the mosque is extant.

This mosque is known to the people living in the area but is not a major attraction like the buildings on al-Muizz Street, which was the main road in the once palace city of the Fatimids.[39]

The location
It lies at the beginning of Khan Abu Taqiya Street, which is off al-Muizz Street on the west side, in al-Khurunfish area. The original building consisted

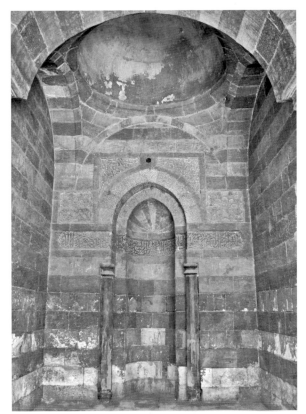

Figure 2.16. The *mihrab* of the Takiya-Madrasa Suleimaniya.

of a Friday mosque, a cistern, and a *mazmala bikhar-ka*—an area for the storage of water jars covered with a movable mashrabiya screen to keep the water cool—but in the Ottoman period this term developed to refer to the *sabil*.[40] In addition to the previous structures was a *kuttab*, a minaret, and shops, as well as an ablution area and two *fisqiyas* (drinking fountains), but only the mosque survives.

The date

The mosque is dated in the Index of Cairo's Islamic Monuments to the tenth/sixteenth century, while its *waqf* document is dated to 18 Dhu al-Qa'da 934/4 August 1527.[41] Ottoman *waqf* documents were usually written the same year as or a couple of years after the construction of a foundation; therefore, one can assume the mosque was built between 934/1527 and 936/1529.

The plan

The mosque has two façades: the *qibla* façade, which overlooks Khan Abu Taqiya Street, and the northeastern façade, which overlooks al-Khurunfish Street. Originally, underneath both façades were doors leading to shops; thus it was a suspended mosque like the Fatimid Mosque of al-Salih Tala'i', located outside of Bab Zuwayla, the Fatimid southern gate of the city of Cairo. The main façade, which corresponds to the *qibla* wall inside the mosque, includes the main entrance at its southern end (figure 2.18).

The entrance is recessed, flanked by two *maksala*s or benches, and topped by a tri-lobed arch. The *waqf* document mentions a wooden door with metal facing, but this did not survive, and today it has been replaced by a plain door. The entrance is crowned by the tri-composition of the joggled lintel, lunette, and relieving arch. This arrangement is topped by a rectangular window with a simple metal grille. The whole entrance is framed with a simple double molding that forms a loop at the apex. The conch does not include stalactites, but one can see ribs in the two lower lobes of the tri-lobed entrance, which remind us of portals from the Qaytbay period. The document mentions two superimposed rooms above the entrance, the first for the *bawwab* (the doorkeeper) and the second for the imam.[42]

The projecting wall of the *qibla* iwan shows a slight projection of the *mihrab* with a bull's eye above and a recess on each side of the *mihrab* projection. Each recess contains a lower rectangular window with a metal grille and a Qalawun set of windows above. The corners of the *mihrab* projection have an engaged column on each side, topped with bell-shaped bases and capitals. The northeastern façade is plain and does not seem original.

The interior

The entrance leads to a vestibule with a recess and a stone bench, called a *mastaba* in the *waqf* document, and according to the deed, the wall of the recess was pierced with a window. On the left, there is another recess with a *mastaba* with a cupboard or a *khazana*

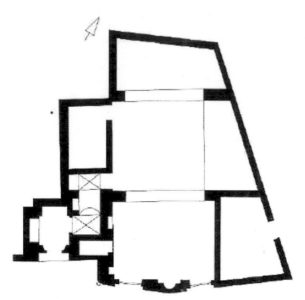

Figure 2.17. The plan of the Mosque of Muhibb al-Din Abu al-Tayyib (after Abu al-'Amayim, *Athar al-Qahira al-islamiya fi-l-'asr al-'uthmani,* 19).

haıta above it. This vestibule was paved with a colored marble floor and was clad with a dado. A door on the right of the vestibule leads to a corridor *(dihliz)* that is 4.35 meters wide and only 1.35 meters long. There are two doors on the left of this corridor: the first leads to stairs that ascend to the roof, and the second is used today as a storage area. According to the deed, this storage area was originally the *mazmala* intended for the storage of water jars. Opposite the *mazmala* is another door that leads to the interior, which, according to the deed had a metal-faced door that cannot be seen today.

The ceiling of the corridor alternates between a cross vault at the beginning, followed by a barrel vault, then by another cross vault. The opening in the ceiling was to air the *mazmala* as in the Madrasa of Sultan Qaytbay in the Northeastern Cemetery. The corridor leads to a covered *durqa'a* or inner court,

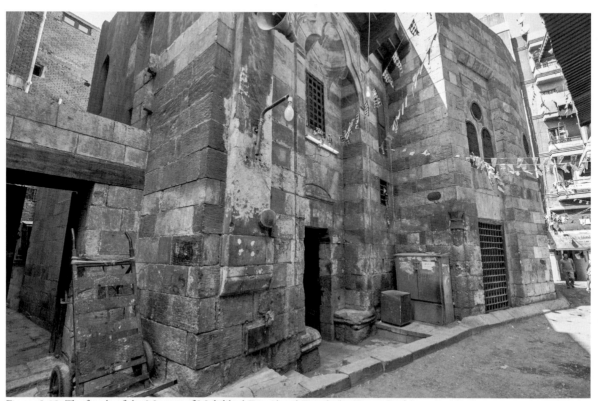

Figure 2.18. The façade of the Mosque of Muhibb al-Din Abu al-Tayyib (by Karim Saada).

rectangular in shape, measuring 6.97 × 6.50 meters and one step lower than the two iwans. According to the deed, the ceiling above the *durqa'a* was made of painted wood. The original ceiling did not survive, but a few wooden pieces remain without any paint.

The *qibla* iwan opens onto the *durqa'a* by a pointed arch (figure 2.19). On each side of the *mihrab* is a pointed arched recess, which encloses the rectangular windows located on the façade, as mentioned above. Above this is another pointed arched recess with the Qalawun set of windows. These contain stucco grilles and colored glass, like the bull's eye above the *mihrab*.

On the right as one faces the *mihrab* are two recesses, one on each side of a door that leads to the imam's room. The recesses are called *kutayibat* in the *waqf* document; thus they were more likely used to store books. The door is topped by a small window. According to the deed, there were four cupboards on the opposite wall, but none survive today. We are told in the deed that the founder endowed books on religious studies, Arabic language, history, and Sufism. The iwan was paved with a colored marble floor and was clad by a dado, which on the *qibla* wall rose up to the bull's eye window. The marble panels had a marble frame incised and inlaid with colored paste. Unfortunately, only a few pieces remain on the *qibla* wall today.

The *mihrab* and minbar

The *mihrab* of the Mosque of Muhibb al-Din displays clear Mamluk influence. The lower part is decorated with colored marble panels in black, red, and white. The middle part displays twelve-pointed stars in marble mosaic, above which is a carved marble frieze with miniature arches and a chevron design in the conch. The conch is framed with a joggled decoration with God's name in the center. The spandrels of the *mihrab* are decorated with an abstract arabesque pattern in carved marble-and-paste inlay.

The minbar to the right of the *mihrab* is made of ivory and wood, including ebony and pitch pine wood, which were, according to al-Dessouki, imported.[43] The main decoration consists of full, half, and

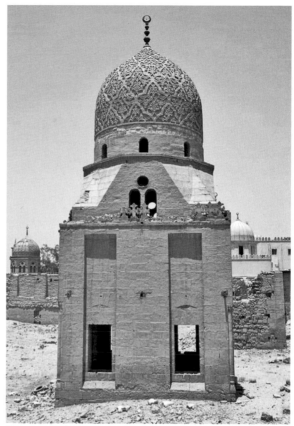

Figure 2.19. The rear façade of the mausoleum of Prince Suleiman (after Archnet).

quarter twelve-point stars. The plaque above the door has a *naskhi* inscription that reads "Enter in peace."

The ceiling still survives, but is in bad condition. It shows wooden beams between rectangular and square panels decorated with geometrical and leaf patterns with remains of paint. The wooden frieze under the ceiling is inscribed with the Throne Verse (Qur'an 2:255) in *naskhi* carved in relief, but only a small part remains in the southwest corner of the iwan.

The iwan opposite the *qibla* opens today by a plain opening onto the *durqa'a*. It opened originally, according to the deed, by a pointed arch similar to the one on the *qibla* iwan. The back wall of this iwan had *kutayibat* and a door leading to some of the dependencies of the mosque. A new, simple, wooden *dikka*

reached by steps can be seen in the back wall of this iwan. 'Ali Pasha Mubarak describes the mosque as having two iwans and two *sidilla*s (shallow iwans) surrounding the covered court.[44] The arch of the *sidilla* in the south can still be seen, but the one opposite has completely disappeared and looks today like a large but shallow recess. The Comité mentions the addition of this building—after inspection—to the monuments of Cairo to put an end to the demand to demolish it and asked the Ministry of Religious Endowments to restore it.[45]

The Mosque of Muhibb al-Din Abu al-Tayyib can be considered a Mamluk-style building where the prayer area is a distortion of the Mamluk *qa'a* plan,[46] which consists of two main iwans facing a court covered with a lantern ceiling. Nevertheless, what survives today is the result of modern renovations. It was a small neighborhood mosque, built in the local style, that was unaffected by changes in the political scene.

The Mausoleum Dome of Prince Suleiman (951/1544)
Monument Number: unlisted

The founder
Islamic architecture historians have long debated who the founder of this Mamluk-looking mausoleum was. While the majority of sources attribute this mausoleum dome to Suleiman Pasha al-Khadim, a dive into historical chronicles uncovered another plausible theory regarding its founder. Sources assert that Suleiman Pasha al-Khadim died in banishment in Malgara in East Anatolia in 955/1548 and not in Cairo. One assumption previously made was that he ordered the mausoleum dome to be built at the same time of his *takiya*-madrasa, while he was serving as the Grand Vizier of the Ottoman Empire.

The more plausible theory on the founder is that it belongs to Prince Şehzade Suleiman, son of Şehzade Ahmet, son of Bayezid II, son of Mehmet the Conqueror, who was the cousin of Sultan Selim. According to Ibn Iyas, Prince Suleiman and his brother 'Alaeddin fled to Egypt to escape family intrigues for the throne against Sultan Selim.[47] Prince Suleiman died from the plague

on 17 Safar 919/24 April 1513 and was followed by his brother 'Alaeddin on Saturday, 8 Rabi' al-Awwal 919/14 May 1513. According to Ibn Taghribirdi, they were buried "in the desert" and the funerary prayers were attended by Sultan al-Ghuri. A foundation inscription in the interior, which is no longer extant, was read by the Orientalist August Ferdinand Mehren, detailing that this mausoleum dome was erected much later, at the order of Sultan Suleiman the Magnificent, the son of Selim, during the reign of Suleiman "the Agha of the Arab Sultanic Mamluks of Egypt in 951/1544"[48]. Inscribed in the tilework of the exterior drum was the Throne verse and Qur'an 2:18[48]:

فى ايام مولانا السلطان الأعظم ..سليمان خان بن السلطان
سليم خان بن السلطان بايزيد خان بن السلطان محمد خان خلد
الله ملكه، امر بإنشاء هذه القبة المباركة من فضل الله تعالى
الجناب العالى المولى الأميرى الكبيرى العاملى سليمان اغا
المماليك السلطانية العرب بمصر المحروسة آمنه الله وغفر الله
بتاريخ شهر المحرم سنة 951هـ

In the days of our great Sultan… Suleiman Khan the son of Sultan Selim Khan the son of Sultan Bayezid Khan the son of Sultan Mehmet Khan, may God immortalize their reign. This blessed dome was ordered by the grace of God by… Suleiman the Agha of the Arab Sultanic mamluks in Egypt the protected… in Muharram 951.

The location
The mausoleum dome is located in the courtyard of the Complex of Barsbay al-Bajasi in the Northeastern Cemetery, opposite the Khanqah of Faraj ibn Barquq. Turkish sources mention the burial place of both amirs as the "Havşi Sultan Camii," which may indicate the *hawsh* of the Mosque of Sultan Faraj ibn Barquq, mentioned in chronicles as the burial site of many significant individuals.

The exterior
The Mausoleum of Prince Suleiman is a square chamber crowned by a double-leaf cresting, which resembles those from the Burji Mamluk period. The corners of the

mausoleum feature pyramid-shaped transitional zones, with a Qalawun set of windows in the walls in between, followed by a drum pierced with eight windows and decorated with two rows of square tiles, which included the above-mentioned inscriptions, all of which are topped by a beautifully carved stone dome. The four outer walls are broken into recesses, and the entrance is placed in flat stalactite recess with benches on each side, flanked by two windows in stalactite recesses. The lunette above the joggled lintel contains tiles inscribed with the phrase "*Allahu rabbi*" (God is my Lord). The sides are broken by a plain recess with a rectangular window, and the back façade includes two recesses flanking the *mihrab* projection (figure 2.20).

The dome follows the Qaytbay style of carved domes, with a beautiful stem and leaf design, which resembles that of the Mausoleum of Khayrbak with its curved lozenges filled with arabesque (plate 2.2).

The interior

Its interior architecture includes two tombstones without inscriptions. The *mihrab* is a pointed arch recess decorated with geometrical designs, above which is a *naskhi* inscription with the *shahada*. The inner transitional zones consist of stone stalactite pendentives typical of the Burji Mamluk period.

The mausoleum is clearly a continuation of Burji Mamluk funerary architecture, which was not common in the early Ottoman dynasty. It can be considered strange since all the buildings of Suleiman Pasha al-Khadim adapted the Ottoman style with Mamluk influences, but they definitely include an introduction of the Imperial Style of Ottoman mosques. The drum of the Mausoleum of Prince Suleiman has, unfortunately, lost all of its tiles and can be therefore mistaken today for a late Burji Mamluk mausoleum.

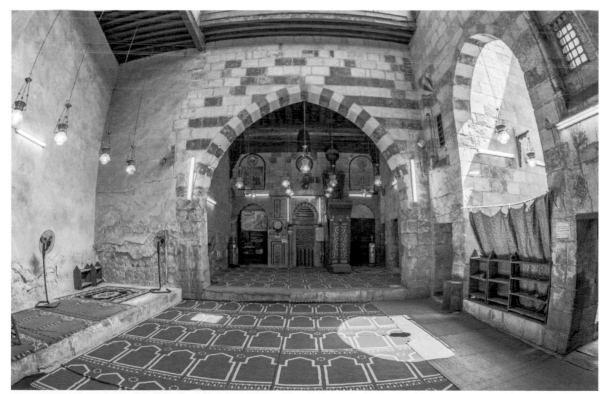

Figure 2.20. The interior of the Mosque of Muhibb al-Din Abu al-Tayyib (by Karim Saada).

The Mosque of Dawud Pasha
(955–61/1548–53)
Number: 472

The founder

Dawud Pasha al-Khadim[49] ibn ʿAbd al-Rahman served as Viceroy of Egypt from 945/1538 to 956/1549, a period of eleven years and eight months during the reign of Sultan Suleiman the Magnificent. This is considered an unusually long period for an Ottoman viceroy. He died in Egypt and was buried in a mausoleum near the shrine of Imam al-Layth.[50] Dawud Pasha is described in the sources as cruel at times, having executed a large number of people, but on the other hand as a man who was interested in culture and possessed a vast number of endowments and books. He was also known to be encouraging and kind to scholars.[51] His endowment deed is a 464 page document written in *naskhi* script, which also includes several of his endowment deeds in Mecca and Medina, and also in Syria.[52] The endowment deed was completed after the death of the founder by his *katkhuda* Ahmad Bey ibn ʿAbdallah, the administrator and supervisor of the foundation, to which he added a number of commercial and residential structures.

The date

The date of the mosque is written on a marble panel on the main entrance (figure 2.21) where one can read two lines of poetry, which with the calculation of *hisab al-jummal* (also known as the abjad computation), where letters represent numbers, gives the result 961/1548. This mosque was completed five years after the death of Dawud Pasha.[53] One can thus assume that the mosque was begun by Dawud Pasha and was finished by his *katkhuda*.[54]

The location

The mosque lies on Suwayqat al-Lala Street, off Port Said Street on the west side, which is part of the Sayyida Zaynab quarter. The name of the road goes back to the Zawiya of Lady Safiya al-Lala, which overlooks this street. This mosque was among many other buildings endowed by the founder and originally part of an entire urban project.

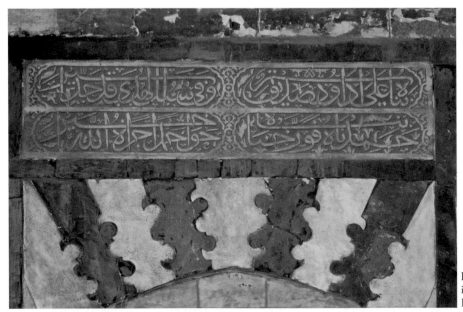

Figure 2.21. The foundation inscription of the Mosque of Dawud Pasha.

The exterior

This mosque overlooks Suwayqat al-Lala Street through a single façade that lies on the northwestern side (figure 2.22). As mentioned in its endowment deed, buildings on both sides bracketed the mosque at the time of its construction, which remains the case until today.[55] The main entrance lies on the western side of the façade and is pierced at the end of a roofed iwan-type platform, ascended to by a flight of four steps (figure 2.23). The description of the entrance in the endowment deed is different from what we see today. Instead of the metal door at the base of the steps, there used to be a wooden door painted in red and green. The entrance led originally to a passageway with two doors, one on the right and the other under the steps, both leading to storage areas.[56] The main entrance at the end of the platform is tri-lobed with stalactites in the two lower lobes and is flanked by two *maksalas*. The plain black marble lintel seen today was originally inlaid with white marble, and the inscription with the two lines of poetry that give the date lies above the joggled relieving arch.

A small square window tops this marble panel, and the whole entrance is framed with a double molding with loops, which end with a larger loop at the apex of the tri-lobed arch.

Another entrance can be seen on this façade to the left of the main entrance after a recess with windows. The entrance is placed in a shallow tri-lobed recess framed by a double molding with loops and is flanked by two small *maksalas*. The door is topped by a window that overlooks the stairs that lead to the hanging *dikka* and the roof. This door is closed today. Two further recesses can be seen on this façade and the remains of a five lobed leaf cresting still survive until today.

The minaret

The minaret, which is no longer extant, was demolished in 1941.[57] It was a brick minaret and consisted of a square shaft that was 3.75 meters high, topped by a pyramid-shaped transitional zone. Above the transitional zone was an octagonal shaft ending in a balcony on stalactites, and the top part was round with a pointed finial.[58]

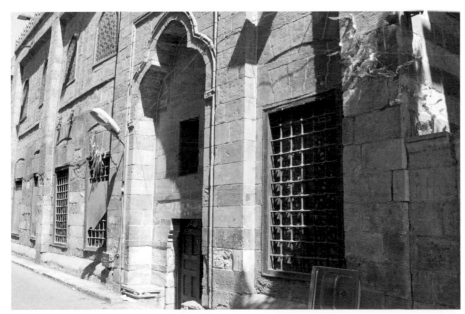

Figure 2.22. The façade of the Mosque of Dawud Pasha.

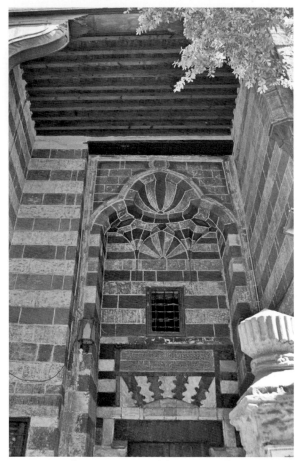

Figure 2.23. The main entrance of the Mosque of Dawud Pasha.

The *sabil*

The *sabil* mentioned in the endowment deed no longer exists. It was located beside the ablution area and was covered with a brick dome, which is a rare feature in Cairene *sabil*s.

The plan

The main entrance leads to a *dihliz*, or corridor, which is covered today with a plain wooden ceiling. The endowment deed mentions the painted ceiling and marble floor of the *dihliz*. The *dihliz* then bends to the left forming a bent entrance to the prayer area. Today, the lower parts of the walls are covered with

colored marble panels. A small *khilwa*, or room, opens onto the *dihliz* and is used today by people working in the mosque. The plan of the prayer area is quite unusual; it is divided unequally into two spaces by a large arch, but the flooring of the whole area is on one level. There is, in fact, no real separation between the two areas. This interior division, which lacks a clear architectural form, is unusual in both Mamluk and Ottoman architecture (figure 2.25). The closest parallel can be seen in the Mamluk Mosque of Aytmish al-Bajasi (c. 786/1384), but in al-Bajasi the division is more pronounced because of the difference in the ground level. Another parallel would be the nonextant Zawiya of Shaykh Murshid, which originally dated from the Bahri Mamluk period. The prayer area of the Mosque of Dawud Pasha measures 6.17 × 11.10 meters, with four recesses on the northwestern side, each with a raised marble floor and a wooden ceiling. Each of the recesses has a lower and an upper window, the latter with stucco grille and stained glass, which is not mentioned in the deed, which describes clear glass instead. The hanging *dikka* is fixed above the recesses and is made of painted wood. The prayer area is covered with a plain wooden ceiling with a lantern in the center. The arch that divides the space in two is a horseshoe arch, which rests on corbels decorated with stalactites.

The *mihrab* is decorated with marble panels and marble mosaics in the Mamluk style. It is heavily restored except for the conch, which appears in its original state.[59] The wooden minbar found today is not the original one, as it replaces the original white marble minbar.[60] The deed also mentions a marble dado in the prayer area, which did not survive.

The extension (not an *iwan*, because it is not a step higher) on the southwestern side of the prayer area, contains two doors, one leading to the steps going up to the hanging *dikka* and the roof, the second being the second door found on the façade.

The Mosque of Dawud Pasha represents a step away from the Mamluk *qa'a* plan. Space-wise, the architect could have designed a typical late Mamluk *qa'a* plan, but instead he introduced a new space for

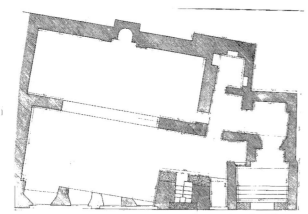

Figure 2.24. The plan of the Mosque of Dawud Pasha (plan after Abu al-ʿAmayim, *Athar al-Qahira al-islamiya fi-l-ʿasr al-ʿuthmani,* 67).

the prayer area, while keeping typical Mamluk features by maintaining and respecting the street alignment, breaking the façade into recesses with windows, using stalactites in the entrance. The fact that this was a suspended mosque, as mentioned in the deed, is also a typical Mamluk feature.

The Mosque of Mahmud Pasha, also known as al-Mahmudiya
(975/1567)
Monument Number: 135

The founder

Mahmud Pasha was the last governor sent to Egypt by Sultan Suleiman the Magnificent before the latter's death in 974/1566. He arrived in Egypt in 973/1565 and remained there until his murder in 975/1567, which earned him the title "the murdered Mahmud Pasha," or *Maqtul* Mahmud Pasha. He is described as strong-willed and courageous but also as a bloodthirsty killer with a passion for collecting money.[61] His *waqf* document shows that he was the founder of several buildings and was the only pasha from the sixteenth century who intended to remain in Egypt, since the document includes a mausoleum for himself.[62] In fact, he was the only pasha before

Muhammad ʿAli to mention this in an endowment deed. The *waqf* document does not include a detailed description of the mosque, as it was written in the month of Dhu al-Qaʿda 947/1566, before the completion of the mosque. In fact, when the pasha died, his properties were auctioned to pay his debt to the Imperial Treasury in Istanbul, and the rest of the sum was dedicated to the completion of his mosque.[63] In the foundation inscription the building is called a mosque, but in the *waqf* document it is called a *turba* where Sufi *hudur* took place. The term "*turba*" in the document does not refer to the mausoleum, but to the mosque as a whole.[64]

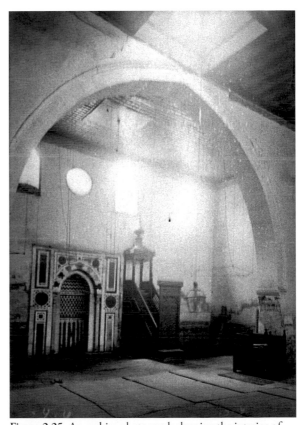

Figure 2.25. An archive photograph showing the interior of the Mosque of Dawud Pasha (courtesy of Ibrahim Ramadan's online compilation of photographs, plans, and elevations of Cairene Islamic Monuments, *al-Athar al-islamiya fi-l-Qahira wa-l-muhafazat al-ukhra*).

The location

The mosque overlooks Salah al-Din Square below the Citadel, the square that was originally called Maydan al-Rumayla.[65] The importance of Maydan al-Rumayla goes back in history to the time of Ahmad ibn Tulun's dynasty. It was given special attention during the Bahri Mamluk dynasty by sultans Baybars al-Bunduqdari and al-Nasir Muhammad, who refurbished the *maydan* and ordered its plantation and the construction of princely palaces around it.[66]

The exterior

The mosque has four façades, so it is a freestanding building (figure 2.26). The main façade is the southwestern one with the entrance portal placed in the center and the minaret in the southern corner. Originally there was a *sabil* in the western side of the façade, only the foundation of which can be seen today (figure 2.27). Part of the *sabil*'s floor was taken to the Museum of Islamic Art in Cairo.[67] An old photograph by Frith[68] and a plate in *Description de l'Égypte* show the whole complex encompassed by a stone wall with an arched entrance flanked by two benches leading to a court that opened onto the front of the main entrance of the mosque. This court led to a structure to the right of the entrance of the mosque (figure 2.28). Nahid Hamdi in her PhD thesis suggests that this may have been the remains of a *takiya*, which consisted of several *khilwa*s, and that the outer stone wall joined the *takiya* to the *sabil*, but this is not mentioned in any of the sources.[69] On the other hand, Abu al-'Amayim states that this room was for *khadim al-jami'* (the caretaker of the mosque), but he too does not mention a source for this information.[70] The *sabil* and the *takiya* were removed in 1298/1881 by the Comité de Conservation and were replaced with the present wall of wrought iron and the steps ascending to the mosque.[71]

The entrance

The entrance is placed in a tri-lobed arched recess framed with a double molding with circular loops, topped by a larger loop at the apex, and is flanked by two benches. Three rows of stalactites cover the area

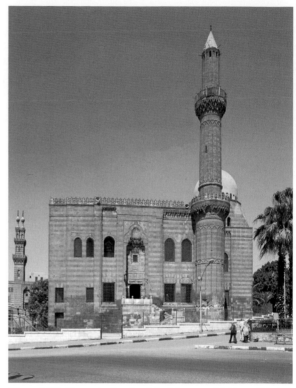

Figure 2.26. The main façade of the Mosque of Mahmud Pasha.

of the two side lobes. The upper frame of the door is decorated with a joggled lintel, topped by a joggled relieving arch. This arrangement is crowned with a small rectangular window with a plain metal grille. The late Mamluk influence is abundant in the overall appearance of the entrance.

The main façade

Three recesses break the monotony of this façade: one on the right and two to the left of the main entrance. The one on the right of the entrance is wide with two superimposed windows covered with stucco grilles and stained glass, while the first recess to the left of the main entrance is narrow and has only one window covered with a stucco grille and stained glass. The second recess is wider and is also pierced with windows that probably overlooked the room of the *sabil*, which was located there.

Figure 2.27. The nonextant *sabil* of the Mosque of Mahmud Pasha (drawing after *Description de l'Égypte* Vol. I, pl. 67, courtesy of the World Digital Library Online Art Collection).

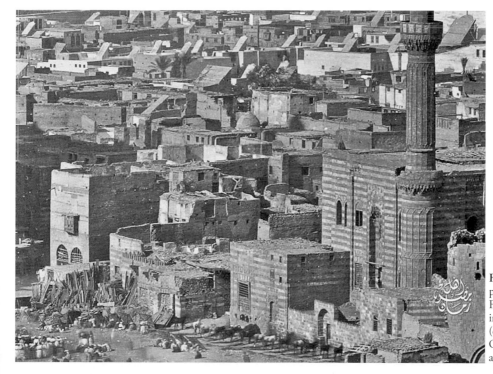

Figure 2.28. An archive photograph by Francis Frith from the Citadel in Salah al-Din Square (courtesy of the J. Paul Getty Museum online art collection).

The minaret

The minaret is located on the right as one faces the main entrance. It is built of stone and starts from the ground. It is a fluted, round minaret with stalactites under the balconies. The five-lobed leaf cresting at the level of the roof of the minaret joins that which adorns the skyline of the mosque. The minaret consists of three round tiers and ends in a pointed finial.

The northwestern façade

This façade is broken with three stalactite recesses; the middle one is wider than the other two, and they all contain superimposed stucco windows with stained glass.

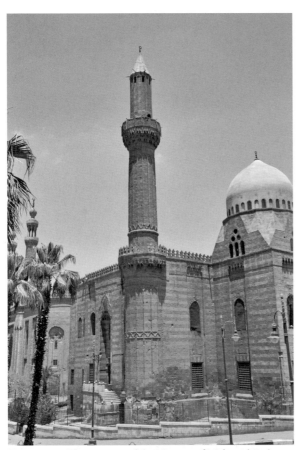

Figure 2.29. The minaret of the Mosque of Mahmud Pasha.

The northeastern façade

The second entrance of the building is located in the middle of this façade. It leads to the ablution area and can be reached by ascending a couple of steps. It is a stalactite entrance with a window overlooking a vestibule behind it. The entrance is not flanked by any benches like the ones found in the main entrance. On each side of the entrance, a recess with two superimposed windows breaks the monotony of the plain wall.

The southeastern façade

This is the *qibla* side of the building, with the projecting mausoleum of Mahmud Pasha. The three freestanding sides of the mausoleum are broken with four stalactite recesses pierced with windows, including a bull's eye window between the two recesses of the *mihrab* of the mausoleum. The exterior transitional zone is pyramid-shaped like one of the mausoleums of the Burji Mamluk Mosque of Qijmas al-Ishaqi, with three elongated windows and three oculi in between. Above this stands the sixteen-sided drum area. Hasan 'Abd al-Wahhab has pointed out that the square room and the transitional zone area are built of stone; however, the dome and the drum area are of bricks.[72] One can assume here that a carved stone dome was intended in the original construction design of the mosque, yet the murder of the pasha required an abrupt wrap-up, so a brick dome was built.

The plan

The interior consists of a square room that measures 19.75 meters on all sides, and is divided with a lower corridor that leads to the ablution area from the main entrance (figure 2.31). A lantern ceiling on four columns covers the center of the corridor (figure 2.32). The lantern ceiling is painted with geometrical and leaf patterns and is inscribed with a Qur'anic verse, a hadith, and the name and title of Mahmud Pasha and date of construction, 975/1568.[73]

The *qibla* wall is 19.75 meters long, with the *mihrab* in the center, flanked by a door and a recess on either side. The door on the right of the *mihrab* leads to a small vaulted chamber, while the door on the left leads

to the mausoleum. Each door is topped with a window decorated in a stucco grille and stained glass. Two more windows can be seen, one on the right and one on the left of the prayer area on this side of the lower corridor. The *mihrab* is plain, with the exception of its colored stone facing. Both the hanging *dikka* on the wall opposite the *mihrab* and the minbar are made of wood (figure 2.33). A small door in the northern corner leads to steps that rise up to the *dikka* and the roof.

The wooden ceiling of the interior is painted with star patterns, *bukhariya*s, and stem-and-leaf designs. A Qur'anic frieze runs in the cornice underneath the ceiling.

The interior of the mausoleum

The square mausoleum is only 6.75 × 6.82 meters inside with a plain *mihrab* in the middle of the *qibla* wall and a pointed arched recess with windows in the two sidewalls. The wall opposite the *mihrab* contains

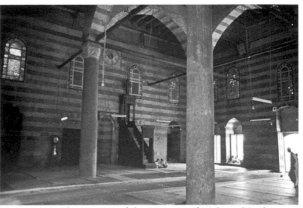

Figure 2.31. The interior of the Mosque of Mahmud Pasha (after Archnet).

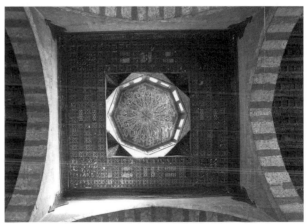

Figure 2.32. The lantern of the Mosque of Mahmud Pasha (after Archnet).

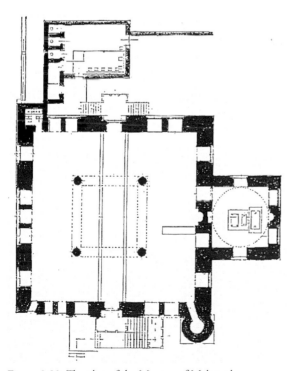

Figure 2.30. The plan of the Mosque of Mahmud Pasha (after Max Herz Pasha).

the door to the mausoleum from the prayer area and a blind recess. The tombstone is made of stone with four pomegranates at the corners and with a round column at the head side.

The inner transitional zone consists of stone pendentives with seven tiers of stalactites and windows in between consisting of three elongated windows and three oculi, above which is the drum area.

The Mosque of Mahmud Pasha can be considered to be more Mamluk than Ottoman. The choice of location, placed between two splendid Mamluk buildings— the Madrasas of Sultan Hasan and Qanibay al-Rammah—was meant to convey the power and

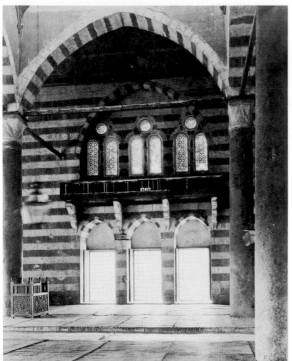

Figure 2.33. An archive photograph by Creswell of the *dikka* of the Mosque of Mahmud Pasha (courtesy of the V&A online art collection).

grandeur of the new ruling dynasty. Nevertheless, the result was rather disappointing, as al-Mahmudiya did not compete, not even closely, in size or quality of craftsmanship with its two neighboring buildings. The only Ottoman feature of the exterior is the rounded minaret with a pointed hood. Bates adds that the isolation of the mosque from its surroundings is an Ottoman feature that continued in Cairene Ottoman architecture.[74] The location of the mausoleum seems to copy the Madrasa of Sultan Hasan nearby. The plan imitates that of the Khanqah-Mausoleum of Sultan Barsbay in the Northeastern Cemetery (c. 833/1430) with its division into three by a corridor that runs in the middle of the prayer area. However, in this case because of the larger space of the mosque, a lantern was added on top of four columns to bring more light and ceiling height to the mosque. Also, in this case, the corridor leads to the ablution area

and not the mausoleum. The hanging *dikka* can be considered the only Ottoman feature in the interior. One must mention that the peculiar location of the *sabil*, which obscured part of the main façade, and the *takiya,* which was built in front of the minaret, may indicate a later construction date for both.

The Mosque of Sinan Pasha
(979/1571–72)
Monument Number: 349

The founder

Sinan Pasha was of Albanian origin and was raised among the *devshirme* that were considered the elite group of Janissaries. He was appointed Governor of Egypt in 975/1568 for a short tenure, which lasted for only nine and a half months. He was then recalled to Istanbul in order to be the commander of a campaign to overthrow the Zaydis in Yemen. But in 978/1571, he was reappointed Governor of Egypt for the second time, a rule that lasted one year and ten months, until 980/1573.[75] His many successful campaigns promoted him to the position of grand vizier, a post that he filled five times between 988/1580 and 1003/1595.[76] He died in 1003/1595 at the age of eighty and was buried in Istanbul. He was the founder of many pious buildings in the many cities he governed.

The location

The mosque was built on the east bank of the Nile in Bulaq and directly overlooked the Nile before it shifted its course. As the illustrations of Robert Hay show, the Mosque of Sinan Pasha overlooked the Nile until the end of the 1111s/1700s.[77] The mosque is described in its *waqfiya*[78] as being part of a large complex that included three khans, a hammam, a *sabil, kuttab, qasr* (palace), a *bayt* (house), a *ma'sara* (a press), as well as shops.[79]

The plan

It is the second mosque to be built in Egypt in an Imperial Ottoman style, yet so different from Suleiman Pasha's mosque in the Citadel. It is a large

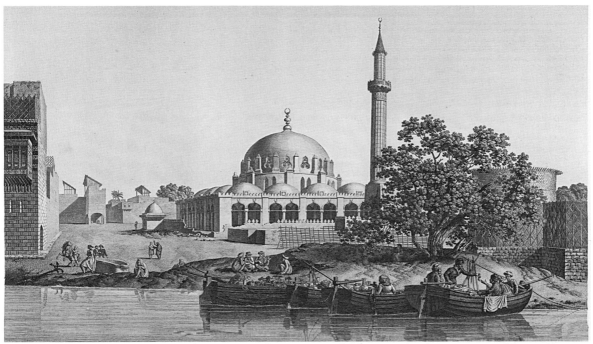

Figure 2.34. A drawing of the Mosque of Sinan Pasha (after *Description de l'Égypte* , Vol I, pl. 25, courtesy of the World Digital Library Online Art Collection).

domed building, surrounded by porticos on three sides with a minaret in its south corner (figure 2.36). The dome, which is above a square prayer area, is built of stone but topped with plastered bricks and was originally covered in lead sheets. Its drum area has an upper and a lower tier. The upper one is sixteen sided; each side is pierced with a tri-lobed window, framed on two sides by octagonal buttresses. On the other hand, the lower tier, which is also octagonal, has double windows with pointed arches on each side. These are flanked by octagonal buttresses, which are more massive than the ones of the upper tier. The drum of this mosque measures 15 meters in diameter, making it the largest stone dome in Cairo, even larger than those in the Khanqah of Faraj ibn Barquq, which measure 14.35 and 14.40 meters in diameter.[80]

The porticos around the three sides of the square prayer area are covered with miniature domes in the typical Ottoman style, all made of bricks, and each portico has an entrance on its side. The entrances on

the southwestern and the northwestern sides show a triple arch not seen in the northeastern side. This probably indicates a restoration done after the construction of a new street on that side in 1902.[81] Today, a double tri-lobed cresting runs around the four sides of the mosque; nevertheless, an old photograph shows a stepped cresting, very unusual for that period (figure 2.37). This plan of a domed mosque surrounded by porticos on three sides has parallels with the Mosque of Piyale Pasha in Beyoğlu (c. 981/1573) and the Çinili Mosque in Üsküdar (c. 1049/1640), both located in Istanbul. The arches of the portico of the Mosque of Sinan Pasha are framed with double moldings and are supported by tie beams, both of which are Mamluk features.

The two *mihrab*s in the porticos are mentioned in the *waqfiya*. One of them was destroyed in renovations, while the other remains on the eastern side today. The doors leading into the mosque are topped by a muqarnas hood (figure 2.38).

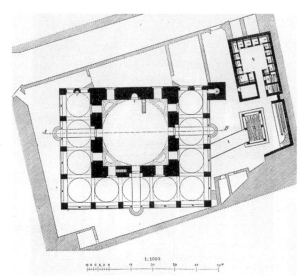

Figure 2.35. The plan of the Mosque of Sinan Pasha (after Archnet).

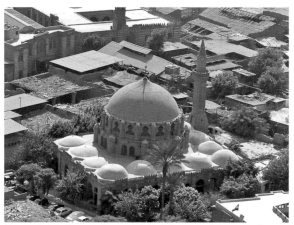

Figure 2.36. An aerial view of the Mosque of Sinan Pasha (after Archnet).

The minaret

On the southern corner of the mosque is a short, pointed-top minaret, reached through a staircase from the southwest corner of the mosque. A balcony resting on stalactites separates the two round shafts. The bulkiness of the lower round shaft of the minaret indicates that it probably was intended to carry a taller second shaft, but instead it carried a disproportioned brick top (figure 2.39). A plate in *Description de l'Égypte* also shows a faceted second shaft like that of the lower one, but instead today this second shaft is plainly plastered. The pointed top of the minaret was once covered in lead and topped by a gilt copper finial. Hasan 'Abd al-Wahhab believes that the minaret was left incomplete, as its pointed top is placed halfway on its second tier.[82]

The interior

The prayer hall is a square, domed chamber, with walls that are pierced by deep recesses. The *mihrab*, which is flanked by marble columns, is decorated in the typical Mamluk style with marble paneling and a chevron design in its hood, followed by a geometric design in its middle section, surrounded by a joggled voussoir and topped by a round oculus (plate 2.3).

The minbar is a later addition since it doesn't match the description of the minbar in the *waqfiya*.[83] The overhanging wooden *dikka* is supported by wooden corbels and could be reached by a staircase in the northeastern recess in the northwestern wall. The *waqfiya* mentions many Qur'an reciters who recited the Qur'an at regular intervals and that the hanging *dikka* was intended for muezzins; this is a very unusual feature for Cairo and one may assume that the leaders of the Qur'an reciters used it also.

The transitional zone, which cannot be seen from the exterior, consists of a large squinch divided in its interior into a tri-lobed squinch over the window recesses at the four corners of the prayer area, all decorated with muqarnas friezes. Two of the four conches of the squinches have "Allah" written in them while the other two have sunburst designs. This type of transitional zone imitates late Mamluk domes, namely the Fedawiya dome and the dome of the Zawiya of al-Damirdash in al-Abbasiya. Bates observes that the low positioning of the arched transitional zones truncates the corners, giving the interior the impression of having a cylindrical shape.[84]

Above the transitional zone area, one can see stained-glass windows displaying a floral design of

designed by an Ottoman architect but was executed by local craftsmen. The plate that depicts the mosque in *Description de l'Égypte* (figure 2.34) hints that the mosque was surrounded at one time by a not-so-high wall topped with fleur-de-lis cresting, making it plausible to think that maybe the Mosque of Sinan Pasha followed the Ottoman tradition of complexes with several structures that were encompassed by a wall or a portico—in this case it is a modest wall—that groups the different units of a complex together.

Single-domed prayer areas with porticos on the outside were also built in Turkey and Syria, where the portico was built on the side of the main entrance. The interior of the Mosque of Sinan Pasha lacks decorations, except for the *mihrab*. The corridor at the

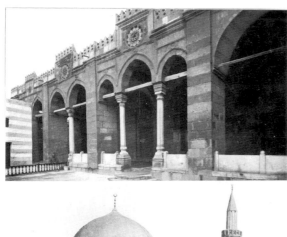
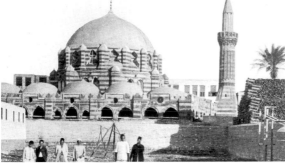

Figure 2.37. Archive photographs of the Mosque of Sinan Pasha (courtesy of the V&A online art collection).

eight circles around a central one. They alternate between pierced windows with colored glass and blind decorations. These correspond to the lower tier of the drum area seen outside. A narrow corridor with a wooden balustrade runs above the stalactites of the lower tier of the dome. The same staircase leading to the hanging *dikka* also rises up to this corridor. Behind this are the tri-lobed windows in the upper tier of the dome.

No trace of painting can be seen inside the dome of the prayer area, unlike the Mosque of Suleiman Pasha in the Citadel, and also no marble dados exist except in the *mihrab*.

The Mosque of Sinan Pasha can be considered an Ottoman-style plan introduced to Egypt at that time, but the plan did not gain popularity since the only other mosque with a similar plan appeared in the Mosque of Muhammad Bek Abu al-Dhahab, built almost two centuries later. It could have been

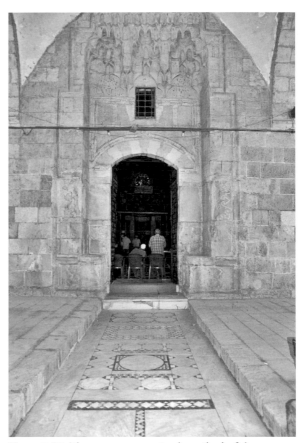

Figure 2.38. The entrance opposite the *mihrab* of the Mosque of Sinan Pasha.

Figure 2.39. The minaret of the Mosque of Sinan Pasha (drawing from *Description de l'Égypte,* Vol. I, pl. 25, courtesy of the World Digital Library Online Art Collection).

level of the second tier of the drum with its wooden balustrade is a novelty and the *waqfiya* does not specify its function. It will appear again later in the Mosque of al-Malika Safiya and may have been for the cleaning of the windows or for the *waqqad* to light the lamps, since the *waqfiya* informs us that they had to be lit at dawn and at sunset and were extinguished after the evening prayer. Also unusual is the total absence of inscriptions in the mosque. This may be because Sinan Pasha never saw his mosque completed, as he left Egypt to lead military campaigns and never came back. Therefore, it can be assumed that the intended inscriptions (if any) were never completed.

One must add here that Sinan Pasha also built a mosque for himself in Syria, almost fifteen years after his mosque in Cairo. He was appointed Governor of Syria in 995/1587 and constructed his mosque there in 998/1590. While the plan of his mosque in Damascus is completely Ottoman and consisted of the single-dome prayer area accessed through a front portico with an open court for ablution, the decoration and architecture are a blend of Cairene and Syrian influences. The entire exterior façade of the mosque is covered with black and white *ablaq* marble within which the entrance stands. The entrance is topped by a ribbed half-dome above several tiers of stalactites, reminiscent of the portal of the Madrasa of Sultan Hasan

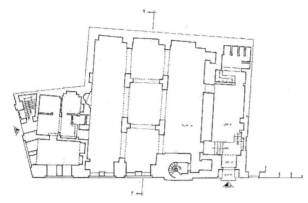

Figure 2.40. The plan of the Mosque of Messih Pasha (courtesy of Ibrahim Ramadan).

in Cairo. The tilework panel beneath the stalactites, which features Ottoman pine trees, tulips, chrysanthemums, and cloves in a blue, green, and white palette, remains interesting and extremely eye-pleasing. Under this panel is the foundation inscription of poetry written in Ottoman Turkish. Following the entrance to the ablution courtyard, the entrance of the mosque is found on the right. The façade and pavement of this courtyard is decorated with black and white *ablaq* marble, which visually connects it with the exterior façade. The shallow domes of the portico are supported on ogive arches. The portico contains a number of windows that overlook the prayer area. Each tympanum above these windows is topped by tilework. A carved white marble slab can be found above the *mihrab* in the portico, which contains the foundation inscription of the mosque inscribed in poetry. This kind of foundation inscription, written as a poem, rarely appears in Cairene architecture from this period, but became popular later on.

The interior plan of the mosque consists of a single-dome prayer area supported on pendentives. The dome is decorated with an epigraphic medallion with the popular verse in Mamluk architecture قُلْ كُلٌّ يَعْمَلُ عَلَى شَاكِلَتِهِ (Qur'an 17:84) at its apex. The variation from Mamluk decoration here is the presence of a thinner band of inscription in cartouches that goes around the medallion in the apex and is surrounded by a vegetal design reminiscent of the Baroque and Rococo peri-

ods. The wall opposite the *mihrab* and the two side walls all carry *dikka*s on columns that are accessed separately. The columns that support the *dikka*s, especially the side ones, divide the area into three, forming small *iwaq*s under the side *dikka*s. The *mihrab* is decorated with marble mosaic forming different geometrical designs. Two large candlesticks flank the *mihrab*, which may have been used at one point to light up the prayer area. The white marble minbar topped with a conical hood is typical of Ottoman pulpits.

The minaret of this mosque is a typical round shaft Ottoman minaret with a pointed finial. The round shaft of the minaret is covered with a combination of blue and green tiles. Old photographs show a shield surrounding the upper round shaft of the minaret below the pointed finial.

It seems clear that both mosques attributed to Sinan Pasha, in Cairo and in Damascus, feature an Ottoman plan of a single-dome prayer area with porticos of shallow domes. However, his mosque in Damascus reflects a clearer Ottoman identity than the one conveyed in Bulaq in Cairo.

The Mosque of Messih Pasha (983/1575)
Monument Number: 160

The founder

He was the Pasha of Egypt during the reign of the Ottoman sultan Murad III, the grandson of Sultan Suleiman the Magnificent from his son Selim II. He was appointed in this post and arrived in Egypt in 982/1574, and remained there until 988/1580. He was known for his keenness on enforcing laws and issued the death sentence to many lawbreakers, which led to him being described by historians like al-Bakri as a murderer.[85] The pasha was also known to depend largely on a Shafi'i shaykh called Nur al-Din Abi al-Hasan 'Ali al-Qarafi al-Ansari who is mentioned several times in his *waqf* deed, and to whom he made an exceptional endowment.[86] His *waqf* document shows that he not only built a mosque, but a whole complex, which included a *ribat* with a mausoleum and a

sabil-kuttab, as well as an ablution area and a drinking trough for animals.[87] A *zuqaq* or small street separated his complex from the madrasa he built for Shaykh Nur al-Din. The only part that survives is the *ribat,* which is known today as the Mosque of Messih Pasha. The reason the building is called a *ribat* in the document is because the founder appointed one hundred poor men to always be there for prayers as well as for reciting the Qur'an and hadith, and this was typical at *ribats* in Cairo at the time.[88] The building was also open to everybody for regular daily prayers; therefore, it also functioned as a mosque. The founder also built a *rab'* that faced the mosque and stood between the Mosques of Sultan al-Ghuri (c. 916/1510) and his mosque—which today would be part of Sayyida Aisha Square, but is no longer extant. Beside the *rab'* was the house of Shaykh Nur al-Din, which according to the document would be used by the succeeding shaykh of the mosque after the death of Shaykh Nur al-Din, but this has also not survived.[89]

The location

The mosque stands today facing the Citadel, on Salah Salem Street, overlooking the Sayyida Aisha Bridge, at the edge of the Southern Cemetery.

The exterior

The mosque has two façades: the main northeastern façade overlooks Salah Salem Street, and the southeastern one overlooks a narrow alley leading to the cemetery behind it. The main façade includes the entrance at its northern end, in addition to the minaret, which stands beside it. A *sabil* can be found at the eastern end of the façade.

The main entrance is placed in a tri-lobed arched recess with stalactites in the lower side lobes and just one tier of stalactites at the base of the upper central lobe. A double molding with circular loops frames the entrance. A wooden door can be seen at the end of the recess, which is flanked by two benches and is topped with a joggled lintel and relieving arch, above which is a rectangular window crowned by stalactites.

Beside the entrance, one can see two recesses with rectangular windows below and a Qalawun set

of windows above, following the façade of the *sabil,* which also shows a recess with the same arrangement of windows. The *kuttab* that was located above the *sabil* is no longer extant. The second façade, the southeastern one, also shows a recess with the same set of windows, beside which there is a plain door that leads to the interior of the *sabil.*

The minaret

It is a typical round Ottoman minaret supported on a square base that rises up to the roof, followed by a small square transitional zone before it becomes round with vertical moldings. It contains a balcony supported on stalactites and is topped by a pointed finial.

The plan

The main door leads to a *durkah* or vestibule with stairs on the left that lead to the interior of the building. Opposite the main entrance are also stairs that lead to a platform with a wooden ceiling. An entrance can be seen on the south side of this platform, which also leads to the prayer area. A second entrance in this platform leads to the ablution area, which may have replaced an old burial place.[90]

The interior of the prayer area consists of a rectangular space divided into three aisles running parallel to the *qibla* wall. Each aisle consists of three pointed arches on two marble columns, the middle arch being wider than the two side arches (figure 2.43).

The *mihrab* today is plain with the exception of the sunburst design in the conch and the double molding with continuous loops that frames it, topped by a round window. Like most Ottoman *mihrabs* in Cairo, the *mihrab* is slightly skewed to the right to face the direction of Mecca.

A 1921 photograph by Creswell indicates that the *mihrab* we see today is not the original one. The original *mihrab* must have resembled earlier Mamluk ones, as the remains of the plaster that normally holds marble decoration can still be seen in the photograph (figure 2.44). Today, to the right of the *mihrab* are

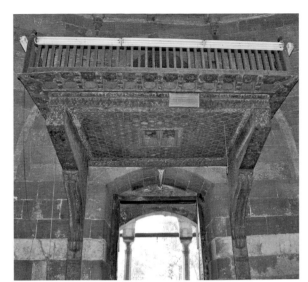

Figure 2.41. The *dikka* of the Mosque of Sinan Pasha.

Figure 2.42. The façade of Mesih Pasha Mosque.

two in the second aisle, each pierced with two windows. Above the window of the second aisle one can see the hanging wooden *dikka*.

The southwestern side of the prayer area shows the remains of five cupboards that are blocked today. The ceiling of the mosque is made of plain wood and is pierced with a lantern in the center. The photograph taken in 1921 by Creswell shows, unlike today, that the mosque had once rested on pillars. Abu al-'Amayim mentions that this was a restoration and that the pillars in the photograph were built around the marble columns for better support of the scaffolding added at the time to support the ancient arches.[91]

The mosque is heavily restored and, unfortunately, its *waqf* document does not include a detailed description. Nevertheless, it does mention a *shadirwan* in the *sabil* and that the foundation inscription ran in a frieze under the ceiling of the *kuttab* with the name of the founder and the date of construction, but these no longer exist.[92]

The mosque today shows a single-space plan seen before in the Mosques of Mahmud Pasha and Murad Pasha, with three aisles running parallel to the *qibla* wall, resting on columns with a small lantern ceiling. The only novelty here is that the central aisle is not lower, which typically formed a corridor in the center instead of a court. This plan will be revived again in the seventeenth century, but one cannot be sure here whether this is part of a modern restoration, or dates back to the original construction, although the 1921 photograph by Creswell negates the presence of a lower corridor. The whole mosque is built on the site of an earlier mosque built by the Bahri Mamluk sultan al-Nasir Muhammad.[93]

The Mosque of Murad Pasha
(986/1578)
Monument Number: 181

The founder

two recesses with a window above each, and on the other side of the *mihrab* are three doors; the first two lead to a room that lies beside the *sabil*, and the third door leads to the *tasbil* room itself. Abu al-'Amayim suggests that the entire *qibla* wall was demolished and rebuilt by the Ministry of Antiquities, without mentioning the source of this information.

Four pointed arched recesses occupy the northeast side of the prayer area, two in the first aisle and

He was originally the *katkhuda* of Maqtul Mahmud Pasha. The term *katkhuda* is a Persian term, where *kat* meant "house" and *khuda* meant "head" or "owner,"

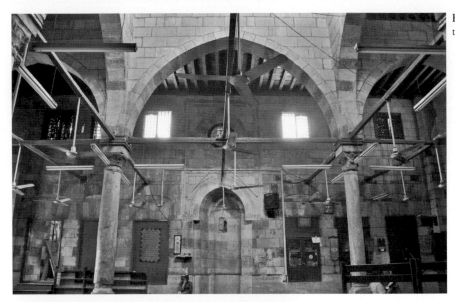

Figure 2.43. The interior of the Mosque of Messih Pasha.

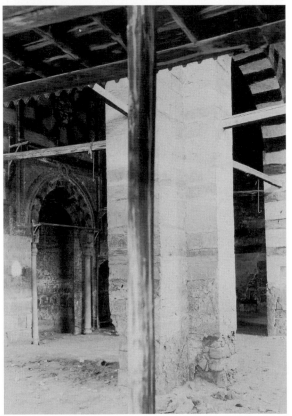

Figure 2.44. An archive photograph by Creswell of the interior of the Mosque of Messih Pasha (courtesy of the V&A online art collection).

a term used in the Ottoman period to signify an important official.[94] After the death of Mahmud Pasha, he filled the post of *sancak beyi*, which means a ruler of a certain part of a province, but he was then removed and came back to Egypt for three years from 977/1569 to 979/1571. After leaving Egypt for the second time, he held many posts in different provinces of the Ottoman Empire until his death in Diyarbakır in 1020/1611. He was buried in Istanbul in the mausoleum he built for himself attached to his madrasa. Murad Pasha built a mosque in Egypt as well as another one in Damascus, in addition to the Souq al-Tawaqiya and the dome on Bab al-Barid there.[95] Murad Pasha was never a governor of Egypt, but his title "pasha" here is an indication that he was a powerful statesman. 'Asim Rizq mentions that he was *na'ib al-Sham* in 975/1568.[96]

Waqf document number 435 dated to Rajab 1268/April 1852, which belongs to Murad Pasha, is mentioned by Abu al-'Amayim and is located in the Ministry of Religious Endowments in Cairo under the name of Mustafa Halabi al-Kulshani.[97] Nevertheless, al-Haddad wrote that although it was mentioned by several sources, the *waqf* cannot be found today.[98]

The location

The mosque lies on Bayn al-Nahdayn Street, which is the northern extension of Port Said Street at the intersection with Jawhar al-Qa'id Street.

The exterior

The mosque overlooks Bayn al-Nahdayn Street only on one façade, which is located on the northwestern side. This façade shows two entrances, one at each end above three shops. The main entrance, which lies on the north side, is placed in a tri-lobed recess where the upper lobe is filled with stalactites and the two side lobes with ribs, and is flanked by benches on the sides, which classifies it as a typical late Burji Mamluk Qaytbay style. The whole entrance is framed with a double molding with circular loops (figure 2.46). The lintel and relieving arch are topped by a plain, rectangular window. This entrance leads to a vestibule or *durkah* that measures 1.60 × 1.35 meters, which leads to four steps ascending to a platform that measures 2.50 × 1.68 meters, with a door on the right that leads directly to the prayer area. The ceiling that covers the *durkah* and the platform is made of plain wood.

The second entrance occupies the south end of the façade. It is also a tri-lobed recess flanked by benches, and above it is a Qur'anic inscription.[99] The tri-lobed arch of the entrance is framed with a double molding with loops and stalactites in all three lobes. The molding on the sides of the recess is without loops. The plain wooden door is topped with a joggled lintel and relieving arch framed with a double molding with loops. Above this is a rectangular window also framed with the same molding. The entrance leads to a small *durkah* measuring 2.43 × 1.65 meters that leads to three steps that lead to a small platform and to the ablution area. A door on the right of this platform opens onto steps leading to the "*kuttab al-sabil*," the roof, and the minaret, which is no longer extant.[100] This part is now used as a clinic, and the original wooden roof was replaced by a modern-day cement one. A shop now replaces the ancient *sabil*.

The façade between the two entrances is occupied by shops, above which are three recesses. The middle

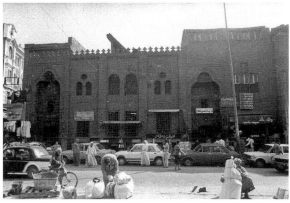

Figure 2.45. An archive photograph of the façade of the Mosque of Murad Pasha in Cairo (courtesy of Ibrahim Ramadan).

recess is pierced with two rectangular lower windows and two arched upper ones. The two side recesses have only one window below and a Qalawun set of windows above. The whole façade is topped with a tri-lobed cresting.

The minaret

The minaret was demolished by the Comité in 1302/1885 after it was found to be leaning.[101] A drawing of the minaret drafted by the Ministry of Antiquities shows a typical Ottoman round and faceted minaret with one balcony on stalactites and a pointed finial.[102] Only the base of the minaret survives today, with a visible break in bond with the mosque itself, which may indicate that it was added after the completion of the mosque.

The plan

The interior of the mosque consists of a rectangular space measuring 10.40 × 10.50 meters and is divided into three aisles running parallel to the *mihrab* and the *qibla* wall. Each aisle contains three pointed arches on two round marble columns. The central aisle is lower than the others and forms a passageway reminiscent of the plan of the Khanqah-Mausoleum of Sultan Barsbay and al-Mahmudiya Mosque (figure 2.47).[103] This central lower corridor apparently had a beautiful marble mosaic floor, judging by a drawing

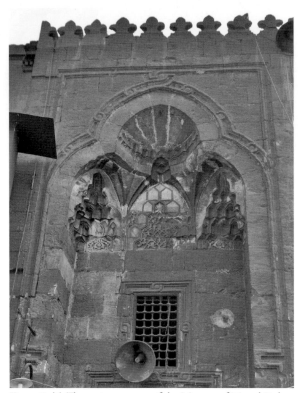

Figure 2.46. The main entrance of the Mosque of Murad Pasha.

a *mashrabiya* railing is very similar to earlier Mamluk minbars.

The two side walls of the prayer area are pierced with an entrance that provides access to the mosque.

The hanging *dikka* on the wall opposite the *mihrab* rests on two columns and stands above the two long windows of the façade. The *dikka* can be reached by a staircase on the northern side.

The ceiling of the prayer area is made of painted wood and consists of square pieces held together by nails. In the middle of the central aisle is a small lantern with windows but with no decoration.

The Mosque of Murad Pasha is a continuation of a plan that was introduced to Cairo as early as the Burji Mamluk Khanqah-Mausoleum of Sultan Barsbay in the Northeastern Cemetery and was seen in several

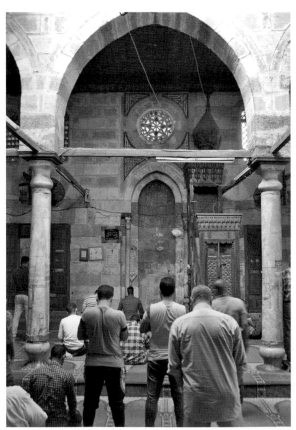

Figure 2.47. The interior of the Mosque of Murad Pasha.

drafted by the Ministry of Antiquities (figure 2.48).[104] Today the floor is entirely covered with carpets.

The center of the *qibla* wall contains the *mihrab*, which is topped with a bull's eye window covered with a stucco grille and stained glass and is flanked by two book cupboards. Each of the two cupboards is topped by a rectangular window also with a stucco grille and stained glass. 'Ali Pasha Mubarak mentions colored marble panels on the *qibla* wall, but these cannot be seen today.[105] The upper part of the wall shows a stone carving under which is a Qur'anic frieze in foliated *naskhi* script.[106] Interesting is the design in the four corners of the bull's eye window above the *mihrab*; it is a geometrical pattern in colored marble, and the design resembles that found in the spandrels of the entrance of the complex of Sultan Qalawun al-Alfi (c. 684/1285). The minbar is made of wood and is decorated with twelve-pointed stars as well as half and quarter ones and

Figure 2.48. The original marble mosaic floor of the central corridor of the Mosque of Murad Pasha (by the Ministry of Antiquities).

Ottoman buildings that preceded this one. The presence of two entrances close to each other on the façade is rare in Cairene architecture, yet it was seen before in the mosque of Dawud Pasha. The *mihrab* decorated with stone carving cannot be considered a novelty, as it was seen in the Takiya Suleimaniya, which was influenced by the Mosque of Qaytbay in Qal'at al-Kabsh.

The *sabil*

A plan drafted by the Ministry of Antiquities in 1989 shows the *sabil* that stood on the right of the second entrance with only one window. It contained a cistern below and a *kuttab* above. The *kuttab* was still functioning at the time of 'Ali Pasha Mubarak's writing, but today the *sabil* has become a shop and the *kuttab* a clinic.[107]

To compare this building with his complex in Damascus, one also sees an amalgamation of Mamluk and Ottoman features in its architecture and decoration. In Damascus, Murad Pasha built a much bigger complex that consisted of a mausoleum, a mosque, and a *takiya*. The entrance to his complex is placed in a plain tri-lobed recess, with no stalactite decorations in its lobes but with the presence of groin ribs. The entire entrance is clad with black and white *ablaq* marble. Upon entering the complex, one finds a courtyard paved entirely with black and white *ablaq* marble with a fountain in the center. The courtyard is surrounded by porticos with shallow domes, behind which are rooms for the disciples of the *takiya*. The entrance of the mosque from the courtyard could be taken for Mamluk with its tri-lobed appearance,

topped by a half-dome decorated with the sun-ray motif mounting tiers of stalactites. Above the doorway is a foundation inscription panel inscribed with poetry.

This mosque, like that of Sinan Pasha in Damascus, is a single-dome prayer area resting on pendentives. The *mihrab* is decorated in the typical Mamluk style and the minbar is made of carved white marble; however, unlike Ottoman pulpits, it is topped by a round bulb and not a conical top. The minaret of the Complex of Murad Pasha in Damascus is a Mamluk style minaret, with an octagonal shaft, a pavilion top, and a round bulb as its finial. The octagonal shaft contains an interesting feature of tri-lobed recesses on its facets, each flanked by two engaged columns with a chevron design. A shield, like that in the Mosque of Sinan Pasha in Cairo, can also be seen in the upper tier of the minaret.

Murad Pasha built a mausoleum for himself attached to this mosque. The uncommon feature about this mausoleum dome is the high octagonal drum area that is considered unusual in Damascene architecture. He, in fact, was never buried in this mausoleum, and was buried in another one he built attached to the madrasa that bears his name in Istanbul. One can conclude that the two mosques in Damascus, Sinan and Murad Pasha's, show Ottoman style plans with added Mamluk features and a Mamluk style minaret in the second. On the other hand, the mosque of Murad Pasha in Cairo is a Mamluk plan, with an Ottoman minaret. This shows again the extensive Mamluk influence on the architecture of the Ottoman rulers in Cairo compared to their architecture in Syria.

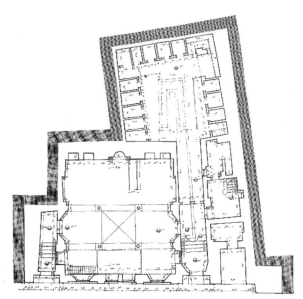

Figure 2.49. The plan of the Mosque of Murad Pasha (plan courtesy of Ibrahim Ramadan).

Conclusion

The religious monuments of the sixteenth century show a decline in buildings erected for Sufis, with numerous mosques, but only one surviving *zawiya* and one *takiya*-madrasa. Among the variety of styles seen in the surviving mosques, only two show the imported Ottoman plan, namely those of Suleiman Pasha inside the Citadel and Sinan Pasha in Bulaq. This is a very small number compared to the many mosques built in Syria in the Ottoman style. One must add here that although the two mosques mentioned above show an architectural style that is 'foreign' to Cairo, the interior shows both new and continued decorative elements from the Mamluk period.

Although both mosques of Suleiman Pasha al-Khadim, as well as that of Sinan Pasha, are classified as Ottoman mosques, their plans differ and can be subdivided into two styles. The Mosque of Suleiman Pasha al-Khadim followed the prototype of the fifteenth century mosque of Üç Şerefeli in Edirne, also known as the Imperial-style plan. Its space is divided into two, made up of a covered prayer area topped with a dome, a half dome that is preceded by an open courtyard, and a

portico that is topped by shallow domes. On the other hand, the Mosque of Sinan Pasha in Bulaq introduced a plan that was commonly employed in Turkey, which might be described as a single-space prayer area, topped entirely by a large dome. Its domed prayer area is surrounded on three external sides by a portico topped by shallow domes.

The Mamluk *qaʿa* plan continued, with its two large iwans and two smaller ones facing a lower covered court, which replaced the open court of earlier buildings, and was covered in most cases with a lantern ceiling. This is a style already known toward the end of the Mamluk period in the buildings of Sultan Qaytbay.

A new plan, derived from Mamluk plan prototypes emerged. This includes the division of space into three rather than two iwans, and a central court, but with three aisles divided by columns supporting arches, where the middle aisle is a lower corridor, as already seen in the plan of the Khanqah-Mausoleum of Sultan Barsbay in the Northeastern Cemetery. This plan was present in the Ottoman period in the Mosques of Mahmud and Murad Pasha. The former divides a square space and the corridor joins the main entrance with the ablution area, while the latter is a rectangular space where the corridor joins two entrances to the prayer area. Both mosques are covered by flat wooden roofs with a lantern in the center, which was absent in their Mamluk prototype. The design is very successful as a solution to a regular space that is too large or long to be covered by a dome, and is the technique defined by Doris Behrens-Abouseif as the Baldachin plan.[108] Very similar to the above approach to space is the division into three by columns that support arches, but without a lower central corridor, as seen in the Mosque of Messih Pasha. Yet one cannot help but wonder whether modern restorations changed this feature—as was already seen in the Mosque of Murad Pasha—or whether it was always intended to be a one-level space.

Finally, a novel approach to space can also be seen in two buildings: the Mosque of Dawud Pasha and the nonextant Zawiya of Shaykh Murshid mentioned

in chapter one, where the division of the area is maintained by a large arch that symbolically divides the prayer area into two. The fact that this approach to space is seen in both the prayer area of a mosque and a *zawiya* shows a new interest in the spatial management of prayer areas, regardless of the major function of the building.

Buildings for Sufis, as mentioned before, do not follow a certain plan, yet they designed their buildings according to space and need. The novelty is the introduction of the *takiya*-madrasa, a teaching institution with rooms surrounding the open court, which replaced the *khanqah* institution of the Mamluks. The plan was imported from Turkey, but as with the mosques, the plan was Ottoman, but the decorations were entirely Mamluk.

The religious monuments of the sixteenth century show a variety of approaches to space, mostly based on plans from Mamluk Cairo and not Ottoman Turkey. Cairo's architectural history did not change much, and the huge complexes of its predecessors still dominated and influenced the city. A change in rulers did not significantly alter the outlook of the city or its people. Would these changes be seen in the next century?

Buildings of the Seventeenth Century

Cairo becomes the melting pot of people with different needs and tastes reflected in the architecture. Major religious buildings from the seventeenth century reflect a new identity.

The Mosque of al-Malika Safiya
(1019/1610)
Monument Number: 200

The founder

Safiye Sultan, or al-Malika Safiya, was the favorite concubine of the Ottoman sultan Murad III and the mother of his heir, Sultan Mehmet III. She was originally a Venetian young lady, captured by pirates at the age of thirteen and sold in Istanbul to the royal court. Her beauty caught the attention of the sixteen-year-old Murad III, who succeeded his father Selim II to the throne in 982/1574. Her mosque in Cairo was not originally commissioned by her, but by 'Uthman

Agha, who held the post of Agha Dar al-Sa'ada, or black eunuch in charge of the royal harem as well as the Egyptian *waqf* estates of the holy cities in the Hijaz. He was one of her agents and slaves, who could only be allowed to build a mosque or make endowments if manumitted. Intrigues in the royal harem led to his execution before the beginning of the construction.[1] When he died, no proof was found to prove his freedom, which led to legal problems, so the mosque and all the endowments reverted to al-Malika Safiya. She endowed the mosque with a deed that provided for a general supervisor, thirty-nine custodians, two imams, a *khatib* (preacher), in addition to a timekeeper, a repairman, a gardener, and an incense burner.

The location

The building lies today in the area to the east of Muhammad 'Ali Street, the area of the tanneries that were removed in the year 1008/1600, which then

became known as the al-Habbaniya quarter. 'Uthman Agha planned the foundation of a mosque and a mausoleum in this quarter because it had become popular as a residential area among several black Ottoman eunuchs and he probably planned to retire there. The present mosque is an Ottoman Imperial-style building probably designed especially for al-Malika Safiya, since the construction of the mosque designed for 'Uthman Agha had not even begun.[2] The mosque faces a small square and can only be reached by ascending a long flight of semi-circular steps, and although not very visible from Muhammad 'Ali Street, it still dominates the area around it. The mosque was originally surrounded by a wall with gates, only one of which has survived, overlooking Dawudiya Street (figure 3.1).[3] A section drafted by the Ministry of Religious Endowments shows vaulted areas under the mosque and precisely under the area of the entrances, which may indicate that it was a suspended mosque built above shops.

The exterior

The exterior walls are broken into plain recesses with windows in two levels and an entrance on three sides, excluding the *qibla* wall. The main entrance, which overlooks the small square, lies in a groin-vaulted tri-lobed recess; the other two are composed of shallow tri-lobed recesses framed with moldings with angular loops. The breaking of the façades into recesses was not very common in Ottoman buildings in Turkey, but the plainness of the recesses makes it also very different from most Mamluk façades.

A typical round Ottoman minaret with a pointed finial stands at the southeastern corner of the mosque. Strangely enough, it only shows one balcony and "has no remarkable architectural feature."[4]

The plan

The plan resembles that of the Mosque of Suleiman Pasha al-Khadim, where the rectangular space is divided into two: an open courtyard surrounded by a portico topped with shallow domes and a domed prayer area. All three entrances that lead into the courtyard of the mosque, along with the fourth that

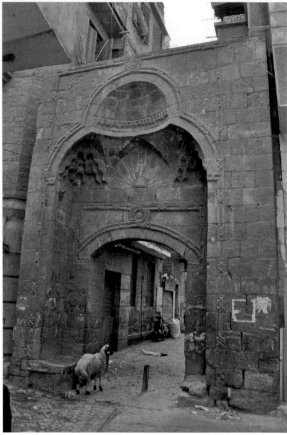

Figure 3.1. The only surviving gate that led to the Mosque of al-Malika Safiya.

leads from the courtyard to the domed prayer area, are topped with cross vaults. The portal leading to the prayer area from the courtyard is a tri-lobed stalactite entrance, very Mamluk in style. A marble slab was added on this portal when the new endowment deed was written after al-Malika Safiya became the new owner of the land. It includes her name, titles, and the name of Ismail Agha *nazir al-awqaf* along with the date of completion (figure 3.4).

The covered prayer area is also different in plan from the one in the Mosque of Suleiman Pasha al-Khadim, discussed earlier. Here the plan shows a central dome carried on six granite columns in the center, surrounded by five domes, two on each side

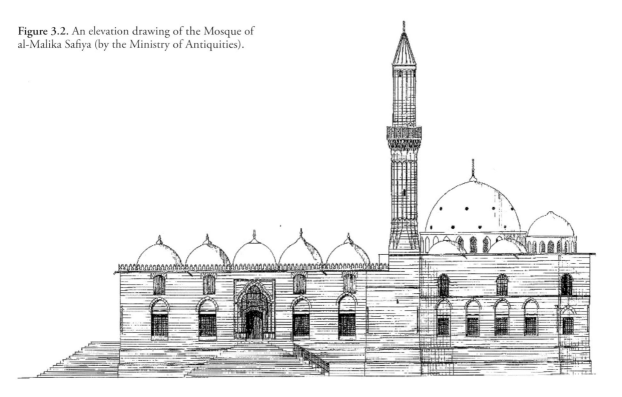

Figure 3.2. An elevation drawing of the Mosque of al-Malika Safiya (by the Ministry of Antiquities).

and one above the *mihrab*. A smaller dome covers the northern corner of the wall facing the court, which is also the wall opposite the *qibla* wall. A wooden corridor runs around the base of the central dome as in the Mosque of Sinan Pasha, and one can see the usual hanging *dikka* opposite the *mihrab* (figures 3.5 and 3.6). An upper gallery, covered with a wooden screen, can be seen in the wall opposite the *mihrab*, an area probably reserved for women, a feature very common in Turkey but not in Egypt. This gallery is accessible through a narrow staircase in the southwestern corner of the domed prayer area.

The *mihrab* is decorated with marble panels, reminiscent of the style of Mamluk *mihrab*s, but with the Ottoman signature of blue and white tiles in the spandrels. The marble minbar stands directly beside the *mihrab* and not under the big central dome as in the Mosque of Suleiman Pasha al-Khadim. The smaller dome above the *mihrab* projects out of the back wall of the mosque.

Finally, a question arises: was the plan of this Imperial-style mosque sent by al-Malika Safiya to Cairo since 'Uthman Agha was not a pasha, able to commission this type and scale of a project? The tanneries in that area had already been removed and there was enough space to accommodate this architectural style of a mosque, especially since the new owner was an important member of the Ottoman dynasty. This was the first building to be attributed to a member of the Ottoman royal family and the first one to be named after a female patron since the conquest in 924/1517. The only two mosques that preceded this one that were built in the Ottoman Imperial style were those of Suleiman Pasha al-Khadim in the Citadel and Sinan Pasha in Bulaq, and both of the men were important governors who ruled Cairo over several periods. It seems that imported plans from Turkey were reserved for powerful pashas or members of the royal family as a reflection of exclusiveness and status.

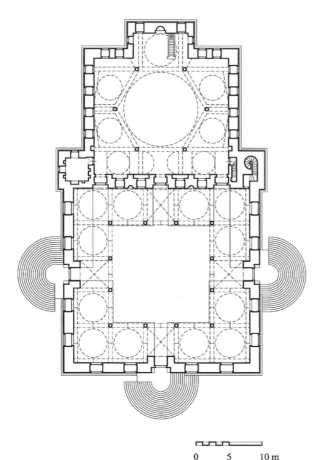

0 5 10 m

Figure 3.3. The plan of the Mosque of al-Malika Safiya (after Archnet).

The Mosque of al-Burdayni
(1025/1616)
Monument Number: 201

The founder

The founder of this mosque was Karim al-Din Ahmad al-Burdayni al-Shafiʿi, whose name is inscribed under the ceiling inside the mosque and on the minaret. His name also appears on deeds concerning buildings in the neighborhood of the mosque with the title *khawaja*, which normally indicates an important person, either a rich merchant or a scholar.[5] One can assume

he was a rich shaykh or scholar because of the use of the title "al-Shafiʿi" after his name. The endowment deed of his mosque has unfortunately not survived; nevertheless, ʿAli Pasha Mubarak mentions that the income of a shop under the mosque was used to support the religious duties of the building.[6]

The location

It is located on al-Dawudiya Street, which is off Muhammad ʿAli Street, near the Mosque of al-Malika Safiya. It is completely different from the former because of its overall Mamluk appearance, which contrasts with the Imperial-style Mosque of al-Malika Safiya. The Mosque of al-Burdayni is well integrated into the street and was not placed on a platform as in the case with earlier buildings.

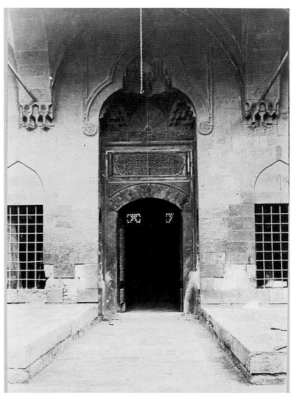

Figure 3.4. An archive photograph by Creswell of the entrance of the domed prayer area of the Mosque of al-Malika Safiya (courtesy of the V&A online art collection).

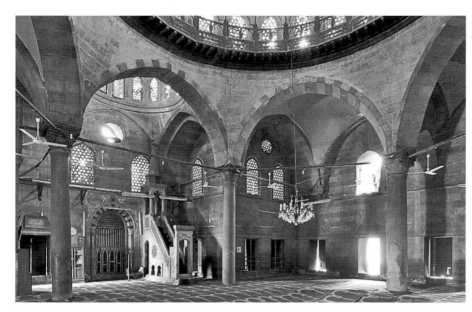

Figure 3.5. The interior of the Mosque of al-Malika Safiya.

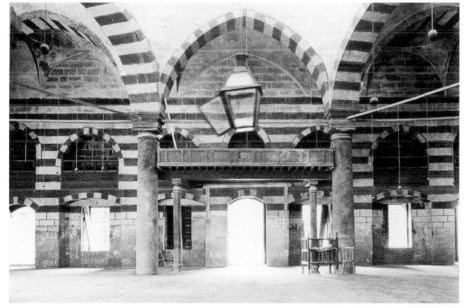

Figure 3.6. An archive photograph by Creswell of the *dikka* of the Mosque of al-Malika Safiya (courtesy of the V&A online art collection).

The exterior

The building overlooks the neighborhood through two façades. The main one is the southwestern façade, which overlooks the main road, and the northwestern façade overlooks 'Atfat al-Burdayni. The main façade has a small entrance at its southern end, which leads to an open corridor behind the *qibla* wall and to the ablution area under the mosque, after which it is broken into four stalactite recesses. Each recess contains two windows: a rectangular lower one and a Qalawun set of windows above. To the left of the recesses lies the main entrance, which can be reached by going up

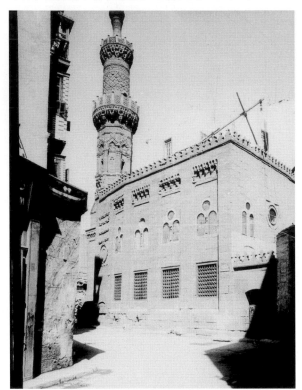

Figure 3.7. The southwestern façade of the Mosque of al-Burdayni (after Archnet).

which is quite unusual for this period. One must add here that it does lack the usual pavilion top of Mamluk minarets and instead one sees a simple upper bulb rising directly above the second balcony. This minaret is dated to 1038/1629, so thirteen years after the foundation date of the mosque. The inscription on the minaret is illegible, but one can still read part of the name, the date, and the word "al-Shafi'i," which refers to the founder (figure 3.9). The parapets are made of pierced stone and are almost completely covered with stone carving. With time, this minaret started leaning and was dismantled and rebuilt in 1955.[7] It shows a revival of the Mamluk-style minarets, after a century of building Ottoman-style ones, and is the only one in Ottoman Cairo that bears an inscription. Unlike earlier Mamluk minarets, the base of the minaret is concealed below the roof level.

four steps. The remains of a stone balustrade can be seen on the right as one goes to the entrance. A plain recess with a bench can be seen on both sides, and the entrance lies in a tri-lobed recess with stalactites in the two side lobes and is framed with a double molding with loops that end in a larger loop at the apex filled with a geometrical design. The double molding then moves upwards forming two horizontal bands above the entrance. The window above the door is bracketed by a column on each side and is crowned with stalactites. Above the entrance are remains of a five-lobed leaf cresting. Finally, the façade continues to the left of the entrance and projects out slightly. This part is only broken by a single recess (figure 3.8).

The minaret, like the façade, is typical of the style of the Burji Mamluk period. Instead of having a circular shaft, it is octagonal with stone carving and inscriptions,

Figure 3.8. The entrance of the Mosque of al-Burdayni.

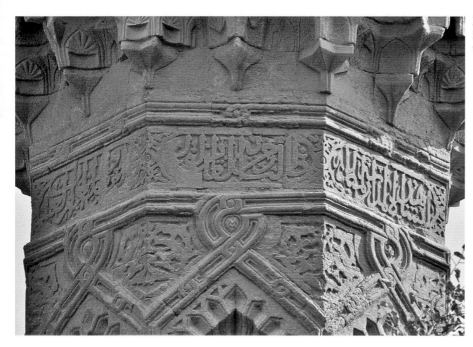

Figure 3.9. A detail of the inscription on the minaret of the Mosque of al-Burdayni.

The plan

The Mosque of al-Burdayni consists of a single-space prayer hall with a small *sidilla* (recessed area) on the left as one goes in, which is at a higher level than the prayer area, and another *sidilla* to the left of the *mihrab* measuring 2.94 × 2.20 meters, which is also one step higher than the prayer hall. It contains windows on the side, which overlook the ablution area under the mosque (plate 3.1). The other walls of the *sidilla* are pierced by built-in cupboards.

The entrance leads directly to the prayer hall, which measures 6.56 × 7.56 meters. On each side of the *mihrab* are two windows in a recess that overlooks the corridor behind the *qibla* wall that leads to the ablution area. The southwest side of the prayer hall also shows three recesses, pierced with two windows each, all overlooking al-Dawudiya Street.

The hanging *dikka* is a rectangular wooden structure, supported by a wooden corbel on each side and an octagonal marble column in the center. The balustrade is divided into panels, each decorated differently with a mixture of geometrical and leaf patterns. The balustrade was restored by the Comité de Conservation in 1943.[8]

The whole interior is covered with colored marble panels that rise all the way to the ceiling on the *qibla* wall. A nineteenth-century drawing by Willem de Famars and Émile Prisse d'Avennes depicts accurate details of the mosque's southern wall and suggests that perhaps, at one time, the whole mosque was covered with marble panels and mosaic all the way to the epigraphic cornice beneath the ceiling (plate 3.2).

The marble paneling and the *mihrab*, with its polychrome marble mosaics inlaid with mother of pearl, is very similar to Bahri Mamluk decoration of the Qalawun family rulers. Interesting here is the square panel above the *mihrab*, which features circles in different marble colors, framed at the corners by a geometrical design that resembles that found in the spandrels of the entrance of the Complex of Qalawun. Unusual here is that the marble paneling and decorations reach all the way beneath the cornice of the ceiling on the *qibla* wall, very untypical

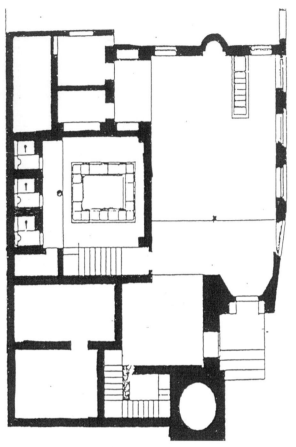

Figure 3.10. The plan of the Mosque of al-Burdayni (plan after Émile Prisse d'Avennes, *L'Art Arabe d'après les monuments du Kaire depuis le VIIe siècle jusqu'à la fin du XVIIIe*).

ones, but follows in the Mamluk tradition of having a round bulb. The double-shutter door of the minbar is also of wood inlaid with ivory, and above it are two small panels of square Kufic script with the *shahada* and another panel in angular Kufic inscribed with prayers upon the Prophet Muhammad. Two inscribed marble panels must be mentioned because of the use of the Kufic script. The first is on the southwest side of the *sidilla* and contains prayers and Sura 112, and the other is beside the window of the southern corner with the name of Muhammad in geometrical Kufic.

One could have easily dated this mosque to the late Mamluk period instead of the early Ottoman one, yet one hundred years had passed since the conquest of the city, which should have been a sufficient period for the evolution and spread of the new Ottoman style.

A tomb for al-Burdayni is mentioned in 'Ali Pasha Mubarak's *al-Khitat al-tawfiqiya*[11] and was confirmed by Abu al-'Amayim, who mentions a burial vault discovered during the restorations of 1997 by engineer Mahmud al-Tukhi located at the northeastern corner of the prayer hall that would have been attached to the *sidilla* found to the left of the *mihrab*.[12]

Very little is known, unfortunately, about the founder of this mosque, whose title is al-Shafi'i, but the fact that this building was intended as a mosque and a madrasa for the Shafi'i school gives rise to speculations that maybe he was an influential, probably Turkish, Shafi'i shaykh.[13] It is clear from the architecture of the Mosque of al-Burdayni that the Mamluk style still survived and was in popular demand.

The Mosque of Alti Barmak
(1033/1627)
Monument Number:126

The founder

Muhammad Effendi ibn Muhammad was known as Alti Barmak, which in Turkish means "six fingers." He was originally from the city of Skopje, now the capital of the Republic of North Macedonia, an area

of both the Mamluk and Ottoman periods. One can add here that the carved and painted wooden ceiling, the wooden inscription frieze that contains the foundation inscription in typical Mamluk *thuluth* script and a few verses from the Qur'an, and the wooden minbar all show a typical Mamluk style and the high-quality craftsmanship of many Mamluk buildings.[9] The minbar, which resembles the earlier Mamluk ones, is made of wood inlaid with ivory and features the twelve-pointed star design. The minbar was restored by the Comité as mentioned in their Bulletin dated to 1307/1890.[10] The hood of the minbar is not pointed like other Ottoman

that became part of the Ottoman Empire from the middle of the fourteenth century to 1912. It was part of the Ottoman province of Eyalet of Rumelia, which means land of the Romans in Turkish. He was visited by Evliya Çelebi, since he was a known scholar.[14] Al-Haddad mentions that Evliya writes of his visit to him first in Skopje then in Cairo, where he was an imam teaching *fiqh* in the Mosque of al-Malika Safiya. He died, according to al-Haddad, in Egypt in the year 1033/1627, and was buried behind the *mihrab* of his mosque, as described by Evliya in al-Haddad, and mentioned by Su'ad Mahir.[15] One must assume here that the mosque was built before his death, since it is mentioned by Evliya, and not in 1033/1627, as mentioned in the index of Islamic monuments.

The location

The mosque overlooks al-Ghandur Street, off Suq al-Silah, and was built, according to Ramsi in his verification of Ibn Taghribirdi, on the site of the Madrasa of al-Amir Baybars al-Dawadar, which was built in 725/1325.[16]

The exterior

It is a rectangular building with the main façade overlooking the north side, the entrance placed in the western corner and the minaret in the eastern corner. It is a suspended mosque above shops and can be entered after ascending a flight of six steps. The façade is broken into five recesses with rectangular windows below and a Qalawun set of windows above (figure 3.11).

Figure 3.11. The elevation of the Mosque of Alti Barmak (by the Ministry of Antiquities).

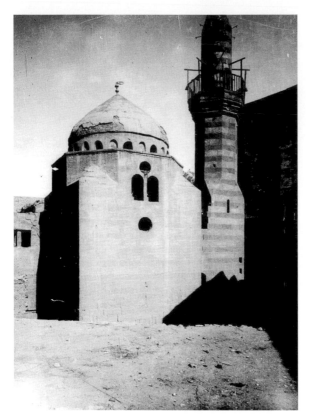

Figure 3.12. The mausoleum dome and minaret of the Mosque of Alti Barmak (courtesy of Ibrahim Ramadan).

The tri-lobed entrance is high and deep with benches, framed by a double molding with loops. Above it one sees corbels carrying a projection that supported a nonextant annex above.

To the right of the entrance is a one-window *sabil* where the lintel and relieving arch of the window are framed with a double molding with angular loops.

The minaret is short and is relatively plain; it starts with a small square, followed by an octagon that ends in a balcony above four tiers of moldings instead of stalactites, topped with a pointed finial.

The southeastern façade, which overlooks 'Atfat al-Ghandur, is plain, except for the minaret and the dome of the mausoleum located behind the *qibla* wall. A single Qalawun set of windows with a round window

below breaks the monotony of this façade, which corresponds to the *qibla* wall inside the mausoleum. The southwestern side of the mausoleum contains two rectangular windows overlooking the ablution area. The plain brick dome of the mausoleum is supported with a pyramid-shaped transitional zone, which imitates that found in the Mosque of Qijmas al-Ishaqi (c. 886/1481) (figure 3.12).

The southwestern façade is plain, and is situated above four shops with two levels of windows.

The plan

The entrance leads to a rectangular corridor with a door on the right that leads to the *sabil*, and four steps that ascend to the interior of the mosque on the left. The corridor is roofed with cross vaults and at its end is

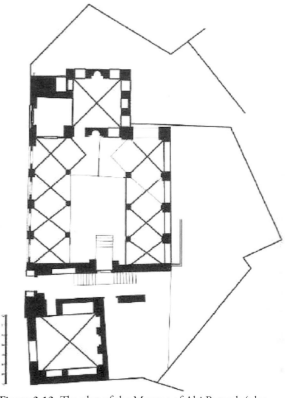

Figure 3.13. The plan of the Mosque of Alti Barmak (plan after Abu al-'Amayim, *Athar al-Qahira al-islamiya fi-l-'asr al-'uthmani,* 155).

the ablution area. The interior of the prayer area consists of a rectangular space that measures 14.03 × 12.92 meters, divided into a wide central aisle and two narrower side aisles supported with arches on six columns running perpendicular to the *qibla* wall. The central aisle is covered with a cross vault above the *mihrab* and followed by a painted wooden ceiling with a leaf design in poor condition in the remaining aisles. The side aisles are covered entirely with cross vaults (plate 3.3).

The *mihrab* is placed in the center of the *qibla* wall. It is flanked by a rectangular window on its right and by a door leading to the mausoleum behind it on the left. Above the *mihrab* is a bull's-eye window, and to the left of the door leading to the mausoleum is another window that overlooks its interior. Both the *mihrab* and the *qibla* wall are covered with beautiful polychrome tiles from İznik.[17] The decoration of the *mihrab* consists of tilework featuring flowers and leaves in blue on a white background, and the conch is covered with different tiles that appear to be from a later restoration date. These square tiles feature pomegranates, cloves, and tulips in blue, green, and red on a white background. The red color is in slight relief because its substance is made of a paste full of iron oxide that is applied in a second firing above the transparent glaze.[18] The red İznik tiles with the floral motifs remind us of the tiles found in the early seventeenth-century mosque of Sultan Ahmet in Istanbul. Hans Theunissen adds that to the right of the *mihrab* are eighteenth-century tiles from the Tekfur Sarayı workshop in Istanbul.[19] There is a wooden inscription frieze in Ottoman Turkish script placed in cartouches that runs above the tilework of the *mihrab* and the *qibla* wall, which states that Alti Barmak is in fact buried under the *mihrab* of the mosque.[20]

A *dikka* can be seen above the entrance to the prayer area opposite the *mihrab*.

The mausoleum

This is located behind the *qibla* wall, a rare occurrence in Cairene mosque architecture. It consists of a square room with a *mihrab* and several cupboards. The two recesses on the southwestern side contain windows

overlooking the ablution area. A small iwan that opens by a pointed arch on the square room can be seen in the southwestern side. The iwan only measures 2.88 × 3.93 meters with a window overlooking the interior of the prayer area. It is roofed with a cross vault. The *mihrab* of the mausoleum is plain and without side columns, and the plain dome is supported on squinches and a drum area with twelve windows.

The *sabil*

This *sabil*, which lies on the right as one faces the entrance, overlooks the main street by one window. The *sabil* room is rectangular, roofed with cross vaults, and the walls are broken with recesses.

The Mosque of Alti Barmak is unfortunately in ruins today. The area used for prayers is now beside the ablution area and at the rear of the mosque. The plan resembles that of a *riwaq* mosque without a court. The use of cross vaults to cover a prayer area was never popular in Cairo, although they are seen as early as the Mashhad al-Juyushi (c. 478/1085) and in the Mosque of Aqsunqur (c. 747/1346). The location of the mausoleum behind the *qibla* wall was also seen before in the Complex of Sultan Hasan (c. 757–63/1356–62) and at the al-Mahmudiya nearby (c. 974/1567).

The Mosque of Yusuf Agha al-Hin (1035/1625)
Monument Number: 196

The founder

Yusuf ibn Abdallah al-Hin was a grand Circassian Mamluk amir during the Ottoman period in Egypt. He held several important posts and was well known for his love of charity. He died in 1056/1646, eleven years after the construction of his mosque. Hasan ʿAbd al-Wahhab mentions two endowment deeds in his name: one dated to 11 Shaʿban 1044/30 January 1634, and the other dated to 18 Jumada al-Thaniya 1045/29 November 1635.[21] Al-Haddad states that these endowment documents were not to be found, and therefore, one must rely on the information given by ʿAbd al-Wahhab.[22]

The location

The mosque lies at Ahmad Mahir Square (previously known as Bab al-Khalq Square) at the intersection of Muhammad ʿAli Street and Port Said Street (previously known as al-Khalij Street). Yusuf Agha al-Hin built a mosque there, to which he added a *sabil*, a *kuttab*, a *rabʿ* and other buildings, including a mausoleum attached to his mosque, where he was buried.[23] The mausoleum was, unfortunately, demolished when Muhammad ʿAli Street was built in 1289/1873, and the remains of the founder were moved to the northern iwan of the mosque.

The foundation date of the mosque can be found on a marble plaque above the entrance:

أنشأ الامير يوسف جامعاً للذكر والنجوى أرخته لله مسجد
أسس على التقوى

Amir Yusuf has constructed a mosque for remembrance and communing with God. Dedicated to God, a mosque founded on piety.

As written above, the foundation date can be calculated according to *hisab al-jummal* to 950/1543. ʿAli Pasha Mubarak dates the building to the early sixteenth century.[24] A wooden frieze under the ceiling of the *sabil* located in the southern part of the building reads that it was finished in the month of Rajab 1035/April 1625, which is closer to the date of the deed. One can only wonder whether the mosque was begun at that early date and left unfinished, or that the *hisab al-jummal* does not apply in this case.

The mosque is freestanding on four sides, and stands in the middle of Port Said Street. At first glance, the mosque of Yusuf Agha al-Hin appears more Mamluk than Ottoman in style.

The main façade lies on the southeastern side of the mosque with the entrance and the minaret at the northern end, and the *sabil-kuttab* at the southern end. Bracketed between the latter structures is the wall of the *qibla* iwan (figure 3.14).

The main entrance of the building is placed in a plain tri-lobed recess, framed by a double molding with angular loops and topped by a round loop at

its apex. The entrance is not a deep recess, but is flanked by a bench on each side. The area around the doorway is decorated with marble cladding in black and white. The doorway is topped with a rectangular window faced with metal grilles, flanked by two engaged marble columns and topped by a stalactite hood. On each side of the rectangular window is a carving of a circle with a loop on each side framed by moldings, and above that is the inscription plaque mentioned earlier. The minaret stands to the left of this entrance. It is a typical round Ottoman minaret consisting of one balcony on tiers of stalactites with a pointed finial.

The façade between the entrance and the *sabil* is broken into recesses, one to the right of the *mihrab* and two on the left. Each recess is pierced with two windows: a lower rectangular one and a Qalawun set of windows above. The wall at the back of the *mihrab* is broken with a bull's-eye window. The skyline of the mosque is crowned with five-lobed leaf crestings.

The façade of the *sabil* is pierced with the usual wide window with a projecting marble slab on three corbels. This window is framed by a molding with angular loops. The entrance to the *sabil* is reached by ascending a small flight of steps. Two stone panels frame the lintel; they are carved with a tri-lobed leaf design, and underneath them are two other panels carved with a geometrical design of eight-pointed stars with a small boss in the center. The façade of the *kuttab* above the *sabil* consists of two-pointed horseshoe arches supported on a central column, framed by a molding with angular loops, shielded off by a wooden balustrade and a slanting wooden shed.

The northeastern façade is the wall of the vestibule behind the main entrance, and it includes one of the façades of a second *sabil*, added by the Comité de Conservation in 1939 (figure 3.15).[25] It can be entered through an entrance, also added by the Comité, which is pierced in the middle of this façade. The area of the vestibule contains one recess, similar to the ones found on the main façade. The entrance is placed in a rectangular recess framed by

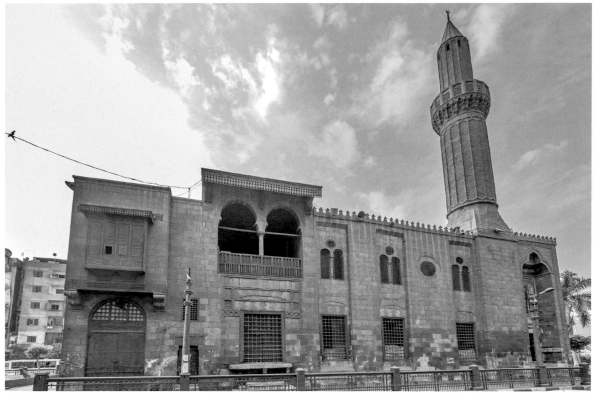

Figure 3.14. The main façade of the Mosque of Yusuf Agha al-Hin (by Karim Saada).

a double molding with continuous angular loops, and is crowned by four tiers of stalactites. Above this door lies a rectangular window framed by the same molding, which also frames the lintel, the relieving arch, and the two rectangular panels on each side of the lintel. The recess is shallow but is still flanked by a bench on either side. The wooden door of the *sabil* is decorated with a geometrical design of a six-pointed star in the tongue-and-groove technique. A second window found above the one over the entrance is also framed, continuing the molding that frames the whole recess. The cresting found on the main façade continues to top this one as well, in spite of the addition of the *sabil* in the twentieth century, after the *khalij* or canal was replaced with the present Port Said Street at the end of the nineteenth century by Khedive Ismail.

The western façade consists of the wall of the iwan opposite the *qibla* wall, which includes the second façade of the added *sabil* (figure 3.16). The façade of the iwan projects out, and its upper part is covered with a wooden *mashrabiya* screen that at one time overlooked the canal. The lower part is broken into two windows, and under each is a pointed arched recess. The two sides of the iwan are also pierced with windows, and under the northeastern one, to the left of the iwan, is a shop descended to by a flight of steps. The façade of southern *sidilla* (shallow side iwan) of the mosque also projects out a little and has windows.

The southwestern façade seems to be entirely rebuilt by the Comité, which added latrines in its western corner and a house with beautiful *mashrabiya* windows in its southern corner.[26]

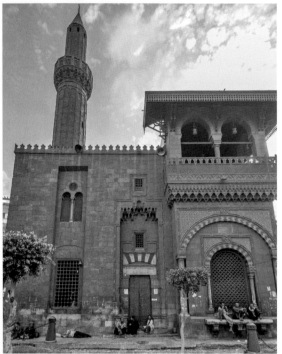

Figure 3.15. The northeastern façade of the Mosque of Yusuf Agha al-Hin (by Karim Saada).

The plan

The main entrance leads to a vestibule, faced with a bench. To the left of the vestibule is an archway that leads to a corridor that ends in the *durqaʿa* or covered court of the mosque, which is topped with a plain wooden roof. The ceiling of the corridor is made of wood and is painted with a stem and leaf design. In the middle of the ceiling are two medallions with Qur'anic inscriptions that form a star pattern.[27] The interior plan consists of a *durqaʿa* with two iwans: the *qibla* iwan and the one opposite, which are flanked by two smaller *sidillas* on the sides (figure 3.18). The iwans open onto the court by pointed horseshoe arches resting on stalactite corbelled springings. In the southern corner is a door topped by a window that opens onto stairs descending to the new ablution area. The *mihrab* in the *qibla* iwan is not placed exactly in the middle of the space of the iwan; it is aligned to the court, with windows placed in recesses on either side (figure 3.19). The main iwan extends further to the south, making more room in this area for people praying close to the *qibla* wall in the

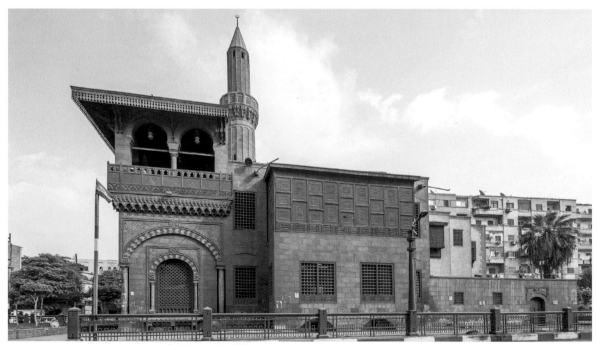

Figure 3.16. The western façade of the Mosque of Yusuf Agha al-Hin (by Karim Saada).

qibla iwan. A bull's-eye window can be seen above the *mihrab*, which is plain and flanked with two plain marble engaged columns. Remains of modern paint can be seen in the spandrels. The wooden minbar features a geometrical pattern consisting of an alternation between rectangular and square designs, carved and not installed in the tongue-and-groove technique. The flat ceiling of the iwan is painted with a geometrical star pattern and a leaf design. An inscription band runs under the ceiling with Qur'anic script and prayers written in cartouches.[28] A similar inscription can be seen under the plain wooden ceiling of the *durqa'a*.[29] It is framed above with a narrow frieze with the words "*wa al-hamd li-Allah wahdu* [Thanks to God alone]" in foliated *naskhi*. The ceiling of the iwan opposite also shows faint remains of paint, but the main attraction in this space is the windows that had once overlooked the *khalij*. In this iwan is a wider *dikka* supported by a column in the center and the side walls of the iwans. According to the present doorkeeper of the mosque, this *dikka*, and the one installed inside the southern *sidilla*, were both accessible at one time by a spiral staircase that was placed in the southwestern corner of the *durqa'a*.

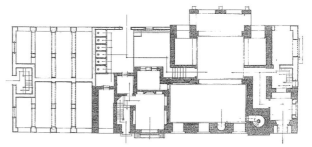

Figure 3.17. The plan of the Mosque of Yusuf Agha al-Hin (plan by the Ministry of Antiquities).

The two *sidilla*s in the southern and northern sides are plain, but the deep recess in the northwestern side of the northern *sidilla* has a wooden ceiling with a medallion, inscribed with the names of Muhammad and 'Ali (figure 3.20), and is broken by a window overlooking the side street, the former *khalij*. Above this *sidilla* is a wooden *dikka* that is reached through a door to the left of the *mihrab* in the *qibla* iwan. As mentioned above, the marble tombstone of the founder was placed in this *sidilla* after the destruction of the mausoleum in the late nineteenth century.

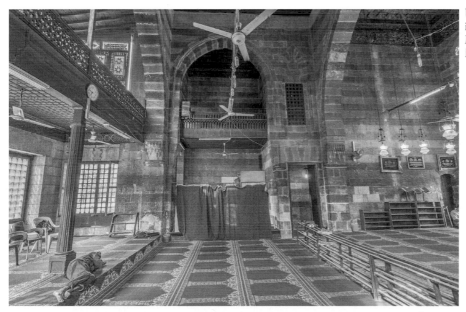

Figure 3.18. The *durqa'a*, iwans, and *sidilla*s of the Mosque of Yusuf Agha al-Hin (by Karim Saada).

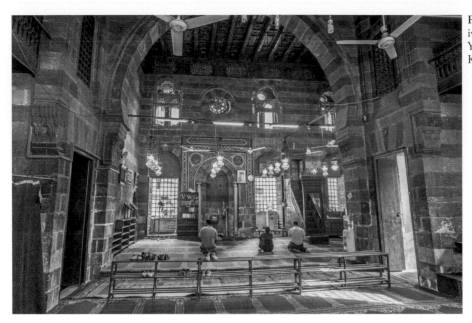

Figure 3.19. The *qibla* iwan of the Mosque of Yusuf Agha al-Hin (by Karim Saada).

The *sabil*

The original *sabil* can be entered through a door on the southern side of the main façade. It is pierced with one window that overlooks the street on this side, and contains a square marble basin and a *shadirwan* on the opposite wall with a cupboard on each side. Remains of paint can be seen on the wooden ceiling and a Qur'anic inscription, which ends in the date of completion: "in the month of Rajab of the year 1035 and thanks to God alone."[30]

This mosque dominates the area because of its location, which lies at the intersection between two main streets that overlooks the Museum of Islamic Art and Cairo's principal police station. The only indication on the exterior that it is an Ottoman building is its round minaret with a pointed finial, and the double molding with angular loops, instead of the round ones so commonly found in buildings during the period of Sultan Qaytbay at the end of the Mamluk period. The plan of the interior with two iwans and two *sidilla*s overlooking a covered court is also reminiscent of late Mamluk buildings from the Qaytbay period, yet the hanging *dikka* was not

common before the Ottomans, although it appears as early as in the Mosque of Aslam al-Bahai al-Silahdar (c. 746/1346), one of the amirs of Sultan al-Nasir Muhammad. The two *dikka*s in the side *sidilla*s can be considered a novelty in Cairo. The three *dikka*s found in this mosque are not accessible from one to the other, which leads to the speculation that they served different functions, especially that two of them were reached by a staircase in the *durqa'a*, thus unlikely to have been meant for women, while the third *dikka* was reached through a staircase accessible from a door so close to the *mihrab* where men usually pray.

The Mosque of Taghribirdi (1044/1634)
Monument Number: 42

The founder

The founder of this mosque is al-Amir Muhammad Bek Taghribirdi ibn Ibrahim Bek al-Defterdar, about whom not much is known.[31] Nicholas Warner in his *Monuments of Historic Cairo*[32] dates this building to the sixteenth century, which contradicts Abu

al-'Amayim, who bases his claim on that of Hasan Qasim,[33] who proposes the date 1044/1634 based on the reading of the date inscribed at the end of the inscription frieze under the mosque's ceiling. This is also the date given by al-Haddad, which would be during the reign of Sultan Murad IV and Ahmad Pasha, the Governor of Egypt.[34]

The location

It lies in the heart of the Fatimid palace city, off al-Muizz Street on the west side near the Mosque of al-Shaykh Mutahhar. The mosque was part of a complex, which included a *wikala*, and the mosque was built behind it. The *wikala* was built with two axially placed entrances that form a connection between the mosque and the street, similar to the case of the *wikala* and Mosque of Suleiman Pasha al-Khadim in Bulaq.

The exterior

The mosque overlooks the street through two main façades: a southwestern and a northwestern one. The first contains the main entrance to the mosque, the minaret on the eastern corner, and one side of

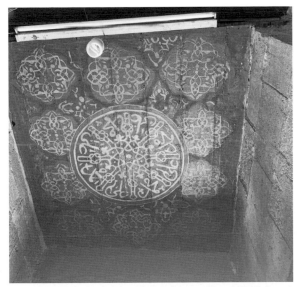

Figure 3.20. The roundel with "Muhammad" and "'Ali" found in the northeastern *sidilla* in the Mosque of Yusuf Agha al-Hin.

the *sabil-kuttab* at the western corner, and it faces Maqasis Street. Two staircases with stone-carved balustrades face each other and lead to the main portal, which leads to a platform in front of the entrance. The main entrance is placed in a flat recess with a bench on each side, topped by a stalactite hood with four levels of stalactites (figure 3.22). The lintel and the relieving arch are framed with a double molding with circular loops, which also frames the small rectangular window above.

Two recesses flank this entrance and are crowned with a flat hood of two levels of stalactites and two superimposed windows. A third recess found in the projecting western corner of the minaret is pierced with windows that overlook the *qibla* side of the prayer area.

The façade of the *sabil* is also framed with double molding with loops around the lintel and relieving arch, above which is the balustrade of the *kuttab*. Plain engaged columns decorate the corners of the metal grille of the lower window, which shows a grille of plain squares below but with an interesting tri-lobed leaf design in the upper part.

The northwestern façade contains the second façade of the *sabil-kuttab* as well as the second entrance to the mosque. The entrance here lies in the northern corner and is placed in a tri-lobed recess with stalactites in the two lower lobes, flanked by a bench on each side and framed with the double molding with loops surrounding the lintel, the relieving arch, and the small window above. Three small rectangular windows can be seen above the recess. The façade of the *sabil* on this side is similar to the one overlooking the main street, and one can see on the left a small arched opening for the filling of the cistern underneath.

The minaret stands above the slight projection of the wall at the eastern end of the main façade. It is a hybrid Mamluk-Ottoman minaret though quite plain. It starts with a plain square above which is an octagonal shaft that ends in stalactites under the balcony, followed by a round third shaft that ends in a pointed finial.

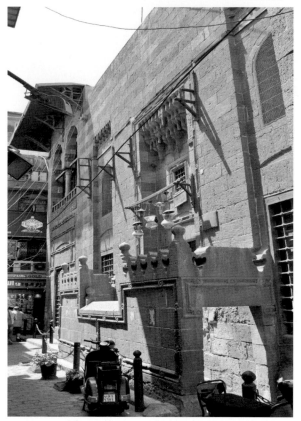

Figure 3.21. The southwestern façade of the Mosque of Taghribirdi (by Karim Saada).

The plan

The main entrance leads to a covered corridor that divides the rectangular space of the interior into two higher platforms facing each other and separated by a lower corridor that leads from the main entrance to the ablution area inside. This corridor serves as a *durqa'a* or a small covered court with a plain lantern in the center (figure 3.24).

The *qibla* side contains the plain *mihrab*, wooden minbar, and cupboards that have lost their doors. The southern wall is broken by a tall recess that reaches the top part of the wall and is pierced with windows that overlook the main street. A small door in the corner leads up to the minaret and the roof. The northern wall is broken by a pointed arch and contains four ascending steps that lead to a platform and then to a room, which probably served as the burial chamber. This room opens onto the *qibla* area by a wooden *mashrabiya* screen and a window in the opposite direction, which overlooks the ablution area below.

The platform opposite is also one step higher than the corridor, and its walls are also broken with recesses and windows. In the southwestern corner of the mosque is a small door that leads to the *tasbil*

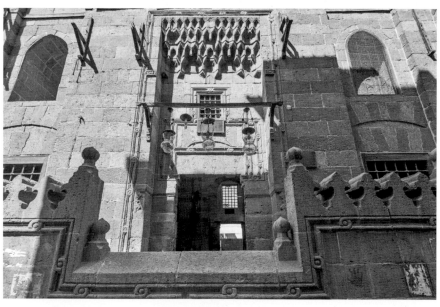

Figure 3.22. The entrance of the Mosque of Taghribirdi.

square panel tops the area in front of the hanging *dikka*. It shows a much poorer quality in its ornaments and inscription design and contains a badly preserved arabesque and floral design at the center. The whole panel is bordered by a poor-quality inscription that also contains the Throne Verse. The color palette of these panels includes gold, blues, crimson red, green, and violet. The center of the prayer area is topped by a lantern, which is obviously a modern-day restoration, but traces of a floral ornament that had once framed it are still evident (plate 3.4). A frieze of a Qur'anic inscription[36] placed in cartouches runs under the ceiling, at the end of which is the now illegible foundation inscription read by Hasan Qasim as mentioned above.

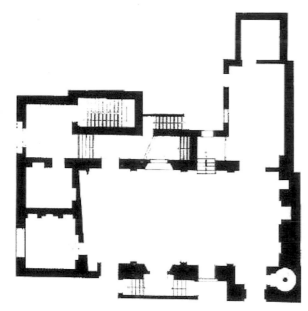

Figure 3.23. The plan of the Mosque of Taghribirdi (plan after Abu al-'Amayim, *Athar al-Qahira al-islamiya fi-l-'asr al-'uthmani,* 169).

room, used today as a prayer area for women. The wooden *dikka* occupies the whole width of the iwan opposite the *mihrab* and can be reached by a wooden staircase located on one side. The front of the *dikka* rests on three columns and the back rests on the wall. A wooden Qur'an chair, which was dismantled and rebuilt by the Comité, is mentioned by al-Haddad but cannot be seen in the mosque today.[35]

The wooden ceiling of the rectangular prayer area is made with small squares with a nail in the center, a novelty for this period, which imitates the tiles with nails that cover the dome of the Zawiya of Shaykh Se'oud. In the middle of the ceiling of each iwan is a painted square framed with a narrow Qur'anic inscription frieze. The square panel above the area in front of the *mihrab* consists of a medallion in the center framed by an inscription frieze that contains the Throne Verse. The four corners are decorated with a floral design in which Chinese influence is apparent, while the center features a variation of the arabesque design, mostly common on carpets. The second

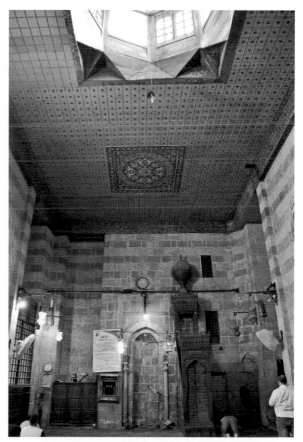

Figure 3.24. The *qibla* wall of the Mosque of Taghribirdi.

The plan of this mosque might be best described as a Mamluk *qa'a* plan with a covered courtyard, yet the courtyard is replaced here by a corridor that leads to the ablution area and is covered with a lantern. However, the Mamluk-style *qa'a* plan is distorted here by a side iwan to the left of the *mihrab* for a tomb. One can consider this an attempt to revive late Mamluk architecture, where this case shows a variation of the one-room mosque, but where the Mamluk influence dominates both the exterior and the interior. We know very little about the founder, but he may have been a descendent of a Mamluk family making a statement about their continuous existence in Egypt. This mosque remains unique in Cairene architecture due to its Chinese influence and the style of its ceiling. This also raises questions about its dating. The only other Cairene ceiling resembling this one in its division into small squares but without the central nails can be seen in the iwan opposite the *qibla* side of the Madrasa of the Bahri Mamluk amir Sunqur Sa'di, which is known to have been rebuilt by the Mevlevi convent in the sixteenth or seventeenth century and restored by Professor Fanfoni in 1979.[37]

The Mosque of Marzuq al-Ahmadi (1045/1635)
Monument Number: 29

The founder

The mosque was built by 'Ali Bey al-Faqari *amir al-li-wa' al-sultani* (Prince of a Royal Brigade) and attributed to Shaykh Marzuq al-Ahmadi (d. 677/1278), who was a follower of the well-known Sufi Shaykh al-Sayyid Ahmad al-Badawi, who is buried in the city of Tanta.[38] Shaykh Marzuq lived in a small *zawiya* in this location, and when he died he was buried in the *zawiya*, which was surrounded by an unused piece of land. In 1042/1632 the land was rented by al-Faqari Bey, which included the above-mentioned tomb. The witness of the deed of rent was Shaykh Husayn Didi al-Ahmadi al-Marzuqi, who helped build the mosque to dedicate it to the Maraziqa Sufi order, which is a branch of the Ahmadi order.[39] The

foundation inscription can be seen at the end of the tiraz band under the ceiling of the first aisle in front of the *qibla* wall. The Tariqa al-Maraziqa al-Ahmadi-ya is in fact attributed to the shaykh buried there before the founding of the mosque. Later on, several other shaykhs of the same *tariqa* were buried with the founder.

The location

The building lies on Habs al-Rahba Street at the intersection with Darb al-Tablawi, which is part of al-Jamaliya Street found parallel to the old Fatimid Qasaba, today known as al-Muizz Street.

The exterior

The building has three freestanding façades. The northwestern façade is the main one, where the entrance is placed in a recess and is flanked by two benches. On the north side and to the right of the entrance, there are three shops and two recesses pierced with windows (figure 3.25). The tri-lobed arch of the entrance is plain without stalactites but framed with a double molding with angular loops. A similar molding frames the lintel and the relieving arch and a rectangular panel carved with a geometrical design on each side. Two small windows above the entrance overlook the interior *durkah*. A carved Qur'anic inscription band runs across the entrance recess above the benches.[40]

The southwestern façade is broken in the middle with a recess, which is pierced with a small door, surmounted by a window. The rest of this façade overlooks the mausoleum of Shaykh Marzuq. This area is divided into two parts: the first contains one recess pierced with two windows, and the second part projects out and is broken also by one recess pierced with another two windows. The door leads to a rectangular corridor that opens onto the interior of the building. The *maqsura*, or wooden screen, that surrounds the tombstone of Shaykh Marzuq al-Ahmadi can be seen to the right of the corridor. On the left, there is a cupboard with steps beside it that ascend to a residence above the mosque and all the way to the roof and the minaret.

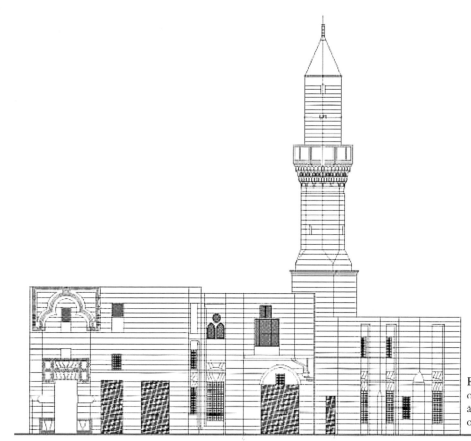

Figure 3.25. The elevation of the Mosque of Marzuq al-Ahmadi (by the Ministry of Antiquities).

The southeastern façade overlooks Darb al-Tabla-wi and includes part of the façade of the mausoleum and the mosque. The façade of the mosque on this side projects out only half a meter and is pierced with windows. This side abuts a new house, which is today the meeting area of the Sufi order. The façade of the mausoleum on this side contains a recess pierced with two windows and a third window placed outside the recess on the upper level.

The minaret projects out from the southwestern corner of the mosque. It starts from the ground with a square base that rises to the height of the façade, after which it contains a stalactite cornice followed by a round, filleted shaft that ends in stalactites under the balcony, which ends with a pointed finial.

The interior

The main entrance opens onto a corridor topped with a plain wooden ceiling and remains of colored marble on the floor, and leads to the prayer area. To the left of this corridor is a deep recess also topped with a wooden ceiling, which contains remains of a painted frieze.

The interior of the mosque consists of a rectangular space that measures 16.70 × 11.60 meters. It is divided into three aisles: a wider central aisle flanked by two narrower ones, each containing three-pointed arches with slight returns supported on round marble columns that run parallel to the *qibla* wall.

The *mihrab*, which can be seen opposite the main entrance, is flanked by two cupboards on the left and

two windows on the right, a lower and an upper one, which overlook Darb al-Tablawi. The *mihrab* is plain, except for its two engaged and fluted marble columns. Inside the recess of the *mihrab* on the ground is what is claimed to be the footprint of Prophet Muhammad (figure 3.26). The *mihrab* is topped with a square formed of two-colored stones with a bull's-eye window covered with a wooden grille. The minbar beside the *mihrab* is made of wood and is decorated with a common geometrical design seen in many Ottoman wooden minbars.

The hanging *dikka* opposite the *mihrab* stands on two marble and two wooden columns. The wooden ceiling of the prayer area shows remains of paint and a plain lantern in the center. The tiraz band

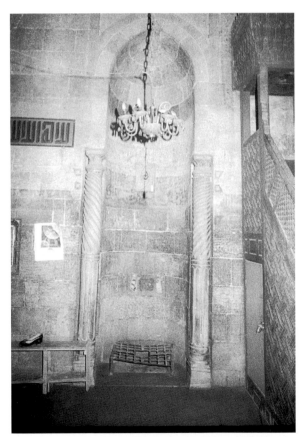

Figure 3.26. The *mihrab* of the Mosque of Marzuq al-Ahmadi (courtesy of Ibrahim Ramadan).

under the ceiling contains remains of a Qur'anic inscription in *naskhi* script placed in cartouches, as well as the foundation inscription.[41]

The mausoleum

The mausoleum lies in the southern corner of the mosque. It is a rectangular room that measures 9.64 × 7.80 meters and overlooks the *qibla riwaq* through a pointed arch. It is covered with a plain wooden ceiling and is pierced with windows and a pointed arch recess in the southwestern side. The tombstone is surrounded by a wooden *maqsura*, which according to the caretaker was restored in 1979. All that remains of the original tombstone is the column that includes the date 1043/1634, which precedes the building of the mosque by one year.

The layout of the Mosque of Marzuq al-Ahmadi can be really considered a *zawiya* or *takiya* with an attached residence on the upper floor. It is thus a smaller version of the *takiya* discussed earlier in "The Bridge," but with more emphasis on the prayer area than on the shaykh or founder of the *tariqa*, which is a clear indication of the declining influence of Sufi shaykhs during this period. The building is in need of restoration and maintenance and is only visited by a few people today, in spite of its excellent location in the middle of a highly touristic neighborhood. The plan with the three aisles and lantern can be considered a development of the plan of the mosque-madrasa attached to the Khanqah-Mausoleum of Sultan Barsbay (c. 833/1430) in the Northeastern Cemetery, which also included a separate *zawiya* and a *ribat* for Sufis. Nevertheless, the Mosque of Marzuq al-Ahmadi was not designed to host the plan that consists of two higher platforms with the lower corridor in the center but was rather built as a prayer area all on one level. In conclusion, this mosque is a Cairene Ottoman building that can be considered a variation of the Baldachin Plan for the absence of a lower central corridor. However, the absence of the division makes this mosque's plan a variation that is more Ottoman than Mamluk.

The Zawiya of Radwan Bey
(1037/1627)
Monument Number: 365

Although several *zawiya*s were built in the seventeenth century, only the Zawiya of Radwan Bey remains in its original state.

The founder

Radwan Bey al-Faqari was a mamluk who belonged to Dhulfiqar Bey, the head of the Fuqariya division of Mamluk beys. Radwan Bey dominated the political scene of Egypt and was given the important post of Amir al-Hajj from 1039/1630 to 1065/1655. His responsibilities included organizing the pilgrimage caravan that departed from Egypt each year to Mecca (except for one year, when he was summoned to Istanbul by Sultan Murad IV and was sent to prison, with all his property confiscated). When Sultan Murad IV died that same year and was succeeded by his brother Sultan Ibrahim, Radwan Bey was freed and came back to Cairo, where he managed to regain his property. He was praised by historians for his role in the development of the area south of Fatimid Cairo, and many buildings south of Bab Zuwayla are attributed to him, including the *wikala* that partly survives today and his palace; nevertheless, the *zawiya* is the only building that survives intact.[42]

The location

It is located south of Bab Zuwayla, after Khayamiya (tentmakers *wikala*) of Radwan Bey. In an alley to the right, the remains of the complex of the amir and the *zawiya* are found. Some scholars believe that the *zawiya* replaced the Mosque of al-Amir Baktut al-Badri (c. 710/1311) and that the mausoleum found inside the *zawiya* today is that of Amir Baktut. However, in the *waqf* document, according to al-Haddad, there is mention of a *zawiya* attributed to Shaykh al-ʿUwayti, which Radwan Bey rebuilt and endowed.[43] ʿAli Pasha Mubarak dates this *zawiya* to 1060/1650, although the *waqf* deed states that it was built in 1037/1627.[44]

The exterior

The building overlooks the street through two façades. The entrance is placed in the northwestern façade and is reached by ascending three steps. To the left of the plain entrance is a recess with two superimposed windows and a window surmounting the entrance. The northeastern façade is plain and broken by one plain recess.

The plan

The door opens directly onto the interior, which is a rectangular space that measures 10.80 × 7.80 meters. This space is divided into two by a wooden beam parallel to the *mihrab*, supported on a stone column that stands in the middle of the *zawiya*, with two additional pillars attached to the side walls for support (figure 3.28). The *mihrab* found today is entirely renovated. One window with a wooden grille located on the left overlooks the ablution area outside. Two doors on the same side of the *zawiya* lead to the roof and to the ablution area respectively.

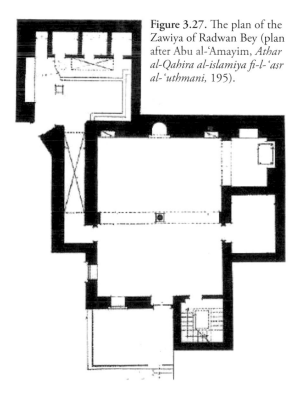

Figure 3.27. The plan of the Zawiya of Radwan Bey (plan after Abu al-ʿAmayim, *Athar al-Qahira al-islamiya fi-l-ʿasr al-ʿuthmani*, 195).

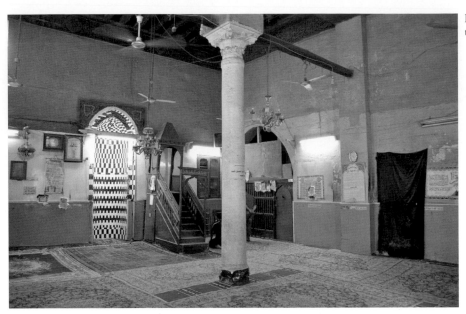

Figure 3.28. The interior of the Zawiya of Radwan Bey.

There are two rooms to the right of the prayer area: the first is used for storage and the second is the Mausoleum of Shaykh al-'Uwayti. His mausoleum is small and rectangular in shape and measures 4 × 2 meters with no dome or *mihrab*, but with remains of a painted ceiling.

The wooden ceiling of the interior of the *zawiya* also shows remains of paint, below which is an inscription frieze with white painted script on a blue background with verses of poetry from the *Burda Qasida* of Imam al-Busiri.

The building on the whole is small compared to earlier *zawiya*s, but it was a part of a whole complex and bears witness to the importance and influence of religious scholars and Sufis during the seventeenth century.

The Mosque of 'Uqba ibn 'Amir (1066/1655)
Monument Number: 535

The founder
The founder of this mosque is Muhammad Pasha al-Silahdar, the governor of Egypt during the reign of Sultan Mehmet IV, the son of Sultan Ibrahim Khan. He arrived in Egypt in 1062/1652 and was deposed after only three years in 1065/1655. He was described by historians as generous and pious, and according to Ibn al-Wakil,[45] he ordered the whitewashing of all the mosques and was therefore nicknamed "the Father of Light" by al-Sadat al-Wafa'iya Sufi group, according to 'Ali Pasha Mubarak.[46]

Muhammad Pasha ordered the rebuilding of the shrine and *zawiya* of 'Uqba ibn 'Amir al-Juhani, which he turned into a mosque and shrine. 'Uqba ibn 'Amir (d. 58–9/677–8) was a well-known Companion of Prophet Muhammad who was a poet and a transmitter of hadith. He became an active supporter of his friend Mu'awiya ibn Abi Sufyan against 'Ali, the fourth and last of the Righteous Caliphs, during the first Muslim civil war. After Mu'awiya became the caliph and the founder of the Umayyad dynasty in 41/661, he appointed 'Uqba as Governor of Egypt in 44/664 until his replacement by Maslama ibn Mukhallad al-Ansari in 49/669. 'Uqba ibn 'Amir remained in Egypt until his death in 58–9/677–8 and was buried in a simple tomb in the Fustat Cemetery.[47] During the fourteenth century,

Figure 3.29. The arched gateway and the vestibule of the Mosque of 'Uqba ibn 'Amir (by Karim Saada).

the Mamluks built a *zawiya* and tomb over his grave. Centuries later, during the Ottoman period, precisely in 1066/1655, Muhammad Pasha rebuilt this *zawiya* and tomb as a mosque and shrine, and added other buildings around it that included a cistern, two *mazmala*s with water jars for the thirsty, a *kuttab* to teach the orphans, as well as housing for the people involved in the upkeep of this group of buildings. The buildings also included a kitchen to cook for the Qur'an reciters, the workers, and visitors to the shrine.[48] He also ordered a drinking trough be built for animals not far away from the complex, in addition to a coffee house and a garden.[49]

The location

The complex is located in the Cemetery of Imam al-Layth, south of the Shrine-Mausoleum of Imam al-Shafi'i, at the end of 'Uqba ibn 'Amir Street, a burial area of many shrines that were, and still are, popular among Egyptians who visit shrines regularly, including the shrine of the early Sufi shaykh Dhu al-Nun al-Misri (d. 245/859) and the memorial shrine of the famous Sufi woman Rabi'a al-'Adawiya, who is in fact buried in Iraq and not in Egypt.

The exterior

The complex can be entered through an arched gateway, to the left of which lies the small, green-painted, domed mausoleum of Fatima bint al-Hasan ibn al-Anwar. To the right of the mausoleum is a slab inserted in the wall stating that this is the burial place of both 'Uqba ibn 'Amir and 'Amr ibn al-'As (figure 3.29). The exact burial place of the Companion of the Prophet and general of the army that conquered Egypt has been a matter of debate for a long time. The hypothesis of its being located inside the Mosque of 'Uqba ibn 'Amir was greatly supported by 'Abd al-Baqi al-Sayyid 'Abd al-Hadi, professor of Islamic history at Ain Shams University, in a research paper presented at a conference at the university in 2017.[50] The arched gateway leads to a vestibule with three stone *mastaba*s and is topped by a wooden roof (figure 3.30). As one turns left, a corridor leads to a square area surrounded by buildings that probably formed part of the complex built by the pasha in 1066/1655, which is today the residence of several families. Straight ahead lies the main entrance of the mosque (figure 3.31).

Figure 3.30. The foundation panel of the Mosque of 'Uqba ibn 'Amir (by Karim Saada).

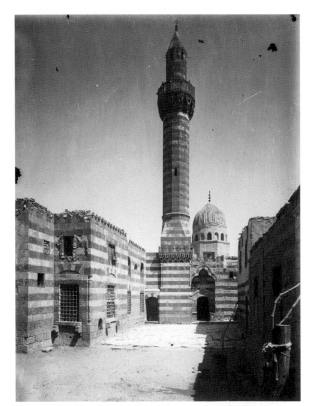

Figure 3.31. The façade of the Mosque of 'Uqba ibn 'Amir (courtesy of Ibrahim Ramadan).

The main façade is located on the southwestern side, with the minaret standing to the left of the main entrance. The entrance is placed in a plain tri-lobed recess, framed with a molding with a loop at the apex in a recess and flanked by small benches. The minaret is a typical Ottoman minaret with an octagonal shaft on a pyramid-shaped transitional zone, which consists of one balcony on stalactites and a pointed finial. Above the door is a marble panel with the foundation inscription in Ottoman Turkish, which contains six lines in *thuluth* script and gives the date of 1066/1655. The skyline of the building is crowned with tri-lobed cresting. There are two plain side entrances to this façade: the one on the right leads to an open area that contains the ablution area today,[51] while the entrance on the left leads to an open space paved with a stone floor with two doors. The door on the left, which is closed today, led to steps that ascend to the *kuttab*.[52] The second door, found opposite the first one, leads to another open space.

The southeastern façade

This is the façade of the *qibla* wall and the mausoleum. It contains five windows with wooden grilles that overlook inside the prayer area through stucco grilles with

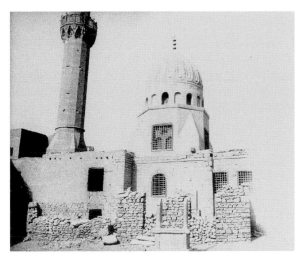

Figure 3.32. A closeup on the dome of the mausoleum of the Mosque of 'Uqba ibn 'Amir (courtesy of Ibrahim Ramadan).

stained glass (figure 3.32). The third window, which is round, is the one located above the protrusion of the original *mihrab*, replaced inside by a *mihrab* in the southeastern corner. The façade of the mausoleum is pierced with a rectangular window faced with a wooden grille behind which is a stucco grille with stained glass that is located above the *mihrab* of the mausoleum. The dome of the mausoleum stands on a pyramid-shaped transitional zone above, which stands on a drum with sixteen windows, eight of which are blind. Above the drum is a recessed frieze that was originally filled with tiles like those on Prince Suleiman's dome (c. 951/1544) in the Northeastern Cemetery. Only three tiles have survived, featuring a vase with flowers, flanked by trees on both sides, colored in blue and green on a white background.[53] The dome is broken with convex and concave ribs, which remind us of the Mamluk dome of Tankisbugha in the Southern Cemetery (c. 760/1359). The apex of the dome features a finial with three round bulbs and a crescent, which according to the *waqf* document, were covered with brass and gold.[54]

The northwestern façade

This is the façade of the second aisle of the mosque, which overlooks an open court with some burials through two lower windows faced with metal grilles, surmounted by four rectangular windows covered outside with wooden grilles and inside with stucco ones with stained glass.

The interior

The main entrance leads to a rectangular vestibule that measures 4.65 × 6.50 meters and is covered with a wooden roof. There is a green-painted tombstone on the right with an illegible inscription on its marble slab (figure 3.33). This burial place is considered by many, including Professor 'Abd al-Hadi, who based his research on the writings of Harmala al-Tagibi (d. 243/857), as the original tomb of 'Amr ibn al-'As (d. 43/663), who died before his friend and companion 'Uqba ibn 'Amir and was apparently buried in a simple tomb in this area. To the left of this area are steps that ascend all the way to the roof and the minaret. On the left side after these steps is an extension to the vestibule, which is located on a step higher and is today separated by a green curtain. This extension is pierced with two rectangular windows: one that overlooks the ablution area and another that overlooks the prayer area, both of which are faced with wooden grilles. This area is used today as a storage area, but it also includes a tombstone of Shaykh Muhammad al-Aqbi (d. 1093/1682).

Figure 3.33. The green painted tombstone attributed to be the original tomb of 'Amr ibn al-'As.

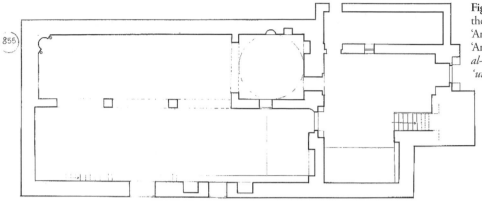

Figure 3.34. The plan of the Mosque of 'Uqba ibn 'Amir (plan after Abu al-'Amayim, *Athar al-Qahira al-islamiya fi-l-'asr al-'uthmani*, 199).

The prayer area consists of a rectangular space that measures 9.50 × 17.40 meters, which includes the Mausoleum of 'Uqba ibn 'Amir in the southern side (figure 3.34). The space is divided into two aisles by three pointed arches, resting on two octagonal piers in the center, the wall of the mausoleum on the right, and a projection of the wall on the left-hand side (figure 3.35).

The *mihrab*, seen today in the eastern corner, faces the correct orientation to Mecca. It is made of plain stone and includes some remains of floral designs. The original *mihrab* was located in the middle of the southeastern side of the *qibla* wall, as can be seen from the projection on the exterior of the mosque and the round window above it. This was replaced by a flat *mihrab* of carved stone, framed by a double molding with angular loops, which contains a carving of a lamp hanging from the center of its arch, dangling by three chains. This is peculiar since the projection seen on the outside of the mosque would normally indicate a recessed *mihrab* on the inside. It is not clear when this restoration and correction was done, but since the stone used matches that used in the rest of the wall, one can assume soon after or just before the inauguration of the mosque. The *qibla* wall is pierced with two windows on each side of the original *mihrab* and with a round one above it, all of which are covered with stucco grilles and stained glass. Beside the newly corrected *mihrab* at the corner of the prayer area is a wooden minbar abutting

the *qibla* wall. The hanging *dikka* lies in the center of the second aisle and can be reached by wooden steps. Remains of paint still survive on its base.

The ceiling of the prayer area is made of painted wood. The cornice of the ceiling above the first aisle contains an inscription band placed in cartouches. The inscription starts with the *Basmala* followed by verses from al-Busiri's *Burda* in Persian script on a floral background. This reminds us of the inscription in the Mausoleum of the Mamluk amir Sunqur Sa'di (c. 715–21/1315–21), which later became a Turkish *takiya* for the Sufi Mevlevi order in the sixteenth century.

The mausoleum of 'Uqba ibn 'Amir lies in the southern side of the first aisle of the mosque, and opens onto the prayer area through a pointed arch covered with a wooden grille (figure 3.36). A small door in the grille leads to the interior of the mausoleum. It is a square room with a *mihrab* on the left that is topped by a window. The *mihrab* is framed with a double molding with angular loops. The *mihrab* is flanked by a cupboard on the right and by a marble panel on the left that contains six lines of Qur'anic verses[55] inscribed in *naskhi* script followed by "This is the tomb of 'Uqba ibn 'Amir, the carrier of the flag of the Prophet of God."

The mausoleum is pierced with two more windows: one overlooks the vestibule and the other the entrance of the prayer area. A black stone on that side is attributed to the Prophet Muhammad; many believe it is holy and claim that the Prophet once walked on it.[56] The

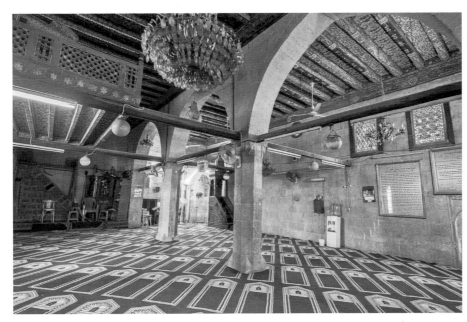

Figure 3.35. The interior of the Mosque of 'Uqba ibn 'Amir (by Karim Saada).

tombstone is found in the middle of the mausoleum and is inscribed at the front with the name of 'Uqba ibn 'Amir and states that the place was restored by the vizier Muhammad Pasha in the year 1066/1655. A tiraz band runs under the transitional zone; it contains inscriptions placed in cartouches[57] and is framed by two bands painted with floral motifs. The transitional zone consists of four large triangular pendentives, pierced in the walls between them with windows; each group consists of a Qalawun set of windows. The drum area above the transitional zone is pierced with eight windows. The entire walls and the interior of the mausoleum show remains of carving and painting, featuring both geometrical and floral designs (figure 3.37).

The dependencies

The large court in front of the mosque, mentioned above, contained according to the *waqf* deed sixteen doors that led to different dependencies, only ten of which survive today.[58] Two doors remain on the right as one enters the complex; the first led to residential units still in use until today and the second to a *mazmala* for the storage of water jars. On the southeast side, as one enters the open court, only two of the six doors mentioned in the *waqf* deed remain.[59] The northeastern side retains its three doors, which were already described as the main façade of the mosque. The northwestern side had five doors, three of which led to sleeping quarters, one to a *mazmala* and the kitchen, and the fifth to a new building built in the eighteenth century. The *kuttab* is unfortunately very badly preserved; it consisted of a room with several windows and cupboards.

This complex of buildings is very popular among the inhabitants of the area and pilgrims who visit the Companions of the Prophet and the Sufi shaykhs and scholars buried there, but remains unfortunately less known to the rest of the population or to visitors interested in Islamic architecture. It is definitely worth a visit, not only because of the importance of the people buried there, but also because of its rather unusual plan and the fine details of its decoration, especially its dome and the surviving paint inside it. The whole area and the road leading to it need much repair; however, it has the potential to be converted into a touristic area, attracting many visitors seeking more insight and knowledge of the spiritual side of Islam. The plan of

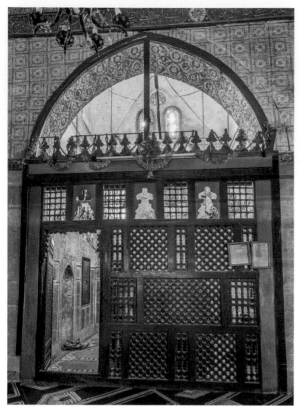

Figure 3.36. The entrance to the mausoleum of 'Uqba ibn 'Amir (by Karim Saada).

the building is more like a *zawiya* attached to a mausoleum, which resulted in a very irregular one-room plan. The change in the location of the *mihrab* may be due to a miscalculation in the plan that had to be rectified, resulting in a rather strange prayer area.

The Mosque of 'Abidy Bek, also known as the Mosque of Sidi Ruwaysh (1071/1660)
Monument Number: 524

The founder

The founder of this mosque is 'Abidy Bek ibn Amir Bakir, *amir al-liwa' al-sultani* (Prince of a Royal Brigade), as written on a marble plaque that used to be located above the main entrance of the mosque,

but no longer exists today.[60] Ramsi (in his verification of Ibn Taghribirdi) adds here that this mosque was built over the ruins of the Madrasa al-Mu'izziya built by al-Malik al-Mu'izz 'Izz al-Din Aybak al-Turkumani (c. 654/1256) that was renovated by 'Abidy Bek. The mosque later became known as the Mosque of Sidi Ruwaysh, due to the fact that the shrine of Shaykh Ruwaysh, who in fact has nothing to do with the mosque, is located right behind it.[61]

The location

It is found on Corniche al-Nil, almost facing the Nilometer on the island of Manial al-Rawda.

The exterior

The building overlooks the street by two façades; the main one with the entrance portal is the western façade overlooking the Corniche. "The main exterior façade relies on bilateral symmetry to give a sense of grandeur to a small building."[62] The shallow portal is placed in the center and is emphasized by a pishtaq frame. Today, the entrance lies three meters below the present street level and is blocked with a metal grille in front of it. It is placed in a plain tri-lobed recess, framed by a double molding with angular loops running all around its joggled lintel and relieving arch. The wooden door of the entrance is topped by a rectangular window faced with a wooden grille and crowned by a tri-lobed cresting. In 1320/1903, Max Herz and the Comité of Conservation of Arab Monuments inspected the mosque and decided not to include it in the list of preserved Islamic buildings in Cairo; however, they removed the marble plaque above the door, which included the foundation inscription, in addition to the tilework, which covered the *qibla* wall and the *mihrab*.[63] The entrance portal is flanked with a shallow plain recess pierced with two windows on each side, a large rectangular one below faced with a metal grille and a smaller one above, which are blocked today. The mosque is entered today through a door to the right of the main entrance, which leads directly to the ablution area, and to the left of which is the door that leads to the interior of the prayer area.

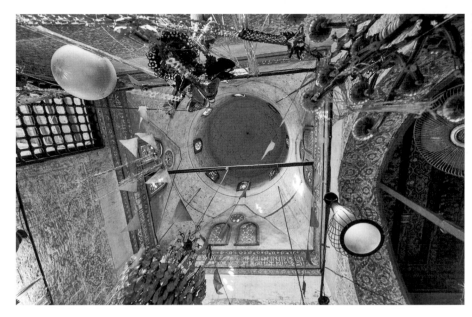

Figure 3.37. The dome of the mausoleum of 'Uqba ibn 'Amir (courtesy of Ibrahim Ramadan).

The second façade lies on the northern side and faces the Shrine of Sidi Ruwaysh behind the *qibla* wall. It is a plain façade pierced with windows overlooking the prayer area and a round one above the *mihrab*.

The minaret stands above the side entrance of the mosque. Despite its typical conical top, the shaft recalls earlier Mamluk ones in its octagonal, unfaceted appearance, as is common in Ottoman minarets. The minaret contains only one balcony that rests on stalactites, like most Ottoman minarets in Cairo.

The plan

It is an almost square building divided into three aisles and nine bays by four large granite columns with Corinthian capitals carrying pointed arches that run both parallel and perpendicular to the *qibla* wall. Although the plan appears regular, the columns are placed in an uneven alignment from one another, which creates a confusing distortion (figure 3.40). All the plans published of the mosque to date misleadingly show the four columns placed at the corners of a perfect square, when in fact, the two rear columns are shifted to the south to align the *mihrab* with the

direction of Mecca. Seven of the nine bays are covered with shallow domes on pendentives, yet the bay in the center is topped with a lantern and is covered by a modern wooden ceiling. The bay above the *mihrab* is topped by a much larger dome, supported on stalactite squinches with a drum pierced by eight plain windows. Nonetheless, this dome is a result of a later restoration work and is not the original one.[64]

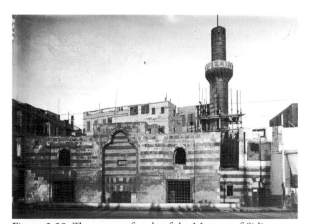

Figure 3.38. The western façade of the Mosque of Sidi Ruwaysh (courtesy of Ibrahim Ramadan).

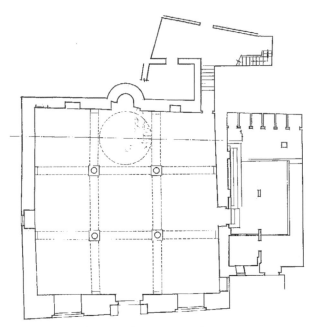

Figure 3.39. The plan of the Mosque of Sidi Ruwaysh (plan after Abu al-ʿAmayim, *Athar al-Qahira al-islamiya fi-l-ʿasr al-ʿuthmani,* 202).

Today, the *mihrab* of the Mosque of Sidi Ruwaysh appears plain; however, Comité *Bulletins* state that Max Herz Bey removed the tilework that decorated the *qibla* wall in 1903, as mentioned by ʿAli Pasha Mubarak.[65] The large plain hanging *dikka* opposite the *mihrab* stands above the main entrance and rests on two of the granite columns of the bays. It can be reached by a wooden staircase, which stands today inside the prayer area reserved for women and separated by a screen. The stucco grilles of the windows all appear to be part of a recent restoration. A wooden minbar stands beside the *mihrab*. To the far right of the minbar is a wooden door that leads to the staircase that ascends to the roof and minaret.

The Mosque of Sidi Ruwaysh is a small mosque well taken care of by the caretaker and quite popular among the inhabitants of the area; otherwise, it is not that well known. It can be easily missed among the tall buildings around it but is well worth a visit. The plan continues the nine-bay mosque plan popular in many parts of the Islamic world for small neighborhood

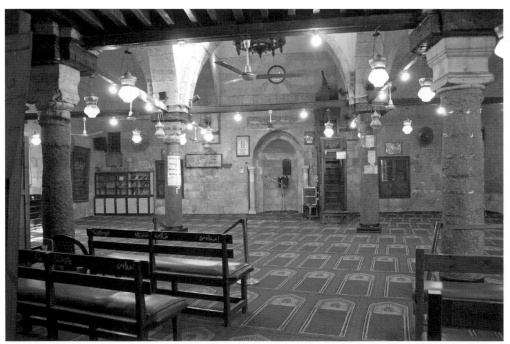

Figure 3.40. The interior of the Mosque of Sidi Ruwaysh.

mosques. The plan is seen as early as the Mosque of the Sharif Tabataba in Cairo built during the Ikhshid dynasty (c. 323–358/ 935–969) in the area of 'Ain al-Sira, which is unfortunately in ruins today.

Ribat al-Athar, also known as Athar al-Nabi (1080/1664)
Monument Number: 320

The founder

This *ribat* was originally built by al-Sahib Taj al-Din Muhammad ibn al-Sahib Fakhr al-Din Muhammad Baha' al-Din 'Ali ibn Hinna al-Misri (640–707/1242–1307). Taj al-Din died before the completion of the *ribat*, but it was completed by his son Nasir al-Din Muhammad. Taj al-Din purchased the relics of the Prophet from the tribe of Banu Ibrahim in Yanbu for 60,000 silver dirhams and brought them to Cairo and put them in this *ribat*. Some of the earliest references to the *ribat* and its contents were written by al-Safadi (696–764/1296 1363) and al-Maqrizi, who mention a fragment of the Prophet's spear, a wooden bowl, tweezers, and a kohl applicator.[66] Ahmad Taymur Pasha mentions a lot of details about the relics, yet there are discrepancies with other sources and historians regarding the exact items found in this *ribat*, with some sources including a short stick, a copper kohl applicator, a needle used to sew leather footwear, and tweezers used for removing thorns, as well as a wooden bowl named al-Ashfa.

During the Mamluk period, four sultans contributed to Ribat al-Athar and the relics of the Prophet. Sultan Sha'ban endowed the building as a madrasa for the Shafi'i jurists, who received a monthly salary from the *waqf*.[67] A century later, in his complex built on either side of the Fatimid Qasaba, Sultan al-Ghuri built a mausoleum for himself attached to the *khanqah* he built for Sufis. His mausoleum was intended to house the relics of the Prophet that he removed from Ribat al-Athar, which had fallen into ruins by that time. These relics were placed in a cupboard in the Mausoleum of al-Ghuri between Rabi' al-Awwal and Jumada al-Awwal 910/August and October 1504.[68]

Nevertheless, Ahmad Taymur Pasha states that this probably occurred between the years 906/1500 and 921/1515, which is the missing part of Ibn Iyas's history of Egypt, when in fact it is elaborately mentioned in Ibn Iyas's *Bada'i' al-zuhur fi waqa'i' al-duhur* under the year 910/1504.[69] Ibn Iyas narrated that this was an unprecedented and bizarre act by the sultan for which he acquired a *fatwa* to turn his mausoleum into a holy shrine.[70] According to Taymur, al-Ghuri mentioned in his *waqfiya* that his mausoleum was to house his body, the relics removed from Ribat al-Athar, in addition to a Qur'an attributed to 'Ali ibn Abi Talib, the son-in-law of the Prophet, and another Qur'an attributed to Caliph 'Uthman that was originally found in a cupboard in the Madrasa of Qadi al-Fadil in Darb al-Qazazin, today found near the Mosque of al-Husayn.[71] This is confirmed by the foundation's most important document, the *waqfiya*, number 883, which is currently preserved in the Ministry of Religious Endowments in Cairo:

> [The Tomb] was prepared by the patron, whose noble name has been mentioned above—may God give him a most long and pleasant life—for the burial of himself, his children and his harem. At the far end of this tomb, there is a noble *mihrab* with a marble-revetted recess and hood. It is flanked by two chests, one for the noble Qur'an of the [Caliph] 'Uthman, and the other for the Noble Relics of the Prophet [Muhammad]. Each [box] has a gold-colored door made from imported wood.[72]

Ahmad Taymur Pasha states that in 926/1520 during the reign of Khayrbak, in order to invoke the flood the 'ulama' would bring out a shirt that belonged to the Prophet, found among the relics in the Mausoleum of Sultan al-Ghuri, and wash it in the water of the Nilometer.[73]

The foundation inscription, which dates to 1074–5/1663–4, mentions that Ibrahim Pasha al-Defterdar, who reportedly prayed in the Mosque of Athar al-Nabi on 12 Shawwal 1073/May 20 1663, expanded

and restored the mosque and endowed it with money and land. Evliya Çelebi, the Turkish traveler, visited Cairo in 1082/1672 and lived there for approximately nine years, during which he visited the footprint of the Prophet. He provided a detailed description of a large property, which he alternates in calling a *takiya* and a *khanqah*, that included a beautifully decorated mosque, a famous *ribat* that accommodated a hundred married Sufis of the Khalwati order, a dome chamber built above the footprint of the Prophet, and pavilions for pilgrims built close to the Nile.[74] This is the earliest mention of a stone engraved with the footprint of the Prophet that existed in this mosque, whose authenticity is debated by historians. Sultan Mehmet IV added a waterwheel to irrigate the adjoining garden, and this is confirmed by the Turkish inscriptions on the building, dated to 1077/1667.[75]

By 1203/1789, according to al-Jabarti, word reached Qadi al-'Askar that the relics of the Prophet were still in the cupboard in the mausoleum of Sultan al-Ghuri, which included at that time a piece of his shirt, a stick, and a kohl applicator. He summoned *mubashir al-waqf* (the caretaker of the waqf), and ordered him to put these relics in a box, sprinkle them with rose water, parade them around the city, and then return them to their place in the cupboard of the mausoleum of al-Ghuri.[76] The holy relics remained in the Mausoleum of al-Ghuri until 1275/1858.

In Rajab 1224/August 1809, al-Jabarti also mentions Khawaja Mahmud Hasan Bazrajan Pasha as a contributor to the structures of Athar al-Nabi, where he added a palace and rebuilt the mosque known as al-Athar al-Nabawiya in its original form.

In 1275/1858, the relics were moved from the Mausoleum of al-Ghuri to the Mosque of Sayyida Zaynab and then to the Citadel. By 1304/1886, they were moved again to Diwan al-Awqaf, and a year later to Abdin Palace, and finally to a chamber in the Mosque of al-Husayn. In his book published in 2012, Ahmad Taymur Pasha mentioned that relics still exist in the Mosque of al-Husayn in a chamber built by the orders of Khedive Abbas Hilmi II in 1311/1893, and can still be visited on certain occasions.[77]

The location

Ribat al-Athar is located near the Metro station of al-Zahra', under the flyover of the Ring Road near the Corniche leading to Maadi.

The exterior

The building is enclosed with a wall on three sides, except for the side with the dome and minaret, which originally would have faced the Nile. Above the southern side of the building's enclosure is an inscription plaque:

> A water channel was made in the name of Sultan Mehmet IV; a water dispensary was built beside it. May the thirsty, while drinking the water provided by him, say many prayers for the glory of this sultan. When it was completed [Hatif] said its date. This pious work has been made suitable for the name of Sultan Mehmet IV. In the year 1077/1667.[78]

This façade is broken by windows and is pierced by a small entrance (figure 3.41). All the walls of the exterior are plain and are pierced with rectangular windows faced with simple metal grilles, topped by arched windows in wooden frames. The main entrance is placed in a shallow arched recess, flanked by two small *maksala*s (benches). The dome is quite small in proportion and rests above a pyramid-shaped transitional zone, which is reminiscent of the exterior transitional zone of the dome of Qijmas al-Ishaqi. It is a stone dome decorated with a chevron design, but the carving is very shallow, unlike Mamluk domes with the same design such as that of Faraj ibn Barquq and al-Mu'ayyad Shaykh built during the Burji Mamluk period. The minaret is in a simple Ottoman style and contains only one balcony over stalactites. The balustrade of the balcony is not pierced. Underneath the dome and minaret is a small door that leads to the shrine under the dome, which still houses the footprint of the Prophet.

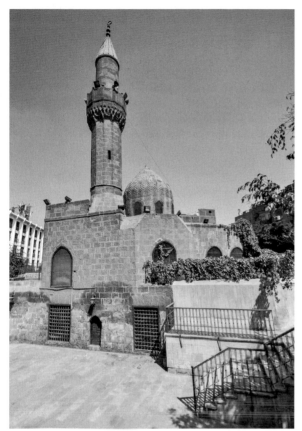

Figure 3.41. An exterior view of the Mosque of Athar al-Nabi (by Karim Saada).

The plan

The interior follows the three-aisle arrangement made up by three arches supported on four columns, which form two rows of three arches that run parallel to the qibla wall, an arrangement seen in several early Ottoman mosques. In this case, as in the Mosque of Marzuq al-Ahmadi, the prayer area is on one level, without a corridor leading to an ablution area as in the Mosque of Mahmud Pasha or earlier in the Mausoleum of Sultan Barsbay in the Northeastern Cemetery. The arcade here merely functions as a support for the wooden roof. The two octagonal columns found in the second aisle contain a wide *thuluth* script that reads on the right-hand column "Has ordered the

restoration of this blessed place" and on the left-hand column "our lord the Sultan al-Malik" (figure 3.43).

According to Iman Abdulfattah, four other columns from the *ribat* are now preserved in the Museum of Islamic Art in Cairo (MIA 3720-23).[79] The information provided by historians, combined with the inscriptions on these columns, limit the assumption of the patrons of these columns to four Mamluk sultans who made endowments or restorations to this building: al-Ashraf Sha'ban, al-Zahir Barquq, Faraj ibn Barquq, and Sultan al-Ghuri. Nevertheless, it is worth mentioning that during the survey done by the Comité of the building in 1900, two octagonal columns found in the surrounding enclosure with "al-Nasir Nasir al-Dunya wa-l-Din Faraj" written on them are mentioned.[80]

The *mihrab* of the prayer area is plain, except for some simple *entrelacs*. The minbar is of wood and is decorated with rectangular and square panels that intertwine, similar to that found in the Mosque of Yusuf Agha al-Hin. Around the *mihrab* and minbar

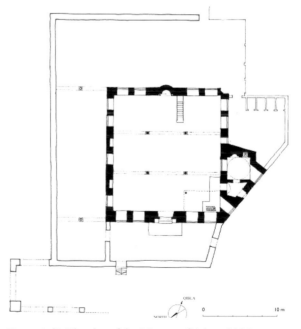

Figure 3.42. The plan of the Mosque of Athar al-Nabi (plan after Abu al-'Amayim, *Athar al-Qahira al-islamiya fi-l-'asr al-'uthmani,* 211).

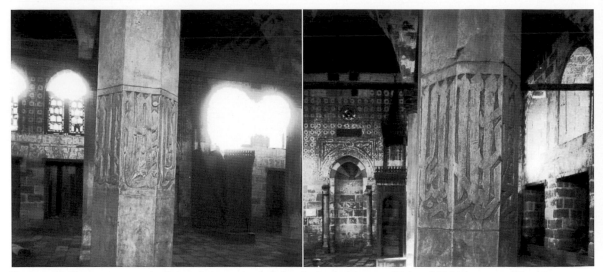

Figure 3.43. The two octagonal columns that contain *thuluth* script in the Mosque of Athar al-Nabi (courtesy of Ibrahim Ramadan).

are traces of paint in small square panels that resemble tilework, similar to those found inside the mausoleums of al-Kulshani and of 'Uqba ibn 'Amir. The rest of the mosque is relatively plain except for traces of paint on plaster that covers the upper parts of the walls and forms a chevron design in red, white, and black, which may be a later addition.

To the right of the entrance, located in the western corner of the third aisle, a wooden *dikka* rests on one column and the side walls; it can be reached by a simple wooden ladder at the back.

Beside the hanging *dikka* is the entrance to a small vestibule that leads to the domed shrine chamber. Beside this entrance is an inscription plaque with four lines of Ottoman Turkish script:

God has turned the virtuous nature of Sultan *Muhammad* Ghāzī [Mehmet IV; r. 1058-99/ 1648–87] towards pious works. God Almighty has inspired his sincere heart.

He built this mosque above the Footprint and named the sacred place for its founder, Ibrāhīm, who is the just Governor of the Kingdom of Egypt.

He is the humblest servant of the sovereign of the age. In this manner he brought to life a work of art in his name. Rubbing his face on the likeness of the footsteps of the sultan, may he be the recipient of prayers of intercession for judgment day.

Praying justly, Zakī said this chronogram, "in this place a lofty mosque without peer has been founded."[81]

The walls of the domed chamber are clad with blue and white tiles that were imported from Turkey.[82] The domed chamber contains a *mihrab* with a rounded conch and a pointed recess on its right. Both the *mihrab* and the recess are entirely covered with tiles. The sill of the pointed arch recess next to the *mihrab* now contains the footprint of the Prophet. In the tympanum of the recess above the footprint, there is an inscription panel in two lines in Ottoman Turkish (figure 3.44): "This shrine was renewed by Ibrahim Pasha. May God prolong his life, above the footprint."[83]

Taymur Pasha, in fact, refers to two footprints that belong to the Prophet and describes the stone

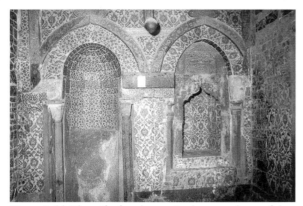

Figure 3.44. The *mihrab* and recess in the mausoleum of the Mosque of Athar al-Nabi (courtesy Ibrahim of Ramadan).

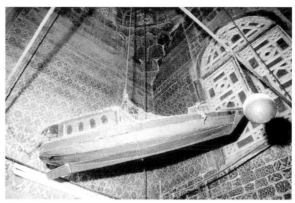

Figure 3.45. The boat that was hanging from the dome of the Mosque of Athar al-Nabi (courtesy of Ibrahim Ramadan).

as reddish; however, only one white stone footprint is visible today.[84] The footprint(s) must have been installed prior to the restoration attributed to Ibrahim Pasha, since two of the inscriptions imply that the mosque was built around it. What can be extrapolated from this is that the circumstances of the arrival or deposit of a footprint(s) attributed to the Prophet are not clear, nor whether the arrival of the footprint(s) preceded the rebuilding and subsequent name change of the mosque under the patronage of the Ottoman governor of Egypt.

From the inside, the dome of the shrine rests on Mamluk-style stalactite pendentives. Archive photographs, available online courtesy of Ibrahim Ramadan, show a wooden boat hanging from the apex of the dome of the shrine.[85] The only source that mentions this boat is an article by Samar Safi al-Din in *al-Masriyun*, in which she alternates between stating that it symbolizes the boat that provided the stones for the construction of the building, or that it was the boat that carried on board the builders of this building (figure 3.45).

Ribat al-Athar is a mixture of both Mamluk and Ottoman styles, since it originally dates from the Mamluk period and is almost completely rebuilt by the Ottomans. The main point of interest in the building is its shrine dome and the Ottoman tiles added

to it. The Ottoman sultan was then the new *Khadim al-Haramayn al-Sharifayn*, a title that was passed on to him after the vanquishment of the Mamluk Empire and the acquisition of the holy cities; thus, this building shows the continuation of the veneration of the holy relics from the Mamluk period, as a way of political and religious legitimization, emphasizing that the Ottoman sultans were the successors of the Prophet in his role as the Leader of the Faith.

The Mosque of Aqsunqur al-Faraqani al-Habashli (1080/1669)
Monument Number: 193

The founder

This mosque was originally built by al-Amir Shams al-Din Aqsunqur al-Faraqani al-Silahdar, inaugurated on 4 Jumada al-Awwal 676/3 October 1277. It included the teaching of both the Shafi'i and Hanafi schools of law; thus, the building became known as the Madrasa al-Fariqaniya.[86] This amir was originally a mamluk of Najm al-Din Amir Hajib, and was later bought by Sultan Baybars al-Bunduqdari. He died in 678/1277, during the reign of al-Malik al-Sa'id Baraka Khan, the son of Sultan Baybars (r. 675–8/1277–80). His residence stood beside his mosque,

and both buildings were in ruins by the time of the Ottoman conquest of Egypt. In 1080/1669, Amir Muhammad Katkhuda Mustahfizan,[87] an officer of the Janissaries, ordered the rebuilding of the mosque, which became known as the Mosque of al-Habashli (or al-Habashi) since the full name of the new founder was Muhammad Katkhuda Mustahfizan Yusuf Agha al-Habashi, which referred to his occupation in the slave trade from Ethiopia. The *waqf* document mentions he was appointed as *serdar*, which means army leader to the Janissaries sent to Ethiopia.[88] Several *wikala*s in the al-Gamaliya and Tabbana areas are attributed to him, in addition to several *sabil-kuttab*s.[89]

The location

The Mosque of Aqsunqur al-Faraqani al-Habashli lies on Darb Sa'ada Street, behind the principal Cairo police station, behind the court of law opposite the Museum of Islamic Art and parallel to Port Said Street.

The exterior

The mosque overlooks the street by two façades. The first is a southern one, at the eastern end of which stands a typical Ottoman minaret with a small square base followed by a rounded shaft and a pointed finial. It is broken into three stalactite recesses, also with two windows and a tri-lobed cresting. The other façade, which is the main one, lies on the western side; at its southern corner lies the *sabil* and at the northern end stands the main portal. This façade is broken by a single stalactite recess with a rectangular window below and a Qalawun set of windows above, and is topped with a tri-lobed cresting, making it more similar to Mamluk façades than Ottoman ones.

The main entrance lies in a tri-lobed stalactite recess, framed with a double molding with round loops, which revives the Mamluk style, with the exception of the presence of the tiles in the lunette. The façade of the *sabil* also shows the presence of similar tiles above its window. The molding of the portal frames a rectangular area above the relieving arch, dividing the space above it into small rectangular panels that are

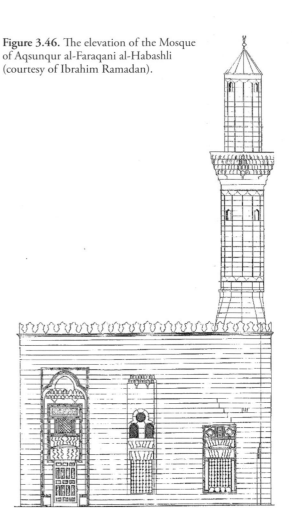

Figure 3.46. The elevation of the Mosque of Aqsunqur al-Faraqani al-Habashli (courtesy of Ibrahim Ramadan).

currently plain. This is surmounted with a window above the relieving arch and a rectangular panel that features the geometrical star design. The stalactites of the portal end with the same miniature flowers found in the Mosque of Sinan Pasha in Bulaq that are typically found in Ottoman mosques in Turkey.

The plan

The entrance leads to a *durkah*. On its left, there is a door that leads to the ablution area. The wooden ceiling of the *durkah* shows remains of paint. The plan

inside consists of a small open court surrounded by four iwans, the largest of which is the *qibla* iwan. A well, covered by a marble basin dated to 1052/1642, thus twenty-seven years prior to the foundation of the Ottoman mosque, was found in the middle of the courtyard. The basin, which features a carved floral design and an inscription on it that includes the name Ahmad Agha and the date, was removed to the Museum of Islamic Art in Cairo.[90] This basin was brought to the mosque at an unknown date.

The *qibla* or Mecca iwan is a rectangular space divided into two aisles with pointed arches running parallel to the *qibla* wall. The first aisle shows two arches resting on a marble column in the center and the two side walls, while the second aisle shows three arches resting on two marble columns in the center

and the two walls (figure 3.48). To the right of the *mihrab* is a door that leads to a small room with a plain wooden roof that probably served as *khilwa* for the imam. To the left of the *mihrab* is a cupboard, followed by a door that opens onto steps that ascend to the roof and the minaret. The southwest side of the iwan is broken by a recess with windows, while the northeast side is broken by another recess, but with a higher floor, which opens onto the iwan through a pointed arch. The wooden ceiling of this iwan has lost most of its paint, but remains of a tiraz band inscribed with Qur'anic verses and the date 1080/1669 can still be seen.[91] The *mihrab* recess is flanked by two corner columns carrying a pointed arch and framed with a double molding with loops. The recess is covered with colored marble in black, white, and red, and features a repetitive star pattern in the center, while the conch features a radiating pattern from a central pointed arch. The spandrels show a carved floral design painted in gold on a white background. The whole *mihrab* appears as a recent restoration. Above the *mihrab*, one sees a carved geometrical pattern and, in its center, a large tile with a vase and flowers in blue on a white background. A wooden minbar stands right beside the *mihrab*.[92]

The northwestern iwan, which is opposite the *qibla* iwan, opens by a pointed arch onto the open court. A door on the southwestern side leads to the *sabil* with a window above it. The wooden ceiling has lost most of its paint and inscription band. The plain *dikka* in this iwan stands on two marble columns and is also supported on the side walls, which can be reached though steps on its side.

The northeastern iwan is a rectangular space that opens onto the court through two flat wooden beams resting on a marble column in the center, above which is a pillar of ten superimposed stones forming a high impost block to give a higher ceiling to the iwan (figure 3.49). The paint of the wooden ceiling and the beams in this iwan has faded and only traces of it still survive. In the southeast side is a door with a window above that opens onto a small room with a wooden ceiling.

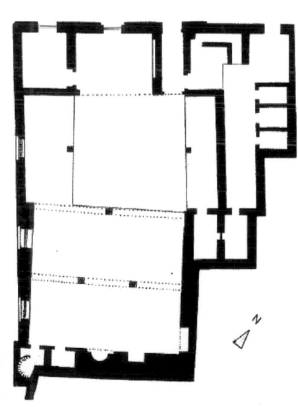

Figure 3.47. The plan of the Mosque of Aqsunqur al-Faraqani al-Habashli (plan after Abu al-'Amayim, *Athar al-Qahira al-islamiya fi-l-'asr al-'uthmani*, 222).

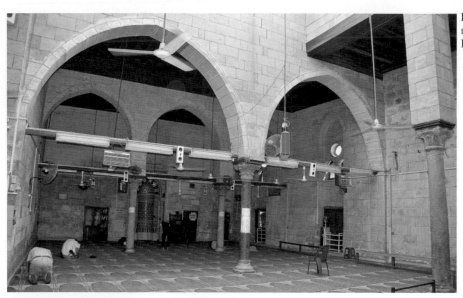

Figure 3.48. The interior of the Mosque of Aqsunqur al-Faraqani al-Habashli.

Figure 3.49. The marble with impost blocks in the side iwan.

The southwestern iwan was similar to the northeastern one, as shown in an archive photograph, but only the raised floor and the base of a column have survived today.

The sabil

This can be reached through the door in the iwan opposite the *qibla* iwan, and it retains its colored marble floor and painted ceiling with the band under it bearing a Qur'anic inscription.[93]

This mosque, in terms of its ground plan, can be considered one of the most interesting ones built during the Ottoman period. Its approach to space may be considered Mamluk for the presence of the open courtyard and four iwans, but it has many unusual features, especially the *qibla* iwan with its two aisles, one with two arches and one with three arches parallel to the *qibla* wall. The result is that the arches of the two arcades are not aligned. The column supporting the two arches of the outer arcade lies right in front of the *mihrab*, obstructing its view. Only the Mosque of al-Suwaydi (c. 834/1430, monument number 318), which is located in al-Fustat, shows this same feature in its plan. One can also add that the side iwans with a column in the center are quite unique in Cairene architecture.

The Mosque of Mustafa Jorbagi Mirza
(1110/1698)
Monument Number: 343

The founder

Mustafa Jorbagi Mirza was the son of Yusuf Jorbagi Mirza; both men held the military title *jorbagi*, which meant "head of the infantry." It is not known whether his connection with the Janissary corps was real or honorary. Eminent persons such as rich and influential merchants were sometimes given military titles, which led to them becoming patrons of architecture.[94] This opened the door for a new power relation between conquerors and locals, and it led to modifications in the structure of the society. Some Janissary officers became artisans and tradesmen, and even merchants, while others found it convenient to affiliate themselves to the Janissary corps.[95] Mustafa Jorbagi Mirza built in Bulaq a *wikala*, a house, and a *sabil-kuttab* near his mosque, but only the latter survives besides his mosque. A second *wikala*, a hammam, and a dyer's house to dye textiles in Bulaq are also mentioned, as well as a tomb in the cemetery of Imam al-Layth.

The location

It is located on Mirza Street in Bulaq, not far from the Mosque of Sinan Pasha and behind the *wikala* known as Wikalat al Balah, which is now for textiles.

The exterior

The building, which is a suspended mosque, rises above shops and has two façades: the main one is located on the northwestern side, which includes the entrance and the minaret (figure 3.50). This is the only façade that can be observed as a whole due to the surrounding buildings and the narrowness of the street.

The entrance is placed in a tri-lobed recess with stalactites reached by three steps and flanked by two benches (figure 3.51). A double molding with angular loops frames the entrance, whose wooden door is covered by brass nailed onto the wood. The

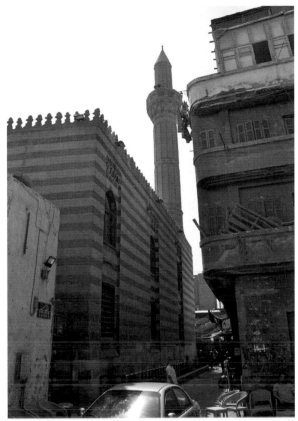

Figure 3.50. The northwestern façade of the Mosque of Mustafa Jorbagi Mirza.

plain lintel is topped by a joggled relieving arch and a lunette engraved with a geometrical pattern. The composition formed by the double moldings with angular loops that frame the upper part of the door is interesting. The framed zones are clad in between with colored marble. The window above the entrance overlooks the vestibule inside. The overall impression of the portal recalls the entrance of al-Ghuri, with the variation of the hexagonal *entrelacs*.[96]

The façade of the mosque is broken into three stalactite recesses pierced with two superimposed windows: rectangular ones below and round-arched ones above. The cresting crowning the mosque is the typical five-lobed cresting, found commonly in Ottoman buildings. In the southern and part of the

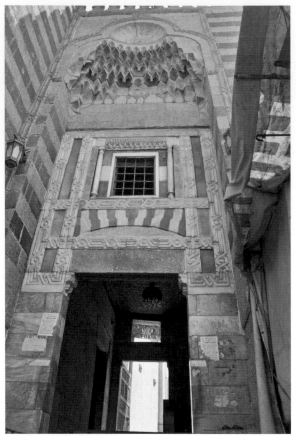

Figure 3.51. The entrance of the Mosque of Mustafa Jorbagi Mirza.

eastern façades, remains of a stepped cresting can still be seen, which were part of a later addition. The northwest corner is chamfered, like the ones often found in earlier Fatimid and Mamluk buildings, and the southwest corner is decorated with an engaged column, typically found in many Anatolian madrasas and a few Mamluk ones, such as that of Sultan Hasan. The main façade once housed five shops, the fifth of which is blocked today.

The minaret rises beside the portal; it has a polygonal shaft ending with stalactites under the balcony, followed by a pointed top. However, as pointed out by Tschirgi, the balustrade of the balcony is constructed of stucco and not of stone, which follows local

Cairene tradition.[97] Its position near the entrance and the fact that it is built on the roof, in addition to its pyramid-shaped transitional zone, are all features seen on both Mamluk and Ottoman minarets; "however, the longish curved triangles in the zones of transition are rarely used in Mamluk architecture."[98]

The plan

The prayer area is found on the left of the vestibule. Its entrance is topped by a small ceiling with painted motifs of octagonal coffers, decorated with a flower inside each. The plan is skewed from the street due to the need to adjust to the *qibla* orientation and street alignment (figure 3.52). The mosque consists of a court, topped today with a roof and pierced with a lantern. All the aisles inside the mosque run parallel to the *qibla* wall. The *qibla riwaq* is two aisles deep, while all the other three sides are only one aisle deep. The columns inside the mosque vary in having octagonal and circular shafts. The court is placed one step lower than the rest of the mosque. The *waqf* document states that in the *sahn* (court), there is a drain for rain water, based on which Williams suggests that perhaps back then the mosque was intended to have an open court.[99] The *waqf* also mentions two iwans, which resulted from the mosque being built on an irregular piece of land, and these are two irregular quadrilateral areas. The former area is elevated two steps higher than the *riwaq* level, and the latter one step only.

The *qibla* wall is located on the right-hand side of the entrance. It is broken by four windows in the upper level of the wall and an oculus located above the *mihrab*, which is faced with a modern-looking roundel. The *mihrab* is a pointed arched recess that is not centralized in the middle of the *qibla* wall, beside which stands the minbar, which forms a focal point. The *mihrab* is flanked by two slender marble columns and is entirely decorated with a variation of panels and marble mosaics, reminiscent of the Mamluk style (plate 3.5). A two-tear-drop motif with a roundel in between decorates the spandrels of the *mihrab*, like that found in the Madrasa of Sultan Barquq. The

hood is decorated with a chevron design, underneath which lies a row of miniature recesses with colonnettes, typically found in Mamluk *mihrab*s.

The minbar beside the *mihrab* was described in the *waqf* document as a gilded, wooden minbar. The depiction of the two vases flanked by two pine trees on the back of the imam's seat is interesting; however, this kind of decoration on the back of the imam's seat was found in Mamluk minbars, and usually depicted candlesticks and a dangling lamp (figure 3.53). Traces of color can still be seen on the stalactite crown of the minbar below its rounded bulb, which stands out from other Ottoman minbars, which would normally have a pointed top.

There is a door to the right of the minbar that leads to a small room that was probably reserved for the use of the shaykh. The *waqf* document states one *malqaf*, while Tschirgi counts a total of three *malqaf*s in the mosque today.[100]

A lot of marble work "whose lavishness is comparable only to the Mosque of al-Burdayni and the Mosque of Suleiman Pasha at the Citadel"[101] decorates the lower part of the *qibla* wall and part of the north and south side walls. The lower part of the

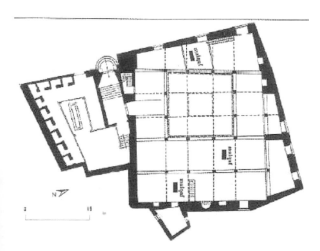

Figure 3.52. The plan of the Mosque of Mustafa Jorbagi Mirza (plan after Abu al-'Amayim, *Athar al-Qahira al-islamiya fi-l-'asr al-'uthmani,* 256).

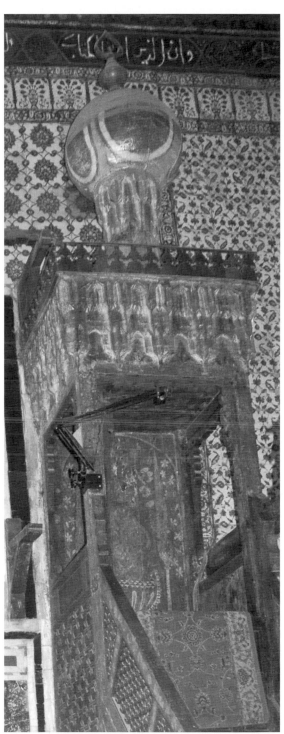

Figure 3.53. The rear of the minbar of the Mosque of Mustafa Jorbagi Mirza.

dadoes is covered with rectangular polychromed marble panels topped by roundels with *entrelacs*, the spandrels of which are decorated with marble mosaics, with the corners of the panels decorated with a geometrical bird design. A frieze of interlacing sleek tri-lobed leaves in red and black paste incised in carved marble runs below those panels; the style is reminiscent of the *qibla* iwan of the Mosque of Qijmas al-Ishaqi and the inscription frieze in the Mosque of Suleiman Pasha al-Khadim. This same technique is seen on two panels on the *qibla* wall (plate 3.6). They fill up the entire hood and spandrels of what looks like miniature *mihrab*s, located in the side annexes on the *qibla* wall.

The walls above the marble dado are covered with İznik tiles all the way up the ceiling, like the restoration works of the Mosque of Aqsunqur (c. 746/1346) by Ibrahim Agha Mustahfizan in 1062/1652, but of a lesser quality. According to Williams, they came from a relatively decadent atelier. Crecelius, as mentioned by Tshirgi, identified two panels on the *qibla* wall as Moroccan *zillij*-type tiles, manufactured from red clay with green, blue, yellow, and brown colors, which were probably added in the eighteenth century, as similar tiles can be seen in the Mosque of Muhammad Bek Abu al-Dhahab on al-Azhar Street (c. 1187/1774).[102]

The floor of the mosque of Mustafa Jorbagi Mirza is covered with polychrome marble in geometrical patterns similar to Burji Mamluk floors, namely in the Madrasa of Sultan Barquq (c. 786–8/1384–6) and the Madrasa of Janibak (c. 885/1480).

The ceilings of the mosque are made of wood and are all decorated except for the area above the court. Tschirgi identifies three different styles: the first, a flat ceiling of a three-sided pattern in relief seen in the vestibule; the second, the ceiling of the two iwans on the side, which are similar to the first but with hexagonal stars with a rectangle in the center filled with the ten-pointed star; and the third, a plain ceiling above the *sahn*, and whose authenticity has been challenged above. Also, the lantern is very simple and was probably added at the time of the covering of the court.

The *dikka*

The hanging *dikka* in the Mosque of Mustafa Jorbagi Mirza is a typical Ottoman *dikka*, reached by wooden stairs that can be seen opposite the *qibla* wall. Its base is decorated with a simple star pattern and with a balustrade of carved wooden panels. The *waqf* document states that the *dikka* was for the Qur'an reciter.[103]

The inscriptions

The Mosque of Mustafa Jorbagi Mirza is covered with several inscriptions along its walls. There is an inscription band that runs in the cornice below the ceiling, where the epigraphy is placed in cartouches. Above the entrance door are other inscription bands also written in cartouches. Interesting is how nearly every side and *riwaq* in the mosque contains the name of Mustafa Mirza and prayers and praises for him. Nevertheless, there is a variation between the date of completion in Rajab 1110 and 1111/January 1699–1700 appearing within these inscriptions. Also, the patrons mentioned in these inscriptions vary between Mustafa Mirza, "the late" Mustafa Mirza, and his son al-Amir Jorbagi, leading to speculations that the mosque was completed after the death of Mustafa Mirza, or perhaps, more constructions or additions were made by his son. This theory is supported by the fact that there is a discrepancy between the shape and number of windows regarding what is written in the endowment deed and what we see today. Some of the windows are placed in deep recesses while others are flat with the same level of the fenestration of the interior. Tschirgi assumes that the later covering of the court and the *malqaf*s may have necessitated the piercing of more windows and more *malqaf*s than the ones mentioned in the deed.

Conclusion

The architecture of the seventeenth century shows only two buildings that followed the Ottoman Imperial-style plan imported from Istanbul. These are the Mosque of al-Malika Safiya and the Mosque of Sinan Pasha, despite the variations in their plans. In both cases, the plan may have been sent from Istanbul, but

it was executed in Egypt by local craftsmen, which explains the many Mamluk features in both. All the other mosques show variations in the Mamluk plans but display few Ottoman features. In most Mamluk buildings where the variation of the *riwaq* or iwan plan has a central court, it became covered during the end of their empire, as in the Madrasa of Qaytbay in the Northeastern Cemetery, or reduced to a lower corridor, as in the Khanqah-Mausoleum of Sultan Barsbay. The Mosque of Yusuf Agha al-Hin, for example, shows a continuation of the four-iwan plan, with a covered court and the *sabil-kuttab* arrangement at the corner, but with the addition of the typical Ottoman round minaret with a pointed top. The Mosque of Taghribirdi also shows a variation of the *qa'a* plan seen in so many Mamluk palaces, but with a lower corridor covered with a lantern ceiling that leads to the ablution area. The Mosque of al-Burdayni appears entirely Mamluk on the outside, including its minaret, but inside it is a small version of the one-room mosque plan, without columns or iwans, which can be classified as Ottoman.

Two other plans dominate this period. The first is where the prayer area is divided into three by two or more columns or arches, one with and the other without a lower central passageway, which in fact can be considered a development of the Khanqah-Mausoleum of Sultan Barsbay in the Northeastern Cemetery, but with the addition of a lantern in the center. This plan was seen with the presence of a lower corridor in the Mosques of Mahmud Pasha and Murad Pasha and without a lower corridor in the Mosques of Sidi Ruwaysh, Marzuq al-Ahmadi, and Ribat al-Athar (also known as Athar al-Nabi). The ceilings in most cases are made of wood, decorated with paint executed in a mediocre quality, with a rare occurrence of a cross vault in the Mosque of Alti Barmak. The different plans were adopted simultaneously, but very few buildings were funerary.

*Zawiya*s in the seventeenth century became generally smaller and much simpler in architecture when compared to earlier ones, as seen in the Zawiya of Radwan Bey with its one room divided in the center by a column, carrying a wooden beam and a small room of a mausoleum covered with a flat wooden ceiling. The façades of buildings in most cases appear more Mamluk than Ottoman, but the Ottoman influence can be seen in the lack of decorative details above windows in recesses, in the double moldings with angular loops instead of the circular ones used during the Qaytbay period, and the use of Iznik-style tiles found in lunettes and surrounding the drums of the domes and on *qibla* walls. The ultimate Ottoman signature in mosques was conveyed with the pointed-top minaret, which served as a symbol of the ruling dynasty, although Mamluk-style minarets were built for non-political figures as in the case of the Mosque of al-Burdayni. The overall impression shows that Ottoman control over architecture in the province of Cairo was not strong, which probably reflected the political situation in the capital, and also shows that a marked mingling of the elite society of Turks and Egyptians had occurred.

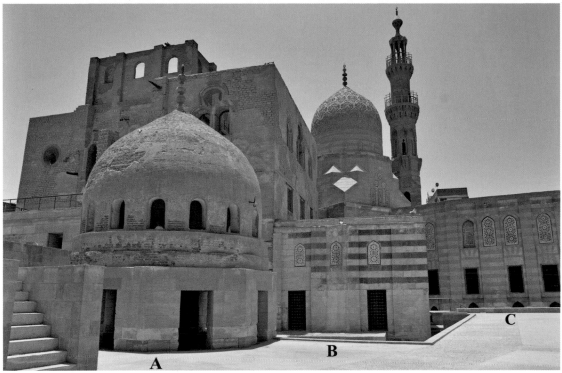

Plate 1.1. The rear of the Mosque and Madrasa of Khayrbak, Alin Aq, and the Zawiya of Shaykh 'Abdallah al-Baz.

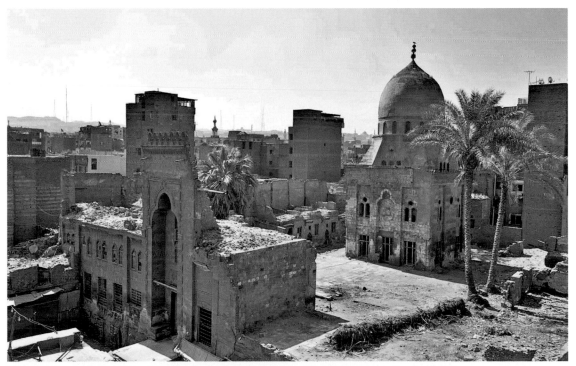

Plate 1.2. An aerial view of the Takiya al-Kulshani (courtesy of the World Monuments Fund website).

Plate 1.3. The elongated hall of the Mosque-Madrasa of Khayrbak.

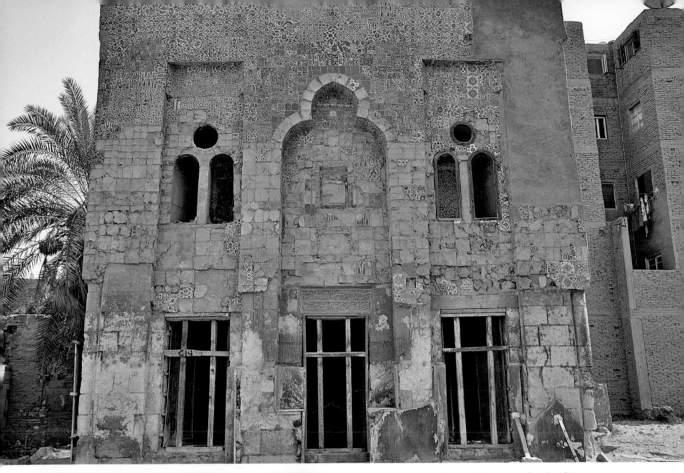

Plate 1.4. The main façade of the mausoleum dome of the Takiya of al-Kulshani.

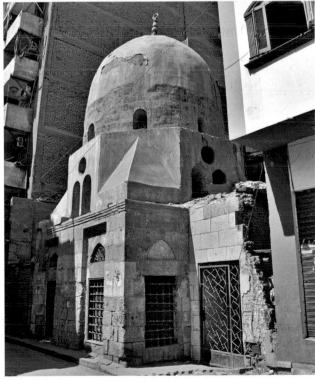

Plate 1.5. The dome of the Zawiya of Shaykh Seoud.

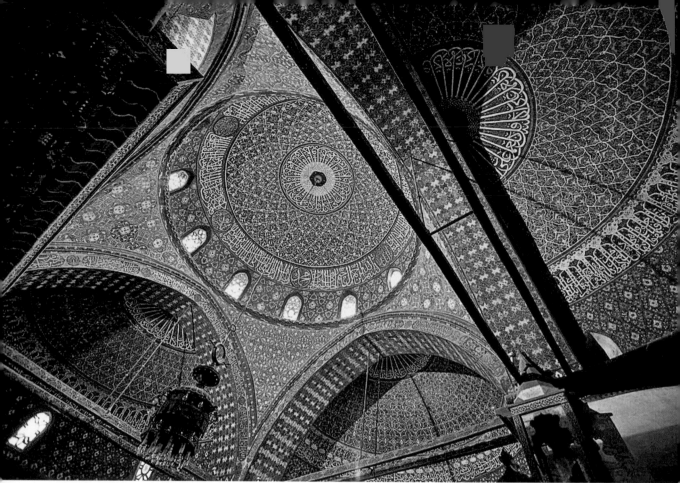

Plate 2.1. The central dome and semidomes of the Mosque of Suleiman Pasha al-Khadim (courtesy of Museum with No Frontiers Islamic Art online collection).

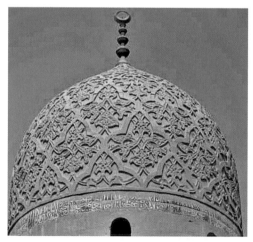

Plate 2.2. The dome of the mausoleum of Prince Suleiman at the time where it retained most of its tilework (by Karim Saada).

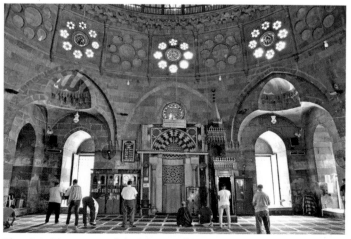

Plate 2.3. The interior of the Mosque of Sinan Pasha.

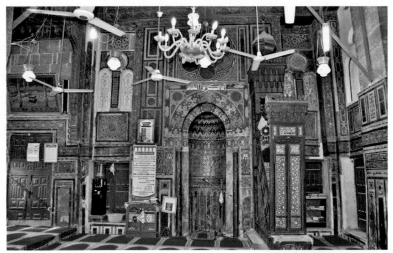

Plate 3.1. The interior of the Mosque of al-Burdayni.

Plate 3.2. The walls of the Mosque of al-Burdayni (see page 94, figure 3.10. for the drawing by Émile Prisse d'Avennes).

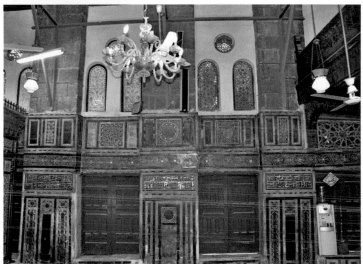

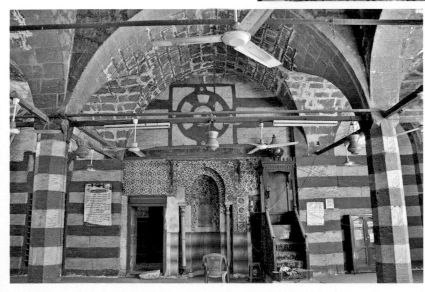

Plate 3.3. The *qibla* wall of the Mosque of Alti Barmak.

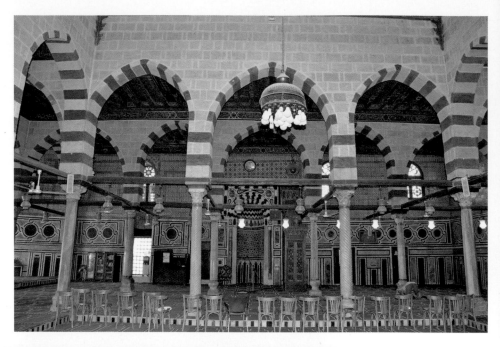

Plate 3.4. The interior of the Mosque of Mustafa Jorbagi Mirza.

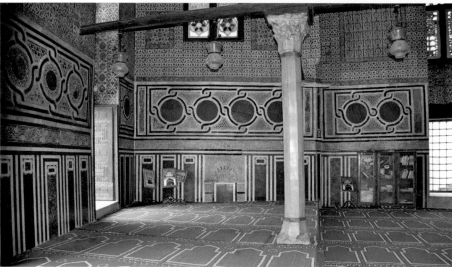

Plate 3.5. The *sidilla* inside the Mosque of Mustafa Jorbagi Mirza.

Plate 3.6. The wooden panels in the ceiling of the Mosque of Taghribirdi.

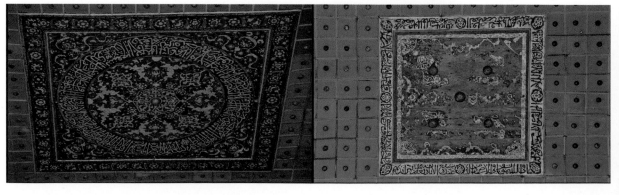

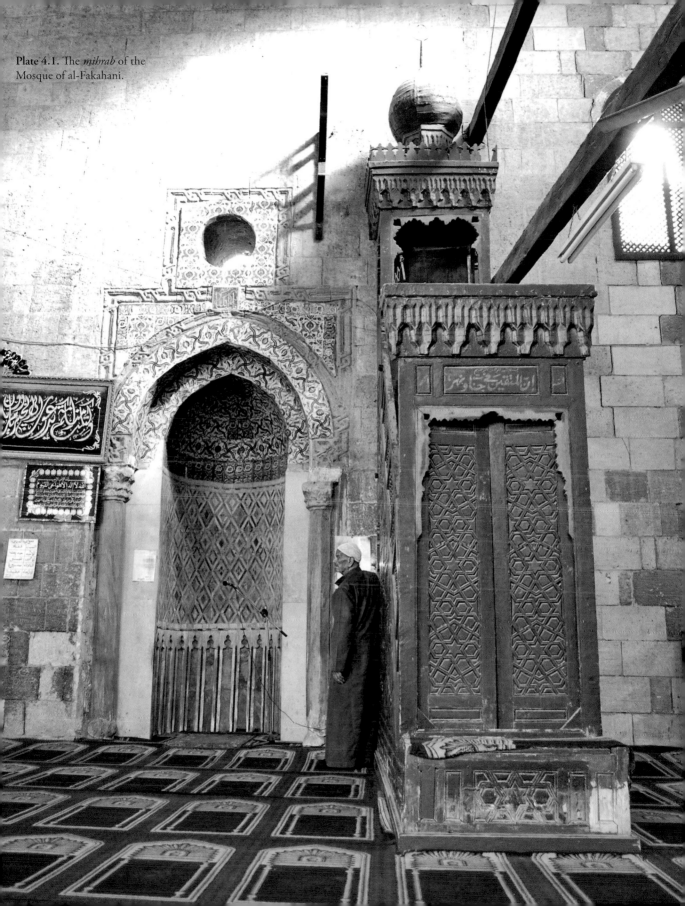

Plate 4.1. The *mihrab* of the
Mosque of al-Fakahani.

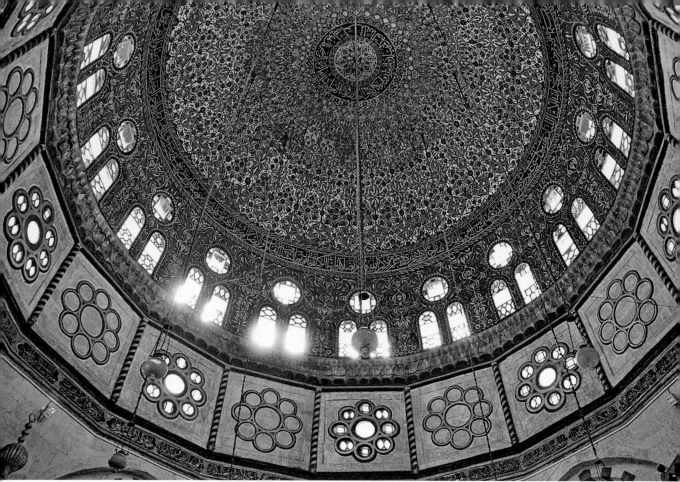

Plate 4.2. The interior view of the dome of the Mosque of Muhammad Bek Abu al-Dhahab.

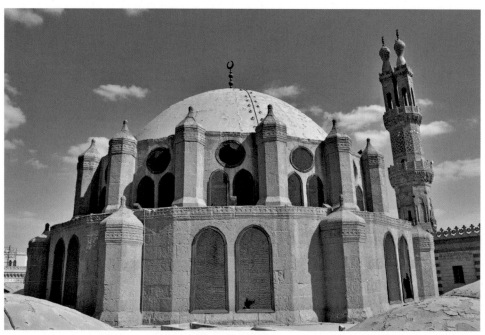

Plate 4.3. The exterior view of the dome of the Mosque of Muhammad Bek Abu al-Dhahab.

Chapter 4

The Buildings of the Eighteenth Century

The 'Mamluk Revival' is now face to face with the local hybrid style.

The eighteenth-century religious architectural scene in Cairo is dominated by the figure of 'Abd al-Rahman Katkhuda, who is considered one of the greatest sponsors of architecture of the Ottoman period in Egypt. André Raymond attributes to him with certainty thirty-three monuments that were either built or rebuilt by him, and adds that there were many more, as al-Jabarti mentions eighteen Friday mosques alone, in addition to many other buildings.[1]

We have already seen that the Ottomans in general introduced several innovations and developments in the field of architecture, especially plans, but they in fact contributed very little to the field of architectural decoration. The last decade of the Mamluk period,

which corresponds to the reign of Sultan Qaytbay (r. 873–901/1468–1496), had witnessed buildings that were in general smaller in size than those of the early Mamluks; however, the decade can still be considered a golden age of stone carving and a new style of marble inlay. This interest in high-quality surface decoration was not carried on by his successor, al-Ghuri (r. 906–22/1501–16). Stone carving still continued in the latter's complex but was mostly "shallow carved and repetitive," and definitely not as deeply carved or dense with embroidery like the arabesques and marble inlay of his predecessors.[2] This lack of interest, and probably also know-how, since many craftsmen were taken to Istanbul, continued in the Ottoman period. We saw in the previous chapters an interesting blend of Mamluk and Ottoman features in plans and architectural details except for the "sporadic use of Turkish tiles."[3] The Mosque of Suleiman Pasha al-Khadim, for example, shows an Ottoman plan, but the interior

decoration is completely Mamluk in style. The façades of the Takiya Suleimaniya, the Mosque of Mahmud Pasha, and the Mosque of Yusuf Agha al-Hin all imitated Mamluk façades except for the presence of the round Ottoman minaret and the scarcity of decoration and carving. Other mosques were built with very plain façades, especially those built after the last decade of the sixteenth century, namely those of al-Malika Safiya and Murad Pasha. In the mid-eighteenth century, 'Abd al-Rahman Katkhuda revived the arts of carving and exterior decoration, as will be shown in this chapter. His first building was the *sabil-kuttab* he built on al-Muizz Street in the area known as Bayn al-Qasrayn (between the two palaces), followed by the Mosque of al-Maghariba located on Port Said Street, which is completely renovated today. He also built a *sabil-kuttab* and a mosque facing Bab al-Futuh, as well as several water troughs for animals, and *sabils*. Last but not least, he extended the *qibla* area of the Mosque of al-Azhar and then built his tomb, where he was buried behind the original *qibla* wall of the mosque. He also built the mosque beside the Shrine-Mausoleum of Imam al-Shafi'i in the Southern Cemetery in place of the original Ayyubid madrasa built by Salah al-Din al-Ayyubi. Moreover, he restored many shrines until he was forced to leave for the Hijaz by 'Ali Bey al-Kabir. A few of his buildings will be discussed below to help identify what is known as the 'Abd al-Rahman Katkhuda style, and as Doris Behrens-Abouseif writes, "I cannot find a repertoire of stylistic elements in Cairo's Islamic architecture that can be so closely associated with a specific sponsor as that of 'Abd al-Rahman Katkhuda façades."[4]

The work of 'Abd al-Rahman Katkhuda:
The Zawiya
(1142/1729)
Monument Number: 214

The location

This *zawiya* is located on the east side of al-Mugharbalin Street, which is part of the main extension of the Fatimid Qasaba south of Bab Zuwayla, and stands beside the Mamluk Mosque of Janibak. It replaced an earlier *zawiya* of Shaz Bek al-A'war, and according to *waqf* deed number 940 in the Ministry of Religious Endowments dated to 18 Rabi' al-Awwal 1174/28 October 1760, the *zawiya* included a *mihrab*, a minaret, and dependencies.[5]

The founder

'Abd al-Rahman ibn Hasan Jawish al-Qazdughli was the Katkhuda of Egypt and one of the Mamluk amirs during the time of 'Ali Bey al-Kabir. He occupied many posts until he became, like his father before him, a *katkhuda* in the Janissary corps of the Ottomans, which was considered one of the highest posts in a province of the Ottoman Empire. Between 1152/1740 and 1173/1760, and before his death in 1190/1776, he is credited with a long list of pious deeds and restorations, especially of shrines, as well as many monuments and works for public welfare. Among his many works was the restoration of the Bimaristan of Sultan Qalawun. His last years were spent in exile in the Hijaz and he died shortly after his return to Cairo.

The exterior

It is a small, suspended prayer area with the main façade built over three shops beside the entrance (figure 4.1). The three windows of the façade above the shops are plain rectangular ones with simple metal grilles and placed each in a round arched multi-lobed recess. Each window is framed on two sides with an engaged column and the whole composition is framed with a double molding with angular loops and with a larger loop at the apex. Above the arches one sees three horizontal double moldings with loops, and between the second and the third one the same molding forms squares enclosing round windows. The cresting is the typical Ottoman five-lobed leaf cresting.

The entrance lies at the northern end of the façade, and above it one sees a small stone balcony with a carved balustrade and resting on a corbel of stalactites, which was probably for the muezzin instead of a minaret. The entrance shows two engaged columns with stalactite capitals carrying a round arch,

Figure 4.1. A drawing by Émile Prisse d'Avennes of the Zawiya of 'Abd al-Rahman Katkhuda in al-Mugharbalin Street (after Émile Prisse d'Avennes, *L'Art Arabe*).

The elaboration in façade decoration revives earlier traditions, especially those dating from the time of Sultan Qaytbay at the end of the fifteenth century. It started with 'Abd al-Rahman Katkhuda's *sabil-kuttab* and became the style of the period. It seems, as Doris Behrens-Abouseif points out, that not only patterns but also techniques that had been forgotten for centuries were now being revived. Although elements of early Cairene as well as Ottoman architecture appear incorporated, the general character of this combination is neither Mamluk nor Ottoman. The decorator seems to have looked everywhere for ideas to add to his own inventions, which he then integrated into an unusual combination, thus forming a distinctive style to be seen on other buildings.[6]

The Mosque of al-Amir 'Uthman Katkhuda al-Qazdughli known as al-Kikhya Mosque (1147/1734)
Monument Number: 264

The founder

'Uthman Katkhuda was the son of Hajj 'Ali Agha and the father of al-Amir 'Abd al-Rahman Katkhuda. He rose in ranks and gained power and wealth, especially after the death of many high officials in the plague of 1148/1735.[7] He is known for many pious deeds, which included the building of the *zawiya* for the blind in the Mosque of al-Azhar and this mosque in the al-Azbakiya quarter. He was a highly respected figure, but was at the end killed in a plot in the house of al-Amir Muhammad Bek al-Defterdar, which took place during the reign of Bekir Pasha and in which many amirs were killed.[8] His deed numbered 2215 in the Ministry of Religious Endowments, which is dated to 1149/1736, mentions the mosque, a *sabil*, a *kuttab*, a hammam, shops, and *khilwa*s, in addition to a large *dar* or house with reception areas, kitchens, and living quarters.[9] The deed also mentions that the imam had to be a Shafi'i shaykh. He also arranged for the teaching of Islamic law to seven students, the Shafi'i school to three students, and hadith to six students, as

decorated with cushion voussoirs and a small bench or *maksala* on each side. A double molding with loops frames the lintel, lunette, and relieving arch. The lunette is decorated with colored tiles showing a leaf design. A carved stylized tree design can be seen on the two sides of the lintel, lunette, and relieving arch, in addition to a geometrical carved design. The whole façade with its cushion voussoirs and carved stone decoration revives the carvings found at the time of Sultan Qaytbay toward the end of the Burji Mamluk Dynasty. The same style of extensive stone carving can also be seen on the façades of the Mosque of al-Shawazliya (figure 4.25), and the Mosque of Yusuf Jorbagi, also known as the Mosque of al-Hayatim, which will be covered later in this chapter.

The entrance leads to stairs that ascend to the first floor and the prayer area, which is a rectangular space with a plain *mihrab* and three windows overlooking the main street. Another entrance leads to the small balcony (figure 4.2).

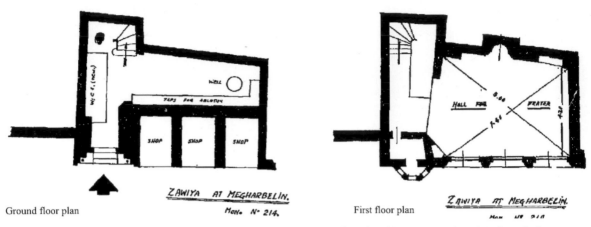

Ground floor plan

First floor plan

Figure 4.2. The plan of the Zawiya of 'Abd al-Rahman Katkhuda (plan after Abu al-'Amayim, *Athar al-Qahira al-islamiya fi-l-'asr al-'uthmani*, 289).

well as a muezzin to call for prayers in the suq at each of the five prayer times. The deed, in fact, mentions several other buildings built by the founder but these are no longer extant, and attributed to him are also several *riwaq*s in al-Azhar Mosque.[10] He was buried with his master, Amir Hassan Katkhuda in the cemetery.[11]

The location

The building lies facing Opera Square at the corner of Qasr al-Nil Street in the al-Azbakiya quarter. Al-Azbakiya gained importance at the end of the Burji Mamluk Dynasty in 880/1475, when al-Amir Azbak ordered a lake to be dug and filled with water from the Nile via the Khalij al-Nasiri (al-Nasiri canal) during the annual flood.[12] Many buildings were then built surrounding the lake, which led to the area becoming a rich and important residential area.[13] The buildings on this side of the lake were bought or obtained by 'Uthman Katkhuda through *istibdal* and demolished to make room for his complex.

The exterior

The mosque overlooks the street through three façades. The main one lies on the northeastern side with the entrance ascended to by a flight of nine steps. The deed, in fact, mentions only eight steps of red stone

leading to a marble platform and in front of it lies a garden surrounded by a fence with the mausoleum of Shaykh Muhammad Abu Futah.[14] An archive photograph shows a building that was constructed perpendicular and attached to the right side of the main façade, which probably caused the disappearance of the garden and mausoleum of the shaykh (figure 4.4). The entrance of the mosque lies in a projecting plain tri-lobed recess, surrounded with a double molding with angular loops and a large round loop at the apex and is flanked by two small benches. A carved design of a six-pointed star can be seen above the benches. The double-shutter wooden door is covered with metal nailed onto the wood consisting of a large circle filled with a geometrical pattern, and framed by small tri-lobed leaves forming a stylized sunburst design. The four corners are then covered with a design of a quarter circle. The whole design is reminiscent of the Bukhariya motif found on several Mamluk portals of the Burji Mamluk Dynasty. The lintel is made of granite, and the lunette is covered with tiles and topped with a joggled relieving arch, and the whole area is framed on the two sides with rectangular panels filled with tiles. A small window with an engaged column on each side fills the space above the relieving arch and below the tri-lobed conch.

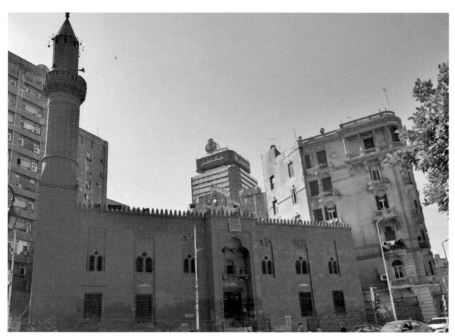

Figure 4.3. The northeastern façade of Kikhya Mosque.

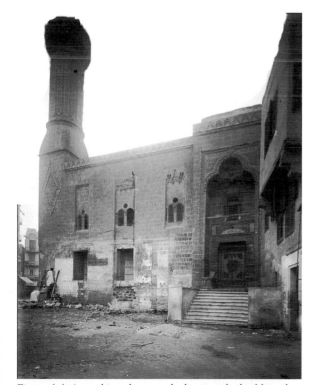

Figure 4.4. An archive photograph showing the building that blocked the main façade of Kikhya Mosque.

The façade on both sides of the entrance is broken into two recesses on each side and is pierced with a rectangular window below and a Qalawun set of windows above. The lateral recesses at the far end of each side of the façade are left without a stalactite hood. Flanking the entrance on either side are two Qalawun sets of windows, which are placed on the upper level and not in a recess. The minaret of the mosque of 'Uthman Katkhuda is located on the utmost left of the main façade. It is a typical Ottoman style minaret with a large base that starts from the ground and has a pyramid-shaped transitional zone that rises above the skyline of the mosque. The two-tiered minaret is faceted and topped by a rebuilt conical top. A drawing drafted by the Ministry of Antiquities shows a large lozenge on the base of the minaret that can no longer be seen.

The second façade lies on the northwestern side and is plain, while the third façade lies on the southeastern side and is broken at its upper level by two recesses, each with a window resting on three engaged columns. Between the two recesses is a square formed by a double molding with loops with a circle in the middle,

also surrounded with a double molding with circular loops. A small entrance leading to the ablution area can be seen on that side. Finally, the cresting crowning the building is the typical Ottoman style five-lobed leaf.

The plan

The plan consists of a lower open court, which measures 12.77 × 11.70 meters, covered with a marble floor. It had a well in the center, which today is closed. The court is surrounded today by four arcaded halls or *riwaq*s, three aisles deep on the *qibla* side, and one aisle deep on the other three sides. The marble columns and the four granite corner ones around the courtyard all support pointed arches (figure 4.6). Above the three arches that open onto the court on the Mecca side is a marble plaque with four lines of a *thuluth* inscription carved in relief, which is the foundation inscription and the date of completion 1147/1734. The inscription is framed with a double molding with angular loops. Two plans were found, drawn seven years apart, which show a few discrepancies. In the plan dated 1903, a room found beside the side entrance of the mosque was labeled as a *khilwa*.

The open court was originally covered, as stated in the deed, and the date of the removal of this covering is unknown, but it was probably in the early 1800s, when parts of the complex were demolished by the Ministry of Antiquities.[15] Interesting are the columns facing the *mihrab* because they are of blue marble. The number of columns on this side is twelve, carrying fifteen pointed arches as mentioned in the deed.

The *mihrab* is decorated with colored marble. The lower part of the recess shows marble panels, the middle part a star design and the conch a chevron design. The spandrels are decorated with a geometrical design resembling the design on the spandrels of the entrance of the complex of the Bahri Mamluk Sultan Qalawun. Above the *mihrab* is a stucco oculus with the names of the four Righteous Caliphs. On each side of the oculus is a rectangular window with stucco grilles and stained glass, but all the windows appear renovated. A beautiful wooden minbar stands beside the *mihrab* with a design consisting of vertical and horizontal short parts of wood surrounding small squares. The onion-shaped bulb of the minbar was, according to the deed, gilt.[16] The two walls of the

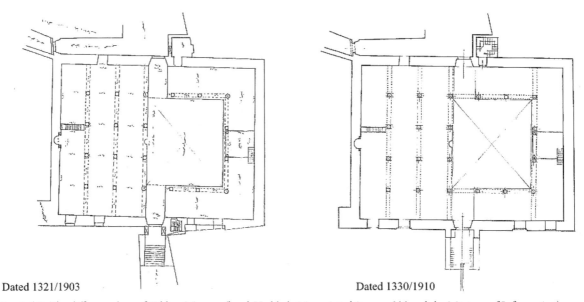

Dated 1321/1903 Dated 1330/1910

Figure 4.5. The different plans of Kikhya Mosque (by al-Haddad, *Mawsuʿat al-ʿimara,* 644 and the Ministry of Information).

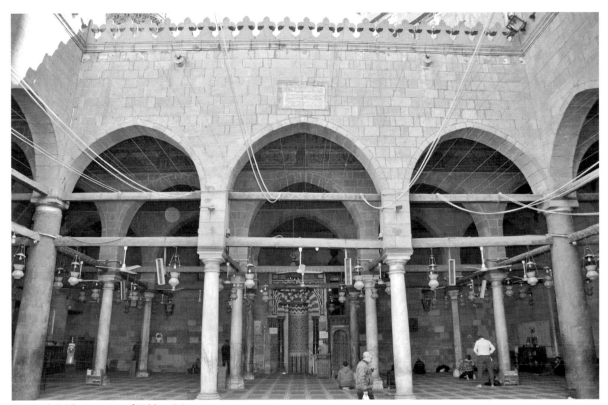

Figure 4.6. The interior of Kikhya Mosque.

side *riwaq*s are also broken with windows; one side originally overlooked the tomb of the shaykh, which was removed in 1934, and the other overlooked a garden. Today, both sides overlook streets. The door that leads to the ablution area also leads to steps that go up to the roof and to *khilwa*s that are no longer extant.

The *riwaq* opposite the Mecca side is only one aisle deep and consists of four granite columns carrying five pointed arches and opens by three arches onto the court. The *dikka* rests on two marble columns and the side walls, and is reached by wooden steps attached to it. Most of the remaining paint of the *dikka* is in a poor state of preservation.

The mosque's plan and decorations continue the tradition of the prior century, which combines both Mamluk and Ottoman features as already seen in the

Mosque of Mustafa Jorbagi Mirza. The hypostyle mosque plan, which goes back to the time of Prophet Muhammad, obviously remained an ideal plan whenever there was available space. The al-Azbakiya quarter, and especially the area around the lake, was not densely populated, but prestigious, which made the return to the hypostyle plan possible.

The Mosque of al-Fakahani
(1148/1735)
Monument Number: 109

This mosque was originally built toward the end of the Fatimid Dynasty during the reign of the Fatimid caliph Abu Mansur Ismail al-Zafir bi-Amr Allah (549/1154), who ordered the building of the mosque

to replace stables known as Dar al-Kibash. Al-Maqrizi dates it to 543/1148, but in fact al-Zafir ascended the throne a year later.[17] It was originally called al-Afkhar Mosque, and by the fifteenth century it became known as al-Fakahani Mosque because of the fruit stands surrounding it. According to the *waqf* deed number 2226 in the Ministry of Religious Endowments, in 1148/1735, al-Amir Ahmad Katkhuda al-Kharbatli heavily renovated the mosque. He in fact rebuilt it, keeping only the wooden doors and some inscribed stones.

The founder

He was an officer of the Janissary corps and one of the powerful amirs who belonged to the Kharbatli family and who rose in position, becoming very rich and influential; however, like 'Uthman Katkhuda, he was killed in the sad event at the house of Muhammad Bek al-Defterdar, mentioned before, in the year 1149/1736. He was buried in the domed mausoleum he had built for himself and attached to the Madrasa of al-Amir Sudun (c. 873/1468) in the Batniya area behind the mosque of al-Azhar.

The location

The mosque is located on the eastern side of the southern extension of the Fatimid Qasaba, known today as al-Muizz Street in today's Suq al-Ghuriya at the corner of Harat Khushqadam.

The exterior

The mosque today has three façades , two of which can be considered main ones: the northwestern façade overlooking al-Muizz Street and the northeastern one, which overlooks the Harat Khushqadam. The third façade, the southwestern one, overlooks a narrow street named 'Atfat al-Rasam. The mosque is suspended above shops and can be entered from two entrances, one on each of the two main façades .

The entrance in the northwestern façade is deep and opens by a pointed arch onto the street and is framed by a double molding with angular loops (figure 4.8). Above the pointed arch one can see a

manzara, which is a small covered projecting wooden balcony, an unusual location on the exterior of a building, but it may have been for the observation of ceremonies, either religious or military. Seven steps lead up to the platform in front of the door and the ceiling of the platform is of painted wood. On the left is a small door leading to a small room overlooking the main street, which is again an unusual feature in mosque architecture in Cairo. The wooden door is placed in a plain, shallow tri-lobed recess, and is the original Fatimid door with its carved panels.[18] The plain lintel is framed with typical double molding, and the lunette is covered with tiles painted with a star design mixed with an arabesque in green, blue and violet on a white background. The relieving arch, although plain, is also framed with the molding. Above the relieving arch is a small square window with a wooden grille in a recess with two corner columns and a stalactite hood, framed by two inscribed square panels, one on each side.

Figure. 4.7. The elevation of the Mosque of al-Fakahani (by the Ministry of Antiquities).

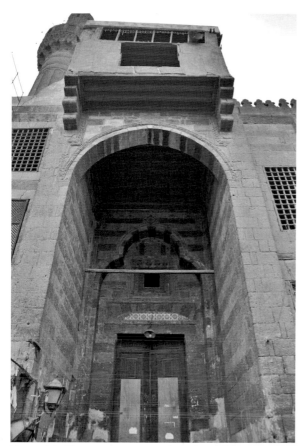

Figure 4.8. The main entrance and *maqsura* of the Mosque of al-Fakahani.

The entrance lies in the middle of the façade and is flanked by five recesses pierced with two superimposed rectangular windows covered with plain metal grilles on each side. The minaret stands on the left as one faces the entrance and is a typical round and faceted Ottoman minaret with one balcony on stalactites and a pointed finial. The *sabil-kuttab* lies at the northern end of this façade, with colored tiles in the lunette, the double molding with loops and carved panels as well as the foundation inscription with the date of completion 1148/1735. The cresting is the typical five-lobed leaf.

The northeastern façade has in its center the second entrance of the mosque (figure 4.9), which overlooks Khushqadam Street or Hara. It can also be reached by climbing eight steps to the platform in front of the door. The Fatimid wooden door with its carved panels lies in a plain tri-lobed shallow recess, the whole composition framed with the double molding with loops. It is very similar to the first entrance, but here one sees above the door a marble panel with an inscription mentioning the renovation of the mosque by Ahmad Katkhuda and the date 1148/1735. The rest of the façade to the right of the entrance is plain with windows above the shops and the second window of the *sabil* with the *kuttab* above. On the other side of the entrance lies the ablution area.

The plan

The interior of the mosque consists of a lower central covered courtyard surrounded by covered *riwaq*s, two aisles deep toward Mecca and the southern *riwaq*, one aisle deep on the northern side. The *riwaq* opposite Mecca is also one aisle deep with more depth behind the aisle on the two sides of the entrance. Both the Mecca and the opposite side open by three arches onto the court, and the side *riwaq*s by only two, one larger than the other while resting on three columns. Four of the columns are of granite and were given as a present by 'Uthman Katkhuda.[19] The court floor was originally covered with colored marble, as mentioned by 'Abd al-Ghani.[20] It had in its center a fountain, which is no longer extant. The ceiling of the *sahn* is of wood and had a lantern, which cannot be seen today.

The *mihrab* is a pointed arched recess, flanked by a column on each side and covered with tiles decorated with a stylized lozenge pattern not seen before,[21] and a stem-and-leaf design in blue, green, red, and light blue on a white background (plate 4.1). The spandrels are also filled with tiles, reminiscent of those seen today in the *qa'a* on the upper floor in Bayt al-Suhaymi and decorating the entrance of Masjid al-Kikhya Mosque. The whole *mihrab* is framed with the double molding with angular loops, which also frame the oculus above it. Hasan 'Abd al-Wahhab adds that one of the tiles is inscribed with letters in white on a blue background which reads "*Ma sha' Allah* (God has willed)" with the date 1141/1728,

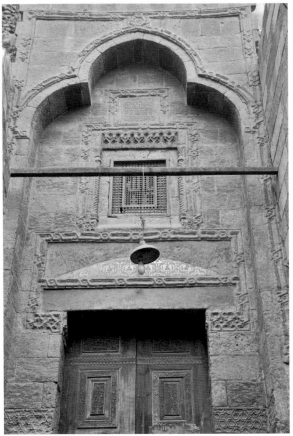

Figure 4.9. The side entrance of the Mosque of al-Fakahani.

Mamluk minbars. There was a door, now blocked, beside the *mihrab*, which opened onto a small room probably for the imam. The windows of the *qibla* wall have all been blocked except for two small ones.

The *riwaq* opposite includes, in its northeastern side, two doors that lead to two small rooms. The main entrance, which is on al-Muizz Street, opens onto this *riwaq* through a lower, narrow passageway directly to the central court. To the right of the entrance as one faces it from the interior, one can find what appears to be the base of a pillar but is in fact a base that carries the minaret, and beside it extends the extra depth behind the aisle all the way to windows overlooking the main street. To the left of the entrance, the extra space forms a second aisle. The *dikka* lies above the entrance corridor on this side. It is of wood and supported by the columns of the arcade and a back wall. The *dikka* is reached through a wooden ladder, and a small door in the *dikka* leads to the steps to the roof.

The mosque is also entered from the second entrance through a lower corridor directly to the central court. The ceiling of the mosque is of wood with remains of paint, and with two lanterns today above the Mecca *riwaq*.

which means that the tiles were not especially made for this mosque since they predate the building by seven years.[22] Prost attributes the tiles of the façade to Anatolia without mentioning a specific location, and the *mihrab* to Maghribi ceramists working in Cairo.[23] Meineke-Berg, basing herself on this date, attributes all the tiles to the Tekfur Sarayı workshop in Istanbul.[24] Theumissen attributed the tiles to four different production centers: İznik, Kutahya, Tekfur Sarayı in Istanbul, and Cairo, between 1728 and 1734, and adds, "This situation adequately illustrates the confusion surrounding Ottoman period tilework in Cairo."[25] The minbar is made of wood with a design of a twelve-pointed star, as was common in

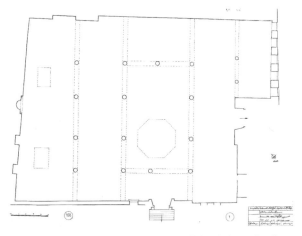

Figure 4.10. The plan of the Mosque of al-Fakahani (by the Ministry of Antiquities).

The appearance of a hypostyle mosque in a dense-ly built area may seem strange, but it is in fact based on the regularity of the available space on which one can build a regular plan mosque. The amir, who knew that the mosque would later be attributed to him for being its restorer, kept the memory of its Fatimid times alive by maintaining the plan, the doors, and a few carved stone blocks.

The Mosque of al-Shaykh Mutahhar
(1157/1744)
Monument Number: 40

The location
The Mosque of al-Shaykh Mutahhar lies on the north-west corner of the intersection of al-Muski Street and al-Muizz Street. The lunette covered with tiles above the door, the minaret above the entrance, and the *sabil-kuttab* belong to the constructions made by 'Abd al-Rahman Katkhuda. They front a much older building so heavily restored that one cannot identify its original structure. This was originally the Suyufiya Madrasa built by Salah al-Din al-Ayyubi near the market of swords for the Hanafi school of law.

The identity of the person buried in the tomb of the mosque, commonly referred to as al-Shaykh al-Mutahhar, is debated. This tomb is believed to be the small Shrine-Tomb of Shaykh 'Izz al-Din ibn Abi al-'Izz, as mentioned by al-Maqrizi, which was located in a small mosque known as the Halabiyin Mosque, beside the Suyufiya Madrasa.[26] When the mosque was built, the shrine-tomb was incorporated in it, and the whole structure was renovated by 'Abd al-Rahman Katkhuda in the eighteenth century to be known as the Mosque of al-Shaykh Mutahhar.[27]

The exterior
The main and only façade overlooks al-Muizz Street and contains the entrance with the minaret and the façade of the *sabil-kuttab*. The entrance shows a late Mamluk style tri-lobed entrance with dripping sta-lactites in the two lower lobes only, and a fluted shell design in the upper lobe. The whole is framed with

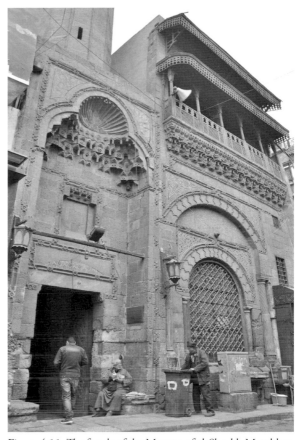

Figure 4.11. The façade of the Mosque of al-Shaykh Mutahhar.

a double molding with angular loops, which also frames the lintel. The signature of the craftsman 'Ali Shaltut is carved in the center of the portal conch, which may indicate his innovative role in the creation of a new carving style that can be attributed to the 'Abd al-Rahman Katkhuda period (figure 4.12).[28]

The façade of the *sabil* consists of a round-arched recess under which is a smaller round arch framing a rectangular window with an intricate metal grille. The whole is framed with the same molding. Above this is the wooden balustrade of the *kuttab* over sever-al rows of wooden stalactites, and the wooden ceiling of the *kuttab* can be seen from the street.

The minaret is the typical round and faceted Ottoman minaret with one balcony and a pointed finial.

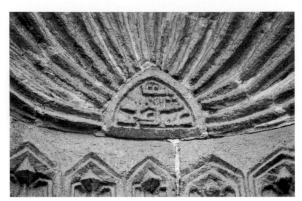

Figure 4.12. A detail of the signature of 'Ali Shaltut in the semidome of the portal of the Mosque of al-Shaykh Mutahhar.

The plan

The entrance leads to a long corridor with a door on the right that opens onto the *sabil* and a smaller door that opens onto a staircase that leads to the *kuttab*. Further along the corridor, the entrance to the ablution area is on the right, and straight ahead, the entrance to the prayer area. Before reaching the prayer area at the back of the building is a small portico resting on columns with a plain *mihrab* with tilework in its spandrels. The orientation of the *mihrab* had been miscalculated, and was rebuilt facing a little to the right to indicate the direction of prayer. The plan of the prayer area consists of three aisles with a lantern in the center. Attached to the prayer area are the tombs of the shaykh and the mother of 'Abd al-Rahman Katkhuda. A marble plaque in the southwestern corner has a *naskhi* inscription in relief with prayers. On one of the marble tombstones is written that whoever dies on a Friday or the night before is saved from the punishment of the tomb, but the deceased remains unidentified. The second tombstone has the name of the mother of the founder and the date 1170/1756. The *mihrab* shows a typical Mamluk style with colored marble and a geometrical design in the spandrels reminiscent of the design in the spandrel of the entrance of the complex of Sultan Qalawun.

This building, like the Mosque of al-Fakahani, shows a unique feature of Cairene Islamic architecture. Unlike architects in other Islamic cities, Cairo's

architects were masters of making use of surviving structures, reincorporating them with later buildings attached or added nearby, and restoring buildings that were constructed in former dynasties.

The Complex of Sultan Mahmud I also known as the Takiya Mahmudiya (1164/1750)
Monument Number: 308 and the *sabil* Monument Number: 59

This is the first religious foundation built by an Ottoman sultan in Egypt, which indicates a belated imperial interest in architectural patronage in this province. During the eighteenth century, the main challenge to the Porte came from the Janissaries who were in control of Egypt's economic resources through the tax farming system and through their involvement in commerce, especially the coffee trade, which allowed them to recruit and strengthen their position and also strengthen their bonds with the population.[29] The two most important leaders of the Janissaries were Ibrahim Katkhuda and his successor 'Abd al-Rahman Katkhuda, and the rising power of the Janissaries was met with the decline in Ottoman control.

The reign of Sultan Mahmud I was overshadowed by the aftermath of the Tulip Age[30] and the uprising of the Janissaries in the year 1142/1730, forcing Sultan Ahmad III to abdicate. Sultan Mahmud I tried to

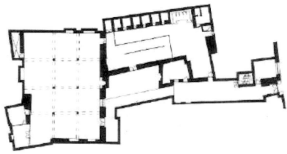

Figure 4.13. The plan of the Mosque of al-Shaykh Mutahhar (plan after Abu al-'Amayim, *Athar al-Qahira al-islamiya fi-l-'asr al-'uthmani*, 293).

stabilize the unrest and control border disputes with the Russians, the Habsburgs, and the Safavids.[31] The sultan was interested in literature and poetry; he founded both the library in the Hagia Sophia and the famous Tophane Fountain in Istanbul and commissioned the construction of the Nuruosmaniye Mosque, also in Istanbul, that was later completed by Osman III.

The location

The building is located on Darb al-Jamamiz Street off of Port Said Street. It occupies the corner of Harat al-Habbaniya toward the Sabil of Beshir Agha Dar al-Sa'ada.

The endowment deed as well as the inscriptions on the façade identify the building as a madrasa, a *sabil*, and a *kuttab*. The *Description de l'Égypte* in the late eighteenth century identifies it as a *takiya*, and 'Ali Pasha Mubarak also calls it Takiya al-Habbaniya.[32] The term *takiya* was discussed before in the Takiya-Madrasa of Suleiman Pasha al-Khadim explaining the Turkish word of *tekke*, which is equivalent to *takiya* in Arabic, as a hospice for Sufis. The epigraphy and the *waqf* document indicate that Beshir Agha, the chief eunuch of the Imperial Harem, acted as a proxy of Sultan Mahmud I in establishing the foundation.[33] Doris Behrens-Abouseif points out the date on the building is 1164/1750 and the deed is dated to 25 Jumada al-Thaniya 1167/19 April 1754, shortly after the execution of Beshir Agha in 1166/1752.[34]

The madrasa was designed to accommodate forty students to study with a Qur'an teacher. There was also a large staff of administrators and workers, but the deed does not give any details of the teaching curriculum or which school of law the teaching would be based on. The *kuttab* was dedicated to twenty schoolboys, a Qur'an teacher with an assistant, as well as Qur'an reciters and an Arabic teacher. The *mihrab* inside the *sabil* and the lavish tile decoration inside suggest it was used as an oratory and for special meetings. One may assume that the staff were mostly Turks, which necessitated an Arabic teacher.

The façade

The building originally overlooked the *khalij* and was suspended or built over shops, twelve of which are along the main façade and others open onto the southern Sikkat al-Habbaniya Street, while a modern building abuts the northern façade. The main façade is centered by an elevated pishtaq entrance and the *sabil* with the *kuttab* above it stand on its southern side. The higher wall of the latter makes it appear as a different structure. The rounded profile of the *sabil* and *kuttab* was a novelty in Cairo at that time, but it "advertises the architectural fashions of Istanbul" since it was already used by the architect Sinan for the *sabil* attached to his own mausoleum "anticipating the rounded façade of the Baroque period."[35]

The rounded, arched recess of the main portal repeats the cushion voussoirs already seen in the side recesses of the projecting towers of the Fatimid Bab al-Futuh and repeated in the Bahri Mamluk portal of the Khanqah of Sultan Baybars al-Jashankir and the Zawiya of 'Abd al-Rahman Katkhuda on al-Mugharbalin Street (figure 4.15). The use of double moldings with angular loops as frames as well as the İznik tiles to fill the lunettes and relieving arches above windows and doors continue the tradition of earlier Ottoman buildings. The foundation inscription in *thuluth* script is found above the relieving arch; as mentioned above, it calls the building a "madrasa" and mentions

Figure 4.14. The façade of the Takiya and Sabil of Sultan Mahmud I (courtesy of Ibrahim Ramadan).

the name of Sultan Mahmud I and the date of construction. On either side of the marble plaque of the foundation inscription are two medallions inscribed with "Allah" and "Muhammad," underneath which are two projecting whirling motifs.

The whole façade is broken into rectangular windows above the shops and topped by the typical five-lobed leaf cresting. A carved horizontal band with an arabesque design runs above and below the windows of the madrasa, a feature not seen before in Ottoman

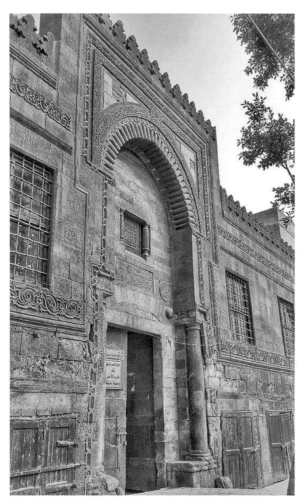

Figure 4.15. The main entrance to the Takiya and Sabil of Sultan Mahmud I (courtesy of Historic Cairo Online photographs).

buildings in Cairo, but the carved band framing the arch of the door ending in a loop and framing the spandrels recalls the bands that decorate the façade of the Zawiya of 'Abd al-Rahman Katkhuda.

Two other entrances are also highly decorated in this building: the portal of the *sabil* and that of the *kuttab* above (figure 4.16). The first does not form a pishtaq above the ceiling of the façade as in the main entrance, although it lies on the same side. The entrance of the *sabil* lies in a shallow, pointed arched recess, decorated in its top part with a unique design of interlocking scrolls within a rectangular frame in high relief. The marble lintel above the entrance is inscribed with three lines, each consisting of four cartouches of foundation inscription narrated in the form of a poem. It mentions the name of Beshir Agha and Sultan Mahmud I. According to Bernard O'Kane, the phrase "هذا سبيل ماؤه نيل حلا يجلو الصدى" adds up to 1173 according to the Abjad computation, and not to 1164, the date of the monument."[36] The use of poems as foundation inscriptions was a novelty in Cairo, "but it must have been inspired by the epigraphic innovations of Sultan Ahmed III [as] seen on his spectacular fountain near the Topkapi Palace in Istanbul."[37] The marble plaque of the foundation inscription is flanked on either side by decorative panels depicting vases of flowers. The lunette is also decorated with tilework showing floral motifs of white, green, and red on a blue background, similar to the one found in the lunette on the main portal of the building. The decoration above the entrance is topped by a window decorated with an intricately carved metal grille depicting different floral motifs, including tulips, which symbolize the Ottoman Empire.

The third entrance of this building is found on the southern façade and leads to the *kuttab*. The lintel above the doorway is carved with three tiers of four cartouches inscribed with the foundation in the form of a poem. According to O'Kane, "the phrase بيتا يروق النبلا مكتب بر نافع amounts to 1167 in abjad computation."[38] One can conclude from this that the main entrance of the building is the earliest of

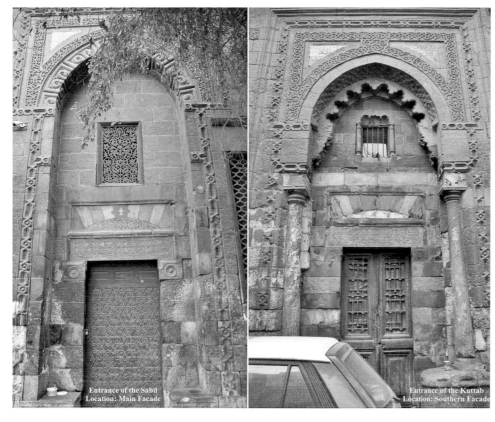

Figure 4.16. The entrances to the *sabil* and *kuttab* of the Takiya and Sabil of Sultan Mahmud I.

all three (559/1164), followed by the entrance of the *kuttab* (562/1167), then that of the *sabil* (568/1173). The marble plaque of the foundation inscription is flanked by panels similar to those found on the entrance of the *sabil*, which depict vases and flowers. On either side of this doorway are tiny carvings of tulips, whirling motifs, and pine trees, all of which are typical Ottoman architectural motifs. This entrance shows a combination of influences and displays the most complex decoration of all three entrances. The outer pointed arch is carved in its soffits by a number of lozenges, reminiscent of those found on Bab al-Futuh, while the inner polylobed arch is very much similar to that found on the Zawiya of 'Abd al-Rahman Katkhuda in al-Mugharbalin.[39] Surrounding both arches is a band of carved motif showing a stem-and-leaf design that flows in a braided arrangement,

forming the upper circular lobe on the apex of the arch and framing the spandrels. The spandrels are decorated with tilework depicting blue floral motifs on white backgrounds. The whole entrance is surrounded by a double molding with angular loops.

The façade of the *sabil* is the most decorated part of the building; its bold curve recalls the fashion in Istanbul and it is further accentuated by two timber leaves, one above the *kuttab* and one above the *sabil*. The attachment of the *sabil* and *kuttab* at a corner of a building continues the Mamluk tradition that started in the late Bahri Mamluk Madrasa of Uljay al-Yusufi on Suq al-Silah Street, but here its increased proportions in relation to the madrasa are a contrast from those seen during the Mamluk period. Different from the madrasa is its striped masonry with black and red stone combined with white

marble, elaborated window grilles, and epigraphy. A cartouche above each of the three large windows is carved with the Tughra of Sultan Mahmud I. Evliya Çelebi mentions an earlier Tughra in Cairo, namely the golden Tughra of Sultan Murad IV hanging on a large panel on a wall in one of the pasha's palaces in the Cairo Citadel,[40] in addition to the Tughra found in an archive photograph in the Mosque of Athar al-Nabi. Two epigraphic medallions can also be seen between the windows of the *sabil* with the name of Sultan Mahmud I, which are reminiscent of Mamluk blazons. The longest inscription can be seen in a chain of cartouches beneath the wooden eaves containing poetry praising the building and referring to Beshir Agha as founder on behalf of the sultan. This is followed by an attribution to Hasan al-Zuhdi and the year 1163/1750; he must have been the poet, since Beshir Agha himself was an accomplished calligrapher yet never a poet.

The plan

The madrasa is reached through a flight of steps between the shops. The plan consists of an open court with a fountain on columns carrying a wooden roof, which retains parts of its paint. The court is surrounded by a portico with shallow domes, behind which are the rooms so similar to the Takiya-Madrasa of Suleiman Pasha al-Khadim mentioned above. The façade of the prayer hall, which lies in the middle of the eastern façade, is slightly higher than the portico and opens by a tri-lobed recess entrance onto the court. The prayer area is a small room with two recesses: the northern one used to be a library while the southern one includes a windcatcher. The *mihrab* of the prayer area is skewed to the right to face the correct Mecca orientation, the ceiling of the entire room is of painted wood, and the whole space overlooks the courtyard through two windows. All of the rooms are meant to accommodate one person, except for double rooms in the corners. In the northeast corner of the court is a door that leads to steps that go down to the kitchen, washing area, and other utilities.

The ground plan shows divergence between the exterior and interior axes because of the location of the

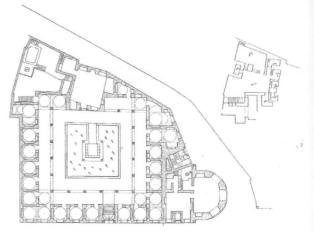

Figure 4.17. The plan of the Takiya and Sabil of Sultan Mahmud I (courtesy of Ibrahim Ramadan).

entrance, which in fact includes in its southern extension the *sabil*. Although the *sabil* is a separate structure, with its own entrance on the main façade, the main entrance is in the middle of the whole façade and does not correspond with the central axis of the courtyard.

The plan of the *takiya*-madrasa is Ottoman; so are the curved *sabil* façade, the intricate iron grilles with arabesque designs, the imported İznik tiles, and the epigraphic decoration. Nevertheless, neither the sultan nor Beshir Agha ever came to Cairo. The plan was imported, but the supervision must have been delegated to Ottoman officials, most probably from the large community of black eunuchs who had settled down in the neighborhood of the Mosque of al-Malika Safiya found close by. Also, one must add that there is no evidence to claim the involvement of imperial craftsmen in the construction; local craftsmen must have been used under the supervision of an Ottoman official. In addition to this, there is very little reason to believe that the craftsman 'Ali Shaltut, whose name is carved on the portal of the Mosque of al-Shaykh Mutahhar and was believed by Doris Behrens-Abouseif to be the initiator of the style of carving popularly used during the period of 'Abd al-Rahman Katkhuda, was involved in the construction of this building.

Figure 4.18. The plan of the Mosque of al-Azhar (after Archnet).

The work of 'Abd al-Rahman Katkhuda:
Al-Azhar Mosque
(1167/1753–4)
Monument Number: 97

Al-Azhar Mosque was originally built by Jawhar al-Siqilli in the year 361/972 as a mosque and a teaching area of Shi'a Islam for the Fatimids. It was added to by several Mamluk sultans who turned it into a famous Sunni school and prayer area. It was not until the 1740s during the Ottoman period that the Mosque of al-Azhar started receiving a major "facelift" by 'Uthman Katkhuda al-Qazdughli and his son 'Abd al-Rahman Katkhuda.[42] 'Uthman Katkhuda built a *zawiya* called Zawiyat al-'Umyan (the Zawiya for the blind) and rebuilt the *riwaq*s attributed to Qaytbay, namely the Turkish and Syrian *riwaq*s.[43]

His son 'Abd al-Rahman Katkhuda added three entrances to al-Azhar Mosque (figure 4.18): Bab al-Muzayyinin (the Barbers' Gate) on the western façade, Bab al-Sa'ayida (the Gate of the Upper Egyptians) on the southern façade, and Bab al-Shurba (the Soup Gate) on the eastern façade of the mosque. He also added a *kuttab* and attached a minaret to Bab al-Muzayyinin, as seen in the painting by Émile Prisse d'Avennes in *L'Art Arabe d'après les monuments du Kaire depuis le VIIe siècle jusqu'à la fin du XVIIIe* (figure 4.19). He remodeled the upper part of the minaret of the Madrasa Aqbughawiya to match the Ottoman minarets he added (figure 4.20). Behind Bab al-Muzayyinin, he also redecorated the outer façade of the Taybarsiya Madrasa. He also expanded the *qibla riwaq* to the east by acquiring the properties in that area. By doing so, he demolished the walls on either side of the Fatimid *mihrab*, added four aisles behind it, and thus expanded the overall area of the *haram*. On the south side of the mosque, he added Bab al-Sa'ayida (figure 4.21), which is a magnificent double door with extensive stone carving that led to a small courtyard (figure 4.22) from which the mausoleum he built for himself could be accessed. It also led to a *riwaq* called Riwaq al-Sa'ayida that he added in his newly constructed extension. As at Bab al-Muzayyinin, 'Abd al-Rahman

The *takiya* was restored in 1996 and is now used by the employees of the Ministry of Antiquities in charge of the area. The *waqf* deed, which was written in Turkish, is in the Ministry of Religious Endowments number 908, and it does not describe the building, but only the people working there. According to Abu al-'Amayim, papers were found left by Muhammad Ihsan Abdul-Aziz (1902–1961), the last of the Ottoman teachers, and dated to 17 Ramadan 1368/13 July 1949 that briefly describe the building and report that there were students living there until World War I and that they were all from Turkey, as in the Takiya of Muhammad Abu al-Dhahab.[41] When the number of Turkish students decreased, they started accepting other nationalities of students studying in al-Azhar. The papers also mention that the books in the library were moved to al-Azhar Mosque, and that thirteen rooms were used by students and the rest by staff. Muhammad Ihsan Abdul-Aziz in Abu al-'Amayim also added that the building was in fact a madrasa to teach Arabic and religious studies, and that he does not know why it became known as a *takiya*.

Figure 4.19. A drawing of Bab al-Muzayyinin (the Barbers' Gate) by Émile Prisse d'Avennes (Émile Prisse d'Avennes, *L'Art Arabe*).

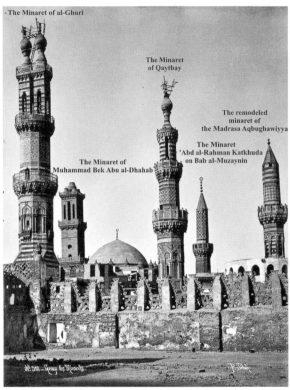

Figure 4.20. The minarets of the Mosque of al-Azhar (courtesy of the Historic Cairo online photographs).

Figure 4.21. An archive photograph of Bab al-Sa'ayida in al-Azhar Mosque (after Ibrahim Ramadan).

Katkhuda also added an Ottoman-style minaret on top of the gate. Finally, the third gate added by 'Abd al-Rahman Katkhuda is located behind the *qibla* extension he added. Bab al-Shurba is located beside a number of shops (figures 4.23 and 4.24), and like the other gates added by Katkhuda, it is topped by an Ottoman-style minaret.

The style of decoration shows a continuation of the revival of the Qaytbay style of stone carving and exterior decoration. This whole new extension was renovated by Khedive Tewfik Pasha in the year 1306/1888. The new *qibla* wall today has three *mihrab*s. The main central one with the dome above it is decorated with colored marble in the usual Mamluk style. Beside it is the wooden minbar and the two other *mihrab*s; the second *mihrab* is known as Mihrab al-Dardir,[44] and the third is the one added by the Comité.[45]

Figure 4.22. An archive photograph of the courtyard inside Bab al-Sa'ayida in al-Azhar Mosque (after Ibrahim Ramadan).

Figure 4.23. Bab al-Shurba and shops found behind the *qibla* wall of al-Azhar Mosque (courtesy of Thesaurus Islamicus Foundation).

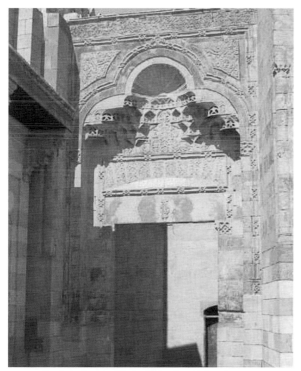

Figure 4.24. A detail of Bab al-Shurba of al-Azhar Mosque (courtesy of Thesaurus Islamicus Foundation).

The works of 'Abd al-Rahman Katkhuda in the Mosque of al-Azhar show a concentration on façade decoration with the addition of carved friezes, lobed arches, arches with cushion voussoirs, moldings with angular lopes, all reminiscent of the works of Sultan Qaytbay toward the end of the Burji Mamluk Dynasty, but with many Ottoman details discussed before.

The Mosque of Yusuf Jorbagi known as the Mosque of al-Hayatim (1177/1763)
Monument Number: 259

The founder

The founder is al-Amir Yusuf Jorbagi, who is mentioned in some documents as Amir Yusuf Jorbagi Gamalyan Hayatim. His name was tied to his military title, where *Jorbagi* was equivalent to the title of a *Yuzbashi* (Captain or Lieutenant) of the Ottoman army, *Gamalyan* was one of the seven *ojak*s of the Ottoman army, of which he was the leader, and finally Hayatim was the name of the street where he resided. The Gamalyan group of *ojak*s played an important role in the administration of the country, although they were mentioned several times as a cause of unrest and trouble.[46]

The location

It is on Harat al-Hayatim, located off Port Said Street, between the Mosque of Sayyida Zaynab and the Takiya of Sultan Mahmud I.

The exterior

The main façade with the entrance lies on the southern side, and the minaret and *sabil-kuttab* and a second entrance are located at the northern end of the façade. The main entrance is placed in a tri-lobed shallow recess, flanked with two small benches. The two lower lobes are filled with stalactites while the upper lobe is decorated with a fluted shell design seen before on several entrances. The whole is framed with a double molding with angular loops. The wooden door is carved in relief with geometrical and arabesque designs; it was later painted by the Comité in 1933. A marble plaque can be seen above the door with the foundation inscription in *thuluth* script in

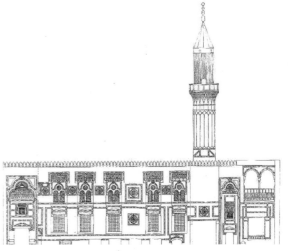

Figure 4.26. The southern elevation of the Mosque of Yusuf Jorbagi (by the Ministry of Antiquities).

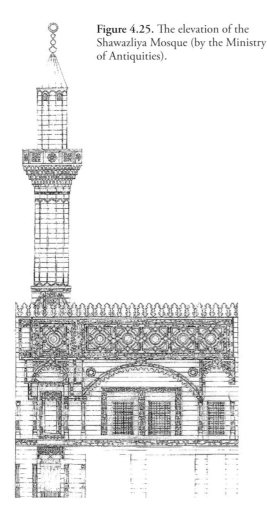

Figure 4.25. The elevation of the Shawazliya Mosque (by the Ministry of Antiquities).

cartouches placed on two lines and carved in relief with the date at the end in numbers (1177/1764).[47] The lunette is covered with blue and white tiles decorated with geometrical designs filled with stylized flowers, which were made, according to Su'ad Mahir, in Damietta during the twelfth/eighteenth century.[48] The whole, including the carved relieving arch, is framed by the usual molding. The part above the relieving arch is divided by horizontal moldings into five parts with extensive stone carving and a small square wooden window with two engaged columns and a stalactite hood. Stone carving can also be seen in the spandrels of the portal. The lintel above each window is inscribed and the lunettes are covered with tiles.

The façade projects out, and the whole mosque is suspended above five shops. Each of the five stalactite recesses above the shops hastwo superimposed windows; the lower is rectangular in shape and the upper a Qalawun set. The novelty here is the amount of carving along the whole façade. Two horizontal carved friezes separate the windows with square carvings in between the recesses, and two oculi in a square carved panel in the center indicate the *mihrab* wall.

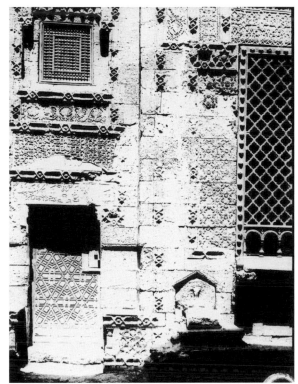

Figure 4.27. The carvings on the façade of the Mosque of Yusuf Jorbagi (by the Ministry of Antiquities).

leads to the mosque. The second entrance, which lies beside the *sabil*, leads also to a small vestibule with an entrance leading to the mosque on the left and another leading to the *sabil* on the right. The mosque shows the regular plan seen in many Ottoman buildings from that period: a rectangular space that measures 22.05 × 15.44 meters, divided into three aisles parallel to the *qibla* wall. Each aisle consists of five-pointed horseshoe arches resting on four marble columns and the side walls. The *mihrab* is framed on one side by three windows and on another side by two, and is decorated with colored marble panels. The ceiling of the mosque is of plain wood and the lantern did not survive. One must add here that the interior is quite plain when compared to the exterior decoration, which is a continuation of the 'Abd al-Rahman Katkhuda style.

'Abd al-Rahman Katkhuda was undoubtedly a great patron of architectural decoration, since most of his buildings were renovations of earlier foundations to which a new façade was added. He revived the highly decorative façade architecture of the Mamluks, helping Cairo to maintain the title of the city of the Mamluks, which is still used today.

A small entrance, which can be seen beside the *sabil* window next to the last shop, is decorated with double moldings and stone carvings and is very highly decorated (figure 4.27). The *sabil-kuttab* opens with one window onto the main road. The amount of carving on this façade is striking and can be considered the zenith of the style of 'Abd al-Rahman Katkhuda.

The minaret is round and faceted with a beautifully carved stone balustrade on stalactites, while the rounded top is ribbed with very narrow and shallow ribs and then the pointed finial. It is rather short when compared to many other Ottoman minarets.

The plan

The entrance leads to a vestibule with a plain wooden ceiling. To its right, a staircase rises three steps and

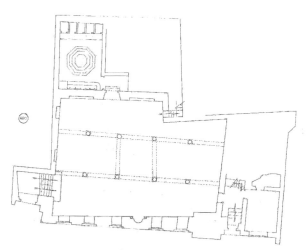

Figure 4.28. The plan of the Mosque of Yusuf Jorbagi (by the Ministry of Antiquities).

The Mosque of Muhammad Bek
Abu al-Dhahab
(1187–8/1773–4)
Monument Number: 98

The founder
Muhammad Bek Abu al-Dhahab was an important and influential amir, originally a mamluk of the Amir 'Ali Bey al-Kabir, who bought him in 1175/1761 and took care of his education. He then rose in status several times and became a close companion of his master. When 'Ali Bey al-Kabir declared the independence of Egypt from Ottoman power, his close companion was beside him and in 1185/1771 he was sent at the head of an army to liberate Syria. However, in Damascus he secretly became the ally of the Ottomans with the promise to help them take over Egypt's rule. In the conflict between Muhammad Bek and 'Ali Bey al-Kabir, the latter was killed in 1187/1773 and Egypt once again became a province of the Ottoman Empire, with Muhammad Bek as its leader.[49] He died in 1189/1775 on a campaign in Syria, but his body was brought back to Egypt and was buried in his mosque.

The location
The mosque overlooks al-Husayn Square and the Khan al-Khalili area and stands directly opposite Bab al-Muzayyinin (the Barbers' Gate) of al-Azhar Mosque.

The exterior
The mosque was built beside the Mosque of al-Azhar to be an extension to the former, and Muhammad Bek Abu al-Dhahab appointed well-known teachers to teach there as well as muftis for the four schools of law. He also added a library with many books and attached to the mosque a *takiya* for Turkish Sufis, a *sabil*, and a watering trough for animals, which were located on the southern side of the mosque. According to Hasan 'Abd al-Wahhab, the Ministry of Religious Endowments restored the *takiya* and made it available for Turkish students.[50]

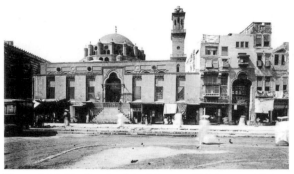

Figure 4.29. The façade of the Mosque of Muhammad Bek Abu al-Dhahab (courtesy of Ibrahim Ramadan).

The Mosque of Muhammad Bek Abu al-Dhahab is a suspended mosque, accessible through two entrances: one is through a flight of steps perpendicular to Bab al-Muzayyinin (the Barbers' Gate) of al-Azhar Mosque, and the other is through an entrance located on the same side as the mosque's *qibla* wall (figure 4.30). The entrance perpendicular to al-Azhar Mosque is located in a pishtaq and features a tri-lobed composition, reminiscent of the Qaytbay style with the exception of the tiles in its lunette. In the central lobe of the tri-lobed entrance, there is a square marble plaque. The whole entrance is framed with a double molding with angular loops. The second entrance mirrors the style of the one on al-Azhar Street but with a different inscription in the marble plaque (figure 4.31).

A *ziyada* is built around the northern and northwestern borders of the mosque, corresponding with the area allocated for the shops underneath it, which appear to be an afterthought since they cut into the double-arched windows of the portico. As one goes up the flight of steps, the mosque's portico is shielded off by a *maqsura*, forcing the mosque's visitors to turn slightly to the left to access the perimeters of the portico surrounding the prayer area. 'Ali Pasha Mubarak describes the Mosque of Muhammad Bek Abu al-Dhahab as being surrounded by a *maqsura* with three entrances that lead to the portico surrounding

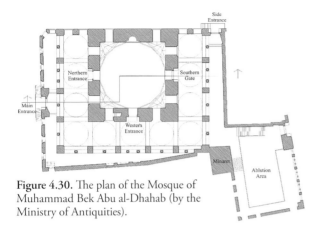

Figure 4.30. The plan of the Mosque of Muhammad Bek Abu al-Dhahab (by the Ministry of Antiquities).

the mosque that then leads to the prayer area itself.[51] The prayer area has three entrances that are aligned with the entrances of the *maqsura*.

To the left of the above-mentioned *maqsura* entrance lies the mausoleum of Muhammad Bek Abu al-Dhahab and his daughter 'Adila Hanim, the wife

of Ibrahim Bek al-Alfi.[52] It is shielded off from the rest of the mosque's portico by an intricate metal grille. Up until 2016, photographs show a tombstone covered with an embroidered textile dated to 1266/1850, but this no longer exists. The apex of the shallow dome covering the mausoleum area within the mosque's portico is inscribed with Qur'an 9:21 painted in a gold color, and it gives the date of death of the founder as 1189/1775 (figure 4.32). Remains of tiles can still be seen on the walls made in the Maghribi school of ceramists with a dominant blue and dark yellow colors, mostly depicting vegetal designs. One can also see a depiction of minarets and domes showing signs of a random arrangement, with one panel bearing the inscription "عمل الحميد" (The Works of al-Hamid). Three complete panels and remains of a fourth are particularly interesting, as they have a parallel to a complete one kept nowadays in the Sidi Qasim al-Jalizi Museum in Tunisia that dates from the eighteenth century as well. It

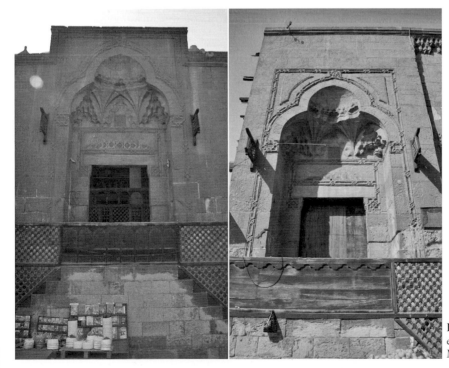

Figure 4.31. The main and side entrances of the Mosque of Muhammad Bek Abu al-Dhahab.

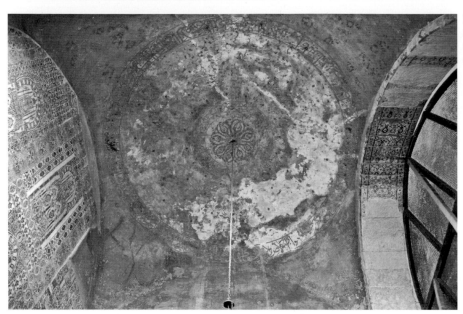

Figure 4.32. The shallow dome above the mausoleum of Muhammad Bek Abu al-Dhahab.

depicts an Ottoman mosque atop an intricately decorated tree that symbolizes Islamic Paradise. The prayer area can be entered through three doors located on its northern, western, and southern sides. Its western gate shows a Syrian influence with its flat stalactite hood and *ablaq* marble cladding. A marble plaque can be found above the doorway with an inscription consisting of two lines that are the beginning of the foundation inscription in poetic form. On the northern gate, which faces the Mosque of al-Husayn, the poem continues in two more lines with the name of the founder. The southern gate leads to the ablution area (figure 4.33).

The mosque's style replicates the single-dome mosque plan introduced to Cairo by Sinan Pasha, which did not become popular. Unlike the dome of the mosque of Sinan Pasha, the dome of the Mosque of Muhammad Bek Abu al-Dhahab is completely covered with painted decorations, featuring a variety of vegetal motifs combined with Qur'anic verses. The apex of the dome is inscribed with Qur'an 112:1–4. A large inscription band running under the dome carries verses 24:35–37, which mention

God as the light of the universe and the houses of God where prayers are said with his permission. Another narrower band of inscription placed in cartouches contains verses 48:1–15 and two cartouches from Sura 33 (plate 4.2).

Like the Mosque of Sinan Pasha in Bulaq, the mosque's drum is surrounded with an array of circular windows arranged to form a flower-like motif. The massive dome of Muhammad Bek Abu al-Dhahab's mosque rests on spherical tri-lobed squinches; the hood of the two squinches on the *qibla* wall read "Allah" while the rear ones feature a sunray motif. The *mihrab* is decorated in the typical Mamluk style with marble panels and mosaic and flanked by two engaged side columns. The spandrels are decorated with stem-and-leaf designs, with the right one reading "ما شاء الله" (what God wills) and the left "لا قوة إلا بالله" (no power but God). The hood of the *mihrab* features a chevron design, its middle tier is decorated with marble mosaic forming the Mamluk star pattern inlaid with mother-of-pearl, and the lowest tier is decorated with marble paneling. Above the *mihrab* there is an oculus that displays the

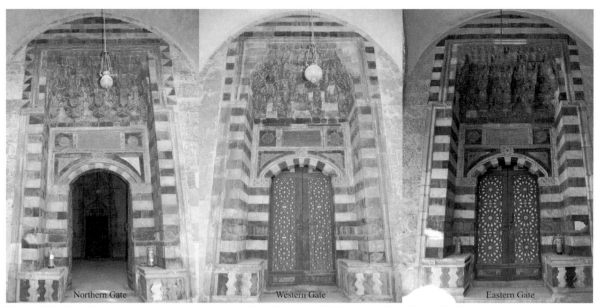

Figure 4.33. The three entrances to the prayer area of the Mosque of Muhammad Bek Abu al-Dhahab.

shahada. The wooden minbar is a typical Mamluk minbar with its star patterns inlaid with ivory. Above the doorway of the minbar there is another bulb that is typically found only above the shaykh's seat on the top part of the minbar (figure 4.34).

The entrance opposite the *mihrab* lies under the hanging *dikka,* which is accessible through an entrance next to the rear windows of the mosque. The same flight of stairs rises up to the rooftop. Once on the roof, one sees the projection of the shallow domes of the portico surrounding the prayer area and the majestic central dome of the mosque. On the exterior, the dome appears to have a double-tiered drum. In its lower tier, the flower-motif windows of the prayer area's interior do not correspond with the simple double rounded-arched windows on the exterior, while the Qalawun sets of windows on the upper tier correspond normally both inside and outside the mosque (plate 4.3). The double-tiered drum of the mosque's dome is surrounded with miniature buttresses with pointed tops. Their shafts are carved with an array of an interesting-looking heart-shape motif. There is a sundial on the

rooftop of the mosque, which includes the name of Muhammad Bek Abu al-Dhahab, and states that it was made by Mahmud ibn Husayn al-Nishi on 18 Rajab 1188/24 September 1774.

In the mosque's southern portico, in the area between the prayer area and the mosque's side entrance, there is a shallow recess that may have functioned as an external *mihrab* for those who were forced to pray in the portico when the mosque was overflowing with people of the faith. The southern entrance of the mosque's *maqsura* leads to a corridor that connects the mosque's side entrance to the ablution area. Overshadowing the corridor is the huge minaret of the Mosque of Muhammad Bek Abu al-Dhahab. It is a three-tiered minaret, divided by two balconies with a continuous square shaft and a pavilion top. In a drawing by Émile Prisse d'Avennes, the minaret of the Mosque of Abu al-Dhahab can be seen in its complete form, with five bulbs crowning its pavilion. This is reminiscent of al-Ghuri's minaret on the southern side of the Qasaba, which lies in view of the Mosque of Abu al-Dhahab (figure 4.35).

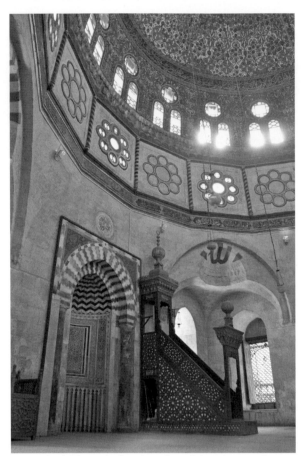

Figure 4.34. The *mihrab* and minbar of the Mosque of Muhammad Bek Abu al-Dhahab.

The *sabil* and water trough are located on the southern façade of the Mosque of Abu al-Dhahab. They are part of the reconstructed *takiya* that has been restored by the Ministry of Religious Endowments. On that side of the building the modern entrance of the *takiya* is pierced in the back wall of the trough and the entrance crosses over the sunken basin of water trough. The *sabil* of Abu al-Dhahab is a two-window *sabil*, reminiscent of the style of corner *sabil*s built by the Mamluks. The windows are shielded off by intricate metal grilles, which are the Ottoman signature in this case, in addition to the presence of the blue and white tiles in the lunettes.

The Mosque of Muhammad Bek Abu al-Dhahab continues the idea of the single-dome Ottoman Imperial-style mosque that was introduced to Egypt by Sinan Pasha in Bulaq, with the addition of a burial area for the founder as well as a *takiya* and *sabil-kuttab* attached to it, thus turning the building into an institution that compliments the teachings of al-Azhar.

The Takiya Refa'iya (1188/1774)

The founder

According to al-Jabarti, this *takiya* was among a series of constructions built by 'Ali Bey al-Kabir in Bulaq that included a market place *(qaysariya)*, a khan, shops *(hawanit)*, a grain storage area, and a small mosque.[53] In 1929, the mosque was registered as al-Takiya al-Refa'iya.

The location

The Takiya Refa'iya was relocated almost a block away from its original construction site. It used to lie on Wikalat al-Kharnub Street in Bulaq and was relocated in the late 1930s and early 1940s to its current location beside the Mosque of Sinan Pasha to make room for a hospital. The new location for the *takiya* was decided upon by members of the Comité in 1936.[54]

The exterior

The mosque overlooks the street through two façades: a northern one and a western one. The northern façade has the entrance in its eastern corner. The entrance is a shallow tri-lobed entrance with stalactites in the two lower lobes and a shell-like fluted hood, and is flanked by two side *maksala*s. The stalactites in the two side lobes of the entrance bear a swastika design, while the rest feature a flower-like motif within them. The lintel above the door is of marble and bears a poetic inscription arranged in two lines placed in cartouches that praise the building and mention Muhammad Bek Abu al-Dhahab as the one who completed its construction after the death of his master in 1188/1774. The lunette may have contained

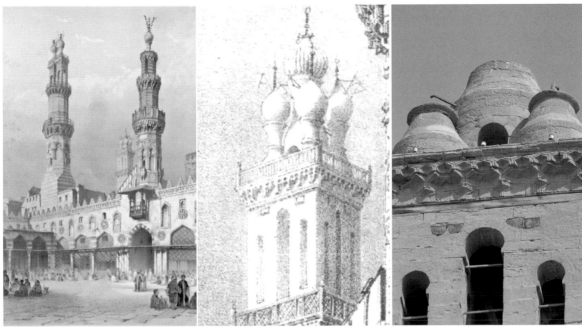

Figure 4.35. A detail of a drawing by Émile Prisse d'Avennes of al-Azhar Mosque showing the full bulbs that topped the minaret of the Mosque of Muhammad Bek Abu al-Dhahab and their state nowadays (after Émile Prisse d'Avennes, *L'Art Arabe*).

tilework, but unfortunately it did not survive. The whole entrance is framed by moldings with angular loops. The façade is broken into three stalactite recesses; two of them are pierced with two rectangular windows with metal grilles and a Qalawun set of windows above each, bracketing a third recess with a single arrangement. Corbels above indicate a second floor as found in one of the archive photographs, but it no longer survives (figure 4.37). Underneath the corbels are fragments of stone carving adorning the area between the upper parts of the recesses.

The western façade contains three stalactite recesses: a large one with two lower windows and two upper Qalawun sets of windows, and two others containing a singular arrangement of the former.

The plan

The entrance leads to a rectangular vestibule. Abu al-ʿAmayim mentions that the vestibule at one point contained the mausoleum of Sidi Muhammad Aziz Ruha, which also appears in a plan drawn by the Comité but no longer survives today. The vestibule leads to a courtyard with three iwans that open onto the courtyard by two arches supported on a column. A small prayer area can be found in the eastern iwan with a simple carved stone *mihrab*. Above the *mihrab*, a roundel bears the *Basmala* and a Qur'anic verse with four smaller circles with a whirling design at its cordial points, placed in a square framed with a double molding with angular loops surrounded by a frieze of stone carving. Between the northern and western iwans, a small room with two windows that open onto the main and western façades can be found.

Abu al-ʿAmayim mentions that before it was relocated, the *takiya* contained two mausoleums; the first belonged to Sidi Muhammad ʿAziz Ruha, whose identity is unclear and subject to debate, while the second mausoleum, which was located in the *qibla* iwan, belonged to Sidi ʿAli al-Maghribi, as shown in an archival photograph published by the same

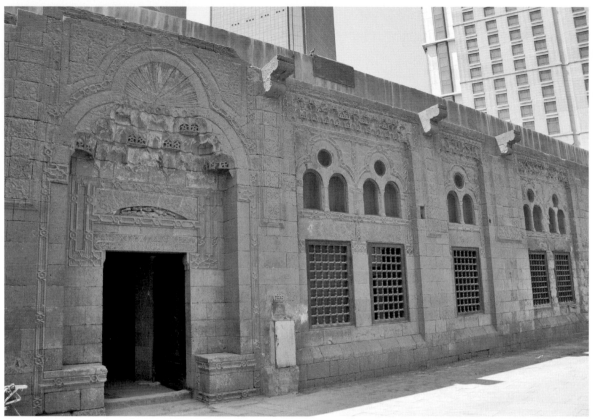

Figure 4.36. The northern façade of the Takiya Refaʿiya.

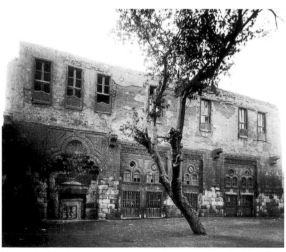

Figure 4.37. The nonextant upper floor of rooms of the Takiya Refaʿiya (courtesy of Historic Cairo online photographs).

author. Abu al-ʿAmayim states that he is uncertain if the burials were relocated with the entire *takiya* or not. A recent photograph, published in 2010, shows a tombstone located in the vestibule of the relocated *takiya* that was covered with a textile inscribed with the name of Sidi al-Maghribi. *Tabaqat al-Minawi* identifies the person in the first mausoleum as Abi ʿAziza ʿAziz al-Maghrabi, who died in 1010/1601 and was buried in the desert and not in Bulaq, which means that before the relocation of the *takiya* this first mausoleum was not so much a burial, but a memorial for a scholar who lived in Egypt at the time.[55] As for the second mausoleum, it belonged to ʿAli al-Maghribi, who was mentioned by Qasim as a pious imam who died in Bulaq in 1070/1659.[56] Today, none of these tombstones are extant.

On the southern side of the courtyard, there is a corridor that leads on its left to a staircase that leads to the upper floor and rooftop of the *takiya*, while on the right it leads to a small room with a *mihrab* that was used by the shaykh of the *takiya*. Straight ahead, one can find the rooms of the *takiya* arrayed around a courtyard with three columns supporting its roof (figure 4.40).

Nowadays, this building is used by the inspectors of Antiquities of the area of Bulaq and has been readapted to its modern use.

The Mosque of al-Sadat al-Wafa'iya 1199/1784

Monument Number: 608

The founder

The founder of al-Sadat al-Wafa'iya was Muhammad Wafa', a follower of the Shazli Sufi order from Tunisia, to whom many miracles were attributed. It is said that during the flood season when the Nile level did not rise, his prayers made it happen. Shaykh Muhammad died in 765/1363 and was buried beside known religious scholars such as Ata' Allah al-Sakandari and Abu al-Seoud in the Southern Cemetery. His mausoleum then became the burial place of his descendants and followers, which turned the entire area into a dedicated space for the Wafa'iya family and order.[57] An older *zawiya* existed there known as Zawiyat al-Sadat ahl al-Wafa' and it was renovated into a mosque by the vizier Ezzat Muhammad Pasha by the orders of Sultan Abdul Hamid I in 1191/1777, who ordered him to dedicate money from the treasury for its construction in the neighborhood of the Companions of the Prophet, and to appoint Shaykh Muhammad Abu al-Anwar ibn Wafa' as a *nazir* (inspector). The *waqf* deed of this mosque has not been found, but 'Ali Pasha Mubarak included a summary of it in *al-Khitat al-tawfiqiya*.[58] It mentions that the complex included many buildings beside the mosque, such as storage areas, residential buildings, *khilwa*s for meditation, *qa'a*s, kitchens, a mill, a coffee house, a *wikala* for the protection of visitors' animals, as well as a burial court, a cistern, and latrines. All the buildings were

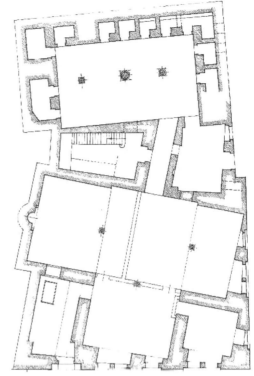

Figure 4.38. The plan of the Takiya Refa'iya (plan after the Comité).

built of stone with wooden ceilings and tiled floors.[59] It took eight years for the construction of the mosque and its buildings, and the inscription frieze under the ceiling of the mosque mentions that the works started in 1191/1777 and finished in 1199/1784.

The location

It is located in the Southern Cemetery, off the Autostrad in the direction of Maadi.

The exterior

The mosque has only one main façade, which lies on its northwestern side and overlooks al-Sadat al-Wafa'iya Square and includes the main entrance. It is placed in a plain shallow tri-lobed recess, surrounded by the usual molding and a white marble plaque, which is the foundation inscription in poetic form,

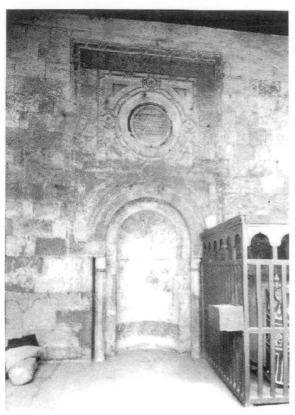

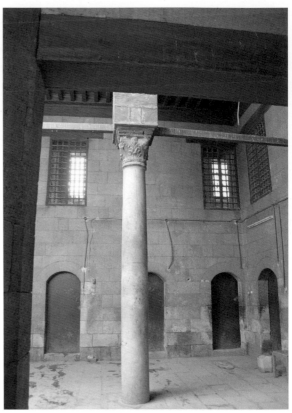

Figure 4.39. An archive photograph showing the *mihrab* of the Takiya Refa'iya and the *maqsura* in the *qibla* iwan (courtesy of Ibrahim Ramadan).

Figure 4.40. The rooms for Sufis of the Takiya Refa'iya.

written in four lines with the date 1186/1772. This is the date of the last renovations done on the *zawiya* before it was turned into a mosque in 1191/1777. One can also notice that the date here was during the reign of 'Ali Bey al-Kabir, who was very interested in the renovation of *zawiya*s.[60] This entrance leads to an open rectangular court, and opposite the outer entrance one can see the entrance to the mosque. Several buildings surround this open court on both sides, and the minaret can be seen above the entrance to the right. The minaret has a square base with a pyramid-shaped transitional zone with an octagonal shaft ending with stalactites supporting the balcony with a round second tier above, which is an onion-shaped finial. According to the *waqf* deed, the finial with its

crescent is made of gilt brass.[61] The entrance of the mosque is unique to Cairene architecture as it followed the Baroque movement that was beginning to spread in Turkey but never became popular in Cairo. It is a slightly rounded arch with a corbeled design on its sides, replacing the traditional tri-lobed feature with side lobes, and with marble carving on its sides featuring flowers and vegetal designs. A foundation inscription panel can be seen above the entrance, written in *thuluth* script in relief in two lines placed in cartouches with the date 1191/1777. Another wider inscription can be seen that bears Qur'anic verses 35:34–35. On each side of the entrance is an inscribed roundel placed in a square frame bearing praises to Sultan Abdul Hamid I (figure 4.42).

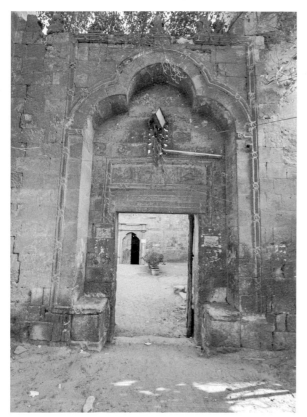

Figure 4.41. The entrance to the Complex of al-Sadat al-Wafa'iya (by Karim Saada).

one aisle deep on the other three sides, with a projected space found near to the right of the entrance. Nowadays a large *mashrabiya* covers the window that overlooks the mosque from the residential area that is found to the left of the mosque entrance. The marble columns support pointed horseshoe arches. In the middle of the court is the main *maqsura* that surrounds the tombs of Shaykh Muhammad Wafa' and his son 'Ali Wafa'. The *maqsura* is placed on a square marble base and made of walnut wood gilt with red gold and topped with a dome carved with gold, which rests on squinches and is carried on six white marble columns. The *maqsura* is decorated with many colors, including gold, with typical Ottoman vegetal motifs, mixed with geometrical patterns and an inscription with the date 1191/1777.

The floor level of the entire mosque is about 30 cm lower than the one right in front of the *mihrab*. To the right of the *mihrab*, one can see a door that leads to the *khilwa* of the preacher, above which is an inscription mentioning the same date. Another door leads to a small room that was dedicated to the storage of oil for the lamps used to light the mosque. The inscription above this door is from Sura 24, which mentions light.

Close to the *qibla* wall on the left is an entrance leading to the residential part of the complex, above which the phrase "ما شاء الله" (What God wills) is inscribed. To the left of this entrance, there is another door that leads to Shaykh al-Sijjada, above which the phrase "اللهم هب لنا الخلوة والعزلة عمن سواك" (May God grant us seclusion from anyone but You) is inscribed.

The *mihrab* is entirely covered with colored marble and decorated in the Mamluk style, except for the decoration in the spandrels that feature Ottoman scroll work with floral designs. Above the *mihrab* is a frieze of Qur'anic inscription in gold, above which is another band in *thuluth* that contains prayers. A wooden minbar stands beside the *mihrab*, which shows remains of paint on its wooden fragments held together by the tongue-and-groove technique, featuring geometrical designs and containing a *mashrabiya*-like balustrade.

To the left of the entrance, one can see a stalactite recess with a window overlooking the interior of the mosque, above which is a marble plaque inscribed with further praises for the sultan as well as the date of construction. A third small entrance leads to the other upper and lower components of the mosque. Above this entrance is another marble plaque, also with poetry and the date 1186/1772, which, as mentioned before, is the date of the last restoration done on the pre-existing *zawiya*. The façade of the mosque is shielded by a wooden cantilever, which is a feature unique to this building.

The plan

The mosque consists of a closed courtyard surrounded by covered *riwaq*s, two aisles deep toward Mecca and

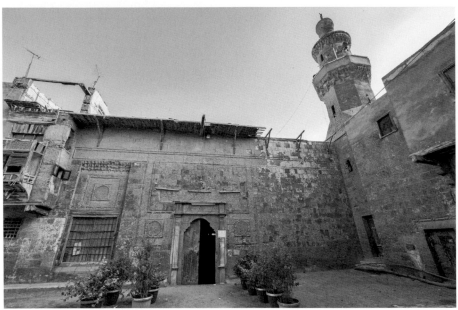

Figure 4.42. The main façade of the Complex of al-Sadat al-Wafa'iya (by Karim Saada).

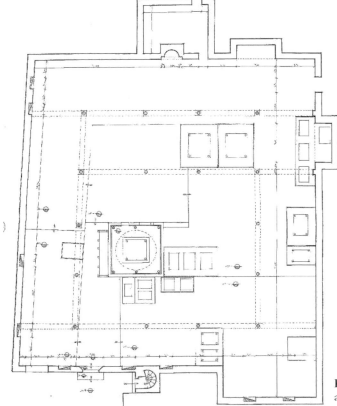

Figure 4.43. The plan of the Mosque of al-Sadat al-Wafa'iya (plan by the Ministry of Antiquities).

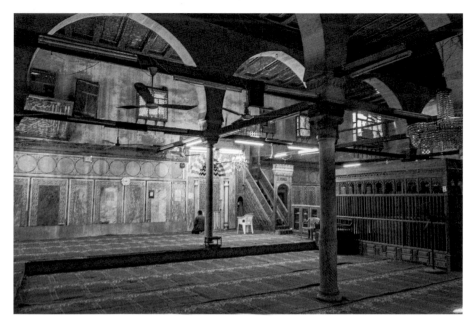

Figure 4.44. The *qibla* wall of the Mosque of al-Sadat al-Wafa'iya (by Karim Saada).

The *qibla* wall is covered with colored marble in red, white, and black featuring roundels in the upper part and marble mosaic and panels in the lower part. In the left corner of the *qibla* wall are two panels of marble that bear poetic script praising Ahl al-Wafa' (figure 4.44).

The mosque contains many tombstones surrounded by *maqsura*s arrayed around Shaykh Muhammad Wafa' and his son. The whole building is covered with a painted wooden ceiling with an inscription band running around it that includes an inscription praising al-Sadat al-Wafa'iya and ends at the eastern corner with the date of completion.

This building, which is a *zawiya* and mosque, displays and revives the importance of this particular *tariqa* (order) that seems to have been so popular that it received the direct attention of the Ottoman sultan. It is reminiscent of the complex of al-Kulshani, with the shaykh and founder's burial being the focal point of an architectural project and his disciples buried around him and with the presence of *khilwa*s, a mosque, and other components.

Conclusion

The Ottoman conquest of Egypt in 923/1517 constituted part of their expansion into the countries of Islam. Their two main Muslim adversaries were the Sunni Mamluks of Egypt and Syria and the Safavids of Persia. Between the years 920/1514 and 923/1517, the Ottomans annexed Syria, Egypt, the Hijaz, and Iraq, as well as parts of eastern Anatolia and northwestern Iran. They also controlled the Red Sea and the Persian Gulf. As mentioned in the introduction, Sultan Selim conquered Syria in 928/1516 and a year later defeated the Mamluks who ruled both areas. At first he killed many Mamluks, as told by Ibn Iyas, who witnessed the massacre and was shocked at the brutality of the Ottomans in Egypt. He portrays Sultan Selim as nervous, cruel, and bloodthirsty and the Ottoman soldiers as bloodthirsty as their sultan.[1] Sultan Selim then decided to incorporate the Mamluks in his army, recognizing their ability as soldiers as well as the common origin of the military slave system in both the Mamluk and Ottoman regimes. He was also conscious of the need to maintain a strong army to face the Safavids. This policy proved in time to be one of the main reasons for the decline of Ottoman power in Egypt. The revolt of Janbirdi al-Ghazali to restore Syria and his granting himself the title *al-Malik al-Ashraf Abu al-Futuhat* prompted the Ottoman sultan Suleiman the Magnificent (r. 926–74/1520–66), the successor of his father Sultan Selim, to eradicate the Mamluks' power in Syria, maintaining them within the boundary of Egypt under the authority of the Turkish viceroy. The nomination of Mamluks as pashas or viceroys after Khayrbak was abolished. Power in general was vested in the person of the sultan, who was also the guardian of the holy sanctuaries of Mecca, Medina, and Jerusalem. The grand vizier was the head of the government, and below him were viziers who controlled the army, provincial governments, and the collection of taxes.

The Ottoman Empire reached its zenith during the reign of Sultan Suleiman the Magnificent. By the end of his reign, its power stretched across the Mediterranean, the Red and Black Seas, and lands from Baghdad to Algeria, as well as a large part of Austria and Hungary that also recognized Ottoman sovereignty. Yet the Grand Vizier Lutfi Pasha, who had been deposed by Sultan Suleiman because of disputes arising in the harem in 947/1541, wrote a book about the history of the Ottoman Empire up to his day in which he was deeply concerned about the fate of the empire. He was able to lay his fingers unerringly on what became in the years to follow the characteristic signs of Ottoman decline: "inflation and speculation, venality and incompetence; the multiplication of a useless and wasteful army and bureaucracy; the vicious circle of financial stringency, fiscal rapacity, and economic strangulation; the decay of integrity and loyalty; and beyond them all the growing, menacing shadow of the maritime states of the West."[2]

Egypt's transition from Mamluk to Ottoman was eased by the fact that the first governor was a Mamluk. His title became Amir al-Umara' (Leader of the Amirs), which was equivalent to the Ottoman title *Beylerbey*. He did not receive the title pasha as his successors did since he was not from the Ottoman ruling establishment. Egypt in fact never became a regular Ottoman province and the military feudal system, which indicated a complete integration of a province into the empire, never applied in Egypt. The viceroy received an annual salary from the Egyptian treasury, which was regularly filled from the *kharaj* (land tax), custom duties collected at sea ports, and tax farms. He was also required to maintain the administration of the province, supervise the yearly pilgrimage caravan, as well as the Ottoman army and navy in the Red Sea and Yemen. Any surplus was sent annually to Istanbul with the agricultural produce.[3] In years of low flood when tax collection could not cover expenses, the viceroy was responsible for covering the required expenses, leading to harsh treatment of the inhabitants.

Architecture can, in many cases, be considered a mirror of a society, although rulers sometimes use it as propaganda to hide a declining economy and power. This was the case at the end of the Mamluk period with the beautiful buildings built by Sultan Qaytbay at a time when the economy and power were in decline. But for the people, prayers were all they could afford to face the problems of economy and the ruthlessness of the angry bureaucrats and army. This heightened the influence of Sufi shaykhs, as discussed in chapter one, "The Bridge." The Mamluk *khanqah* institution was abolished, raising in power the Sufi *tariqa*s. The foundations built for their shaykhs showed different architectural plans that were mostly variations of already existing plans but with the addition of a new style of minaret to indicate the acceptance of the new rulers.

The first Ottoman Imperial-style mosque appears during the reign of Sultan Suleiman the Magnificent and the proclamation of the Qanunname, which brought order to the political organization. "One of the code's most outstanding features is the principle of continuity from Mamluk times, even though the Ottomans had to suppress two serious Mamluk rebellions and put down Bedouin disturbances. The Qanunname expressly states that laws dealing with taxes, customs duties, and other fiscal and administrative matters promulgated by Qaytbay, the Mamluk sultan from 1468–96, who fought the Ottomans in Anatolia, were to remain in force."[4] The Ottoman Imperial-style mosque, built by the viceroy who was sent by Sultan Suleiman, can be considered a symbol of the new rulers, and its decoration a continuation of Mamluk taste and details. But the Ottoman Imperial-style mosque did not dominate the landscape of Cairo. Only two mosques were built in that style during the sixteenth century—the above-mentioned one and that of Sinan Pasha—while only one was built during the seventeenth century, namely the Mosque of al-Malika Safiya, and one during the eighteenth century, the Mosque of Muhammad Bek Abu al-Dhahab. All of these

mosques mingled Mamluk-style decorations with an Ottoman plan, providing the contrast of new versus continuity. *Zawiya*s for Sufi shaykhs remain dominant throughout, alongside the *takiya*-madrasa institution that replaced the Mamluk *khanqah*. The *takiya* was a not a formal teaching institution for Sufis like the *khanqah*, and the two madrasas built in Cairo— namely those of Suleiman al-Khadim and of Sultan Mahmud I—were in fact lodging and meeting places for specific *tariqa*s.

The majority of the surviving religious buildings show a continuation of the various plans built by the Mamluks, especially the Burji Mamluks (r. 784–923/1382–1516). The mosque with no open courtyard or with a covered one, and the division of the space in the prayer area into three aisles divided by columns supporting arches with a lower central corridor (also known as the Baldachin plan), which became so popular in Ottoman buildings, are in fact a continuation of the Khanqah-Mausoleum of Sultan Barsbay in the Northeastern Cemetery in Cairo (c. 833/1430). The *qa'a* plan seen in the Mosque of Taghribirdi and the four-iwan plan with a central lantern as in the Mosque of Yusuf Agha al Hin can also be considered a continuation of the Burji Mamluk dynasty. The sixteenth century introduced a new approach to the closed prayer space, as seen in the Mosque of Dawud Pasha. It can be considered a solution to supporting a small but wide prayer space by an arch and without a central lower corridor, thus achieving a one-space prayer area. Although Mamluk plans continued, and marble panels and mosaic decoration continued alongside, surface decoration declined. Façades became simpler, with very little carving compared to the Mamluk period. It becomes clear that Cairo was different from other provincial capitals like Damascus where the Imperial-style mosque emphasizing Ottoman domination prevailed.

Tilework started with the Bahri Mamluks from the fourteenth century, as can be seen on the minaret of the Khanqah of Sultan Baybars al-Jashankir in the al-Gamaliya quarter, as well as on the dome and minaret of the Mosque of Sultan al-Nasir Muhammad in the Citadel. These were monochrome, usually green, blue, or turquoise, while some tiles with inscriptions had a little more color on the minarets of the above-mentioned mosque as well as at the base of the domes of Khawand Tughay in the Northeastern Cemetery and Amir Aslam al-Baha'i al-Silahdar in the Darb al-Ahmar area, as attributed by Michael Meinecke to Persian ceramists working in Cairo.[5] After the Ottoman conquest, monochrome tilework in green and turquoise-blue continued, as we have seen, in the tiled minaret and domes of the Mosque of Suleiman Pasha al-Khadim, the dome of the Mausoleum of Shaykh Seoud, and the pointed top of the minaret of Shahin al-Khalwati. Blue and while tiles, probably imported from Anatolia, appear in the drum area of the Mausoleum of Prince Suleiman. All of those buildings were built in the first half of the sixteenth century. The use of tilework seems to have lessened during the second half of the sixteenth century, but it revived again later. Tiles imported from the Anatolian town of İznik were first introduced in the late sixteenth and the early seventeenth centuries. "The colors included tomato red (Armenian bole) in addition to cobalt blue, turquoise, (emerald) green and black for contour lines over a white background," like the ones still surviving on the Mausoleum of al-Kulshani.[6] The remaining tiles on the façade are a mixture of locally produced tiles from the second half of the eighteenth century, which include early seventeenth-century blue and white İznik tiles, Tekfur Sarayı tiles with red and yellow Moroccan style tiles, and European style tiles, many with Chinoiserie décor.[7] It seems that when importation of tiles decreased, a local tile industry emerged, which by the 1740s included Maghribi potters. Their produce can be seen not only on the Mausoleum of al-Kulshani, but also on the Zawiya of 'Abd al-Rahman Katkhuda as well as on his *sabil-kuttab* on the Fatimid Qasaba in the area known as Bayn al-Qasrayn, and finally on the Mosque of al-Shawazliya.[8]

The appearance and development of tiles on Ottoman religious architecture can be summarized as follows:

1. Blue İznik tiles reached Cairo during the late sixteenth century, and by the early seventeenth century, the tiles started to include red color.
2. The Tekfur Sarayı Istanbul tiles reached Cairo by the 1730s, and by the 1740s Moroccan ceramists settled in Cairo and formed an atelier inspired by the Tekfur Sarayı designs.
3. From the 1770s a limited number of blue and white tiles from Kutahya reached Cairo.
4. Throughout the eighteenth century, red and blue İznik tiles were used in combination with other tiles in buildings and also to repair or replace older tiles.
5. Finally, the use of tiles with different colors and decoration was to obtain contrast patterns, an application that appears to be directly inspired by the Mamluk style polychrome marble inlay paneling.[9]

During the Ottoman dynasty, Cairo experienced three centuries of urban growth which can be seen on the first map that was drafted by the scholars of *Description de l'Égypte* (figure 5.1). This shows that although the city had lost its position as the capital of an empire, it remained the primary link for trade to the east despite the discovery of the Cape of Good Hope. Al-Qahira district was already crowded during the Mamluk period, but most of the districts surrounding it were not. The "posh" areas were mostly along Birkat al-Fil, al-Azbakiya, and al-Nasiriya to the west. But at the end of the fifteenth century, the southern extension of al-Qahira district had become substantially urbanized, and this continued under the Ottomans starting with the architectural project of Iskander Pasha. He was the viceroy from 963/1556 to 966/1559, and started a building project in the area between Bab Zuwayla and Bab al-Khalq. He built a large mosque, a *takiya*, and a *sabil*, as well as commercial structures to finance the religious ones such as shops, rental buildings, and a sugar refinery, but unfortunately nothing remains of his complex today.[10]

By the year 1600, Sultan Mehmet III ordered the governor Khidr Pasha to buy the tanneries, which bordered the project of Iskander Pasha, and move them to the area of Bab al-Luq.[11] Three mosques were built in this new residential expansion between 1019/1610 and 1034/1625: those of al-Malika Safiya (1019/1610), al-Burdayni (1025–38/1616–29), and Yusuf Agha al-Hin (1034/1625). Many amirs moved to this new residential area, the richer ones building houses along the ponds that became, as André Raymond wrote, "surrounded by a continuous belt of houses."[12] Another major urban construction work in this area was the one undertaken by Radwan Bey directly south of Bab Zuwayla between the years 1038/1629 and 1077/1667. The third urban construction was along al-Darb al-Ahmar between Bab Zuwayla and the Citadel by the amir of the Janissaries Ibrahim Agha. He restored the Mosque of Amir Aqsunqur, adding tiles to the *qibla* wall and to his mausoleum located inside the mosque, and restored other buildings, both religious and residential.

The sixteenth century was, as we have seen, governed quite effectively by Istanbul-appointed pashas until the first problems arose around the year 998/1590 with many Mamluk soldiers revolting. Muhammad Pasha (r. 1015–19/1607–11) managed to put an end to the revolt but his successors began losing power, which shifted to leaders who were Mamluk beys. Only one Imperial-style mosque was built during the seventeenth century, and no new approaches to space were introduced, except for the missing lower central corridor in plans with three aisles from the Mosques of Sidi Ruwaysh, Marzuq al-Ahmadi, and Ribat al-Athar to give the feeling of an undivided single-space prayer area. This can be considered a development in the one-room prayer space, which started earlier with the nonextant Zawiya of Shaykh Murshid and the Mosque of Dawud Pasha. The use of tiles to decorate exterior lunettes and drums of domes, and interior *qibla* walls and *mihrab*s was introduced in the Mosques of Alti Barmak and the Mosque of Mustafa Jorbagi Mirza. *Zawiya*s continued to be built, reflecting the continuing importance of Sufi shaykhs, but

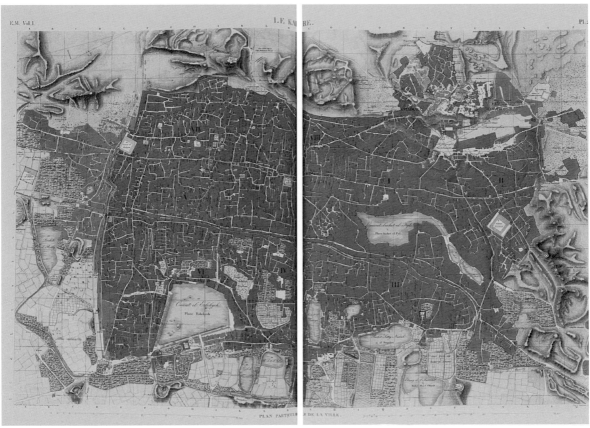

Figure 5.1. Map of Cairo (after *Description de l'Égypte* Vol. I, pl. 26, courtesy of the World Digital Library Online Art Collection).

none were as impressive as the one built for Ibrahim al-Kulshani in early sixteenth century with its mausoleum on a platform in the center of a number of rooms, indicating a veneration of saints. This may suggest the decline of the veneration of Sufi shaykhs in addition to the decline in funds.

The overall impression of the late sixteenth and seventeenth centuries indicates weak control from the Ottoman capital over the architecture in Cairo. It also reflects a marked mingling of Turks and Egyptians, closing the gaps between them and absorbing the newcomers into the local culture and taste. Pashas in general did not build mausoleums since they expected to return to Istanbul in the hope of serving as grand viziers. Except for Mahmud Pasha, none of

the mosques built during the sixteenth century were funerary ones. Funerary mosques became more common in the seventeenth century when many buildings were built by local Mamluk amirs.

A marked change can be seen during the eighteenth century because of the rising power of Mamluk beys in the Janissary corps. The problems of succession to the throne in Istanbul and the intrigues between members of the ruling family there weakened the influence of the sultanate over the provinces, especially Egypt. The Mamluks became more powerful and influential than the soldiers of Turkish origin in the Janissary corps, and this is reflected in the architecture of the city of Cairo, not necessarily in the architectural plans but more in the surface decoration.

The mosque with three aisles would remain dominant alongside irregular plans for Sufi *zawiya*s to deal with the problem of space. New buildings had to fit in already crowded areas, either replacing older buildings or covering irregular small plots of land. Inner decoration diminished while exterior decoration flourished.

The family of Qazdughli, who were Janissaries of Mamluk origin, dominated the political and architectural scenes during the middle of the eighteenth century. Hanna points out the rise of the emphasis on individual households and not the court of rulers.[13] Households became private political centers for the discussion of state matters. Power was decentralized from the residence of the pasha to private households. Many religious buildings were either built or renovated by the Amir 'Abd al-Rahman Katkhuda, especially *zawiya*s for Sufis, indicating the revival and continuation of the influence and interest in Sufism at that time. A marked revival of Mamluk-style influence on architecture can be seen in the appearance of stone carving on the façades of buildings, in spite of the plain interiors of mosques, *zawiya*s, and *takiya*s. The carving is reminiscent of the Qaytbay style at the end of the Mamluk period but with additions, as expected, of Ottoman features such as double moldings with angular loops, pine tree and floral elements, as well as tiles, especially in the lunettes. Stone carving is abundant on the façades of the Mosque of al-Shawazliya and the Mosque of al-Hayatim. Inscriptions in *naskhi* script continued but were now placed in small cartouches and consisted of poetry before the addition of the foundation date. Turkish inscriptions became more common, probably reflecting the rise of the use of the Turkish language alongside Arabic in Egypt. Many Turks had settled down in Egypt and married into Egyptian families, forming a unified society, not rulers and ruled.

Only one Imperial-style mosque was built during the eighteenth century, namely the mosque of Muhammad Bek Abu al-Dhahab, who had helped the Ottomans regain power after the attempt of 'Ali Bey al-Kabir to break away from them. The building follows the plan of the earlier Mosque of Sinan Pasha but with the inclusion of a mausoleum for the founder and his family members. So here we see a pasha, a Mamluk bey, assisting the Ottomans against his Mamluk companions, repeating more or less the scenario of Khayrbak three centuries prior. But this time his Imperial-style mosque shows an amalgamation of the Mamluk and the Ottoman styles where the two identities had become fused, unlike the case of the Mosque of Sinan Pasha, which was meant to impose a solely Ottoman identity by dominating the area around it that was not yet so crowded. This contrasts with the location chosen by Muhammad Bey Abu al-Dhahab, who wanted to fit himself within the urban fabric of al-Azhar quarter, which was bracketed by the prestigious institution of al-Azhar Mosque and the monumental complex of al-Ghuri. His complex also aimed at consolidating Sunni rule over Egypt by intending for his mosque to be a continuation of al-Azhar's institution. The awakening of the sultans' interest in Egypt is intriguing. The three sultans funded three pious buildings during that century: the Takiya-Madrasa of Sultan Mahmud I and the Sabil-Kuttab of Sultan Mustafa with their Tughras carved on the façades, and the restoration of the Zawiya of al-Sadat al-Wafa'iya by Sultan Abdul Hamid I, turning it into a Zawiya-Mosque surrounded by several buildings—a complex like the one built for 'Uqba ibn 'Amir a century earlier. One can interpret this as a final attempt to restore the Ottoman presence in Egypt at a time of revolts and unrest within the Janissary corps.

The city of Cairo is still called today "a Mamluk city" with its magnificently carved stone domes, variety of minarets, and huge complexes of buildings still surviving from the Mamluk period when Cairo was the capital of the Islamic Empire. This architectural zenith led to a disregard for the architecture of the period that followed when Egypt lost its independence and Cairo its status as the capital of the Islamic world. The religious monuments from the Ottoman period may not appear as dominant

in the landscape as their predecessors, but the novel approach to the use of space, the introduction of colored tilework wall facing, and the development of inscriptions all merged with the preexisting style of the Mamluks to establish the Cairene style of religious architecture. The addition of the new round-shaft and pointed-top minarets that also dominate the landscape side-by-side with their predecessors contributed to the skyline of Cairo, which we call today "the City of a Thousand Minarets." Finally, when all the architectural monuments of Ottoman Cairo are revisited, when all the Ottoman religious building plans are framed in their rightful historical context, was Ottoman Cairo a rising star? Or was it a setting sun on a rich architectural heritage? It was, in reality, neither. Ottoman Cairo was a continuing evolution that reflected the architectural development of the city. It integrated the past with the present, culminating in a splendid finale, a perfect city with a brilliant architectural history.

Four Ottoman Sabil-Kuttabs

An Introduction
The *sabils*

The *sabil-kuttab* (in Turkish *sebil-mekteb*) seems at first glance an unusual architectural juxtaposition, yet in religious terms the structure implements two of God's commandments: to supply clean drinking water to mankind and animals and to provide basic Islamic education, often for orphaned or impoverished children as the Qur'an repeatedly urges believers to do.[1] Although unattached drinking fountains and Qur'an schools can be found throughout the Muslim world, the *sabil-kuttab* combination appears to be restricted to Egypt, where the origins of this composition are traced back to the late Mamluk period when *sabil-kuttab*s were part of larger religious building complexes. In the fifteenth century, the earliest "freestanding" *sabil-kuttab*s were built. From then on, this composition developed an independent identity, which reached its full development during the Ottoman period. By the seventeenth and eighteenth centuries, the *sabil-kuttab* had become the most common religious foundation in Cairo.

In the Qur'an, the word *sabil* and its homonyms have been used and mentioned both metaphorically and literally in several suras.[2] A *sabil* can indicate a path or a route, as mentioned by God in Qur'an 16:15 "وأنهارا وسبلا." It was also used to convey obedience of the words and commandments of God. The Qur'an also orders the issuance of zakat to a number of parties, among which is *ibn al-sabil* or the passerby, pedestrian, or traveler.[3] Since water is mentioned in the Qur'an as a symbol of God's creation, the *sabil* was thus regarded as one of God's houses that patrons sought to erect. Their builders' goal to establish a pious foundation, striving eternally for God's reward and for the prayers and *du'a* of their people, in addition to their desire for "self-glorification" and commemoration, could only be established if their fountains were actually used.[4]

Before there were *sabil*s, to satisfy their water needs Cairene residents relied either on rain, which was scarce and insufficient, or wells, which provided brackish water unfit for human use and were used only in times of crisis. The sole source of drinking water was the Nile, which lay at a distance of 800 meters at the height of Bab al-Luq and 1,300 meters from the western edge of al-Qahira.[5] The importance of the Nile water to the residents of al-Qahira was evident for over ten centuries since its foundation; life had been tied to the Nile, whether for its pure drinking water or its use in economic activities.

Raymond states that Cairene water fountains built during the Ottoman period numbered around three hundred *sabil*s (according to *Description de l'Égypte*), and they were distributed evenly through the built-up area in the city depending on the distribution of residents. Most of the Ottoman *sabil*s were attached to buildings, contrary to the popular assumption that *sabil*s became freestanding structures during the Ottoman period. This is mostly due to the scarcity of available space within the city, especially that such a pious institution should be located within a crowded district to serve its citizens and passersby.[6] Unlike during the Mamluk period, *sabil*s built during the Ottoman period were sometimes attached to a residential building. Pauty comments on this by saying that *sabil*s replaced the grandeur they earned by being attached to a mosque with the simplicity they gained by being attached to residences.[7]

Although sizes may vary, all public fountains have the same composition distributed on two levels.[8] The first level was located underground and called the cistern (*sahrij*), which is water storage space. It can differ in size, depending on the overall area available for the *sabil* and the financial ability of its patron. The cistern usually took the form of a square area, topped by shallow domes and supported on columns or pillars. The cistern is pierced with an opening resembling that of a well.[9]

The second level is the *sabil* itself, which is constructed at ground level or a little bit above it and is usually accessible through a separate entrance. This level consists of the *tasbil* room, around which the rest of the dependencies of the *sabil* are laid out. The layout of the *tasbil* room and its dependencies depends on its location and the available area, in addition to many external factors. Yet mostly, the prototype of the *sabil* is either a rectangular or square space with a carved, finely decorated and painted wooden ceiling and marble flooring. Walls were built of finely cut, well-dressed limestone in alternating white and red stone courses. The façade was pierced with large windows with bronze grilles through which people could reach in for water as they pass by. While the exterior architecture was simple and pure, the inner space was always cheerful and colorful.[10] The Qur'an provided the Muslim architect with inspirations through its depictions of Paradise with its springs, fruits, and trees and led him to obtain perfection in both symbolic and aesthetic. In Qur'an 76:17–18, God mentions the springs of *salsabil*. This was translated by the architect into the *shadirwan* with its inclined marble slab, "the *salsabil*." Its chevron design surrounded by figures of animals and fish and the smooth flow of water over this design interplayed with the serene sound of trickling water, which was collected in the water basin decorated with marble mosaics where it remained cool.[11]

The location of the *sabil*, the available area, and regional and artistic variations led to differences in their shapes and layouts, which led to their division and classification into two distinctive types of Cairene Ottoman *sabil*s:

1. *Sabil*s of a local style
2. *Sabil*s of Turkish influence

Collectively, these structures were constructed by the *a'yan* of the Arab provinces and conveyed an array of political, economic, and religious messages. Through the founder's choice of style and ornament, a building could mark a notable household, as seen in the exclusive artistic style of 'Abd al-Rahman Katkhuda, as a power in its own right, and/or as the loyal servant of the Ottoman sultan as in the case

of *sabil*s built during the reign of Muhammad 'Ali, which followed the Baroque and Rococo movement of Istanbul. A *sabil*'s size and ostentation, or the extent of its charitable or intellectual effect, could attest to the founder's wealth and influence.[12]

Ottoman *sabils* of a local style

The local style is the one found in most Cairene Ottoman *sabil*s. Until the eighteenth century, the style of Ottoman *sabil-kuttab*s followed the Mamluk school of art and architecture. The number of *sabil*s built in this style is sixty-three among seventy surviving *sabil*s that belong to the Ottoman period. These *sabil*s retained the Mamluk style in their architecture, as the *tasbil* room was either rectangular or square in its layout, depending on the available construction space. Its flooring was usually covered in marble and its roof was a flat wooden roof that rested either on beams or consisted of squares nailed down at their centers. By following the Mamluk composition of the *sabil*, there was usually a *shadirwan* in a recess in the wall opposite the main *tasbil* window, and beneath the *shadirwan* was a *salsabil* slab where water would run into the *tasbil* basins. The *tasbil* room was always faced with windows, which did not exceed three, through which water was distributed to passersby. The *sabil* windows were preceded on the outside by a marble slab on which to rest the water jugs. *Sabil*s built in the local style are subdivided into three categories.

Single-window *sabil*s (twenty-seven built during the Ottoman period, all dating from the seventeenth and eighteenth centuries)
Most of these *sabil*s (a total of twenty-one) are attached to a pious building built by the same patron: a *wikala*, a mosque, a *manzil* (a house), a mausoleum, a water trough, a *zawiya*, or a *rab'*. Most of them are built either with one *tasbil* window that overlooks the street or two windows that overlook a corner. In some cases, the *sabil* façade includes a *musasa sabil*.

In addition, most of these *sabil*s are topped with *kuttab*s to teach Qur'an to children. A few

*sabil*s are not topped by an additional component, one of which is the *sabil* attached to the Mosque of Aqsunqur al-Fariqani.

Two-window *sabil*s (thirty-three built during the Ottoman period, nineteen of which are freestanding)
Most of the two-window *sabil*s overlook the intersection of two streets. Gradually, this type of *sabil* became independent of any attached buildings. There are thirty-three *sabil*s of this type, nineteen of which are freestanding. By André Raymond's analysis, patrons sufficed with constructing freestanding, small structures that required less funding.[13] Since the overall available space in the city was scarce, this was also a good reason to build in this way. These more simplistic structures can be contrasted with the Mamluk period, which was characterized by grandeur and luxury in its constructions. Many Mamluk *sabil*s were attached to grand projects. In addition, the patron during the Mamluk period was the sultan himself, as opposed to the Ottoman period, in which many founders were amirs or *wali*s who did not expect to remain in Egypt for a long period of time. Thus, when we look at the few sultanic *sabil*s built during the Ottoman period, namely those of Sultan Mahmud I and Sultan Mustafa, they tend to match the Mamluk standards of *sabil* constructions.

Another component of the two-window *sabil* is a residential *qa'a*. These exist in eight of the total number of two-window *sabil*s built in the local style during the Ottoman period. *Kuttab*s tended to detach gradually from *sabil*s, which started to take on a context other than the religious one they enjoyed when they were attached to mosques. By the Ottoman period, a *sabil* started turning into a secular service by being attached to a residence or *wikala*. The Sabil of Muhammad Bek Abu al-Dhahab is the only *sabil* that retained the religious context of the *sabil* by being attached to a mosque and *takiya*.

Three-window *sabil*s
*Sabil*s with three windows are scarce. Their total does not exceed three, matching the surviving number of

three-window *sabil*s from the Mamluk period, reflecting the fact that during the Ottoman period space available for construction was scarce.[14] These three *sabil*s each date from a different century of Ottoman rule in Egypt. All three *sabil*s are topped with *kuttab*s, and two of them are attached to other buildings.

Ottoman *sabils* of Turkish influence

*Sabil*s with Ottoman influence adapted a style that was very alien to Cairene architectural traditions. These types of sabils were first constructed in the eighteenth century. They took *sabil*s in Istanbul as their prototypes, as the *tasbil* room was either square or rectangular, but they overlooked the street through a curvilinear façade. We no longer see stalactites, arabesque, or geometric designs; instead, we see vases with acanthus-like leaves and realistic floral decorations. Ottoman architecture in Cairo showed a revival of several Byzantine and Anatolian patterns, including round arches of the windows dominating the façades, which are often semicircular in shape. The window grilles are made of bronze and have more elaborate designs than those of the late Mamluk and early Ottoman periods.[15]

These *sabil*s overlook the street through three windows placed in recesses, supported on engaged columns.[16] The maximum number of windows found in a *sabil* constructed during the Ottoman period is three.[17] On the other hand, in Istanbul, the Sabil of Mimar Sinan has five windows, while the Sabil of Sultan Ahmet in Tophane (c. 1140/1728) reaches a total of twelve windows. As in local-style *sabil*s, the windows were preceded by a marble slab on which to place water jugs. On the façade of the *sabil*, there was usually a *musasa sabil*, and sometimes two placed either side-by-side or one at either end of the *sabil*'s façade.

The *tasbil* room from the inside was paved with marble flooring and sometimes the walls would contain marble dados, as in the Sabil of Sultan Mahmud I and the Sabil of Sultan Mustafa, while others followed the local-style *sabil*s in their plain walls. The ceiling was usually of painted wood and nailed for support. What is worth noticing in the case of these *sabil*s is the absence of the *shadirwan*, since the water was moved from the well of the cistern to the water basins.[18]

These *sabil*s were based on Istanbul *sabil* prototypes, even in the distribution of the dependencies surrounding the *tasbil* room. Nevertheless, these *sabil*s were unable to compete in number with local-style *sabil*s, since *sabil*s built with Turkish influence in Cairo do not exceed seven between the year 1163/1750 and Napoleon Bonaparte's campaign in the Ottoman territories of Egypt and Syria in 1212/1798. In comparison, local-style *sabil*s built in the same period total around eleven.[19] Even in the case of *sabil*s with Turkish influence, the location of the cistern below and the *kuttab* above are a local variation that show the strength of Cairene architecture.[20]

*Sabil*s built with a Turkish influence are found both freestanding (three) and attached to a pious building (four). Whether they were freestanding or attached, this did change the layout of the *sabil*; they all included a separate entrance to the *sabil* with another entrance to the *kuttab*. This is particularly accentuated in the Takiya of Sultan Mahmud I where we find that the *sabil* and *kuttab* are two totally distinct components of the building.

The functionaries of a *Sabil*

While boys memorized the Qur'an and learned basic Muslim doctrine upstairs, functionaries inside the *sabil* drew water from the cistern, maintained it, filled the basins, and served water to passersby. These functionaries were dedicated to the governance of the *sabil* in a systematic and specialized way. *Waqfiya*s specified the duties of each employee in addition to the rubric on which they were chosen; among the most important of these were the *nazir al-waqf*, *al-mazmalati*, *al-saqqa'*, and *al-farrash* (the doorkeeper).

Nazir al-waqf

The title *nazir al-waqf* was given to the supervisor of the *waqf*, and especially the financial supervisor; he was responsible for overseeing the *waqf*'s service

cycle, maintaining it and developing it, as well as making sure that rights and benefits were distributed based on the endower's wish. Since most *sabil*s were part of large *waqf*s, they were either supervised by the founder of the *waqf* himself or a *nazir* that he had appointed who was rewarded an annual salary in exchange for his services. Because the *nazir* of a *sabil waqf* was so vitally important, some people were listed by name for this position and it was to be passed down to their descendants until the end of their lineage.

Al-Mazmalati

A crucial function in a *sabil* was that of *al-mazmalati*. He was responsible for working in the *sabil* in the hours specified by the endower in the *waqfiya*, transferring water from the cistern to the *mazmala* basins, then distributing it among the thirsty, in addition to filling the water basin of the *musasa sabil* if applicable. Usually he was also in charge of lighting the sabil inside and out, guarding and cleaning the equipment of the *tasbil*, spraying water in front of the *sabil* and cleaning its interior, and drying its basins at the end of the day in preparation for the next. Usually, each *sabil* had only one *mazmalati* regardless whether it was a one-, two-, or three-window *sabil*. Nevertheless, there were cases where the *nazir* appointed three *mazmalati*s, as in the Sabil of 'Abd al-Rahman Katkhuda in al-Nahasin. In some cases, the *mazmalati* could appoint an assistant who was responsible for raising water from the cistern to the *tasbil* basins, and the *mazmalati* would take on the function of water distribution only. In some of the popular *sabil*s, there was a higher post of a *mazmalati* who was responsible only for water distribution in addition to the overall process of *tasbil*. This position was known as *sabili-awwal*, and had three assistants serving water at the windows, plus a fourth individual responsible for raising the water from the cistern. By this, the total number of working employees at a *sabil* reached five employees. Thus, under the Ottoman Empire, the role of the *mazmalati* went from being a functional position to a supervisory

position. The rubric for this post was detailed, specifying a pious and physically capable Muslim man, keen on personal hygiene, with a strong figure and sincere features. Mamluk *waqfiya*s provided more elaborate conditions for the post of the *mazmalati* as being a man free of illness who treated people with kindness and generosity.

Al-Saqqa'

The water transfer process was through the water carriers (*saqqa*'s), who drew water from the river from particular locations and loaded their *rawiya* of cowhide or the *qirba* of goatskin onto camels and donkeys then shuttled back and forth between the Nile and the city.[21] The distribution of water throughout the city was through retail water sellers and specified *saqqa*'s to provide cistern water and others to provide brackish water, typically used for cleaning and other non-drinking uses. According to Raymond, the number of water carriers was around ten thousand during the Ottoman period, if calculated based on needs and consumption, while almost four thousand of them were still working in 1287/1870.[22] The water delivered to houses was tracked by a subscription system, inscribing lines on the client's door that corresponded to the number of deliveries completed. The *saqqa*'s were not mentioned in the *waqfiya*s, as they were not listed as official employees of the *sabil*, since their job was seasonal or annual and only for a limited number of days, usually during flood season. The *saqqa*' did not report to the endower or *nazir al-waqf*, but to a leader of the *saqqa*' clan; only *hisba* documents mentioned the different traits that the *saqqa*' must have. The *muhtasib* should make sure that the *saqqa*' is a pious, honest man who does not mix brackish water with drinking water and who makes sure his *qirba* does not have holes, as this was a form of cheating. He should have a clean vessel that does not affect the taste, smell, or color of the water. Although the principle of running water made the *saqqa*'s job extinct, there are still some rural towns that rely on *saqqa*'s to provide them with drinking water.

The doorkeeper (*al-farrash*)

In addition to the *mazmalati* and the *saqqa*'s, most *sabils* had a doorkeeper to guard them; however, early Ottoman *sabils* did not have a doorkeeper, and it was up to the *mazmalati* to fill those shoes. This feature of a doorkeeper appeared in the late Ottoman *sabils*, especially if the *sabil* was popular and part of a multifunctional complex whose founder was of a high official rank, such as in the Sabil of Sultan Mahmud I on Port Said Street. If there was no doorkeeper, his other duties—sprinkling water in front of the *sabil*, sweeping, cleaning, and lighting it—were done by the *mazmalati* as mentioned earlier, with the exception of a *sabil* being part of a large complex; in this case, another individual was hired precisely for those tasks.[23]

The *kuttabs*

Another important component of the Cairene *sabil*, whether during the Mamluk or Ottoman period, is the *kuttab*. The phenomenon of *kuttabs* attached to *sabils* came from the simple concept of utilizing the upper part of the *sabil* structure and thus adding another public service that would reflect on the patron with more *thawab* and prayers. Evliya Çelebi, during his visit to Egypt (1083/1672–1091/1680), estimated the presence of more than two thousand *sabils* in Cairo alone.[24] The *kuttab* was endowed with an instructor who taught Qur'an, reading, and writing to children of the district, often orphans, and its upkeep was funded by the endowment of the *sabil*. The Cairene *kuttab* came in two styles:

1. The local-style *kuttabs*
2. The Turkish-influenced *kuttabs*

The local-style *kuttabs* usually consisted of a square or rectangular room, while the Turkish-influenced *kuttabs* corresponded to the curvilinear shape of the *sabil* below.

Kuttab rooms contained recesses in the walls that functioned as cupboards for the tools of the *mu'addib* and the children. In some cases, the room of the *mu'addib* or shaykh topped the dependencies of the *sabil*.

The *kuttabs* normally overlooked the street through arches supported on marble columns and were shielded off by a wooden balustrade. The entire structure normally had a wooden roof to shield the interior from the sun. *Kuttabs* built by 'Abd al-Rahman Katkhuda above his *sabil* in al-Nahasin and attached to the Mosque of al-Shaykh Mutahhar had an additional wooden extended roof.

The *kuttab* was usually reached through a common entrance with the *sabil* and a separate staircase. *Kuttab* architecture abided by the concept of "form follows function"; they were relatively simple, as they were merely intended to serve their purpose. Their architecture may have not evolved, since children could have been taught in mosques; however, Prophet Muhammad prohibited teaching calligraphy in mosques because the walls and flooring might be written over.[25]

It may not be a coincidence that *sabil-kuttabs* were commissioned by Hanafi rulers and grandees in a land where followers of the Shafi'i and Maliki legal *madhhabs* far outnumbered those of the Hanafi school. Most patrons of *sabil-kuttabs* specified in their endowments that the *kuttab* would provide instruction according to the Hanafi school. Because many *sabil-kuttabs* provided Qur'anic education to orphans, they could help to ensure Hanafism's continued viability in Egypt. Meanwhile, the drinking fountain, where crowds of people might stop daily, guaranteed wide public exposure to the foundation's mission. Overall, the *sabil-kuttab* gave the Hanafi school much-needed public viability in a region where is was decidedly in the minority.[26]

Sabil of Khusruw Pasha (942/1535)
Monument Number: 52
Typology: Freestanding, Local style, Two-window

The location

The Sabil of Khusruw Pasha lies in the area formerly known as Bayn al-Qasrayn. It was built right opposite the first *sabil* to be founded inside the Fatimid

settlement of al-Qahira—the Sabil of al-Nasir Muhammad—and it covers a fragment of the wall of the Madrasa-Mausoleum of al-Salih Najm al-Din Ayyub.

The founder

Khusruw Pasha was appointed Viceroy of Egypt in Jumada al-Thaniya 942/December 1535 during the reign of Sultan Suleiman the Magnificent, as mentioned in the foundation inscription on the façade.[27] He built this *sabil*, which is the earliest surviving Ottoman *sabil* in Cairo. It is classified as a freestanding, two-window *sabil* with a *kuttab* on top.[28]

The exterior

The *sabil* has two identical façades on the northwest and the northeast (figure 6.1). They are both ornamented with Mamluk-style decorations. Each façade of the *sabil-kuttab* is pierced with a window and metal grille, with the swastika motif on its upper part. Each of the grilles has "Allah" written in two of its openings. Below each window is a marble slab that was used to place drinking jugs. Each marble slab rests on three corbels. The area above each window is highly decorated with marble mosaics. The lintels are adorned with trilobed motifs in positive and negative, the lunette is left plain, and the relieving arch is decorated with the joggled voussoir typical of Mamluk architecture. The whole composition is surrounded, framed, and emphasized by the use of the double moldings with circular loops. The gaps within the moldings are decorated with stone carvings in geometric designs. Above the window composition is a large inscription band carved in marble that contains the foundation inscription and mentions Sultan Suleiman and his lineage, Khusruw Pasha and his titles, and the date of construction.

The *kuttab* above overlooks the street through two sets of two horseshoe arches, each resting on a reused marble column. The openings of the *kuttab* on each of the two façades are protected by a wooden balustrade. The *kuttab* is covered by a wooden roof supported on wooden corbels.

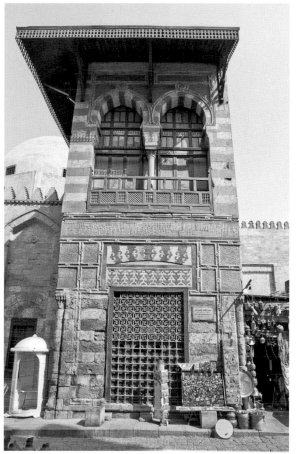

Figure 6.1. The façade of the Sabil of Khusruw Pasha (courtesy of Ibrahim Ramadan).

The interior

The Sabil of Khusruw Pasha can be accessed through a rectangular door on the southern end of the southwestern wall of the *sabil*'s room, which can be reached by a corridor that runs behind the copper and jewelry shops arrayed on the façade of the Madrasa of al-Salih Najm al-Din nowadays. Rare plans, sections, and elevations drawn by the Comité in 1903 show that the *sabil* and *kuttab* used to be accessed directly from an entrance on al-Nahasin Street in the area of Bayn al-Qasrayn, from the northwestern façade of the *sabil* (figure 6.2). They also show that the *sabil* and the *kuttab* each had a

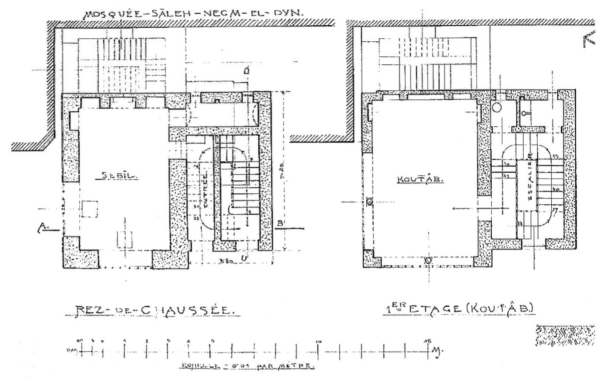

Figure 6.2. The plan of the Sabil and Kuttab of Khusruw Pasha (courtesy of Ibrahim Ramadan).

separate entrance; however, both of these entrances were replaced over time with copper shops and are no longer extant.

From the inside, the *sabil* room is a rectangular space that measures 5.70 × 3.70 meters. On the right as one goes inside, the eastern wall contains three recesses. The center recess contains the *shadirwan*, which was flanked by two columns (nonextant nowadays), while the lateral two were reserved for the tools of the *mazmalati*. The *shadirwan* is crowned with a stalactite hood, underneath which is a carved panel filled with arabesque designs, and below it rests the inclined marble slab or the *salsabil*. The carving of the *salsabil* is both projecting outwards and deep in relief and depicts floral motifs, framed with half-pine tree decorations. The water descended from the *shadirwan* to fill a basin underneath the *salsabil* from which water flowed all the

way to the marble rectangular drinking basins near the windows.

The floor of the *sabil* room is covered entirely with marble panels that form a beautiful geometric pattern. The *sabil* is topped with a flat wooden roof, supported on six beams. The roof is decorated with both geometrical and floral designs. The craftsmen who designed and worked on this *sabil* were keen on not leaving any empty spaces undecorated. A solution to this was to fill up any gaps with stems that branch out of the floral decorations. An inscription frieze runs under the cornice of the *sabil* room in which the Throne Verse is inscribed.

The *kuttab* could be ascended to by a metal staircase that was installed in 1909 behind the southeastern wall of the *sabil*. The *kuttab* follows the same layout as the *sabil* room, but remains a bit wider due to the slimmer walls used to build the upper floor.[29]

Sabil of Taghribirdi
(1044/1634)
Monument Number: 42
Typology: Attached, Local style, Two-window

The location
The Sabil of Taghribirdi is attached to the mosque that bears the same name. Both the mosque and the *sabil* lie on al-Maqasees Street, which branches out from al-Muizz Street.

Above the *sabil* is a *kuttab*, which is in the utmost left corner of the main façade of the mosque and overlooks two streets. Therefore, it might be classified as a two-window *sabil*, built in the local style with metal grilles.

Figure 6.3. The *shadirwan* of the Sabil of Taghribirdi.

The exterior
The *sabil-kuttab* of the Mosque of Taghribirdi is attached to the northwestern end of the mosque and lies at a corner of two streets. It is classified as an attached, two-window *sabil* with a *kuttab* above. It follows the local tradition of Ottoman *sabils* that still follow Mamluk architectural and decorative trends. The *sabil* windows, lintel, lunette, and relieving arch are framed with double moldings with circular loops. Like the Sabil of Khusruw Pasha, the *sabil*'s windows are covered with metal grilles with a swastika motif on their upper part. Also, each window of the *kuttab* above overlooks the street through two horseshoe arches, each resting on a reused marble column. Each opening of the *kuttab*, one on each of the two façades, has a wooden balustrade. The *kuttab* is covered by a wooden roof supported on wooden corbels.

The *sabil* is accessible through two entrances. The first is a large, shared entrance found on the northwestern façade, which leads to the ablution area of the mosque, the *sabil*, and the stairs that ascend to the *kuttab* above. The second entrance leads directly to the room of the *tasbil* from inside the northwestern iwan, which is opposite the *qibla* wall inside the mosque.

The interior
The *sabil* consists of a *tasbil* room, preceded by an attached square room. It contains in its northwestern and southwestern sides the windows that were used for water distribution for people passing by. The northeastern side contains the entrance to the anteroom of the *tasbil* room, beside which is the rectangular *shadhriwan* slab that is topped by a wooden stalactite conch. The *shadhriwan* in the Sabil of Taghribirdi is an inclined marble slab with a chevron decorative design, and an animalistic design of realistic deer, framed by another inscription band (figure 6.3). Al-Husayni states that the inscription is difficult to read nowadays, the entire *shadhriwan* is missing, and the *tasbil* room has been converted into a women's prayer area. At the time of

Figure 6.4. The ceiling of the Sabil of Taghribirdi.

Husayni's writing, the *tasbil* room was covered with modern wood flooring but the original was marble; nowadays it is covered with carpet that can be removed to see the beautiful geometric marble flooring. The ceiling of the *tasbil* is flat wood and divided into small squares, replicating the ceiling of the mosque. The cornice of this room is unique; it depicts palm and pine trees with tulips and chrysanthemums in between (figure 6.4). The *kuttab* on the first floor follows the same ground plan of the *sabil* and overlooks the street through two sets of two horseshoe arches, each resting on a reused marble column. The openings of the *kuttab* on each of the two façades have wooden balustrades. The ceiling of the *kuttab* is composed of wooden buttresses of square and rectangular forms decorated with geometric designs and star patterns.[30]

Sabil of Sultan Mahmud I (1164/1750)

Monument Number: 308
Typology: Attached, Ottoman influenced, Three-window

The location

The Sabil of Sultan Mahmud I is located on Darb al-Gamamiz Street off of Port Said Street. It occupies the corner of Harat al-Habbaniya toward the Sabil of Beshir Agha Dar al-Sa'ada.

The founder

This is part of a complex constructed by Sultan Mahmud I bin Sultan Mustafa Khan in 1164/1750 as inscribed on its main portal.[31] This *sabil* is of great significance among Ottoman *sabil*s in Cairo, as it is the

first sultanic Ottoman *sabil* and the earliest surviving *sabil* of a curvilinear façade in Cairo. It was constructed by order of Sultan Mahmud I in 1164/1750 and was executed by Amir Beshir Agha Wakil Dar al-Saʿada as mentioned in the *waqf* deed and the foundation inscription above the *sabil* and *kuttab*'s entrances.[32]

The exterior

The *sabil*'s entrance lies on the western façade of the complex on Port Said Street. To the right of the *sabil*'s entrance is a *musasa sabil* placed in a semicircular arched recess. Although the *takiya* and *sabil* are attached, the façade can be described and divided into three parts: the façade of the entrance of the *sabil*, the façade of the *tasbil* room, and the façade of the entrance of the *kuttab*.

The entire façade of the *sabil* is striped in *ablaq*, with the use of different masonry shades. The façade of the *tasbil* room occupies the southern part of the complex. A thin epigraphic band runs on top of the entire *sabil* façade and contains inscriptions in *naskhi* placed in cartouches. The *sabil*'s façade is broken by three large semicircular arched recesses framed with

a double molding with angular loops. Each recess is pierced with a semicircular arched window placed in a rectangular frame and used for delivering water to passersby. The spandrels of the large recesses and those of the windows are decorated with stem-and-leaf and floral motifs in Baroque and Rococo styles (figure 6.5). What can be considered the lintels or the arched areas between the larger recesses and the window openings contain the rare Ottoman Tughras in the city of Cairo, inscribed with the signature of Sultan Mahmud I. Between each of the large recesses is an epigraphic roundel with the foundation inscription, which mentions the name of Sultan Mahmud I and the date of construction of 1164/1750.

The *tasbil* windows have been blocked by a modern brick wall for years. This wall was constructed by the Comité in 1952 to protect the intricate grilles of the *sabil*. Only archive photographs show an uninterrupted view of these beautiful metal grilles with their curvilinear scrolls and ornaments (figure 6.6). Each recess is flanked by two sets of engaged marble columns. All three windows are preceded by a marble slab used to rest the water jugs. Passersby had to

Figure 6.5. A detail of the windows of the Sabil of Sultan Mahmud I.

Figure 6.6. An archive photograph that shows the metal grilles of the Sabil of Sultan Mahmud I (courtesy of Ibrahim Ramadan).

ascend three steps to reach these water jugs. The *tasbil* room is shaded by a wooden roof. This was also restored by the Comité in 1952.

The interior

The entrance of the *sabil* leads first to a small vestibule that is fronted by the dependencies of the *sabil*. The cistern occupies the entire space beneath this area and the *tasbil* room. The *tasbil* room is decorated with marble and marble mosaic flooring, wooden ceilings in geometric star patterns, and tilework. The lower parts of the walls are decorated with plain marble dados in black and white. On the eastern wall of this room is a panel of blue and gray marble that depicts a *mihrab*,

flanked by two columns with chevron and twisted designs and topped with a Qur'anic inscription band of verse 3:37. This *mihrab* contains a lantern dangling from the keystone of the arch with a mirrored inscription, which consists of the *Basmala* on a vegetal background. The whole panel is gilded from what looks like a modern-day restoration. Some *waqfiya*s tell us that during the Mamluk period, some *sabil*s were assigned with Qur'an reciters.[33] In the Ottoman period, a *sabil* was furnished with a *mihrab* and had a *mida'a* (an ablution area). One of the *sabil*'s employees acted as imam and the *sabil* was used as a *musalla* for the five daily prayers.[34] This supports Professor Saleh Lamei Mostafa's statement that the Sabil of Sultan Mahmud I originally served as a Qur'an school.[35]

The upper part of the wall is entirely covered with tilework of different colors and motifs. These tiles date from the classical period of Ottoman decoration, which contrasts with the overall Baroque and Rococo style of the *sabil*. A wooden cornice containing inscriptions in cartouches runs underneath the ceiling of the *tasbil* room (figure 6.7).

The *kuttab*

The *kuttab* is accessible through a separate entrance found on the southern façade of the complex. To the right of the *kuttab*'s entrance is a *musasa sabil* placed in a semicircular arched recess, which resembles the one found beside the entrance of the *sabil*. The *kuttab* room corresponds to the *tasbil* room beneath it. It too is preceded by a room before the *kuttab* space, in addition to another room reserved for the *mu'addib*.

Sabil of Sultan Mustafa III
(1172/1758)
Monument Number: 314
Typology: Freestanding, Ottoman influenced,
Three-window

The location

The Sabil of Mustafa III is located on Sayyida Zaynab Square. This *sabil-kuttab* used to be in the vicinity of

the *khalij*. The choice of location here is no coincidence, since "in the period of the flooding of the Nile it was easy to fill the cisterns of these sabils because of the Khalij, which was also full of water. Thus, these sabils could be filled at low costs during the season of the Nile flooding. These costs were, of course, higher when water had to be transported from the relatively distant Nile in winter and spring."[36] Lane describes the connection between the *sabil* and the Mosque of Sayyida Zaynab:

> The rich, and persons in easy circumstances, when they visit the tomb of a saint, distribute money or bread to the poor; and often give money to one or more water-carriers to distribute water to the poor and thirsty, for the sake of the saint. There are particular days of the week on which certain tombs are more generally visited: thus, the mosque of the Hussein is mostly visited, by men, on Tuesday, and by women, on Saturday: that of the Sayyida Zainab, on Wednesday: that of the Imam al-Shafi'i, on Friday.
>
> Many [carriers], and some saqqās who carry the goat's skin, are found at the scenes of religious festivals, such as the mūlids of saints . . . in Cairo and its neighborhood. They are often paid, by visitors to the tomb of a saint on such occasions, to distribute the water which they carry to passengers; a cupful to whoever desires. This work of charity is called *tasbīl* and is performed for the sake of the saint, and on other occasions than mūlids. The water-carriers who are thus employed are generally allowed to fill their [jugs] at a public fountain, as they demand nothing from the passengers whom they supply.[37]

The founder

The *sabil* was founded by Sultan Mustafa III, son of Sultan Ahmed III. He founded above the *sabil* a *kuttab* for teaching children in 1172/1758, as inscribed on the *sabil* and the *kuttab*.

Figure 6.7. The tilework in the Sabil of Sultan Mahmud I (courtesy of Ibrahim Ramadan).

The exterior

This *sabil* is one of the best examples of a *sabil* built in the Ottoman style with a curvilinear façade (figure 6.8). In addition to this, this is the second and last *sabil* founded by an Ottoman sultan in Cairo. The importance of this *sabil* goes back to the peak of artistic manifestation of its architectural composition and the overall appearance of its façade in its decorations that are very similar to the features on the Sabil of Sultan Mahmud I, built four years prior.

The exterior façade is curvilinear with two entrances on its sides. One of them is on Harat Ming and leads to the *sabil*, while the other lies on Sayyida

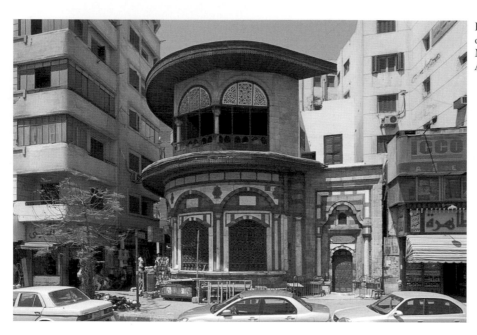

Figure 6.8. The façade of the Sabil of Sultan Mustafa III (courtesy of Archinos Architecture).

Zaynab Square and leads to the *kuttab*, thus segregating the units. As in the case of the Sabil of Sultan Mahmud I, the *sabil*'s façade is characterized by the presence of three large recesses, pierced with three *tasbil* windows that rest on four cylindrical marble columns.[38] The façade is clad with marble facing, which contrasts with the dark *ablaq* that dominates the entire structure. Each of the arched areas between the large recesses and the *tasbil* windows contains a white marble slab inscribed with the Tughra of Sultan Mustafa III. The *tasbil* windows are framed with rich vegetal motifs of naturalistic flowers, sunflowers, and tulips emerging from vases carved in relief and executed in the Baroque and Rococo designs that appeared in Turkey in the eighteenth century.

Each *tasbil* window is preceded by a marble slab on which to place water jugs, which is not supported on corbels, but is attached directly onto the walls of the *sabil*.

The overall composition of this *sabil-kuttab* resembles to a large extent that of the Sabil of Sultan Mahmud I with differences in location and available building area, which led, in the case of the Sabil of Sultan Mustafa III, to the presence of the *musasa sabil* instead of the attached room. This is in addition to the small number of dependencies and attached compartments to the *kuttab*, which does not exceed one room.

The interior

The entrance to the *sabil* leads to the room attached to the *tasbil* room. Beside the entrance to the *sabil* is a recess with a *musasa sabil*. To the left of this room is the room that contains the entrance and descending stairs to the cistern. Nowadays, this opening is completely blocked.

The *sabil*'s flooring is entirely covered in marble, with each marble square framed with colored marble mosaic. The ceiling, like that of the Sabil of Sultan Mahmud I, is of painted wood but is entirely covered in vegetal and floral depictions.[39] The walls of the *tasbil* room are covered in the lower part with a marble dado of rectangular paneling. The upper parts of the walls are covered with Dutch delft blue tiles (figure

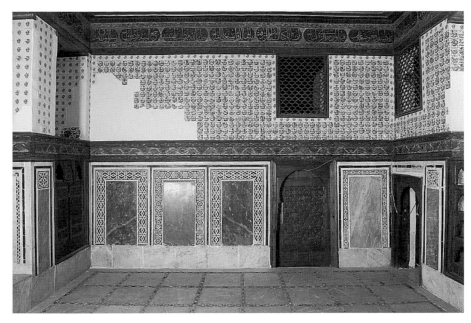

Figure 6.9. The Dutch delft tilework inside the Sabil of Sultan Mustafa III (courtesy of Archinos Architecture).

6.9). While al-Husayni does not mention the Dutch origins of these tiles and merely says that the *sabil*'s interior is covered with blue and white tilework, the uniqueness of these tiles was noticed by Herz as early as 1906.[40] Hans Theunissen connects their presence to the demise of Ottoman tilework production after 1164/1750, accompanied by a general change in taste. The production of polychrome tiles in the Tekfur Sarayı workshops seems to have stopped rather abruptly in the 1160s/1750s.[41] This demise led to the necessity of importing high quality tiles from outside the Ottoman Empire and therefore directed architects and artisans to the blue-and white Dutch tiles, which formed the almost obligatory chinoiserie element of European Baroque and Rococo interiors.

The *kuttab* on the top floor corresponds to the entire area of the *sabil* below, preceded first by an attached room and a latrine.

List of Ottoman Governors of Egypt

Shaded cells indicate the pashas who ruled and constructed buildings in Egypt. (Source: Wikipedia)

Name of Governor	Beginning of Reign	End of Reign
Yunus Pasha	1517	1517
Khayrbak	1517	1522
Çoban Mustafa Pasha	1522	1523
Khayen Ahmed Pasha	1523	1524
Güzelce Kasım Pasha (1st)	1524	1525
Pargalı Ibrahim Pasha	1525	1525
Güzelce Kasım Pasha (2nd)	1525	1525
Suleiman Pasha al-Khadim (1st)	1525	1535
Divane Khusruw Pasha	1535	1537
Suleiman Pasha al-Khadim (2nd)	1537	1538
Dawud Pasha	1538	1549
Lala Kara Mustafa Pasha	1549	1549
Semiz Ali Pasha	1549	1553
Dukakinzade Mehmed Pasha	1553	1556
Iskander Pasha	1556	1559
Sofu Khadim Ali Pasha	1559	1560
Kara Şahin Mustafa Pasha	1560	1563
Müezzinzade Ali Pasha	1563	1566
Mahmud Pasha	1566	1567
Koca Sinan Pasha (1st)	1567	1569
Çerkes Iskender Pasha	1569	1571
Koca Sinan Pasha (2nd)	1571	1573
Hüseyin Pasha Boljanić	1573	1574
Khadim Messih Pasha	1574	1580
Khadim Hasan Pasha	1580	1583
Damat Ibrahim Pasha	1583	1585
Defterdar Sinan Pasha	1585	1587
Kara Üveys Pasha	1587	1590
Khadim Hafız Ahmed Pasha	1590	1594
Kurd Mehmed Pasha	1594	1596
Emir Mehmed Pasha	1596	1598
Khidr Pasha	1598	1601
Yavuz Ali Pasha	1601	1603
Maqtul Hacı Ibrahim Pasha	1604	1604
Hadım Mehmed Pasha	1604	1605
Yemenli Hasan Pasha	1605	1607
Öküz Mehmed Pasha	1607	1611
Sofu Mehmed Pasha	1611	1615
Nişancı Ahmed Pasha	1615	1618
Lefkeli Mustafa Pasha	1618	1618
Cafer Pasha	1618	1619
Hamidi Mustafa Pasha	1619	1620

Name of Governor	Beginning of Reign	End of Reign
Mere Hüseyin Pasha	1620	1622
Biber Mehmed Pasha	1622	1622
Silahdar Ibrahim Pasha	1622	1623
Kara Mustafa Pasha (1st)	1623	1623
Çeşteci Ali Pasha	1623	1623
Kara Mustafa Pasha (2nd)	1624	1626
Bayram Pasha	1626	1628
Tabanıyassı Mehmed Pasha	1628	1630
Koca Musa Pasha	1630	1631
Halil Pasha	1631	1633
Bakırcı Ahmed Pasha	1633	1635
Gazi Hüseyin Pasha	1635	1637
Sultanzade Mehmed Pasha	1637	1640
Nakkaş Mustafa Pasha	1640	1642
Maksud Pasha	1642	1644
Eyüb Pasha	1644	1646
Haydarzade Mehmed Pasha	1646	1647
Mostarlı Mustafa Pasha	1648	1648
Tarhoncu Ahmed Pasha	1648	1651
Khadim 'Abd al-Rahman Pasha	1651	1652
Haseki Mehmed Pasha	1652	1656
Halıcı Damadı Mustafa Pasha	1656	1657
Şehsuvarzade Gazi Mehmed Pasha	1657	1660
Gürcü Mustafa Pasha	1660	1661
Melek Ibrahim Pasha	1661	1664
Silahdar Ömer Pasha	1664	1667
Şişman Ibrahim Pasha	1667	1668
Karakaş Ali Pasha	1668	1669
Bayburtlu Kara Ibrahim Pasha	1669	1673
Canpuladzade Hüseyin Pasha	1673	1675
Cebeci Ahmed Pasha	1675	1676
Abdi Pasha the Albanian	1676	1680
Osman Pasha the Bosnian	1680	1683
Hamza Pasha	1683	1687
Mollacık Hasan Pasha	1687	1687
Damat Hasan Pasha (1st)	1687	1689
Sarhoş Ahmed Pasha	1689	1691
Hazinedar Moralı Ali Pasha	1691	1695
Çelebi Ismail Pasha	1695	1697
Kesici Hasan Pasha	1697	1698
Firari Hüseyin Pasha	1698	1699
Kara Mehmed Pasha (1st)	1699	1704
Baltacı Süleyman Pasha	1704	1704
Rami Mehmed Pasha	1704	1706
Dellak Ali Pasha (1st)	1706	1707
Damat Hasan Pasha (2nd)	1707	1709
Moralı Ibrahim Pasha	1709	1710
Köse Halil Pasha	1710	1711

Name of Governor	Beginning of Reign	End of Reign
Veli Mehmed Pasha (1st)	1711	1712
Kara Mehmed Pasha (2nd)	1712	1712
Veli Mehmed Pasha (2nd)	1712	1714
Abdi Pasha (1st)	1714	1716
Dellak Ali Pasha (2nd)	1716	1720
Recep Pasha	1720	1721
Nişancı Mehmed Pasha (1st)	1721	1725
Moralı Ali Pasha	1725	1726
Nişancı Mehmed Pasha (2nd)	1726	1727
Ebubekir Pasha (1st)	1727	1729
Abdi Pasha (2nd)	1729	1729
Köprülü Abdullah Pasha	1729	1731
Silahdar Damat Mehmed Pasha	1731	1733
Muhassıl Osman Pasha	1733	1735
Ebubekir Pasha (2nd)	1735	1739
Suleiman Pasha al-Azm	1739	1740
Hekimoğlu Ali Pasha (1st)	1740	1741
Hatibzade Yahya Pasha	1741	1743
Yedekçi Mehmed Pasha	1743	1744
Koca Mehmed Ragıp Pasha	1744	1748
Yeğen Ali Pasha	1748	1748
Nişancı Ahmed Pasha	1748	1751
Seyyid Abdullah Pasha	1751	1753
Divitdar Mehmed Emin Pasha	1753	1753
Baltacızade Mustafa Pasha	1752	1756
Hekimoğlu Ali Pasha (2nd)	1756	1757
Sa'deddin Pasha al-Azm	1757	1757
Yirmisekizzade Mehmed Said Pasha	1757	1758
Köse Bahir Mustafa Pasha (1st)	1758	1761
Kamil Ahmed Pasha	1761	1761
Köse Bahir Mustafa Pasha (2nd)	1761	1762
Ebubekir Rasim Pasha	1762	1762
Ahıskalı Mehmed Pasha	1762	1764
Hacı Ahmed Pasha	1764	1764
Macar Hacı Hasan Pasha	1764	1765
Silahdar Mahir Hamza Pasha	1765	1767
Çelebi Mehmed Pasha	1767	1767
Rakım Mehmed Pasha	1767	1768
Ali Bey Al-Kabir	1768	1769
Köprülü Hafız Ahmed Pasha	1769	1769
Kelleci Osman Pasha	1769	1771
Vekil Osman Pasha	1772	1773
Kara Halil Pasha	1773	1774
Hacı Ibrahim Pasha	1774	1775
Izzet Mehmed Pasha	1775	1778
Raif Ismail Pasha (1st)	1779	1779
Ibrahim Pasha	1779	1779
Raif Ismail Pasha (2nd)	1779	1780

Glossary

ablaq: black and white striped masonry

agha: chief of the Janissary militia

'alim (pl. 'ulama'): scholar, doctor of law

amir (pl. umara'): high dignitary

amir al-Hajj: commander of the pilgrimage

'askar: soldier

atabek: Mamluk military title equivalent to commander in chief

awqaf (see waqf)

a'yan: elite

bab: door, gate

bayara: a well

bayt (pl. buyut): house, party of amirs

bayt al-mal: public treasury

bey/bek/bak: dignitary of Ottoman Egypt

beylerbey: governor

bukhariya: a design of medallions with stylized fleur-de-lis

conch: upper part of the arch in a recess or in the mihrab

cuerda seca: a technique used when applying colored glazes to ceramic surfaces. When different colored glazes are applied to a ceramic surface, the glazes have a tendency to run together during the firing process

damascene leaves: an ornament with wavy patterns like those of watered silk

darb: alley

dawadar: secretary

dhikr: repetition of the names of God

dihliz: a narrow corridor

dikka: bench on columns or attached to the wall

diwan: council

durkah: vestibule

durqa'a: internal covered court

entrelacs: (french) A word used to indicate a weaving pattern of interlacing garlands, leaves or a geometric pattern

fisqiya: fountain

hadith: tradition in Islamic religion

hajj: pilgrimage

hanut (pl. *hawanit*): shop

hara (pl. *harat*): residential quarter

hawsh: a funerary enclosure with underground tombs that is open to the sky

hisab al-jummal: *also known as the abjad computation,* is a decimal alphabetic numeral system/ alphanumeric code, in which the 28 letters of the Arabic alphabet are assigned numerical values

hudur: a Sufi ceremony performed in a circle that involves repetition of the name of God and rapid Qur'an recitation for spiritual elevation

iltizam: type of tax farming practiced in Egypt and the Ottoman Empire. Tax farms were assigned to holders who paid fixed annual sums to the empire's central treasury in exchange for use of the property and the right to collect taxes for the empire

istibdal: exchange of *waqf* property

iwan: a vaulted chamber that opens by an arch onto a court and is a step higher than the court

katkhuda: lieutenant colonel

khalij: canal

khan (pl. *khanat*): caravanserai

khanqah: a monastic institution for Sufis

khazina: annual tribute

khilwa: a small room for a Sufi or an imam in a mosque

khuluw: compensation for getting a leased property vacated from the tenant

khutba: Friday sermon

kuttab: neighborhood elementary school

madhhab: school of law

madrasa: school, college of Islamic law

maksala: a bench flanking the sides of an entrance

malqaf: windcatcher

mamluk (pl. *mamalik*): one who is "in the possession" of his master

maqsura: a protective barrier, usually of wood, surrounding the minbar, *mihrab* or a tombstone in a mosque

mashrabiya: latticework balcony of turned wood

mastaba (pl. *masatib*): bench (in front of shops)

maydan: field for equestrian exercises, square

mazmala: a niche to hold water jars

mihrab: niche indicating the direction of the *qibla* (Mecca)

minbar: pulpit

mu'allim: intendant, master of a trade

mubashir al-waqf: the caretaker of the waqf

mufti: the Islamic scholar chosen to form Islamic laws when needed

muqarnas: a decorative device consisting of small niches

musalla: open-air prayer site

musasa sabil: a marble panel with two taps in the exterior of a *sabil* for people to drink or fill containers with water

mustahfizan: name of the Cairo Janissaries

nazir: administrator

nazir al-awqaf: person in charge of the *waqf* documents

ojak: militia

pendentive: a transitional zone consisting of a triangle below the corner of a square room to turn it into an octagon to carry a dome

pishtaq: a rectangular screen rising about a roof-line and framing a portal or an iwan

qa'a: reception hall

qadi (pl. *qudah*): judge

qalawun: a type of window introduced by Qalawun, influenced by Norman Sicilian churches. It consists of a triple window composition of two arched openings, surmounted by an oculus

qanunname: ruling law under the Ottoman Sultan Suleiman the Magnificent

qasr: fort, palace

qaysariya (pl. *qayasir*): covered market, caravanserai

qibla: direction of Mecca

rab' (pl. *rubu*): tenement house

ribat: a type residential building which later varied to define either a caravanserai or a hospice for pilgrims or orphans

riwaq: (*arabic*) arcade *sabil*: a building equipped with a cistern or a well to distribute water to the thirsty for charity

sanjaqiya: the post of governing a province

shadirwan: part of the water fountain inside a *sabil* from which water flows on a marble slab and is collected in a basin underneath

shahada: the Islamic profession of faith

shaykh: religious scholar

sidilla: a shallow iwan or a large recess

suq: market

tabaqa: quarters, lodging

ta'ifa (pl. *tawa'if*): community

takiya: a residential building for Sufis where their cells are built around a courtyard. It usually includes a prayer area

tariqa: a Sufi order

tiraz: The term "tiraz" means "embroidery" in Persian, but, over time, it has come to identify an inscription band found on all manner of objects—from textiles to metalwork to architecture

tughra: royal seal or signature

turba: a burial

wali (pl. *wulah*): governor, prefect of police

waqf (pl. *awqaf*): Islamic system of trust, an endowment deed

wikala: a warehouse, center for wholesale trade, and housing for merchants. This term is now used in Egypt as a synonym for khan. However, in the Mamluk period *wikala*s appear to have been buildings to collect goods so that dues might be levied upon them

Abbreviations

AI Annales Islamologique

BEO Bulletin d'études orientales

BIFAO Bulletin de l'institut Français d'archéologie orientale

CFPR Italian Egyptian Center for Restoration and Archeology

Khitat Kitab al-khitat wa-l-i'tibar fi dhikr al-khitat wa-l-athar

Notes

Notes to Preface

1 Nezar AlSayyad, *Cairo: Histories of a City* (London, 2011). Belknap Press: An Imprint of Harvard University Press; First Edition, 218–19.

2 Sylvie Denoix, "A Mamluk Institution for Urbanization: The Waqf," in *The Cairo Heritage.* (Cairo, The American University in Cairo Press: 2000), 190–202.

3 André Raymond, *Cairo*. Translated by Willard Wood. 2000. MA: Harvard University Press, 235.

4 Published in *al-Majalla al Tarikhiya al-Misriya*, vol. 23 (Cairo, 1976), and verified by Abdeel Rehim Abdel Rahman.

Notes to Historical Introduction

1 Sheila Blair, Jonathan Bloom, and Richard Ettinghausen, *The Art and Architecture of Islam 1250–1800* (Yale University Press, 1994), 132.
 See also: Irwin, Robert, "The emergence of the Islamic World System 1000–1500," in *Cambridge Illustrated History: Islamic World,* ed. Francis Robertson (Cambridge, 1996).

2 Aptullah Kuran, *The Mosque in Early Ottoman Architecture* (Chicago: Center for Middle Eastern Studies, 1968), 27.

3 Kuran, *The Mosque in Early Ottoman Architecture*, 37.

4 Kuran, *The Mosque in Early Ottoman Architecture*, figure 20, page 40.

5 Sheila Blair, Jonathan Bloom, and Richard Ettinghausen, *The Art and Architecture of Islam 1250–1800* (Yale University Press, 1994), 135.

6 Kuran, *The Mosque in Early Ottoman Architecture*, 135–137.

7 Cuerda seca is a technique used when applying colored glazes to ceramic surfaces. When different colored glazes are applied to a ceramic surface, the glazes have a tendency to run together during the firing process.

8 Kuran, *The Mosque in Early Ottoman Architecture*, 144.

9 Kuran, *The Mosque in Early Ottoman Architecture*, 23.

10 Kuran, *The Mosque in Early Ottoman Architecture*, 216–218.

11 Kuran, *The Mosque in Early Ottoman Architecture*, figure 222, 197.

12 Kuran, *The Mosque in Early Ottoman Architecture*, 218–219.

13 Gaston Jean Wiet, *Journal d'un bourgeois du Caire. Ibn Iyâs, Histoire des mamlouks.*, vol. 2 (Paris, 1960), 141; André Raymond, *Cairo*, trans. Willard Wood (Cambridge: 2000), 189.

14 Wiet, *Journal d'un bourgeois du Caire. Ibn Iyâs, Histoire des mamlouks*, 146–153.

15 Wiet, *Journal d'un bourgeois du Caire. Ibn Iyâs, Histoire des mamlouks*, 153.

16 Compensation for getting a leased property vacated from the tenant.

17 Muhammad M. Amin, *al-Awqaf wa-l-haya al-ijtima'iya fi Misr, 648–923 H / 1250–1517: dirasa tarikhiya watha'iqiya* (Cairo: 1980, Dar al-Nahda al-'Arabiya bi-l-Qahira).
 See also: Doris Behrens-Abouseif, *Egypt's Adjustment to Ottoman Rule: Institutions, Waqf & Architecture in Cairo (16th and 17th Centuries)* (Leiden: Brill, 1994), 154.

18 Amin, *al-Awqaf*, 354–61.

19 Behrens-Abouseif, *Egypt's Adjustment*, 146.

20 Behrens-Abouseif, *Egypt's Adjustment*, 153.

21 Ibrahim Pasha was always known as Pargali Ibrahim. At the peak of his power, he was known as Maqbul Ibrahim Pasha, which referred to how much he was preferred by Sultan Suleiman. After his death sentence was issued and he was strangled, he became known as Maqtul Ibrahim Pasha. His full name was never known.

22 Turan, Ebru, "The Marriage of Ibrahim Pasha (ca. 1495-1536): The Rise of Sultan Süleyman's Favorite to the Grand Vizierate and the Politics of the Elites in the Early Sixteenth-Century Ottoman Empire," 3 (2009).

23 Aghas were castrated males. Following the pattern of ancient empires, the early Islamic dynasties, starting with the Umayyads, employed castrated males from different origins, also known as eunuchs, at their courts. They served as companions to the rulers, as keepers of the harem section of the palace, or as military commanders. The Ottomans continued this tradition and many of the eunuchs were trained in the *devshirme* and reached high positions in the army, and many were sent as governors to provinces and even became grand viziers. Jane Hathaway, "The Chief Harem Eunuch of the Ottoman Empire: Servant of the Sultan, Servant of the Prophet," in *Celibate and Childless Men in Power: Ruling Eunuchs and Bishops in the Pre-Modern World*, edited by Almut Hofert, M. Mesley, and S. Tolino (London: Routledge, 2017), 211–25.

24 Type of tax farming practiced in Egypt and the Ottoman Empire. Tax farms were assigned to holders who paid fixed annual sums to the empire's central treasury in exchange for use of the property and the right to collect taxes for the empire. Holders were allowed to keep the balance of collections as personal profit, encouraging them to be diligent and efficient in the collection of taxes. Iltizam became a means of controlling movable officials, a way to prevent the accumulation of large territories by individuals or families, and a guarantee of tax collection in regions far from the center.

25 *Devshirme* was the Ottoman Empire practice of recruiting soldiers and bureaucrats from among the children of their Balkan Christian subjects. Ottoman soldiers would take Christian boys ages 8 to 20 away from their parents in eastern and southeastern Europe and remove them to Istanbul. Kathryn Hain, "Devshirme is a Contested Practice," Historia: the Alpha Rho Papers Vol. II (2012): 165-176.

26 Behrens-Abouseif, *Egypt's Adjustment*, 106–116.

27 André Raymond, *Influences d'Istanbul sur l'architecture et le décor au Caire, au milieu du XVIIIème siècle* Damaszener Mitteilungen > (Damascus: Damaszener Mitteilungen, 1999), vol. 11, 379–383.

28 André Raymond, "Architecture and Urban Development: Cairo during the Ottoman Period, 1517–1798," in *Arab Cities in the Ottoman Period: Cairo, Syria and the Maghreb* (Aldershot: Ashgate Variorum, 2002), 247–63.

29 André Raymond, "Cairo's Area and Population in the Early 15th Century," in *Muqarnas II* (Cambridge, MA: Brill, 1984), Brill, 21–31.

30 André Raymond, "Influences d'Istanbul sur l'architecture et le décor au Caire, au milieu du XVIIIème siècle," 379–383.

Notes to Chapter 1

1 Ibn Khaldun, *al-Ta'rif bi-ibn Khaldun wa rihalati-hi gharban wa sharqan*, ed. Muhammad ibn Tawit al-Tanji (Cairo, 1951), 246–47 in Susan Staffa, *Conquest and Fusion: The Social Evolution of Cairo A.D. 642–1850* (Brill, 1977), 106.

2 Ibn Iyas, Muhammad ibn Ahmad. *Bada'i' al-zuhur fi waqa'i' al-duhur* (Dar al-Fikr, 1982–84): 5:336 and 394.

3 Shinnawi, 'Abd al-'Aziz Muhammad. *al-Dawla al-'uthmaniya: dawla islamiya muftara 'alayha* (The Anglo-Egyptian Library, 1980), 693.

4 Ibn Iyas, *Bada'i' al-zuhur,* 5:397.

5 Behrens-Abouseif, *Egypt's Adjustment,* 182–24.

6 Behrens-Abouseif, *Cairo of the Mamluks: A History of Architecture and Its Culture* (The American University in Cairo Press, 2007), 312–15.

7 Alaa ad-Din Shahin, *Qaytbay's Decoration: An Analysis of the Architectural Decoration of Various Cairene Facades from the Period of Qaytbay* (Unpublished Master's Thesis, The American University in Cairo, 1987), 37.

8 Nicholas Warner, *Monuments of Historic Cairo: A Map and Descriptive Catalogue* (The American University in Cairo Press, 2005), 181.

9 Richard Yeomans, *The Art and Architecture of Islamic Cairo* (Garnet Publishing, 2006), 234.

10 This Sabil al-Mu'minin (Fountain of the believers) was built by the Mamluk amir Sayf al-Din Buktamar ibn 'Abdallah al-Mu'mini (771/1369 70). It was called al-Mu'mini after its founder, but the sixteenth-century historian Ibn Iyas began the practice of calling it Sabil al-Mu'minin. It is so called in a *waqfiya* of Qansuh al-Ghuri. It was in Rumayla Square beneath the Citadel at the point where the mosque of Sayyida Aisha is located today. It is the place where people who were executed in the Citadel were brought for washing before burial. Jamal al-Din Abu al-Mahasin Yusuf Ibn Taghribirdi al-Atabki,. *al-Nujum al-zahira fi muluk Misr wa-l-Qahira* (al-mu'assasa al misriya al-'amma lil-ta'lif wa-l-taba'a wa-l-nashr, 1971), 2:49–50.

11 Behrens-Abouseif, *Cairo of the Mamluks,* 314.

12 Yeomans, *Art and Architecture,* 234.

13 Behrens-Abouseif, *Egypt's Adjustment,* 183.

14 Kessler, Christel. "Funerary Architecture within the City," in *Colloque international sur l'histoire du Caire* (Ministry of Culture, 1996), 267.

15 Shadirwan: A marble slab over which water flows inside a sabil.

16 Doris Behrens-Abouseif, "The Takiyyat Ibrahim al-Khulshani in Cairo," in *Muqarnas V: An Annual on Islamic Art and Architecture,* ed. Oleg Grabar. (Brill, 1988), 44.

17 Behrens-Abouseif, "The Takiyat Ibrahim al-Khulshani," 43 and 58.

18 The Ministry of Religious Endowments, waqf 432.

19 'Ali Mubarak, *al-Khitat al-tawfiqiya al-jadida li-Misr al-Qahira wa-muduniha wa-biludiha al-qadima wa-l-shahira* (Egyptian General Book Authority, 1986), 6:54.

20 Giuseppe Fanfoni, "Recovery of the Mausoleum of Sunqur Sa'di and Restoration of Mevlevi Takiya," *CFPR* (Cairo, 2009), 6.

21 Behrens-Abouseif, "The Takiyat Ibrahim al-Khulshani," 53–56.

22 Behrens-Abouseif, "Takiyat Ibrahim al-Khulshani," 46, figure 2.

23 It is a type of Ottoman *sabil* built in Cairo, usually attached to a bigger *sabil*. It typically consists of a marble panel with two taps from which people could drink. This kind of *sabil* was sometimes the solution for people who could not pay the *saqqa'* or water carrier for water; women would line up to fill their containers to provide water for their houses.

24 Behrens-Abouseif, "The Takiyat Ibrahim al-Khulshani," 47–48.

25 Muhammad Abu al-'Amayim, *Athar al-Qahira al-islamiya fi al-'asr al-'uthmani* (IRCICA Research Center for Islamic Culture and Arts, 2003), 8–12.

26 Behrens-Abouseif, "The Takiyat Ibrahim al-Khulshani," 47–48.

27 Behrens-Abouseif, "The Takiyat Ibrahim al-Khulshani," 59.

28 This was mentioned to the author by engineer Abeer Saad el Din, who was in charge of the restoration of the *takiya* in 2020. The names of some of the people buried there are mentioned in Abu al-'Amayim, *Athar al-Qahira al-islamiya,* 11.

29 Behrens-Abouseif, "Takiyat Ibrahim al-Khulshani," 47 and 52, figures 5 and 11.

30 Hautecoeur, Louis and Gaston Jean Wiet. *Les mosquées du Caire* (Hachette, 1932), 350.

31 Bayhan, Ahmet Ali. "Misir'daki Arap Harfli Kitabeler Üzerine Bir Degerlendirme," *Journal of Language and Literature* Issue: 44 (Ankara, 2017), 279.

32 Abu al-'Amayim, *Athar al-Qahira al-islamiya,* 10.

33 Behrens-Abouseif, "Takiyat Ibrahim al-Khulshani," 53.

34 'Abd al-Wahhab al-Sha'rani, *al-Tabaqat al-kubra* (Mustafa al-Babi al-Halabi, 1954), 148.

35 Behrens-Abouseif, "The Takiyat Ibrahim al-Khulshani," 58.

36 Behrens-Abouseif, "The Takiyat Ibrahim al-Khulshani," 58.

37 Doris Behrens-Abouseif and Leonor Fernandes, "Sufi Architecture in the Early Ottoman Period," in *AI 20* (Cairo, 1984), 103.

38 al-Nabulsi, *al-Haqiqa wa al-majaz fi al-rihla ila bilad al-Sham wa Misr wa al-Hijaz*, edited by Ahmad 'Abd al-Majid al-Haridi (Egyptian General Book Authority, 1986), vol.131.

39 Jean-Claude Garcin, "Deux saints populaires du Caire au debut du XVI siècle," in *Le Bulletin d'études orientales 29* (Institut Francais du Proche-Orient, 1977), 133–35.

40 Leonor, Fernandes, "The Foundation of Baybers al-Jashankir," in *Muqarnas IV: An Annual on Islamic Art and Architecture,* edited by Oleg Grabar (BRILL, 1987), 21–42.

41 Behrens-Abouseif and Fernandes, "Sufi Architecture," 103–14.

42 Behrens-Abouseif and Fernandes, "Sufi Architecture," 103–14.

43 The Ministry of Religious Endowments, *waqf* number 1079, line 18. The *waqf* deed was published by 'Ali al-Miligy in his PhD thesis, "al-Tiraz al-'uthmani fi 'ama'ir al-Qahira al-diniya." PhD thesis, (Cairo University, 1980), 395–410 and mentioned in Muhammad Hamza Isma'il al-Haddad, *Mawsu'at al-'imara al-islamiya fi Misr: min al-fath al-'uthmani ila nihayat 'ahd Muhammad 'Ali, 923–1265 H/1517–1848 M*, vol. 2. (Dar Zahra' al-Sharq, 1998), 119.

44 Su'ad Mahir, *Masajid Misr wa awliya'uha al-salihun* (al-Majlis al-A'la lil-Shu'un al-Islamiya, 1971), 5:73–74.

45 The Ministry of Religious Endowments, waqf number 1079 dated to 8 Shawwal 941/15 April 1535 lines 36–7 and 85–7.

46 al-Haddad, *Mawsu'at al-'imara,* 2:122.

47 Hasan Qasim, *al-Mazarat al-islamiya wa-l-athar al-'arabiya fi Misr wa-l-Qahira al-mu'izziya* (Maktabat al-Iskandariya, 2018), 6:15 and al-Haddad, *Mawsu'at al-'imara,* 2 :122; See also: Tawfiq al-Tawil, *al-Tasawwuf fi Misr ibbana al-'asr al-'uthmani* (Maktabat al-Adab, 1988), 163.

48 Abu al-'Amayim, *Athar al-Qahira al-islamiya*, 14.

49 The plan of the *zawiya* after al-Haddad, *Mawsu'at al-'imara*, 2:631; drawn by the Ministry of Antiquities and dated to May 13th, 1911.

50 al-Haddad, *Mawsu'at al-'imara,* 2:121 and 2:123.

51 Abu al-'Amayim*, Athar al-Qahira al-islamiya,* 14–15.

52 *Bulletins of the Comité de Conservation des Monuments de l'Art Arabe* (1912), 105.

53 Hawsh: An open funerary court.

54 Ministry of Religious Endowments, lines 21–29 and 32–33.

55 Ministry of Religious Endowments, lines 28–31.

56 Ministry of Religious Endowments, lines 27–8.

57 *Bulletins of the Comité de Conservation des Monuments de l'Art Arabe*, vol. 38, report 749, 222.

58 Hasan 'Abd al-Wahhab, "L'influence ottomane sur l'architecture musulmane en Égypte," in *Proceedings of the 22nd Congress of Orientalists*, edited by Zeki Velidi Togan. Istanbul: 1951 (Leiden: Brill, 1957) 2:648.

59 Michael Meineke, "Die Architektur des 16. Jahrhunderts in Kairo, nach der osmanischen Eroberung von 1517," in *IVeme congress international d'art turc* (Aix-en-Provence: Éditions de l'Université de Provence, 1976), 146.

60 al-Sha'rani, *al-Tabaqat al-kubra*, 2:130; al-Haddad, *Mawsu'at al-'imara,* 2:127.

61 al-Haddad, *Mawsu'at al-'imara,* 2:128 footnote 2.

62 Behrens-Abouseif, *Egypt's Adjustment*, 184–185.

63 The Ministry of Religious Endowments, *waqf* number 1074, line 17 on page 29 and lines 1–3 on page 30.

64 The Ministry of Religious Endowments, *waqf* page 14 lines 11–12 and page 15 lines 6–8; al-Haddad, *Mawsu'at al-'imara,* 2:129.

65 The Ministry of Religious Endowments, *waqf* page 14, line 16.

66 al-Haddad, *Mawsu'at al-'imara,* 2:134.

67 Sha'rani in Behrens-Abouseif and Fernandes, "Sufi Architecture," 108.

68 Mubarak, *al-Khitat al-tawfiqiya*, 2:456 and Abu al-'Amayim, *Athar al-Qahira al-islamiya*, 45.

69 Abu al-'Amayim, *Athar al-Qahira al-islamiya*, 43.

70 Mubarak, *al-Khitat al-tawfiqiya*, 5:76.

71 Mubarak, *al-Khitat al-tawfiqiya*, 5:76; Abu al-'Amayim, *Athar al-Qahira al-islamiya,* 44.

72 Mubarak, *al-Khitat al-tawfiqiya*, 5:30.

73 The term "tiraz" means "embroidery" in Persian, but, over time, it has come to identify an inscription band found on all manner of objects—from textiles to metalwork to architecture.

74 Mubarak, *al-Khitat al-tawfiqiya*, 5:29-30.

Notes to Chapter 2

1 Behrens-Abouseif, *Egypt's Adjustment*, 245.

2 Fahmy Abdel Alim Ramadan, "The Mosque of Suleyman Pasha 'Sariyat al-Gabal,'" in *Seventh International Congress of Turkish Art*, edited by Tadeusz Majda. (Warsaw, Polish Scientific Publishers, 1990), 15–27.

3 Abu al-'Amayim, *Athar al-Qahira al-islamiya*, 30.

4 David Ayalon, "The Eunuchs in the Mamluk Sultanate," in *Studies in Memory of Gaston Wiet*, edited by Myriam Rosen-Ayalon (The Hebrew University of Jerusalem, 1977), 267.

5 Ahmed M. El-Masry, *Die Bauten von Hadim Sulaiman Pascha, (1468–1548)*, nach seinen Urkunden im Ministerium für Fromme Stiftungen in Kairo, Klaus Schwarz (Klaus Schwarz, 1991), 15.

6 El-Masry, *Die Bauten von Hadim Sulaiman Pascha*, 16–36.

7 Ülkü Bates, "Façades in Ottoman Cairo," in *The Ottoman City and Its Parts: Urban Structure and Social Order*, edited by I. Bierman, R. Abou-el-Haj, and D. Preziosi (Aristide Caratzas, 1991), 148.

8 El-Masry, *Die Bauten von Hadim Sulaiman Pascha*, 38–9.

9 Fawzi Husayn *Ma'azin al-Qahira* (Dar al-Kitab al-'Arabi, 1969).

10 El-Masry, *Die Bauten von Hadim Sulaiman Pascha*, 47.

11 Quranic Inscriptions. Bernard O'Kane, *The Monumental Inscriptions of Historic Cairo*. Inscription Database by Cultnat.

12 Behrens-Abouseif, *Egypt's Adjustment*, 246.

13 The Ministry of Religious Endowments, *waqf* page 49.

14 The Ministry of Religious Endowments, *waqf* page 47.

15 Jean-Claude Garcin, *Catalogue général du Musée Arabe du Caire. Lampes et bouteilles en verre émaillé* (Institut français d'archéologie orientale, 1929), 118–120.

16 Quranic Inscriptions. O'Kane, Bernard. *The Monumental Inscriptions of Historic Cairo*, Inscription Database by Cultnat.

17 El-Masry, *Die Bauten von Hadim Sulaiman Pascha*, 67.

18 The Ministry of Religious Endowments, *waqf* page 42.

19 The Ministry of Religious Endowments, *waqf* page 42.

20 Jessica Rawson, *Chinese Ornament, the Lotus and the Dragon* (British Museum Press London, 1984), 193–96.

21 Quran 2:255–56, Quran 3:18 and part of verse 19, as well as Quran 3:26–27.

22 The Ministry of Religious Endowments, *waqf* page 11.

23 El-Masry, *Die Bauten von Hadim Sulaiman Pascha*, 83.

24 The Ministry of Religious Endowments; the *waqf* mentions five on page 12.

25 El-Masry, *Die Bauten von Hadim Sulaiman Pascha*, 95.

26 Gaston Jean Wiet, "Matériaux pour servir à la géographie de l'Égypte," in *AI 26* (Institut Français d'Archéologie Orientale, 1919), 1: 56–57. See also: Nelly Hanna, *An Urban History of Bulaq in the Mamluk and Ottoman Periods* (Supplément aux Annales Islamologiques, Cahier No. 3.) pp. ix, 112, 10 pls. (Institut Français d'Archéologie Orientale, 1983), 2, footnote 1.

27 A *rab'* is a tenement house which is basically an apartment complex available for rent.

28 'Ali Mubarak, *al-Khitat al-tawfiqiya*, 5:18.

29 The Ministry of Religious Endowments, *waqf* number 1074, dated to 20 Ragab 979. An extract from the *waqfiya* can be found in Abu al-'Amayim, *Athar al-Qahira al-islamiya*, 57.

30 Abu al-'Amayim, *Athar al-Qahira al-islamiya*, 55–58.

31 Imaret is one of a few names used to identify the public soup kitchens built throughout the Ottoman Empire from the fourteenth to the nineteenth centuries. These public kitchens were often part of a larger complex known as a külliye, which could include hospices, mosques, caravanserais and colleges.

32 Behçet Unsal, *Turkish Islamic Architecture in Seljuk and Ottoman Times, 1071–1923* (Alec Tiranti, 1959), 38.

33 Behrens-Abouseif, *Egypt's Adjustment*, 184–85.

34 Abu al-ʻAmayim, *Athar al-Qahira al-islamiya,* 61.

35 Mubarak, *al-Khitat al-tawfiqiya*, 6:56.

36 *The Bulletins of the Comité de Conservation des Monuments de l'Art Arabe,* (1894), Fascicule 11.

37 Stanford J. Shaw, *The Financial and Administrative Organization and Development of Ottoman Egypt, 1517–1798* (Princeton University Press, 1962), 283–84.

38 The Ministry of Religious Endowments, *waqf* number 1142 and at Dar al-Watha'iq al-Qawmiya, number 298, File 45; al-Haddad, *Mawsuʻat al-ʻimara al-islamiya*, 2:15.

39 Taqi al-Din Ahmad ibn ʻAli al-Maqrizi, *Kitab al-mawaʻiz wa-l-iʻtibar bi-dhikr al-khitat wa-l-athar yakhtassu dhalika bi-akhbar Iqlim Misr wa-l-Nil wa-dhikr al-Qahira wa-ma yataʻallaq bi-ha wa-bi-Iqlimiha* (Dar al-Gharb al-Islami, 1987), 1:458 and 2:27–28.

40 The Ministry of Religious Endowments, *waqf* lines 103–104 mentioned by al-Haddad, *Mawsuʻat al-ʻimara*, 2:22 and Mahir, *Masajid Misr,* 4:523.

41 *The Bulletins of the Comité de Conservation des Monuments de l'Art Arabe* (1951), 10.

42 al-Haddad, *Mawsuʻat al-ʻimara*, 2:19. See also: ʻAbd al-Latif Ibrahim, *al-Watha'iq fi khidmat al-athar al-ʻasr al-mamluki* (Dar al-Tibaʻa al-Haditha, 1980), 389–471.

43 Shadia al-Dessouki, *Ashghal al-khashab fi al-ʻamaʻir al-diniya al-ʻuthmaniya bi-madinat al-Qahira.* Cairo, 1985. Unpublished Master's Thesis, Cairo University, 80.

44 Mubarak, *al-Khitat al-tawfiqiya*, 5:101.

45 *The Bulletins of the Comité de Conservation des Monuments de l'Art Arabe*, Cahier 8, page 54, report 114.

46 A mamluk *qaʻa* plan indicates the presence of iwans (one or more) facing a courtyard.

47 Ibn Iyas, *Badaʻiʻ al-zuhur fi waqaʻiʻ al-duhur*, 4:306.

48 August Ferdinand Mehren, *Câhirah og Kerafât - historiske studier under et ophold i Aegypten* (J.H. Schultz, 1867–68), 59.

49 This title, according to al-Haddad, only appears in *waqf* number 1176 the Daftarkhane of the Ministry of Religious Endowments; al-Haddad, *Mawsuʻat al-ʻimara*, 2:37.

50 Behrens-Abouseif, *Egypt's Adjustment*, 191.

51 Ismaʻil Sarhank, *Haqa'iq al-akhbar ʻan duwal al-bihar* (al-Tabʻa al-Amiriya, 1898), 2:191.

52 Amal Al-'Imari, *Dirasat fi watha'iq Dawud Basha wali Misr* (al-Matbaʻa al-Miriya, 1986), 7–8; al-Haddad, *Mawsuʻat al-ʻimara*, 2:40 footnote 4.

53 Bernard O'Kane, *The Monumental Inscriptions of Historic Cairo*, Inscription Database by Cultnat. O'Kane comments that "The abjad computation comes to 971, later than the date of foundation."

54 Mubarak, *al-Khitat al-tawfiqiya*, 5:111; Mahir, *Masajid Misr*, 5:107.

55 Bates, "Façades in Ottoman Cairo," 151.

56 The Ministry of Religious Endowments, *waqf* number 1176 in al-Haddad, *Mawsuʻat al-ʻimara*, 2:44.

57 Mahir, *Masajid Misr*, 5:111; ʻAmri, *Dirasat*, 39.

58 al-Haddad, *Mawsuʻat al-ʻimara*, Figure 3.

59 al-'Imari, *Dirasat*, 36.

60 al-'Imari, *Dirasat*, 40.

61 Yusuf bin Muhammad Ibn al-Wakil, *Tuhfat al-ahbab bi-man malaka Misr min al-muluk wa-l-nuwwab* (Dar al-Afaq al-ʻArabiya, 1998), 157.

62 The Ministry of Religious Endowments, *waqf* number 1022.

63 Bates, "Façades in Ottoman Cairo," 153.

64 The Ministry of Religious Endowments, *waqf* pages 63–74. The term *turba* used in *waqf* deeds is dealt with in detail in al-Haddad, *Qarafit al-Qahira fi ʻasr salatin al-mamalik.* (Germany, 1986); And al-Haddad, *Mawsuʻat al-ʻimara*, 2:64–65.

65 al-Maqrizi, *Khitat*, 1:313–315 and 2:205–228.

66 Menna M. El Mahy, "Istabl Qawsun: The History and Reconstuction of an Abandoned Palace," master's thesis, American University in Cairo (2017), 53; El Mahy, "'The Secret Garden': Uncovering a Fifteenth Century Extension of Istanbul Qawsun in the Garden of the Cairene Takiya Mawlawiya" (unpublished article, Cairo, 2019), 6.

67 *The Bulletins of the Comité de Conservation des Monuments de l'Art Arabe,* (1906) 23:117.

68 al-Haddad, *Mawsuʻat al-ʻimara*, 2:65.

69 Nahid Hamdi Ahmad, "Watha'iq al-takaya fi al-ʻasr al-ʻuthmani." (Unpublished PhD thesis, Cairo University, 1984). 283.

70 Abu al-ʻAmayim, *Athar al-Qahira al-islamiya*, 84.

71 *The Bulletins of the Comité de Conservation des Monuments de l'Art Arabe,* (1906), 23:117.

72 Hasan 'Abd al-Wahhab, *Tarikh al-masajid al-athariya allati salla fiha faridat al-jum'a sahib al-jalala* (Egyptian General Book Authority, 1946), 1:165.

73 'Abd al-Wahhab, *Tarikh al-masajid al-athariya*, 298; *The Bulletins of the Comité de Conservation des Monuments de l'Art Arabe* (1892–1935) Islamic Art Network, Thesaurus Islamicus Foundation, vol. 23 (1906), 118. http://www.islamic-art.org/comitte/Comité.asp

74 Bates, "Façades in Ottoman Cairo," 154.

75 Mubarak, *al-Khitat al-tawfiqiya*, 5:19.

76 M. Tarek Swelim, "An Interpretation of the Mosque of Sinan Pasha in Cairo," in *Muqarnas X: An Annual on Islamic Art and Architecture* (Brill, 1993), 98.

77 Robert Hay, *Illustrations of Cairo* (Tilt and Bogue, 1840), Plate 27.

78 The Ministry of Religious Endowments, *waqf* number 2869 and a copy of this document is kept in Dar al-Kutub al-Misriya number 813; Swelim, "An Interpretation of the Mosque of Sinan," 101.

79 Hanna, *An Urban History of Bulaq*, figure 9; Swelim, "An Interpretation of the Mosque of Sinan Pasha," 101.

80 Behrens-Abouseif, *Egypt's Adjustment*, 252.

81 Swelim, "An Interpretation of the Mosque of Sinan Pasha," 101.

82 'Abd al-Wahhab, *Tarikh al-masajid al-athariya*, 1:302–05.

83 Swelim, "An Interpretation of the Mosque of Sinan Pasha," footnote 30.

84 Bates, "Façades in Ottoman Cairo," 156.

85 Muhammad bin Abi al-Surur al-Bakri al Siddiqi, *al-Minah al-rahmaniya fi al-dawla al-'uthmaniya* (Dar al-Bashayer Printing and Publishing, 1995), 119. See also: al-Haddad, *Mawsu'at al-'imara*, 2:97.

86 Behrens-Abouseif, *Egypt's Adjustment*, 159.

87 The Ministry of Religious Endowments, *waqf* number 2836.

88 The Ministry of Religious Endowments, *waqf* number 133 lines, 7–8. This is of course different from the early *ribat*s which functioned as military barracks.

89 The Ministry of Religious Endowments, *waqf* number 2836, pages 51–62 and 410–411.

90 Abu al-'Amayim, *Athar al-Qahira al-islamiya*, 98.

91 Abu al-'Amayim, *Athar al-Qahira al-islamiya*, 98.

92 The Ministry of Religious Endowments, *waqf* number 2836, pages 43–45.

93 Chahinda Karim, "The Mosques of the Emirs of al-Nasir Muhammad ibn Qalawun," (unpublished PhD thesis, Cairo University, 1987), 277–298.

94 al-Haddad, *Mawsu'at al-'imara*, 2:80, footnote 2.

95 Muhammad Amin bin Fadl Allah al-Muhabbi al-Hanafi, *Khulasat al-athar fi a'yan al-qarn al-hadi 'ashar* (Press, authoring, translation and publishing committee, 1867), 355–57 and al-Haddad, *Mawsu'at al-'imara*, 2:83.

96 'Asim Muhammad Rizq, *Atlas al-'imara al-islamiya wa-l-qibtiya bi-l-Qahira*, vol. 2. (Madbouly Library, 2003), 302.

97 Abu al-'Amayim, *Athar al-Qahira al-islamiya*, 103

98 al-Haddad, *Mawsu'at al-'imara*, 2:85, footnote 3.

99 Quran 9:18.

100 Mubarak, *al-Khitat al-tawfiqiya*, 3:75.

101 *The Bulletins of the Comité de Conservation des Monuments de l'Art Arabe*, Cahier 3, page 53, report 24, 1885.

102 Abu al-'Amayim, *Athar al-Qahira al islamiya*, 99.

103 Abu al-'Amayim, *Athar al-Qahira al-islamiya*, 100.

104 Abu al-'Amayim, *Athar al-Qahira al-islamiya*, 103; Rizq, *Atlas al-'imara al-islamiya*, 2:314–15.

105 Mubarak, *al-Khitat al-tawfiqiya*, 5:115.

106 Quran 2:144.

107 Mubarak, *al-Khitat al-tawfiqiya*, 3:75 and 5:115.

108 Behrens-Abouseif, *Egypt's Adjustment*, 257–61.

Notes to Chapter 3

1 Behrens-Abouseif, *The Minarets of Cairo: Islamic Architecture from the Arab Conquest to the End of the Ottoman Empire*. (The American University in Cairo Press, 2010), 291.

2 Mubarak, *al-Khitat al-tawfiqiya*, 4:39–41; 'Abd al-Wahhab, *Tarikh al-masajid al-athariya*, 1:308; Raymond, *Cairo*, 219.

3 Abd al-Wahhab, *Tarikh al-masajid al-athariya*, 1:310.

4 Behrens-Abouseif, *The Minarets of Cairo*, 291.

5 Hasan al-Basha, *al-Alqab al-islamiya fi al-ta'rikh wa-l-watha'iq wa-l-athar* (Dar al-Nahda al-'Arabiya bi-l-Qahira, 1989), 2:279–280.

6 Mubarak, *al-Khitat al-tawfiqiya*, 9:243 and vol. 4, 136; al-Haddad, *Mawsu'at al-'imara,* 2:151.

7 Abu al-'Amayim, *Athar al-Qahira al-islamiya,* 145.

8 al-Haddad, *Mawsu'at al-'imara,* 2:157; *The Bulletins of the Comité de Conservation des Monuments de l'Art Arabe* (1882–82), 41.

9 'Abd al-Wahhab, *Tarikh al-masajid al-athariya*, 313.

10 *The Bulletins of the Comité de Conservation des Monuments de l'Art Arabe* (1890), 67.

11 Mubarak, *al-Khitat al-tawfiqiya*, 4:65.

12 Abu al-'Amayim, *Athar al-Qahira al-islamiya*, 145.

13 Qasim, *al-Mazarat al-islamiya*, 6:42 and Abu al-'Amayim, *Athar al-Qahira al-islamiya*, 145.

14 See also al-Haddad, *Mawsu'at al-'imara*, 2:168.

15 Mahir, *Masajid Misr,* 175.

16 Ibn Taghribirdi, *al-Nujum al-zahira*, 9:263, footnote 1.

17 Mahir, *Masajid Misr,* 177.

18 Su'ad Mahir, *al-Khazaf al-Turki*, vol. 2. (al-Jihaz al-Markazi lil-Kutub al-Jami'iya wa-l-Madrasiya wa-l-Wasa'il al-Ta'limiya, 1977), 2: 61–64; And al-Haddad, *Mawsu'at al-'imara*, 2:181.

19 Hans Theunissen, "The Ottoman Tiles of the Fakahani Mosque in Cairo," in *Journal of the American Research Center in Egypt Vol. 53.* Cairo, 2017, 301.

20 Abu al-'Amayim, *Athar al-Qahira al-islamiya*, 154 and Ibn Taghribirdi al-Atabki, *al-Nujum al-zahira*, 9:263.

21 'Abd al-Wahhab, *Tarikh al-masajid al-athariya*, 1:312 and al-Haddad, *Mawsu'at al-'imara*, 2:188.

22 al-Haddad, *Mawsu'at al-'imara*, 2:186, footnote 1.

23 'Abd al-Wahhab, *Tarikh al-masajid al-athariya*, 1:312.

24 Mubarak, *al-Khitat al-tawfiqiya*, 4:102.

25 *The Bulletins of the Comité de Conservation des Monuments de l'Art Arabe* (1936–1940).

26 'Abd al-Wahhab, *Tarikh al-masajid al-athariya*, 1:314.

27 Quran 3:37.

28 Quran 48:1–7.

29 Quran 2:255.

30 Mahmud Hamid al-Husayni, *al-Asbila al-'uthmaniya bi madinat al-Qahira (1517–1798)* (Madbouly Library, 1988), 137.

31 The *deftardar* was equivalent to a finance vizier and this was a post usually occupied by someone sent from Istanbul, but with the increase of the influence of Mamluk beys, they were able to occupy the post. al-Haddad, *Mawsu'at al-'imara*, 2:223.

32 Warner, *Monuments of Historic Cairo*, 96.

33 Qasim, *al-Mazarat al-islamiya*, 6:56; Abu al-'Amayim, *Athar al-Qahira al-islamiya*, 169.

34 al-Haddad, *Mawsu'at al-'imara*, 2:233.

35 al-Haddad, *Mawsu'at al-'imara*, 2:235.

36 Quran 25:1–15.

37 Fanfoni, "Recovery of the Mausoleum of Sunqur Sa'di and Restoration of Mevlevi Takiya," 9.

38 Mubarak, *al-Khitat al-tawfiqiya*, 5:112.

39 Rizq, *Atlas al-'imara al-islamiya*, 2: 1171. And al-Maqrizi, *Kitab al-suluk li-ma'rifat duwal al-muluk* (Dar al-Kutub al-'Ilmiya, 1997), 1:143. And Sakhawi, Muhammad ibn 'Abd al-Rahman, *al-Daw' al-lami' li-ahl al-qarn al-tasi'* (al-Qudsi Library, 1353–55/1934–35), 10:154. And Mahir, *Masajid Misr*, 2:310–14.

40 Quran 9:18.

41 Aisle 1 Quran 24:36–38 and the foundation inscription; aisle 2 Quran 48:1–4 and remains of the foundation inscription; aisle 3 Quran 9:109–111 and remains of the foundation inscription. From al-Haddad, *Mawsu'at al-'imara*, 2:220.

42 Abu al-'Amayim, *Athar al-Qahira al-islamiya*, 193.

43 al-Haddad, *Mawsu'at al-'imara*, 2:322.

44 Mubarak, *al-Khitat al-tawfiqiya*, 6:77.

45 Yusuf bin Muhammad ibn al-Wakil, *Tuhfat al-ahbab wa-l-nuwwab,* 185.

46 Mubarak, *al-Khitat al-tawfiqiya*, 5:128.

47 Muhammad ibn Yarir al-Tabari, "The History of al-Tabari" in *Biographies of the Prophet's Companions and Their Successors,*" vol. 39, translated by Ella Landau-Tasseron (State University of New York Press, 1998).

48 *Waqf* deed of Muhammad Pasha al-Silahdar in the Ministry of Religious Endowments, *waqf* number 932, pages 51–87; al-Haddad, *Mawsu'at al-'imara*, 2:242.

49 The Ministry of Religious Endowments, *waqf* pages 88–102.

50 The details of the research were published in the newspaper al-Yawm al-Sabi', 5 April 2017. "The search for the tomb of 'Amr ibn al-'As by 'Abd al-Baqi al-Sa'id 'Abd al-Hadi."

51 This is described in detail in the *Waqf* document, pages 64–67, but the beautiful fountain described can no longer be seen. al-Haddad, *Mawsu'at al-'imara*, 2:248.

52 The Ministry of Religious Endowments, *waqf* pages 75–76 in al-Haddad, *Mawsu'at al-'imara*, 2:248–49.

53 Rabi'a Hamid Khalifa, *Funun al-Qahira fi al-'ahd al-'uthmani* (Dar Zahra' al-Sharq, 2004), 191–92; al-Haddad, *Mawsu'at al-'imara*, 2:250.

54 The Ministry of Religious Endowments, *waqf* page 74, lines 2–3.

55 Quran 9:18, Quran 2:62, and Quran 3:18.

56 Mubarak, *al-Khitat al-tawfiqiya*, 5:128; and Mahir, *Masajid Misr*, 1:89.

57 Quran 2:355.

58 al-Haddad, *Mawsu'at al-'imara*, 51 and 276.

59 The Ministry of Religious Endowments, *waqf* pages 54–63, in al-Haddad, *Mawsu'at al-'imara*, 276.

60 Abu al-'Amayim, *Athar al-Qahira al-islamiya*, 201.

61 Ibn Taghribirdi al-Atabki, *al-Nujum al-zahira*, 7:14; Abu al-'Amayim, *Athar al-Qahira al-islamiya*, 201.

62 Seif al-Rashidi, "Early Ottoman Architecture in Cairo in the Shadow of Two Imperial Styles." (Unpublished Master's thesis, The American University in Cairo, 1999).

63 Abu al-'Amayim, *Athar al-Qahira al-islamiya*, 201.

64 *The Bulletins of the Comité de Conservation des Monuments de l'Art Arabe*, Cahier 20, report 319: 40–41.

65 *The Bulletins of the Comité de Conservation des Monuments de l'Art Arabe*, Cahier 20, report 319: 40–41.

66 Iman R. Abdulfattah, "Relics of the Prophet and Practices of His Veneration in Medieval Cairo," in *Journal of Islamic Archaeology 1* (United Kingdom, 2014), 82; And al-Maqrizi, *Khitat*, 4:801–04.

67 Ahmad Taymur, *al-Athar al-nabawiya* (Hindawi Foundation for Education and Culture, 2012), 30.

68 Ibn Iyas, *Bada'i' al-zuhur*, 5:68–69.

69 Taymur, *al-Athar al-nabawiya*, 38.

70 Ibn Iyas, *Bada'i' al-zuhur*, 5:68–69.

71 Taymur, *al-Athar al-nabawiya*, 35–37.

72 Abdulfattah, "Relics of the Prophet," 93.

73 Taymur, *al-Athar al-nabawiya*, 38.

74 Evliya Çelebi arrived in Cairo on 4 June 1672 (7 Safar 1083) and stayed for ten years.

75 Abdulfattah, "Relics of the Prophet," 87 and 88.

76 Taymur, *al-Athar al-nabawiya*, 37–38.

77 Taymur, *al-Athar al-nabawiya*, 39.

78 Abu al-'Amayim, *Athar al-Qahira al-islamiya*, 210 and 214; Abdulfattah, "Relics of the Prophet," 89.

79 Abdulfattah, "Relics of the Prophet," 90 and 91.

80 *The Bulletins of the Comité de Conservation des Monuments de l'Art Arabe* (1900), 119–120.

81 Abu al-'Amayim, *Athar al-Qahira al-islamiya*, 210; translated by Iman Abdelfattah, "Relics of the Prophet," 88.

82 *The Bulletins of the Comité de Conservation des Monuments de l'Art Arabe* (1900), 118.

83 Taymur, *al-Athar al-nabawiya*, 19, 50; Abu al-'Amayim, *Athar al-Qahira al-islamiya*, 210.

84 Taymur, *al-Athar al-nabawiya*, 50; Abdulfattah, "Relics of the Prophet," 89.

85 Courtesy of Ibrahim Ramadan's online compilation of photographs, plans, and elevations of Cairene Islamic Monuments, *al-Athar al-islamiya fi al-Qahira wa-l-muhafazat al-ukhra*. https://web.facebook.com/ibrahim.ramadan1953

86 Al-Maqrizi, *Khitat*, 2:369; And Ibn Taghribirdi al-Atabki, *al-Nujum al-zahira*, 7:262, footnote 2.

87 *Mustahfizan* is a term given to the protectors of cities who belong to the Janissary corps.

88 The Ministry of Religious Endowments, *waqf* number 3161, page 1. Another opinion is mentioned stating that he built the mosque after taking land from Ethiopians. Qasim, *al-Mazarat al-islamaya*, 6:95.

89 Mahir, *Masajid Misr*, 5:200.

90 Khalifa, *Funun al-Qahira*, 119.

91 Mahir, *Masajid Misr*, 5:303; 'Abd al-Wahhab, *Tarikh al-masajid al-athariya*, 1:319.

92 Mahir, *Masajid Misr*, 5:202; 'Abd al-Wahhab, *Tarikh al-masajid al-athariya*, 1:318–19.

93 Quran 76:5.; 'Abd al-Wahhab, *Tarikh al-masajid al-athariya*, 1:319; Mahir, *Masajid Misr*, 5:302; al-Haddad, *Mawsu'at al-'imara*, 2:296.

94 André Raymond, "Soldiers in Trade: The Case of Ottoman Cairo," in *British Society for Middle Eastern Studies*. Vol. 18, Cairo, 1991, 23; And *Artisans et commerçants au Caire au XVIIIe siècle* (Damascus: Institut Français de Damascus, 1973–74*), 728; Concepcion G. Añorve-Tschirgi, *The Mosques of Sinan Pasha and Mustafa Shurbagy Mirza as Reflections of Bulaq's Socio-economic Realities; 1571–1698* (master's thesis, The American University in Cairo, 2001), 18.

95 Añorve-Tschirgi, *The Mosques of Sinan Pasha and Mustafa Shurbagy Mirza*, 20.

96 Añorve-Tschirgi, *The Mosques of Sinan Pasha and Mustafa Shurbagy Mirza*, 48.

97 Añorve-Tschirgi, *The Mosques of Sinan Pasha and Mustafa Shurbagy Mirza*, 51.

98 Añorve-Tschirgi, *The Mosques of Sinan Pasha and Mustafa Shurbagy Mirza*.

99 The Ministry of Religious Endowments, *waqf* number 1535, pages 20 and 22; Añorve-Tschirgi, *The Mosques of Sinan Pasha and Mustafa Shurbagy Mirza*, 41; Williams, John A. "The Monuments of Ottoman Cairo," *Collogue International sur l'Historie du Caire,* (Cairo, 1969), 461.

100 The Ministry of Religious Endowments, *waqf* pages 3 and 4; Añorve-Tschirgi, *The Mosques of Sinan Pasha and Mustafa Shurbagy Mirza*, 50.

101 Behrens-Abouseif, *Egypt's Adjustment*, 344.

102 Añorve-Tschirgi, *The Mosques of Sinan Pasha and Mustafa Shurbagy Mirza*, 56.

103 The Ministry of Religious Endowments, *waqf* page 3.

Notes to Chapter 4

1 'Abd al-Rahman al-Jabarti, *'Aja'ib al-athar fi al-tarajim wa-l-akhbar* (Stuttgart: Franz Steiner Verlag, 1994), 2:5; And André Raymond, "Les Constructions de l'Emir 'Abdel Rahman Katkhuda au Caire," *AI 11* (Institut français d'archéologie orientale, 1972), 235.

2 Doris Behrens-Abouseif, "The 'Abd al-Rahman Katkhuda Style in 18th Century Cairo," in *Annales Islamologiques 26* (Institut français d'archéologie orientale, 1992), 120.

3 Behrens-Abouseif, "The 'Abd al-Rahman Katkhuda Style," 120.

4 Behrens-Abouseif, "The 'Abd al-Rahman Katkhuda Style," 124.

5 Abu al-'Amayim, *Athar al-Qahira al-islamiya,* 287.

6 Behrens-Abouseif, "The 'Abd al-Rahman Katkhuda Style," 123.

7 al-Jabarti, *'Aja'ib al-athar*, 1:222 and 250.

8 al-Jabarti, *'Aja'ib al-athar*, 1:222 and 250. In the year 1148/1736, al-Amir Salih Kashef, the husband of Hanem bint Iwaz Bek asked for the *sanjaqiya* (the post of governing a province) from Muhammad Bek Qitas, also known as Qatamish, but was met with opposition. He then pledged help from 'Uthman Katkhuda to kill his three opposing amirs, among whom was Muhammad Qatamish. They met in the house of Muhammad Bek al-Deftardar and had a signal prepared to start the massacre. When the massacre was over and they were checking the deceased, they found 'Uthman Katkhuda dead among them.

9 The Ministry of Religious Endowments, *waqf* pages 34–47; al-Haddad, *Mawsu'at al-'imara* 2:385.

10 Abu al-'Amayim, *Athar al-Qahira al-islamiya,* 1552.

11 al-Haddad, *Mawsu'at al-'imara*, 2:382.

12 Doris Behrens-Abouseif, *Azbakiya and Its Environs from Azbak to Ismail, 1476–1879* (Institut français d'archéologie orientale, 1985), 19–100.

13 Ibn Iyas, *Bada'i' al-zuhur*, 9:116–18; Mubarak, *al-Khitat al-tawfiqiya*, 3:249–251.

14 al-Haddad, *Mawsu'at al-'imara*, 2:394, footnote 1.

15 The Ministry of Religious Endowments, *waqf* page 28 in al-Haddad, *Mawsu'at al-'imara*, 2:399; al-Jabarti, *'Aja'ib al-athar*, 2:435.

16 The Ministry of Religious Endowments, *waqf* number 29 from al-Haddad, *Mawsu'at al-'imara*, 2:403.

17 al-Maqrizi, *Khitat*, 1:357 and 2:30 and 293. *Kitab al-mawa'iz*.

18 Jonathan Bloom, "The Fake Fatimid Doors of the Fakahani Mosque in Cairo," in *Muqarnas 25* [Essays in honor of Oleg Grabar] (Brill, 2008), 231–42. These were restored by the Comité in 1915–19, *The Bulletins of the Comité de Conservation des Monuments de l'Art Arabe*, 38.

19 al-Haddad, *Mawsu'at al-'imara*, 2:426, footnote 1.

20 Ahmad Shalabi 'Abd al-Ghani, *Awdah al-isharat fi man tawalla Misr al-Qahira min al-wuzara' wa-l-bashat al-mulaqab bi-l-tarikh al-'ayni* (Al-Khangi Library for printing, publishing and distribution, 1978), 611–625 in al-Haddad, *Mawsu'at al-'imara*, 2:426.

21 A parallel to this unique motif was found on a chimneypiece, now in the Victoria and Albert Museum (Islamic Middle East, Room 42, The Jameel Gallery, case WN1, shelf EXP) dated 1731 and reportedly rescued from the palace of a high official called Fuad Pasha. In the V&A description, this motif was identified as "pairs of wavy lines" but, in this case, it is surrounded by a sleek scroll of an arabesque.

22 'Abd al-Wahhab, *Tarikh al-masajid al-athariya*, 1:75.

23 Claude Prost, "Les revêtements céramiques dans les monuments musulmans de l'Egypte," in *Mémoires publiés par les membres de l'Institut français d'archéologie orientale* (Cairo, 1918), 25 and Theunissen, "The Ottoman Tiles of the Fakahani Mosque in Cairo," 320.

24 Victoria Meinecke-Berg, "Die osmanische Fliesendekorantion der Aqsunqur Moschee in Kairo," in *Mitteilungen des Deutschen Archaologischen Instituts, Abteilung Kairo*, 29/I (Cairo, 1973), 60.

25 Theunissen, "The Ottoman Tiles of the Fakahani Mosque in Cairo," 321.

26 Al-Maqrizi, *Khitat*, 2:365 wrote that it was built by the Fatimid Vizier Talai' ibn Ruzzik.

27 Mubarak, *al-Khitat al-tawfiqiya*, 5:116 and Ministry of Religious Endowments, *waqf* number 940 dated 1268.

28 Doris Behrens-Abouseif, "The Complex of Sultan Mahmud I in Cairo," in *Muqarnas: An Annual on the Visual Culture of the Islamic World* 28 (Brill, 2011), 200.

29 Daniel Crecelius, *Eighteenth Century Egypt: The Arabic Manuscript Sources* (Regina Books Claremont California, 1990), 59–86.; And Behrens-Abouseif, "The Complex of Sultan Mahmud I," 195.

30 This is the age that started with the Treaty of Passarowitz in 1718 and ended with the Patrona Halil Revolt in 1730. The name Tulip derives from the tulip craze within the Ottoman court society in a period when industry and commerce were being improved and attention to gardens and open spaces was revived, hence the attention to the tulip flower, which signified nobility and privilege. In: Salzmann, Ariel, "The Age of Tulips: Confluence and Conflict in Early Modern Consumer Culture (1550-1730)," in Donald Quataert, *Consumption Studies History of the Middle East and the History of the Ottoman Empire, 1550-1922* (State University of New York Press), 2000.

31 Munir Aktepe, "Mahmud I," in *Encyclopedia of Islam*, 2nd ed., vol. 6, edited by P.J. Bearman (Brill, 1960): 55-58.

32 Mubarak, *al-Khitat al-tawfiqiya*, 3:90 and 6:159.

33 Behrens-Abouseif, "The Complex of Sultan Mahmud I," 196.

34 Jane Hathaway, *Beshir Agha: Chief Eunuch of the Ottoman Imperial Harem (Makers of the Muslim World)* (Oneworld Academic, 2006), 36–37 and 107–09.

35 Behrens-Abouseif, "The Complex of Sultan Mahmud I," 199 figure 32.

36 Bernard O'Kane, *The Monumental Inscriptions of Historic Cairo*, Inscription Database by Cultnat.

37 Behrens-Abouseif, "The Complex of Sultan Mahmud I," 200.

38 Bernard O'Kane, *The Monumental Inscriptions of Historic Cairo*, Inscription Database by Cultnat.

39 More detailed description in the annex of this book, "Four Sabils."

40 Behrens-Abouseif, "The Complex of Sultan Mahmud I," 200–201.

41 Abu al-'Amayim, *Athar al-Qahira al-islamiya*, 392.

42 Nasser Rabbat, "al-Azhar Mosque: An Architectural Chronicle of Cairo's History," in *Muqarnas Volume XIII: An Annual on the Visual Culture of the Islamic World*, ed. Gülru Necipoglu (Brill, 1996), 60.

43 Rabbat, "al-Azhar Mosque," 59–60.

44 Named after the pious shaykh Ahmad al-Dardir who used to pray there near the *mihrab* of 'Abd al-Rahman Katkhuda.

45 'Abd al-Wahhab, *Tarikh al-masajid al-athariya*, 1:59.

46 Ibrahim, *Watha'iq fi khidmat al-athar*, 223–27.; al-Haddad, *Mawsu'at al-'imara*, 2:456, footnote 1.

47 Mubarak, *al-Khitat al-tawfiqiya*, 5:313.

48 Mahir, *Masajid Misr,* 5:252. And al-Haddad, *Mawsu'at al-'imara,* 2:460.

49 'Abd al-Wahhab, *Tarikh al-masajid al-athariya,* 1:351. He adds that the title Abu al-Dhahab was given to him because he distributed gold upon the poor. al-Jabarti, *'Aja'ib al-athar,* 1:417.

50 'Abd al-Wahhab, *Tarikh al-masajid al-athariya,* 1:352.

51 Mubarak, *al-Khitat al-tawfiqiya,* 5:103–105.

52 Mubarak, *al-Khitat al-tawfiqiya,* 5:103–105.

53 al-Jabarti, *'Aja'ib al-athar,* 1:382; Abu al-'Amayim, *Athar al-Qahira al-islamiya,* 429.

54 *The Bulletins of the Comité de Conservation des Monuments de l'Art Arabe,* Cahier 38 report 719: 30–31.

55 Abu al-'Amayim, *Athar al-Qahira al-islamiya,* 431.

56 Abu al-'Amayim, *Athar al-Qahira al-islamiya,* 432.

57 Mubarak, *al-Khitat al-tawfiqiya,* 5: 321–34.; Mahir, *Masajid Misr,* 3:69–71 and 5:271–73.; al-Haddad, *Mawsu'at al-'imara,* 2:494.

58 Mubarak, *al-Khitat al-tawfiqiya,* 5:315–20.

59 Mubarak, *al-Khitat al-tawfiqiya,* 5:319.

60 al-Haddad, *Mawsu'at al-'imara,* 2: page 500, footnote 1.

61 Mubarak, *al-Khitat al-tawfiqiya,* 5:319.

Notes to Conclusion

1 Michael Winter, *Egypt Society under Ottoman Rule 1517–1798* (Routledge, 1992), 9.

2 Bernard Lewis, "Ottoman Observers of Ottoman Decline." In *Islamic Studies,* vol. 1, issue 1, Oxford, 1962. 1:71–72.

3 Mustafa bin 'Abd Allah bin Muhammad al-Costantini, *Dastur al-'amal li-islah al-khalal* (General Authority for National Library and Archives, 1863), 110–32; And Winter, *Egypt Society under Ottoman Rule,* 16–17.

4 Winter, *Egypt Society under Ottoman Rule,* 16.

5 Michael Meineke, "Die Mamlukische Faience dekorationen: Eine Werkstätte aus Tabriz in Kairo (1330–1355)," in *Kunst des Orients,* vol. 2 (Franz Steiner Verlag, 1976–77), 85-114

6 Theunissen, "The Ottoman Tiles of the Fakahani Mosque in Cairo," 294.

7 Theunissen, "The Ottoman Tiles of the Fakahani Mosque," 294–95.

8 Theunissen, "The Ottoman Tiles of the Fakahani Mosque," 313–14.

9 Theunissen, "The Ottoman Tiles of the Fakahani Mosque," 317.

10 Raymond, *Cairo,* 219.

11 Raymond, *Cairo,* 408. endnote 4. Raymond mentions that the document that gives the date and specific nature of the operation was discovered by Nelly Hanna in the Archives of the Tribunal of Bab al-A'li in Cairo (number 73, article 13, 6-6, March 1600).

12 Raymond, *Cairo,* 219, footnote 4.

13 Nelly Hanna, "Culture in Ottoman Egypt," in *The Cambridge History of Egypt: Volume 2: Modern Egypt, from 1517 to the End of the Twentieth Century,* edited by M.W. Daly (Cambridge University Press, 1998), 87.

Notes to Annex

1 Jane Hathaway and Karl Barbir, *Arab Lands under Ottoman Rule 1516–1800* (Routledge, 2020), 110.

2 Quran 2:177, 2:215, 4:36, 9:60, 8:41, 17:26, 30:28, and 59:7. And Saleh Lamei Mostafa, "The Cairene Sabil: Form and Meaning," in *Muqarnas VI: An Annual on Islamic Art and Architecture,* ed. Oleg Grabar (Brill, 1989), 34.

3 Warner, *Monuments of Historic Cairo,* 12.

4 Raymond, *Cairo,* 220.

5 Raymond, *Cairo,* 245.

6 al-Husayni, *al-Asbila al-'uthmaniya,* 28.

7 Edmond Pauty, "Étude sur de monuments l'Égypte de le période ottomane" in the *Bulletins of the Comité de Conservation des Monuments de l'Art Arabe,* fasicule 37, 302.

8 al-Basha, *al-Madkhal ila al-athar al-islamiya,* 201; Mubarak, *al-Khitat al-tawfiqiya,* 1:97.

9 Mubarak, *al-Khitat al-tawfiqiya,* 1:97.

10 Lamei Mostafa, "The Cairene Sabil," 38.

11 Lamei Mostafa, "The Cairene Sabil," 37.

12 Hathaway and Barbir, *Arab Lands under Ottoman Rule,* 112.

13 André Raymond, "Les fontaines publiques (sabil) du Caire à l'époque ottomane (1517–1798)," in *AI 15,* (Institut français d'archéologie orientale, 1979), 236.

14 Husni Nusayr, "Majmu'at subul Qaytbay" (Unpublished master's thesis, Cairo University, 1970), 12.

15 al-Husayni, *al-Asbila al-'uthmaniya,* 35.

16 al-Husayni, *al-Asbila al-'uthmaniya,* 35.

17 al-Husayni, *al-Asbila al-'uthmaniya,* 36.

18 al-Husayni, *al-Asbila al-'uthmaniya*, 35.

19 al-Husayni, *al-Asbila al-'uthmaniya*, 36.

20 al-Husayni, *al-Asbila al-'uthmaniya*, 36.

21 Raymond, *Cairo*, 246.

22 Raymond, *Cairo*, 246.

23 al-Husayni, *al-Asbila al-'uthmaniya*, 308–09.

24 Muhammad Marzuq, *al-Funun al-zukhrufiya al-islamiya fi al-'asr al-'uthmani* (Egyptian General Book Authority, 1970), 26.

25 Muhammad Sayf al-Nasr Abu al-Futuh, *Munsha'at al-ri'aya al-ijtima'iya bi-l-Qahira hata nihayat 'asr al-mamalik* (The National Center for Judicial Studies, 1980), 446.

26 Hathaway and Barbir, *Arab Lands under Ottoman Rule*, 111.

27 al-Husayni, *al-Asbila al-'uthmaniya,* 122.

28 This is the second freestanding *sabil* to be constructed in Cairo after that of Sultan Qaytbay in Saliba. Mahmud Ahmad, *Dalil mujaz li-ashhar al-athar al-'arabiya bi-l-Qahira* (Cairo, 1938), 187.

29 al-Husayni, *al-Asbila al-'uthmaniya*, 122–126.

30 al-Husayni, *al-Asbila al-'uthmaniya*, 127.

31 Mubarak, *al-Khitat al-tawfiqiya*, 3:10 and 6:55.

32 The Ministry of Religious Endowments, *waqf* number 908, page 3, lines 2, 3, 10, and 11.

33 Nusayr, "Majmu'at subul Qaytbay," 18, 107; Lamei Mostafa, "The Cairene Sabil," 35.

34 al-Husayni, *al-Asbila al-'uthmaniya*, 51.

35 Lamei Mostafa, "The Cairene Sabil," 35.

36 Hans Theunissen, "Dutch Tiles in 18th-Century Ottoman Baroque-Rococo Interiors: the Sabil-Kuttab of Sultan Mustafa III in Cairo," in *Electronic Journal of Oriental Studies, 9/3* (2006), 5.

37 Edward William Lane, *The Manners & Customs of the Modern Egyptians* (Nabu Press, Charleston, 2010), 244–45.

38 al-Husayni, *al-Asbila al-'uthmaniya*, 256.

39 al-Husayni, *al-Asbila al-'uthmaniya*, 257.

40 Max Herz, *Catalogue raisonné des monuments exposés dans le musée national de l'art arabe* (Forgotten Books, 1906), 253.

41 M. Zeki Sönmez, "Türk Çiniciliğinde Tekfur Sarayı İmalatı Çiniler," in *Osmanlı'da Çini Seramik Öyküsü.* (Istanbul Stock Exchange Publications, 1997), 29–35; Zeynep Tişkaya, *Galata Surp Krikor Lusavoriç Kilisesi çinileri* (master's thesis, Hacettepe Üniversitesi, Ankara, 2004), 53–59.

Bibliography

'Abd al-Ghani, Ahmad Shalabi. *Awdah al-isharat fi man tawalla Misr al-Qahira min al-wuzara' wa-l-bashat al-mulaqab bi-l-tarikh al-'ayni*. Cairo: Al-Khangi Library for printing, publishing and distribution, 1978.

'Abd al-Wahhab, Hasan. "L'influence ottomane sur l'architecture musulmane en Égypte." In *Proceedings of the 22nd Congress of Orientalists*, edited by Zeki Velidi Togan. Istanbul, 1951; Leiden: Brill, 1957.

———. *Tarikh al-masajid al-athariya allati salla fiha faridat al-jum'a sahib al-jalala*. Cairo: Egyptian General Book Authority, 1946.

Abdulfattah, Iman R. "Relics of the Prophet and Practices of His Veneration in Medieval Cairo." *Journal of Islamic Archaeology* 1 (2014): 75–104.

Abu al-'Amayim, Muhammad. *Athar al-Qahira al-is-lamiya fi al-'asr al-'uthmani*. Istanbul: IRCICA Research Center for Islamic Culture and Arts, 2003.

Abu al-Futuh, Muhammad Sayf al-Nasr. *Munsha'at al-ri'aya al-ijtima'iya bi-l-Qahira hata nihayat 'asr al-mamalik*. Cairo: The National Center for Judicial Studies, 1980.

Ahmad, Mahmoud. *Dalil mujaz li-ashhar al-athar al-'arabi-ya bi-l-Qahira*. Cairo: Ministry of Education, 1938.

Ahmad, Nahid Hamdi. "Watha'iq al-takaya fi al-'asr al-'uthmani." Unpublished PhD diss., Cairo University, 1984.

Aktepe, Munir. "Mahmud I." In *Encyclopedia of Islam*, 2nd ed., vol. 6, edited by P.J. Bearman, 55–58. Leiden: Brill, 1960.

AlSayyad, Nezar. *Cairo: Histories of a City*. 1st ed. London: Belknap Press: An Imprint of Harvard University Press, 2011.

Amin, Muhammad M. *al-Awqaf wa-l-haya al-ijtima'iya fi Misr, 648–923 H / 1250–1517 M: dirasa tarikhiya watha'iqiya*. Cairo: Dar al-Nahda al-'Arabiya bi-l-Qahi-ra, 1980.

Añorve-Tschirgi, Concepcion G. "The Mosques of Sinan Pasha and Mustafa Shurbagy Mirza as Reflections of Bulaq's Socio-economic Realities; 1571–1698." Master's thesis, The American University in Cairo, 2001.

Ayalon, David. "The Eunuchs in the Mamluk Sultanate." In *Studies in Memory of Gaston Wiet*, edited by Myriam Rosen-Ayalon, 267–296. Jerusalem: The Hebrew University of Jerusalem, 1977.

al-Basha, Hassan. *al-Alqab al-islamiya fi al-ta'rikh wa-l-watha'iq wa-l-athar*. Cairo: Dar al-Nahda al-'Arabiya bi-l-Qahira, 1989.

———. *al-Madkhal ila al-athar al-islamiya*. Cairo: Dar al-Nahda al-'Arabiya bi-l-Qahira, 1979.

Bates, Ülkü. "Façades in Ottoman Cairo." In *The Ottoman City and Its Parts: Urban Structure and Social Order*, edited by Irene A. Bierman, Rifa'at Abu-el-Haj, and Donald Preziosi, 129–172. New York: Aristide Caratzas, 1991.

Bayhan, Ahmet Ali. "Misir'daki Arap Harfli Kitabeler Üzerine Bir Degerlendirme." *Journal of Language and Literature*, no. 44 (2017): 251–280.

Behrens-Abouseif, Doris. "The 'Abd al-Rahman Katkhuda Style in 18th Century Cairo." *Annales Islamologiques* 26 (1992): 117–126.

———. *Azbakiya and Its Environs from Azbak to Ismail, 1476–1879*. Cairo: Institut français d'archéologie orientale, 1985.

———. *Cairo of the Mamluks: A History of Architecture and Its Culture*. Cairo: The American University in Cairo Press, 2007.

———. "The Complex of Sultan Mahmud I in Cairo." *Muqarnas: An Annual on the Visual Culture of the Islamic World* 28 (2011): 195–220.

———. *Egypt's Adjustment to Ottoman Rule: Institutions, Waqf & Architecture in Cairo (16th and 17th Centuries)*. Leiden: Brill, 1994.

———. "Four domes of the late Mamluk period." *Annales Islamologiques* 17 (1981): 191–201.

———. *The Minarets of Cairo: Islamic Architecture from the Arab Conquest to the End of the Ottoman Empire*. Cairo: The American University in Cairo, 2010.

———. "The Takiyyat Ibrahim al-Khulshani in Cairo." In *Muqarnas V: An Annual on Islamic Art and Architecture*, edited by Oleg Grabar. Leiden: Brill, 1988.

———. "An Unlisted Monument of the Fifteenth Century: The Dome of Zawiyat al-Damirdaš." *Annales Islamologiques* 18 (1982): 105–121.

Behrens-Abouseif, Doris, and Leonor Fernandes. "Sufi Architecture in the Early Ottoman Period." *Annales Islamogiques* 20 (1984): 103–114.

Blair, Sheila S. and Bloom, Jonathan M., The *Art and Architecture of Islam 1250–1800*. Yale University Press, 1994.

Bloom, Jonathan. "The Fake Fatimid Doors of the Fakahani Mosque in Cairo." *Muqarnas* 25 [Essays in honor of Oleg Grabar] (2008): 231–242.

al-Costantini, Mustafa bin 'Abd Allah bin Muhammad. *Dastur al-'amal li-islah al-khalal*. Cairo: General Authority for National Library and Archives, 1863.

Crecelius, Daniel. *Eighteenth Century Egypt: The Arabic Manuscript Sources*. California: Regina Books, 1990.

Denoix, Sylvie. "A Mamluk Institution for Urbanization: The Waqf" In *The Cairo Heritage*, 191–202. Cairo: The American University in Cairo Press, 2000.

al-Dessouki, Shadia. "Ashghal al-khashab fi al-'ama'ir al-diniya al-'uthmaniya bi-madinat al-Qahira." Unpublished Master's thesis, Cairo University, 1985.

al-'Emari, Amal. *Dirasat fi watha'iq Dawud Basha wali Misr*. Cairo: al-Matba'a al-Misiriyya, 1986.

Evliya Çelebi. *Seyahatnamesi (1672–1680)*. Istanbul: State Printing Office, 1938.

Eyice, Semavi. "Tekfur Sarayı." In *Dünden bugüne İstanbul ansiklopedisi*. Istanbul: The Turkish Ministry of Culture and History Foundation, 1993–95.

Fanfoni, Giuseppe. "Recovery of the Mausoleum of Sunqur Sa'di and Restoration of Mevlevi Takiya." In *CFPR*. Cairo: Dar al-Kutub, 2009.

Fernandes, Leonor. "The Foundation of Baybers al-Jashankir." In *Muqarnas IV: An Annual on Islamic Art and Architecture*, edited by Oleg Grabar. Leiden: Brill, 1987.

———. "Three Sufi Foundations in a 15th Century Waqfiya." In *Annales Islamologiques* 17 (1981).

Garcin, Jean-Claude. *Catalogue général du Musée Arabe du Caire. Lampes et bouteilles en verre émaillé*. Cairo: Institut français d'archéologie orientale, 1929.

———. "Deux saints populaires du Caire au début du XVI siècle." In *Le Bulletin d'études orientales* 29 (1977): 131–143.

al-Haddad, Muhammad Hamza Isma'il. *Mawsu'at al-'imara al-islamiya fi Misr: min al-fath al-'uthmani ila nihayat 'ahd Muhammad 'Ali, 923–1265 H/1517–1848 M*, vol. 2. Cairo: Dar Zahra' al-Sharq, 1998.

———. *Qarafit al-Qahira fi 'asr salatin al-mamalik*. Germany, 1986.

Hain, Kathryn. "Devshirme is a Contested Practice," *Historia: the Alpha Rho Papers* vol. II (2012): 165-176.

Hanna, Nelly. *An Urban History of Bulaq in the Mamluk and Ottoman Periods,* Supplément aux Annales Islamologiques. *International Journal of Middle East Studies* 18, no. 3 (1983): pp. ix, 112.

———. "Culture in Ottoman Egypt." In *The Cambridge History of Egypt: Volume 2: Modern Egypt, from 1517 to the End of the Twentieth Century*, edited by M.W. Daly. Cambridge University Press, 1998.

Hathaway, Jane. *Beshir Agha: Chief Eunuch of the Ottoman Imperial Harem (Makers of the Muslim World)*. London: Oneworld Academic, 2006.

———. "The Chief Harem Eunuch of the Ottoman Empire: Servant of the Sultan, Servant of the Prophet." In *Celibate and Childless Men in Power: Ruling Eunuchs and Bishops in the Pre-Modern World*, edited by Almut Hofert, M. Mesley, and S. Tolino, 211-225. London: Routledge, 2017.

Hathaway, Jane and Karl Barbir. *Arab Lands under Ottoman Rule 1516–1800*. London: Routledge, 2020.

Hautecoeur, Louis and Gaston Jean Wiet. *Les mosquées du Caire*. Paris: Hachette, 1932.

Hay, Robert. *Illustrations of Cairo*. London: Tilt and Bogue, 1840.

Herz, Max. *Catalogue raisonné des monuments exposés dans le musée national de l'art arabe*. Cairo: Forgotten Books, 2019.

Husayn, Fawzi. *Ma'azin al-Qahira*. Cairo: Dar al-Kitab al-'Arabi, 1969.

al-Husayni, Mahmud Hamid. *al-Asbila al-'uthmaniya bi madinat al-Qahira (1517–1798)*. Cairo: Madbouly Library, 1988.

Ibn al-Wakil, Yusuf bin Muhammad. *Tuhfat al-ahbab bi-man malaka Misr min al-muluk wa-l-nuwwab*. Cairo: Dar al-Afaq al-'Arabiya, 1998.

Ibn Iyas, Muhammad ibn Ahmad. *Bada'i' al-zuhur fi waqa'i' al-duhur*. Cairo: Dar al-Fikr, 1982–84.

Ibn Khaldun. *al-Ta'rif bi-ibn Khaldun wa rihalatihi gharban wa sharqan*, edited by Muhammad ibn Tawit at-Tanji. Cairo, 1951.

Ibn Taghribirdi al-Atabki, Jamal al-Din Abu al-Mahasin Yusuf. *al-Nujum al-zahira fi muluk Misr wa-l-Qahira*. Cairo: al-Mu'assasa al-misriya al-'amma lil-ta'lif wa-l-taba'a wa-l-nashr, 1971.

Ibrahim, 'Abd al Latif. *al-Watha'iq fi khidmat al-athar al-'asr al-mamluki*. Cairo: Dar al-Tiba'a al-Haditha, 1980.

al-Jabarti, 'Abd al-Rahman. *'Aja'ib al-athar fi al-tarajim wa-l-akhbar*. Stuttgart: Franz Steiner Verlag, 1994.

Karim, Chahinda. "The Mosques of the Emirs of al-Nasir Muhammad ibn Qalawun." Unpublished PhD diss., Cairo University, 1987.

Kessler, Christel. "Funerary Architecture within the City." In *Colloque international sur l'histoire du Caire*, 257–267. Cairo: Ministry of Culture, 1996.

Khalifa, Rabi'a Hamid. *Funun al-Qahira fi al-'ahd al-'uthmani*. Cairo: Dar Zahra' al-Sharq, 2004.

Kuran, Aptullah. *The Mosque in Early Ottoman Architecture*. Chicago: Center for Middle Eastern Studies, 1968.

Lamei Mostafa, Saleh. "The Cairene Sabil: Form and Meaning." In *Muqarnas VI: An Annual on Islamic Art and Architecture*, edited by Oleg Grabar. Leiden: Brill, 1989.

Lane, Edward William. *The Manners & Customs of the Modern Egyptians*. Charleston: Nabu Press, 2010.

Lewis, Bernard. "Ottoman Observers of Ottoman Decline." *Islamic Studies* 1, no. 1 (1962): 71–87.

Mahir, Su'ad. *Masajid Misr wa awliya'uha al-salihun*. Cairo: al-Majlis al-A'la lil-Shu'un al-Islamiya, 1971.

———. *al-Khazaf al-Turki*, vol. 2. Cairo: al-Jihaz al-Markazi lil-Kutub al-Jami'iya wa-l-Madrasiya wa-l-Wasa'il al-Ta'limiya, 1977.

El Mahy, Menna M. "Istabl Qawsun: The History and Reconstuction of an Abandoned Palace." Master's thesis, American University in Cairo, 2017.

———. "'The Secret Garden': Uncovering a Fifteenth Century Extension of Istabl Qawsun in the Garden of the Cairene Takiya Mawlawiya." Unpublished article, Cairo, 2019.

Mantran, Robert. "L'Égypte au xix-e siècle," in *du Colloque International sur l'Égypte au XIXe siècle.* Paris: Éditions du Centre national de la recherche scientifique, 1982.

al-Maqrizi, Taqi al-Din Ahmad ibn 'Ali. *Kitab al-mawa'iz wa-l-i'tibar bi-dhikr al-khitat wa-l-athar yakhtassu dhalika bi-akhbar Iqlim Misr wa-l-Nil wa-dhikr al-Qahira wa-ma yata'allaq bi-ha wa-bi-Iqli-miha.* Beirut: Dar al-Gharb al-Islami, 1987.

———. *Kitab al-suluk li-ma'rifat duwal al-muluk.* Beirut: Dar al-Kutub al-'Ilmiya, 1997.

Marzuq, Muhammad. *al-Funun al-zukhrufiya al-Is-lamiya fi al-'asr al-'uthmani.* Cairo: Egyptian General Book Authority, 1970.

El-Masry, Ahmed M. *Die Bauten von Hadim Sulaiman Pascha, (1468–1548), nach sein-en Urkunden im Ministerium für Fromme Stiftungen in Kairo.* Berlin: Klaus Schwarz, 1991.

Mehren, August Ferdinand. *Câhirah og Kerafât - historiske studier under et ophold i Aegypten.* Copenhagen: J.H. Schultz, 1867–68.

Meinecke-Berg, Victoria. "Die osmanische Fliesendekorantion der Aqsunqur Moschee in Kairo." In *Mitteilungen des Deutschen Archaologischen Instituts, Abteilung Kairo, 29/I.* Cairo, 1973.

Meineke, Michael. "Die Architektur des 16. Jahrhunderts in Kairo, nach der osmanischen Eroberung von 1517." In *IVeme congres internatio-nal d'art Turc,* 145–152. Aix-en-Provence: Éditions de l'Université de Provence, 1976.

———. "Die Mamlukische Faience dekorationen: Ei ne Werkstätte aus Tabriz in Kairo (1330–1355)." In *Kunst des Orients, vol. 2,* 85-114. Germany: Franz Steiner Verlag, 1976–77.

al-Miligy, 'Ali Mahmud Suleiman. "al-Tiraz al-'uth-mani fi 'Ama'ir al-Qahira al-diniya." PhD diss., Cairo University, 1980.

Mubarak, 'Ali. *al-Khitat al-tawfiqiya al-jadida li-Misr al-Qahira wa-muduniha wa-biladiha al-qadima wa-l-shahira.* Cairo: Egyptian General Book Authority, 1986.

al-Muhabbi al-Hanafi, Muhammad Amin bin Fadl Allah. *Khulasat al-athar fi a'yan al-qarn al-hadi 'ashar.* Cairo: Press, authoring, translation and publishing committee, 1867.

al-Nabulsi. *al-Haqiqa wa-l-majaz fi al-rihla ila bilad al-Sham wa Misr wa-l-Hijaz,* edited by Ahmad 'Abd al-Majid al-Haridi. Cairo: Egyptian General Book Authority, 1986.

Nusayr, Husni. "Majmu'at subul Qaytbay." Unpublished Master's thesis, Cairo University, 1970.

O'Kane, Bernard. *The Monumental Inscriptions of Historic Cairo.* Inscription Database by Cultnat.

Pauty, Edmond. "L'architecture au Caire depuis la conquête ottomane." *BIFAO* 36 (1936–7): 1–69.

———. "Étude sur de monuments l'Égypte de le période Ottomane." In the *Bulletins of the Comité de Conservation des Monuments de l'Art Arabe,* fasicule 37, 295–308.

Prisse d'Avennes, Achille-Constant-Théodore-Émile. *L'Art arabe d'après les monuments du Kaire depuis le VIIe siècle jusqu'à la fin du XVIIIe.* Paris: Le Sycomore, 1983.

Prost, Claude. "Les revêtements céramiques dans les monuments musulmans de l'Égypte." In *Mémoires publiés par les membres de l'Institut français d'archéologie orientale.* Cairo, 1918.

Qasim, Hasan. *al-Mazarat al-islamiya wa-l-athar al-'arabiya fi Misr wa-l-Qahira al-mu'izziya.* Alexandria: Maktabat al-Iskandariya, 2018.

Rabbat, Nasser. "al-Azhar Mosque: An Architectural Chronicle of Cairo's History." In *Muqarnas Volume XIII: An Annual on the Visual Culture of the Islamic World,* edited by Gülru Necipoglu, 45–67. Leiden: Brill, 1996.

Ramadan, Fahmy Abdel Alim. "The Mosque of Suleyman Pasha 'Sariyat al-Gabal.'" In *Seventh International Congress of Turkish Art*, edited by Tadeusz Majda. Warsaw: Polish Scientific Publishers, 1990.

al-Rashidi, Seif. "Early Ottoman Architecture in Cairo in the Shadow of Two Imperial Styles. Master's thesis, The American University in Cairo, 1999.

Rawson, Jessica. *Chinese Ornament, the Lotus and the Dragon*. London: British Museum Press, 1984.

Raymond, André. "Architecture and Urban Development: Cairo during the Ottoman Period, 1517–1798." In *Arab Cities in the Ottoman Period: Cairo, Syria and the Maghreb*. Aldershot: Ashgate Variorum, 2002.

———. *Artisans et commerçants au Caire au XVIIIe siècle*. Damascus: Institut français de Damascus, 1973–74.

———. *Cairo*. Translated by Willard Wood. Cambridge, MA: Harvard University Press, 2000.

———. "Cairo's Area and Population in the Early 15th Century." In *Muqarnas II*, 21–32, Leiden: Brill, 1984.

———. "Les Constructions de l'Emir 'Abdel Rahman Katkhuda au Caire." *Annales Islamologiques* 11 (1972): 235–251.

———. "Les fontaines publiques (sabil) du Caire à l'époque ottomane (1517–1798)." In *Annales Islamologiques* 15 (1979): 235–291.

———. *Influences d'Istanbul sur l'architecture et le décor au Caire, au milieu du XVIIIème siècle*. Damascus, Damaszener Mitteilungen, 1999. Volume: 11, Pages: 379-383.

———. "Soldiers in Trade: The Case of Ottoman Cairo." *British Society for Middle Eastern Studies* 18 (1991): 16–37.

Rizq, 'Asim Muhammad. *Atlas al-'imara al-islamiya wa-l-qibtiya bi-l-Qahira*, vol. 2. Cairo: Madbouly Library, 2003.

Sakhawi, Muhammad ibn 'Abd al-Rahman. *al-Daw' al-lami' li-ahl al-qarn al-tasi'*. Cairo: al-Qudsi Library, 1353–55/1934–35).

Salzmann, Ariel. "The Age of Tulips: Confluence and Conflict in Early Modern Consumer Culture (1550-1730)." In *Consumption Studies History of the Middle East and the History of the Ottoman Empire, 1550-1922*, edited by Donald Quataert. State University of New York Press, 2000.

Sarhank, Isma'il. *Haqa'iq al-akhbar 'an duwal al-bihar*. Cairo: al-Tab'a al-Amiriya, 1898.

al-Siddiqi, Muhammad bin Abi al-Surur al-Bakri. *al-Minah al-rahmaniya fi al-dawla al-'uthmaniya*. Cairo: Dar al-Bashayer Printing and Publishing, 1995.

Shahin, Alaa ad-Din. "Qaytbay's Decoration: An Analysis of the Architectural Decoration of Various Cairene Facades from the Period of Qaytbay." Unpublished Master's thesis, the American University in Cairo, 1987.

al-Sha'rani, 'Abd al-Wahhab. *al-Tabaqat al-kubra*. Cairo: Mustafa al-Babi al-Halabi, 1954.

Shaw, Stanford J. *The Financial and Administrative Organization and Development of Ottoman Egypt, 1517-1798*. Princeton University Press, 1962.

Shinnawi, 'Abd al-'Aziz Muhammad. *al-Dawla al-'uthmaniya: dawla islamiya muftara 'alayha*. Cairo: The Anglo-Egyptian Library, 1980.

Sönmez, M. Zeki. "Türk Çiniciliğinde Tekfur Sarayı İmalatı Çiniler." In *Osmanlı'da Çini Seramik Öyküsü*. Istanbul: Istanbul Stock Exchange Publications, 1997.

Staffa, Susan. *Conquest and Fusion: The Social Evolution of Cairo A.D. 642–1850*. Leiden: Brill, 1977.

Swelim, M. Tarek. "An Interpretation of the Mosque of Sinan Pasha in Cairo." In *Muqarnas X: An Annual on Islamic Art and Architecture*, 98–107. Leiden: Brill, 1993.

al-Tabari, Muhammad ibn Yarir. *The History of al-Tabari: Biographies of the Prophet's Companions and Their Successors*, Vol. 39, translated by Ella Landau-Tasseron. New York: State University of New York Press, 1998.

Taymur, Ahmad. *al-Athar al-nabawiya*. Cairo: Hindawi Foundation for Education and Culture, 2012.

al-Tawil, Tawfiq. *al-Tasawwuf fi Misr ibbana al-ʿasr al-ʿuthmani*. Cairo: Maktabat al-Adab, 1988.

Theunissen, Hans. "Dutch Tiles in 18th-Century Ottoman Baroque-Rococo Interiors: the Sabil-Kuttab of Sultan Mustafa III in Cairo." *Electronic Journal of Oriental Studies* 9, no. 3 (2006): https://www.academia.edu/16486649/Dutch_Tiles_in_18th_Century_Ottoman_Baroque_Rococo_Interiors_the_Sabil_Kuttab_of_Sultan_Mustafa_III_in_Cairo

———. "The Ottoman Tiles of the Fakahani Mosque in Cairo." *Journal of the American Research Center in Egypt* 53 (2017): 287–330. https://lockwoodonlinejournals.com/index.php/jarce/article/view/236

The Bulletins of the Comité de Conservation des Monuments de l'Art Arabe (1892-1935), Islamic Art Network, Thesaurus Islamicus Foundation, http://www.islamic-art.org/comitte/Comite.asp

Tişkaya, Zeynep. *Galata Surp Krikor Lusavoriç kilisesi çinileri*. Unpublished Master's thesis, Hacettepe Üniversitesi, Ankara, 2004. https://www.academia.edu/16486695/The_Dutch_Tiles_of_Surp_Krikor_Lusavori%C3%A7_Church_in_%C4%B0stanbul

Turan, Ebru, "The Marriage of Ibrahim Pasha (ca. 1495-1536): The Rise of Sultan Süleyman's Favorite to the Grand Vizierate and the Politics of the Elites in the Early Sixteenth-Century Ottoman Empire." *Acta Biologica Turcica* 41, (2009), 3.

Unsal, Behçet. *Turkish Islamic Architecture in Seljuk and Ottoman Times, 1071–1923*. London: Alec Tiranti, 1959.

Warner, Nicholas. *Monuments of Historic Cairo: A Map and Descriptive Catalogue*. Cairo : The American University in Cairo Press, 2005.

Wiet, Gaston Jean. *Journal d'un bourgeois du Caire. Ibn Iyâs, Histoire des mamlouks*, vol. 2. Paris: Bibliothèque générale de l'École Pratique des Hautes Études, VIe section, 1960.

———. "Matériaux pour servir à la géographie de l'Égypte." *Annales Islamologiques* 26 (1919): 233–269.

Williams, Caroline. *Islamic Monuments in Cairo: The Practical Guide*. Cairo: The American University in Cairo Press, 2002.

Williams, John A. "The Monuments of Ottoman Cairo." In *Collogue International sur l'Histoire du Caire*. Cairo: Ministry of Culture of the Arab Republic of Egypt, General Egyptian Book Organization, 1969.

Winter, Michael. *Egypt Society under Ottoman Rule 1517–1798*. London: Routledge, 1992.

Yeomans, Richard. *The Art and Architecture of Islamic Cairo*. Garnet Publishing, 2006.

Index

The monument number is in parentheses after the name. A page number in *italic* refers to a figure. A page number followed by n and a number refers to a page and a note number.